1214517

D1619186

Debating Authenticity

DEBATING AUTHENTICITY

Concepts of Modernity in Anthropological Perspective

Edited by

Thomas Fillitz and A. Jamie Saris

with the editorial help of Anna Streissler

Berghahn Books
New York • Oxford

Published in 2013 by
Berghahn Books
www.berghahnbooks.com

©2013 Thomas Fillitz and A. Jamie Saris

All rights reserved. Except for the quotation of short passages
for the purposes of criticism and review, no part of this book
may be reproduced in any form or by any means, electronic or
mechanical, including photocopying, recording, or any information
storage and retrieval system now known or to be invented,
without written permission of the publisher.

Library of Congress Cataloging-in-Publication Data

Debating authenticity : concepts of modernity in anthropological perspective / Thomas Filitz and A. Jamie Saris, [editors].
 p. cm.
 Includes bibliographical references and index.
 ISBN 978-0-85745-496-6 (hardback : alk. paper) – ISBN 978-0-85745-497-3 (ebook)
 1. Anthropology–Philosophy. 2. Authenticity (Philosophy) I. Filitz, Thomas. II. Saris, A. Jamie.
 GN33.D44 2012
 301.01–dc23
 2011052019

British Library Cataloguing in Publication Data

A catalogue record for this book is available from the British Library

Printed in the United States on acid-free paper.

ISBN 978-0-85745-496-6 (hardback)
ISBN 978-0-85745-497-3 (ebook)

Contents

List of Figures vii

Acknowledgements ix

Introduction. Authenticity Aujourd'hui 1
 Thomas Fillitz and A. Jamie Saris

Part I. Authenticity and Authenticating

1. Revisiting 'Culture, Genuine and Spurious': Reflections on Icons and Politics in Ireland 27
 A. Jamie Saris

2. Deceptive Tentacles of the Authenticating Mind: On Authenticity and Some Other Notions That are Good for Absolutely Nothing 46
 Rajko Muršič

Part II. Moral Discourses of Authenticity

3. Authentic Wilderness: The Production and Experience of Nature in America 63
 Lawrence J. Taylor

4. The Moral Economy of Authenticity and the Invention of Traditions in Franche-Comté (France) 78
 Jean-Pierre Warnier

5. 'Oh, That's So Typical!' Discussing Some Spanish 'Authentic' Essential Traits 91
 Jorge Grau Rebollo

Part III. Authenticity: Popular and Academic Discourses

6. Is Form Really Primary or, What Makes Things Authentic? Sociality and Materiality in Afro-Brazilian Ritual and Performance 111
 Inger Sjørslev

7. A Cultural Search for Authenticity: Questioning Primitivism 128
 and Exotic Art
 Paul van der Grijp

8. Wooden Pillars and Mural Paintings in the Saudi South-west: 142
 Notes on Continuity, Authenticity and Artistic Change in
 Regional Traditions
 Andre Gingrich

9. True to Life: Authenticity and the Photographic Image 160
 Marcus Banks

Part IV. Entangled Spaces of Authenticity

10. Questions of Authenticity and Legitimacy in the 175
 Work of Henri Gaden (1867–1939)
 Roy Dilley

11. Constructing Culture through Shared Location, *Bricolage* 196
 and Exchange: The Case of Gypsies and Roma
 Judith Okely

12. Cultural Regimes of Authenticity and Contemporary Art of Africa 211
 Thomas Fillitz

Notes on Contributors 226

Index 229

List of Figures

1.1.	Old money made into jewellery.	35
1.2.	Two boys on a horse. Picture Jamie Saris.	38
1.3.	The Horse Protest: Eddie Kershaw in front of Mansion House.	41
3.1.	Frederic Church, 1846, *Hooker and Company Journeying through the Wilderness from Plymouth to Hartford in 1636*. The Wadsworth Athenaeum.	68
3.2.	Edward Moran, 1875, *Mountain of the Holy Cross*. Autry Museum of Western Heritage, Los Angeles.	69
5.1.	*Bailaora* magnet. Picture Jorge Grau Rebollo.	92
5.2.	Refraction as intentional distortion. Diagram Jorge Grau Rebollo.	94
5.3.	Bullfight as souvenir. Picture Jorge Grau Rebollo.	97
5.4.	*Torero* and *Bailaora* costumes. Picture Jorge Grau Rebollo.	98
5.5.	The silhouette of the bull, found throughout Spain. Picture Jorge Grau Rebollo.	98
5.6.	Flag and bull: two national icons embodying a new one displayed at many news-stands in tourist locations. Picture Jorge Grau Rebollo.	99
5.7.	The Catalan donkey on a starred Catalan flag next to the 'Spanish' bull. Picture Jorge Grau Rebollo.	99
5.8.	A pile of typically Mexican/Spanish hats. Picture Jorge Grau Rebollo.	100
5.9.	A piece of folk authenticity. Picture Jorge Grau Rebollo.	101
8.1.	Geo-morphological map of Saudi Arabia's south-western provinces (from Dostal 2007).	147
8.2.	Defence architecture of a mountain hamlet in Bilad Zahran, al-Baha province. Picture Andre Gingrich.	147
8.3.	Main varieties of village architecture in southern Hijaz and Asir (from Gingrich 2007).	148
8.4.	The village of Dhi 'Ayn below the escarpment face of southern Hijaz. Picture Andre Gingrich.	149
8.5.	Decorated wooden pillar in a living room of southern Hijaz. Picture Andre Gingrich.	149
8.6.	Defence architecture of a rural skyscraper in northern Asir. Picture Pascal and Marie Maréchaux.	150

8.7.	Mural paintings from earth colours inside a living room of Asir. Picture Andre Gingrich.	151
8.8.	Mural paintings from industrial colours on external walls of an Asiri village. Picture Pascal and Marie Maréchaux.	154
9.1.	A reproduction of a contact print taken from the original glass-plate negative of 'Frances with the fairies', July 1917, taken by Elsie Wright. Photograph courtesy of Brotherton Collection, University of Leeds, England.	162
9.2.	A frame still from the Crown Film Unit production *In Rural Maharashtra* (1945), a film about agricultural production in India during the Second World War. Note the strong diagonals and vanishing-point perspective in the image. Photograph courtesy of the National Film and Television Archive, Pune, India.	165
10.1.	Henri Gaden as a young man and colonial officer early in his military career. Archives municipales de Bordeaux, copyright cliché A.M. Bordeaux.	178
10.2 and 10.3.	Two images of Samory Touré, taken by Gaden, the second of which was immediately after his capture by a detachment of troops led by Gaden at the camp of the resistance leader near Nzo, West Africa, September 1898. Archives municipales de Bordeaux, copyright cliché A.M. Bordeaux.	179
10.4.	A scene captured by Gaden of the interior of a colonial building with a French officer, champagne glasses, attendants and a local woman. No date or location given, but probably taken after the Samory campaign. The juxtaposition of these diverse and striking images in the scene doubtless appealed to Gaden's sense of irony.	180
10.5.	A picture by Gaden of French colonial troops moving through the West African bush, 1897–98. Archives municipales de Bordeaux, copyright cliché A.M. Bordeaux.	182
10.6.	A picture by Gaden of French colonial troops moving through the West African bush, 1897–98. Archives municipales de Bordeaux, copyright cliché A.M. Bordeaux.	183
10.7.	A girl at Beyla with a French officer, n.d., probably between 1897–99. Archives municipales de Bordeaux, copyright cliché A.M. Bordeaux.	184
10.8.	A detachable European shirt cuff inscribed with an Islamic amulet to protect the wearer from injury by metal objects, from Gaden's archive in Centre des Archives d'Outre-Mer, Aix-en-Provence (15 APC 1(7), item 117), n.d. Picture by Roy Dilley from Centre d'Archives d'Outre Mer, Aix-en-Provence.	189

Acknowledgements

The contributions to this volume were presented at a ten-day Sokrates-Erasmus Intensive Programme in August 2006 at the Department of Social and Cultural Anthropology of the University of Vienna.

Fourteen scholars, affiliated to the University of Copenhagen, the Autonomous University of Barcelona, the University René Descartes/Paris-5, the University of Sciences et Technologies/Lille-1, the National University of Ireland/Maynooth, the University of Ljubljana, the University of Stockholm, Brunel University, the University of St. Andrews, the University of Oxford and the University of Vienna examined the social practices that produce authenticity, as well as the regional, national and global circuits that make authenticity a stake in the lives of people in concrete social-historical circumstances.

We regret that Johan Lindquist from Stockholm and Werner Zips from Vienna, who delivered papers at the seminar, finally could not contribute to this collection. We wish however to thank them for their active participation. Our colleagues Anna Streissler and Ulrike Davis-Sulikowski (both University of Vienna) have produced invaluable comments on authenticity during the event in Vienna, as did the participating students from the various partner institutions: Andreas Bandak and Peter Bjerregaard (University of Copenhagen), Mario Buletic (Autonomous University of Barcelona), Sabrina Hamache and Anthony Mahe (University René Descartes/Paris-5), Clothilde Sabre and Laurence Nabitz (University of Sciences et Technologies/Lille-1), Fiona Larkan and Fiona Murphy (National University of Ireland/Maynooth), Katarina Altshul, Jana Drasler and Sarah Lunacek (University of Ljubljana), Johanna Gullberg and Hanna Sarnecki (University of Stockholm), Sarah Winkler-Reid (Brunel University), Jan Grill (University of St. Andrews), Saadia Abid, Rao Nadeem Alam, Stefan Bayer, Sabina Bernhard, Sabine Decleva, Julia Doppler, Christina Fischer, Rita Glavitza, Melanie Haider, Gregor Jakob, Judith Keppel, Theresa Leissinger, Kathrin Leitner, Georg Leitner, Severin Lénart, Alexander Maleev, Martin Nagele, Maximilian Neusser, Wanako Oberhuber, Julia Oberreiter, Nadja Petsovits, Johannes Pitschl, Lena Possliner, Katharina Schallerl, Eva Schmid, Katja Seidel, Julia Sonnleitner, Claudia Trupp, Stefan Wolf (University of Vienna) and Monika Weissensteiner (University of Bologna).

The European Commission financed this seminar as a Sokrates-Erasmus Intensive Programme (28545–IC-2–2004–1–AT-ERASMUS-IPUC-3). The Austrian National Agency co-funded the project, the University of Vienna and the Department

of Social and Cultural Anthropology provided the infrastructure and the technical equipment. These two institutions also sponsored the participation of Marcus Banks (University of Oxford). We thank all these institutions for their generous funding and support.

We are grateful to Berghahn Books and Ann Przyzycki, Associate Editor, for supporting this project and Mark Stanton for his expert editorial work.

Last but not least, we wish to express our particular, deep gratitude to Anna Streissler. Without her insight, her ideas, her engagement and energy, neither the Sokrates-Erasmus Intensive Programme, nor the production of this collection would have been possible: Anna co-organized this seminar and has acted as editorial assistant for the present volume.

<div style="text-align: right;">
Thomas Fillitz and A. Jamie Saris

Vienna and Maynooth, Spring 2012
</div>

Introduction

AUTHENTICITY AUJOURD'HUI

Thomas Fillitz and A. Jamie Saris

Introduction

It is difficult to live in Europe or North America and not be struck by the ubiquity of the notion of authenticity and cognate terms in the society at large. Modern consumer society in late capitalism is intimately entwined with debates about authenticity, not just with products, whose validity needs somehow to be authorized – from organic food to art (that is, the sense of authentic origins) – but also with respect to certain sorts of experiences and ways of being-in-the-world (that is, in the sense of the authentic correspondence of content). At this level, authenticity presents us with some productive ambiguities. The modern deployment of authenticity – from its use to sell certain kinds of food, exotic artefacts, works of art, to particular kinds of experiences, such as adventure holidays – presupposes that there is a downmarket variety of what is on offer. Cost is one of the ways of avoiding this part of the market, but connoisseurship is even more necessary. Some marketers such as Michael Silverstein, for example, discuss this phenomenon in terms of a 'Treasure Hunt': with consumers willing to spend considerable time saving money on some items in order to devote more time and resources to discover socially sanctioned value for specific purchases (Silverstein and Butman 2006). Yet, the basis of this connoisseurship is always imperilled as the market massifies, as the treks become easier, and as just what constitutes a genuine class of consumer item becomes subject to ever-greater scrutiny and scepticism (again, think of organic food). Authenticity, then, possesses a surprising social resonance at this moment in history – at once po-faced and ironic – its conditions of possibility seem to be constantly rendered untenable even as it enthusiastically engages more and more of our collective lifeworld.

Our starting point, then, is that authenticity and inauthenticity need to be understood as part of the same process of situated social actors engaging culturally salient ends. Its explosive growth in ideological importance may indeed be a recent concern,

as the philosophers tell us (especially Trilling 1971, Berman 2009, and Taylor 2003), but its social deployment always requires a specific type of work: an understanding of (and developing ways of avoiding) the inauthentic, whether this opposition exists as a barrier to personal achievement, as the nefarious resource of the despised other, as a challenge to the integrity of the self, or as the cunning fake that can, at times, fool even the most sophisticated connoisseur. In other words, the quest for authenticity (Lindholm 2008) requires collective work to discover, recognize and authorize the 'real thing', as well as collective effort to thrust away its opposite.

Into the Field: Anthropology and the Authentic

Viewed thought this optic, anthropology's engagement with authenticity has been complex and deep-rooted, precisely because of the way that debates about authenticity demonstrate the necessary connectedness of terms that are often taken to be far apart in other social sciences, such as individual and social or cultural and psychological. On the one hand, authenticity highlights the philosophical roots in various thinkers who can be loosely labelled 'Romantic', and, on the other, it exposes some of the peculiar ambiguities and opportunities that the primary methodological tools of the discipline, that is long-term ethnographic fieldwork, provided for its practitioners. In other words, anthropology has had, from the beginning, what one might call a professional interest in, and connection to, authenticity. Its subjects were understood to have had (for the most part) more of it than its practitioners, but, happily, some of this authenticity could be invested in both the experience of the Other and in bits of their material culture, and thus be assimilated into the person of the anthropologist. On the other hand, anthropology has had an equally long history of seeing the necessary relational quality of authenticity, as an integral part of any sort of truth claims. 'Genuine' genealogies that villages struggled over in order to invest legitimate political authority (Comaroff and Roberts 1986), or the socially recognized efficacy of magic, and hence the recognition of authentic workers of eldritch powers as distinct from the charlatans (Lévi-Strauss 1967) were the very stuff of classic anthropology constituting both the analysis and much of the drama to be found in ethnographic texts. Thus, the empiricist orientation of method (finding out what really was out there), the very-often individually jarring quality of fieldwork, and the theoretical background of the discipline intersected in mutually revealing ways.

These intersections provided a distinct register of academic writing, the ethnographic, some of whose impact we trace below. For example, analyses of how truth was established in radically different settings, e.g., how good and bad divinations were separated from one another amongst exotic people in far away places, say in witchcraft accusations, became one of the main ways that the strange could be rendered familiar (e.g., Evans-Pritchard 1976), providing a new conceptual lens through which one could examine both 'savage thought' and 'irrational belief' (see also Good 1994). At the same time, the familiar could also be rendered strange through this technique. Consider the effective way that Malinowski juxtaposes the attitude of

his readers towards the British Crown Jewels with the *kula* items he is interested in understanding, precisely to challenge the category of ownership seemingly so evident to the Western mind (Malinowski 1984). If there was not an obvious correspondence between a Western sense of ownership and alienability for certain very highly valued items, then perhaps, there might be room for a calculating individual rationality to authentically orient itself to other kinds of value besides that defined by marginal utility through the object's alienation.

It is therefore somewhat regrettable that recent anthropological work on this most protean but very socially relevant category has tended to move in an analytical direction, trying to get a handle on the defining features of authenticity, in order to properly study it. Lindholm (2008), for example, looks at authenticity for a modern, post-crisis anthropology. Through a series of comparisons, he attempts to develop a place for the anthropologist to investigate authenticity as a social fact (and in the process rehabilitate a comparative sensibility in the discipline at large). Each of his vignettes (encompassing, food, dance, national tradition, among many other phenomena), ends in a similar impasse, stressing what is sometimes called the paradox of authenticity. Subjects search for it in ways that are either contradictory, i.e., the sense of the authenticity of origins is often at odds with the sense of the term that comes from identity or correspondence, or authenticity appears in social life in ways that seem to self-interestedly conflate different social levels in the service of claiming specific socially desirable goods (how the Slow Food movement situates itself in the U.S.A., for example). Lindholm calls for a respect for the quest for authenticity, alongside a scepticism as to its possible achievement. His use of the term 'quest', however, seems rooted in a very Durkheimian discomfort with social change as such, as the desire for authenticity (whatever obvious and immediate upset, up to an including personal and social revolution, it entails) is supposedly but a means to an end of a new stability (a renewed Golden Age, becoming a better person, etc.). In a world where specific types of experience are ever more central to everything from specific productions of subjectivity to the mode of production itself, however, the problem of the inauthentic is clearly ever more fraught (and, of course, ever more interesting). In this case, it might be the quest itself, with its attendant temporalities, tensions and travails that should concern us, than either its beginnings or conclusions.

The Search for the Genuine, the Real and the True

The search for origins of the authentic leads us to some of the founding figures in the social sciences. It is worth recalling that two philosophers, who had a large impact on the nineteenth-century roots of anthropology, are also generally placed at the beginning of reflections of authenticity – Jean-Jacques Rousseau and Johann Gottfried Herder (e.g., Bendix 1998, Lindholm 2008). Rousseau developed the notion of *l'homme naturel*, in opposition to the malevolent effects of civilization he felt he observed in his own contemporaries, represented by the French Court. According to this argument, civilization had been degenerating and was continuing to do so,

degrading the body of the citizen with it, in the process inhibiting the free expression of his emotions and actions (see also Berman 2009). In *Emile*, for example, Rousseau contrasts the images of the machine and the tree to model this opposition. As Berman notes, these images were not opposites, per se, the tree had in fact given birth to the machine: the challenge for Rousseau was what to do with this situation (Berman 2009: 160–170).

In a different context, in reaction to the German situation in which the nobility claimed civilization (generally articulated in French) for itself, as against the suppressed (or non-existent) German bourgeoisie, Herder developed a similar idea rather differently. For Herder, the inner qualities of the subject, expressed in the arts and humanities was allocated a specific collective reality. Subjects participated in a specific national genius as a condition of such expression and, in turn, the distinctiveness of national genius was developed through such expressions. The good, the true and the beautiful, then, would find specific expressions through the particular characteristics of each nation. This move was based on two important assumptions. First, some understanding of difference was categorical in understanding humans, or, to put it better, to be human, one needed to have collective specificities (language, custom, kinship, way of life), as a precondition of creativity. Second, these specificities grew organically (think of trees above) from stable physical and social soil, that is, a group of humans attached to a specific place for a long period of time. This take on authenticity relied heavily on the science of geography for its data, its metaphors and its anxieties. The data of geography could be understood theoretically through this sense of genius, as the harmonious connection between climate, landscape, way of life and artistic expression. Everything from traveller tales through to the published records of early scientific expeditions could then be read anew. The increasing conquest of space that made such descriptions possible (increasingly easy movement and technical innovations in transportation), however, were themselves disruptive and potentially fatal to this sense of genius. European crimes against natives were the most obvious ways that specific geniuses were being destroyed, but movement as such (of both people and ideas) could become a source of worry.

Both Rousseau and Herder value a connection between an inner state and an external expression. Hegel later conceived this relationship as central for the development of man. As described in his *Aesthetics*, the externalization of the inner state enables the individual to reflect upon her/himself and to get a step further in his spiritual being (Hegel 1986). As we well know, Marx reversed this relationship and considered the external state of social actors as determining their being. Thus, the alienation under the capitalist mode of production negated the subject's chance to enter human history as an authentic, self-conscious agent, unless and until external changes in the mode of production occurred. This sort of polarity has left the authenticity debate stranded in a series of hoary binarisms, even as it recognises the special quality of authenticity to precipitate out, and variably value, temporal, spatial and subjective formations: a lost Golden Age, the undesirable nature of other communities, getting the real thing and being more or less true to a self all jostle against one another because of the peculiar history of this term. Regina Bendix's thesis outlines, if not necessarily

resolves, this tension:'Authenticity, ... , is generated not from the bounded classification of an Other, but from the probing comparison between self and Other, as well as between external and internal states of being' (Bendix 1998: 17).

Not surprisingly, it is now a commonplace in anthropology and related disciplines that artifice and authenticity are intimately related, and that real people in concrete social-historical circumstances spend as much time working on their understandings of inauthentic as they put into imagining the more valued part of the opposition. The irony is, as Berman has argued, in the increasing contradiction between

> The permanency of men's pretensions and the transience of their conditions, between the solidity of the identities they claimed for themselves and the fluidity of the roles they actually played. (Berman 2009: 118)

The leitmotif of the historical development of capitalism is how a particular sort of exchange models and remakes increasingly diverse spheres in its image in a fashion that seems designed to intensify this paradox. All that is marketable potentially (maybe inevitably) gravitates towards kitsch, and, of course, nearly everything is marketable. Yet, through it all the stock of authenticity rises. Thus, Benjamin's justly famous reflections on the aura of a work of art seems to need some modification, in the light of several decades. Aura now seems invested in increasing numbers of things and processes. Indeed, we live in an age where even our simulacra are subject to a high standard of perceived verisimilitude – from Hollywood movies to Disneyland rides to political reflections on what our collective heritage is or might mean.[1] But aura is transient, not because of mechanical or, indeed, digital modes of reproduction per se, but because of how aura has itself become a significant source of philosophical, social, and economic value, and therefore increasingly subject to understandings like 'inflation' and 'fraud'. Ironically, we are encouraged by the modern market to 'keep it real!' at a time when reality seems to be able to be replicated with ever-increasing virtuosity (see also Appadurai 1996).

On the Trail of the Authentic

Anthropology has had to regularly engage each of these facets of authenticity: from the search for personal and social genuineness to the authorization of specific objects, various types of connections, even claims of extraordinary experience as real. The results of this engagement have been both contradictory and productive. The salvage sensibility of the first decades of the discipline's existence, for example, now sits very uncomfortably with the scepticism and seeming humility of the post-*Writing Culture* critique (Clifford and Marcus 1987), but both of these sensibilities are specifically configured around productive ambiguities in the discipline's appreciation of authenticity.

For this reason, Franz Boas's conversion from scientific to humanistic approaches to knowledge in Baffinland still lives in the lore of the discipline, if only as a palimpsest. If all things were not exactly made new through this aphoristic conversion, then

at least many things were newly made anthropological. In a different time, however, a new understanding of authenity in anthropology (one based on a desired correspondence between the world-as-it-is and its representation) sees something almost sinister in another incident in Boas's long career, i.e., the cleansing of Kwakiutl Long Houses of certain white trade goods before taking their photographs (see the various contributors to Stocking 1985, also Fabian 1983). Somehow this depiction failed both the Kwakiutl and the discipline on a measure of authenticity. It is more rarely asked: what was the precise nature of Boas's failure in this photograph? Did his interest in taking an authentic picture of Kwakiutl with regard to his understandings of their origins override some sense of authenticity with respect to the correspondence between this series of photographs and the Kwakiutl life with which he had in fact observed and with which he had successfully interacted? Banks, following Dutton, considers precisely this question: how and in what sense can a photograph be labelled inauthentic (see Banks this volume). Yet, the modern disappointment in Boas's photograph seems to also construct a very naïve reader, incapable of decoding the framing of not just this work, but of any representation, and furthermore, seems to suggest that there might be a genre of more authentic representations somewhere, something closer to Rorty's 'Mirror of Nature' (1979), that what is on offer in this series of photographs.

More than anything else, the Kwakiutl photographs forces us to confront ethnography from the viewpoint of culture collecting. Clifford also draws our attention to the ways how social and cultural facts have been selected, and how they have been translated afterwards into monographs of authentic, isolated cultures, such as the famous ones written by Malinowski (Trobriand Islands, 1922), Evans-Pritchard (Nuer, 1940), of Griaule (Dogon, 1938), and well as many others.

> From a complex historical reality (which includes current ethnographic encounters) the select what gives form, structure, and continuity of a world. What is hybrid or 'historical' has been less commonly collected and presented as a system of authenticity. (Clifford 1996: 231)

Clifford clearly sees this work as a way of awakening anthropology from the dream of authenticity, thus he critiques the research focus on isolated, 'primitive' societies grew out of this discursive production of an ethnographic timelessness as against a deracinated and disenchanted modernity. Indeed, until the 1940s, modernity was a theme of only limited interest to many anthropologists (with the qualified exception of those working in the U.S.A. on acculturation). Most of the scholars described societies as relatively unaffected by culture contacts and colonialism, more or less culturally homogeneous, in which every element functionally fitted within the general system. These descriptions were a result of their particular anthropological interest. Clifford extensively describes the strategies applied by researchers to produce these images of social and cultural realities, and, of course, during the past quarter-century the discipline has internalized these critiques (see e.g., Hymes 1972, Fabian 1983, Clifford and Marcus 1986, Amselle and M'Bokolo 1999, Sahlins 1999). The notion of culture, too, has been radically, sometimes painfully, refigured (e.g., Barth 1989;

Keesing 1994, Fox and King 2002) in the wake of this critique. Critical concepts of culture now have to consider that cultural traditions have ideological connotations, constitute a complex interplay with various subsumed and dominated traditions, and have to look at the production and reproduction of cultural forms as problematic in itself (Keesing 1994). Hannerz postulates combination and impurity as fundamental qualities of culture (1992; 1996). Culture, then, is now understood as 'contested, temporal and emergent' (Clifford and Marcus 1987) or a 'combination of diversity, interconnectedness, and innovation, in the context of centre-periphery relationships' (Hannerz 1996: 67), formulations that seem to confine authenticity as a concept and the search for it to the dustbin of history.

Fieldwork, of course, has been deconstructed in similar terms, by situating it within broad Western intellectual trends, as well as by highlighting its darker political impulses. In response to such critiques, new approaches have been elaborated, such as multi-sited fieldwork (Marcus 1995), fieldwork at home, or new ways of 'constructing the field' (Amit 1999), which may now be the Stockholm ballet (Wulff 1997) or a street in London (Miller 2008). These studies need to be understood, at least in part, as a response to the critical reflections outlined above. Concepts of reflexivity were introduced into the ethnographic research process, e.g., the shared social experience for a more general understanding of the culture under scrutiny (Hervik 1994), or in terms of 'participant objectivation' as proposed by Bourdieu '… to explore not the "lived experience" of the knowing subject but the social conditions of possibility – the effects and limits of the act of objectivation' (Bourdieu 2003: 282).

Reading Anthropology while Searching for Authenticity

Such critiques now have a canonical quality in the discipline and they live comfortably as the received wisdom passed on from elders to graduate students during the course of professional training. Nonetheless, the exceptional quality of this encounter with difference created by the intersection of this earlier moment of anthropological theorizing, with classic ethnographic fieldwork and a sense of authenticity should not be lightly discounted. Data and objects were collected and disseminated and new forms of knowledge were produced and circulated. Ideas of other, perhaps even better, more authentic, realities became widely available to reading publics, and certain very charged discussions (of sex and sexuality, of different forms of consciousness and of reflexive understandings of Western society) were given a certain scholarly space, and sometimes even a scientific imprimatur. Genuinely radical impulses (at least according to their followers and, indeed, according to some of their contemporary critics) found these products of fieldwork central to certain re-imaginings that clearly invoked an understanding of authenticity, even if such movements now provoke wry grins or embarrassed grimaces (indeed, if they are remembered at all). Reich's feverish annotating of Malinowski's observations on authentic sexuality amongst savages (Reich 1971) to distinguish sex-positive from sex-negative societies, Gauguin's exoticism (see van der Grijp, this volume), even Castaneda's kitsch reworking of south-western

American ethnography (e.g., 1975), now are subject to disciplinary erasure or derision, but they are not generally given their just due for how they functioned upon their release for at least some readers, at least some of the time, that is, as a scholarly sanction to entertain the idea that other people minding other sheep in other valleys, might indeed have some insights into living better, more genuine lives than 'we' do now. The romance of the other, while certainly not an anthropological innovation per se (see Dilley this volume), found a stable discursive platform in classic anthropological theory and ethnographic writing practices upon which some social critics found it possible to stand (see also the various contributors to Stocking 1989).

Perhaps it is not surprising, then, that the spectre of authenticity can still be found at the anthropological banquet: if not at the table, then at least as a ghostly presence in the room. The institutionalization of anthropology's twin crises of representation and legitimacy, for example, also demarcates a historical moment where politicized First Nations movements have scored a string of impressive political and economic victories in large part on the back of a discourse constructed around a seemingly naive sense of authenticity of origins (especially in Canada and parts of South America), often relying on data collected by an older generation of anthropologists. Indeed, during this period, some anthropologists have embraced this discourse as explicit activists (e.g., Turner 1989, Mayberry-Lewis and Howe 1980). More often, however, anthropology has become engaged, often very uncomfortably, in this process through the production of expert testimony that is almost always understood as an exercise in validation: certifying the continuity of a particular group or authorizing the provenance of an artefact within politically charged settings, where adjudicated claims of authenticity are the primary political stakes [think of the conflict around Kennewick Man in U.S.A. (see Thomas 2000; also Baumann 1999)]. At the same time, in other clashes, anthropology has been marshalled on the side of the state to critique land rights and compensation claims because the unit claiming was not really the same as the unit that was historically aggrieved.

The Contemporary Longing for Authenticity

The twentieth-century anthropological struggle with authenticity, however, was clearly a part of a much broader trend in Western societies' reimaginations of themselves. In the following section we want to scrutinize the contemporary quest for authenticity as a function of that hoary social science construct modernity and in particular its seeming acceleration under the aegis of the globalization processes that marked the end of the twentieth century.

The concept of the autonomous individual in European early modernity gave rise to the personal search for the proper external expression of inner states: direct correspondences were valued as sincere, pure, real, natural and their opposites were, of course, maligned. Art, in particular was seen as a privileged sphere of this search and artists as some of its pioneers. Thus, in the early twentieth century, a community of artists founded a colony on a hill above Ascona, Switzerland and named it Monte

Verità. They were searching for true expressions of emotions and ideas, which were inspired by alternative thinking to the then dominant social ideologies such as patriarchy and militarism.

Today, we are living in a time, in which this longing is not restricted to one dimension of the inner state as spiritual transcendence, or in terms of a more worldly, romantic valuing of the good-true-beautiful. It can mean the search for a natural expression like in Rousseau's meaning or in naturalist movements (e.g., various kinds of vegetarianism), an essentialist core as dealt with by Herder, a spiritual and religious truth in the context of Victor Turner's *communitas* (1969). It can be the longing for the purity of the physical body, e.g., ideals and ideologies of youth, health and beauty, which may be connected to wellness and fitness programmes and medical treatments. This search is often articulated in an anti-modern process, a rejection of ongoing modernity and the appropriation of some old traditions. We further would like to mention the ideal of body motricity[2] as it thrives for perfect mastery of learned movements, as in the case of standard dances (e.g., Viennese waltz, Argentine tango, or Cuban rumba).[3] However, its contrary, an hedonistic, uncoordinated expression fits into this domain as well. This relationship between inner state and external expression may as well take the form of a radical freeing from any values and norms, a 'revolt against convention' (Taylor 2003: 65), as we find it in avant-garde culture, or in many youth cultures (e.g., punk).

We witness similar rearrangements in the new positioning of nation-states and the production of national cultures. In their formative period they attempted to create seemingly homogenous national cultures, entities shared by all and to which all could feel adherent. On these grounds, citizens were supposed to feel the particularity of their membership within a larger community of solidarity. Specific laws regulating membership were formulated, the rule of descent was decisive in some nation-tates, while in others, citizenship was connected to the principle of territory, and other states were combining both. Such processes could well be analysed in the case of the newly independent states, in Africa and elsewhere in the world. These new states faced the problem how to create such a national culture, given the many different regional ones, which did not allow easy production of emotions of national unity. What could constitute an authentic root?

Today's nationalisms have undergone further rearrangements: they appear more sophisticated (Gingrich and Banks 2006). It is very apparent in sports, e.g., in national football teams, which easily include (should one say appropriated?) sportsmen, with migratory backgrounds and/or colonial experiences. How to conceive of national culture, if, moreover, the present nation-states are entangled within wider, transnational formations (cultures), such as the European Union, the UN, WHO and others? Regarding African states, Anthony Kwame Appiah (1992) has critiqued concepts and ideologies, which conceive national culture in the singular, as one, collective, shared and integral entity. All these states, which emerged after the period of Independence, are not formed, and have never been formed, by one single culture. Affiliations of social actors are multiple, and so Appiah claims, should national culture be conceived in the plural.

These dimensions of culture(s), of spaces of modernity, and the interconnected nature of national cultures, are socio-cultural frameworks for the spaces social actors are living in. They may partly be subjugated within one or the other, but they are agents in the combination of the various fields as well, thus constituting their specific lifeworlds.[4] The multiple possibilities of expressing this 'being true to oneself' then, is a consequence or a mirror of the present breaking-off of so-called fixed concepts of the programme of early modernity in Europe.

Thus, diversity itself becomes 'central to the contemporary culture of authenticity' (Taylor 2003: 37). In the late twentieth and early twenty-first centuries, authenticity is no longer exclusively connected to a pre-conceived homogenous, bounded, pure or original culture. We should however, be aware of what is meant by the interconnection between authenticity and diversity. In the form of a collecting of cultures, as Clifford has dealt with (1996: 23), it may refer to all the different expressions of pure and rooted cultures in spatio-temporal coordinates, a programme fitting the goal of Occidental science to create encompassing, universal cultural archives. In a contemporary meaning, this connection may refer to the coeval spatial distribution of a pure authentic. This is the case for instance with the many claims of minority groups, who are sometimes fighting for the political right to have and express their particular culture.

With the central role of diversity for contemporary authenticity, we refer to the particular forms of interconnecting and combining cultural elements within spaces of interstices, in order to produce a specific particularity, be it at an individual level or at the one of a social, collective entity. This latter resembles what we have mentioned earlier, Appiah's assertion of the fundamental cultural diversity of modern African states (see also Jackson, J. 1995).

Material Culture and Authenticity

In contrast to what James Clifford termed the collecting of culture, the scramble for the authentic object/artefact was apparent well before the emergence of anthropology as a discipline. The authenticity of material culture has to be approached from a double perspective, namely on the one hand the artwork and artefact as a means for collections, be they private or for museums and the authentic commodity of the mass consumption sphere on the other.

Which were the criteria of collecting applied by the researchers, how did local people respond to this interest in such characteristic objects? They have been acquired, purchased, extracted with the use of massive pressure, or simply stolen. The accounts of Michel Leiris on the stealing of artefacts and artworks by members of the Dakar-Djibouti expedition (1931–33; Leiris 1988) are a famous example of such practices. Other expeditions in different parts of the world acted in similar ways.

We are interested in which sense such collected artefacts and art works may be considered representations of specific cultures. For the Congo region, in the late nineteenth and early twentieth century, Enid Schildkrout and Curtis Keim quote the

American traveller, collector, and anthropologist, Frederick Starr, who 'notes with frustration how Frobenius' recent purchases in the Pende area had affected both the quantity and quality of what was available' (Schildkrout and Keim 1998: 6). As the German traveller-researcher revealed in many of his publications, he was most interested in objects, which would conform to European high stylistic qualities, to valued materials such as ivory, and to ritual paraphernalia, related to religious beliefs and power practices.

In a further comparative study on collecting practices of two travellers, Richard Starr (1905–06) and Herbert Lang (1908–15), in the Congo in the first decade of the twentieth century, Enid Schildkrout deduces that both, in different ways, have influenced the production of artefacts and works of art by concentrating on some types of objects to the detriment of others (Schildkrout 1998). Lang acknowledged certain pieces as art, while Starr considered objects to be good only if they conformed to his idea of authenticity, i.e., if they coincided with his image of the so-called primitive character of African societies. Lang's focus on what was culturally going on, namely social change and innovation, encouraged the introduction of a certain type of art creation, a 'proto-tourist art, art produced in the "contact-zone" of the early colonial period' (Schildkrout 1998: 189). Starr's agenda of the primitive on the contrary favoured the production of 'fakes: objects made to simulate artefacts that were used in contexts "uncontaminated" by foreign influence' (Schildkrout 1998: 189).

There was a paradox: in the local arena, artists rapidly incorporated the physiognomic traits of these travellers, missionaries and colonizer agents into their stylistic expressions, as can be seen in *colon*-style art works. Beads, pieces of clothes, or various metals, which had been exchanged with European traders, were integrated in objects for local use (Schildkrout and Keim 1998: 26). In local contexts and for local consumption, works of art and artefacts were produced according to local, changing standards.

If we now turn to the mass consumption commodities, Jean-Pierre Warnier emphasizes the paradox character of the authentic commodity (Warnier 1994). How can a commodity be authentic, when it is integrated within the global capitalist market system with augmenting neo-liberal, so-called self-regulating price mechanisms? A commodity is an object or thing considered primarily as exchange value, whereas the authentic object is basically bound to a particular socio-cultural context. Warnier concludes that the authentic object is therefore inalienable, singular and/or personalized.

The authentic commodity thus displays some similarities with the luxury good.[5] One of its main functions is its social and cultural connotation. This may be in relationship to the production of the commodity. In these respects, the authenticity of a commodity is defined by its region of origin, the material used for its production, the production process and the local actors involved in it. The blood sausage from Mortagne in Franche-Comté, for instance, is authentic as it refers to the place or region of origin, is constructed around a whole complex of institutions and is part of the complex of cultural heritage (see Warnier this volume).

Shelly Errington mentions another aspect how in our time a commodity might be viewed as authentic. Authenticity, she advocates, designates more and more that the

artist or the craftsman is an 'authentic Australian Aboriginal, Native American, or whatever' (Errington 1998: 141). U.S. legislation has been adapted to guarantee this fact. 'Authentic Navajo Jewelry' is thereafter only legal as label, if the objects truly have been produced by 'authentic Navajos' (Errington 1998: 141). Judith Okely shows a similar scenario in her contribution. For a commodity to become authentic, Gypsies appropriate mass consumer goods and through their work they transform these 'ready-mades' into characteristic (authentic) Gypsy objects (see Okely this volume).

Authenticating Material Culture

The irony in this understanding of the material is that, a social science understanding that the authenticity of an object is clearly not an inherent quality or essence coexists with the social production of authenticity investing various experts with the ability to discover precisely such a quality or essence. The singular object, the social and cultural value attributed to it is the result of social activities, which are then misrecognized as belonging inherently to the object. In this section, therefore, we would like to emphasize the processes of exclusion, selection and of recontextualization by which particular commodities acquire the status of being authentic. Producers, traders, local governments, marketing agencies, even consumers may in different ways value aspects of the production, the singularity of the natural resource it consists of, any special techniques or specific tools used to its production, or the regionally specific forms of its consumption. Commodities are transformed into authentic ones insofar as they are singularized, they are declared as characteristic for a region, for a culture, they may be individually and/or collectively appropriated. We shall, therefore, look at such processes of defining an object's authenticity.

Joseph Cornet defines three elements, which have to be fulfilled for such objects. First, the object has to meet general aesthetic values; second it has to be created according to characteristic elements of style of a specific society, and, third, there has to be an evidence of use, a patina and certain degradations, like scratches in the texture (Cornet 1975: 52). 'Authentic African art is that art which is produced by a traditional artist for a traditional purpose and *conforms to traditional forms*' (Cornet 1975: 55). Most of the definitions of the authentic African traditional work of art mention in a way or another these elements. In a wider perspective, these criteria are applied to all authentic art, i.e., 'primitive' art and folk art.

In all statements, whether by anthropologists, art historians, art traders, or art collectors, the crucial element is that the work of art has been used in a traditional way. In the European-American art world, this anthropological criterion takes priority over the art historical question of the formal qualities of the object. According to Frank Willett, qualitative aesthetic aspects only come into consideration once the authenticity of the work of art has been acknowledged (Willett 1976: 8).

This criterion may actually lead to some strange issues and decisions. William Bascom mentions that an object may have been carved years ago, but may never have been used, as the person who had commissioned it had died. In respect to the

understanding of the European-American art world it would be inauthentic (Bascom 1976: 316). Or, what if an artist has carved several traditional works of art for the same traditional cultural context, one being bought by locals for local use, the other ones by tourists for display in their living room? Are the former authentic and the latter suddenly inauthentic (see Hammersley-Houlberg 1976: 15)?

The claim of the traditional context of an object for its authentication raises other issues in relation to the particular knowledge involved. Arjun Appadurai sees possible discrepancies of the knowledge about the commodity, which may increase with the distance the commodities are moving from their place of origin. Appadurai differentiates between two broad forms of knowledge, the knowledge connected to production and the knowledge connected to the appropriate consumption (Appadurai 1995: 41ff).

The vast majority of traditional art is nevertheless sold either by art dealers in African metropolises such as Lagos, Kinshasa, Dakar, or Abidjan, or in galleries in the European-American art world. The knowledge of the claimed traditional contexts has to be provided by the dealers and specialists: the biography (pedigree) of the work of art. In an overall perspective, such a biography includes 'the correct identification of the origins, authorship, or provenance of an object' (Dutton 2003). According to Price this includes all the persons who have disposed of the work of art, or who have owned it, the various prices it was exchanged for, in which institutions and places it was exhibited (Price 1989: 155). Many scholars however emphasize that it is nearly impossible to get such provenance for African traditional art. One reason is the missing of collection data (Sieber 1976: 22). Another one is that the works of art have often passed through different hands of dealers, until they are offered to potential purchasers (Steiner 1995). Given the number of people involved in bringing the object into the art market, information about this same object may be altered in one way or another. The knowledge, which is authenticating the work of art therefore gets into an ambivalent situation while travelling. The anthropological contextualization is on the one hand of prime importance for cultural validation by the European-American art world. At the same time, art dealers consciously manipulate aspects of this contextualization. In other words, there is a breach between the flow of objects, which are suspected to have a high cultural and social value if they are authentic, and the flow of the corresponding knowledge.

For the commodity in general, Jean-Pierre Warnier defines three strategies for authenticating them: the domestication, the singularization, and the certification (Warnier 1994: 20ff). Domestication refers to the process by means of which the consumer her/himself appropriate a commodity after having purchased it into their personal environment (the home). By doing so, they produce a system of objects which becomes unique and peculiar to them, although the things are mass consumption products. This can be the case with the souvenir bought in Spain as a representation of 'Spanishness', which is decorating the wall of the living room (see Grau Rebollo, this volume). Another example is the mass-produced do-it-yourself bookshelf, which is painted in a colour dear to the owner and is used as display for plants, for family pictures and other collected paraphernalia.

Singularization is the process within the exchange situation, by means of which traders, marketing agencies, other specialists and specialized institutions create the authentic quality of the commodity. Such an institution is the Tribal and Folk Art Exhibition (alternately in Marin and San Francisco), an annual show that 'contains a tremendous mixture of objects, from Amish quilts to North African jewelry' (Errington 1998: 121). Flee markets (Warnier 1994: 23) are other such spaces, which sell commodities with the label of the singular, authentic. Other institutions, which produce commodity individualization are marketing agencies, mostly hired by local (regional) governments. Foodstuff, garments, furniture are transformed in such a way into products of cultural heritage. All in all, individualization concerns the selection of some commodities to the detriment of other ones, and by referencing the objects to a region, or to a past, which is assumed as characterizing the local culture, thus creating cultural heritage, or by positioning the object in some distant society.

Another practice of certification may be in respect to its production. This may be the place of origin, the singular materiality, the particular production process, the local people involved in it, or the combination of all of these aspects. The country jacket of a famous Scottish brand, although produced in a factory in Lithuania ('made in Lithuania'), is authentic insofar as the yarn of the garment is still from original, especially cared for, Scottish sheep. Major strategies actually consist in accentuating the labels as a means of authenticating: Lacoste's crocodile, the jumping Puma for sportswear, etc., all operate to individualize and certify mass commodities. The immense market potentials of such brands may be seen by the recently introduced fines in the European Union for even purchasing, from street traders, copies of illegally marked commodities. In the centre of Florence, we recently passed prominent warnings, on large columns, alerting tourists against purchasing such objects: 'Buying counterfeit goods knowingly is punishable with fines from €500 up to €10,000'.[6]

There are however other forms of certification, which involve modern technologies. In Austria, organic meat is authenticated only if the natural breeding of the animal is certified by a veterinary, and if the region of production is clearly identified on the product's packaging, by the trader or the supermarket. Referring to wine certification, in France AOC (*Appellation d'Origine Contrôlée*), assigned by the *Institut National des Appellations Contrôlées*,[7] and referring to the preservative corresponding to technical norms, Warnier emphasizes that such an authentication is produced neither with reference to any past, nor to any imagined exotic, but on the grounds of a modern, technical process, which is certifying the 'good object' (Warnier 1994: 13; 25f). We have to acknowledge that techniques and processes of authenticating appear in this light as an immense, economically highly profitable, machinery that has prominently positioned itself in national and transnational systems.

Cultural Stories and Politics of Authenticity

All these spheres of the longing for authenticity are related to the relationship between an inner state and an external expression. Second, they further are connected to a first meaning of diversity. Individuals are longing to be authentic in various con-

texts, as we have shown above. To be true to oneself does not have the meaning it had with Rousseau or Herder anymore. In our times, there is a proliferation of external expression and activities, for what should stand for true, real, original inner states. At a similar token, the idea of the authentic object as well shifted into multiple connotations. In these contexts, diversity refers to the distribution and selection of what fits one's desire for the authentic, be it a behaviour, a state of mind, a particular type of object. For one individual it is the Jackson Pollock painting in the living room, for the other it may be the antique furniture, or the regional foodstuff in the refrigerator. It is a matter of the possibilities at one's disposition.

We have, however discriminated with another notion of diversity. This latter emphasizes the plural arenas of the individual's lifeworlds, where authenticity is searched and produced. Generally, it is expected that authenticity is constituted in an essentialist cultural context: turning objects into what is considered traditional, whether by referring to the craftsman from a specific region, or to the old technique, the material used, or the knowledge materialized in an authentic object, or to self-determination according to a set of values, of customs, of specific body motricities and so forth. This too is the domain which has been dealt with by Hobsbawm and Ranger with the concept of the 'invention of tradition', invention mainly as a reappropriation of elements from the past and their recontextualization within the present modernity (Hobsbawm and Ranger 1983).

On the other side of the spectrum, the authentic may be searched as well from within avant-garde culture. That is for instance the case for alternative movements (Feminist movement, Green movement, World Social Forum), with their refusal of the dominant cultural values and norms and the claim for new ones. In the present, it is a search for the new but is less concerned with taking examples from other pure, original cultures, as it was the case in the early twentieth century. Today, this 'revolt against convention' (Taylor 2003: 65) is more informed by transnational interconnections, as expressed in post-colonial critical theories.[8] Finally, we would like to cite popular mass consumption culture[9] as a cultural space for the search of authenticity. The tourist industry (Selwyn 1996), the enacting of history in theme parks (e.g., in Williamsburg, Virginia), new simulation techniques for experiencing extreme situations, or the transformation of mass commodity into an authentic, individualized thing through consumption may be mentioned in these respects.

Against positioning the authentic quest solely within the pre-modern, Regina Bendix proposes a combination of modern and anti-modern dimensions. According to her model, the quest for authenticity is a longing for the modern and the anti-modern at the same time. 'It is oriented toward the recovery of an essence whose loss has been realized only through modernity, and whose recovery is feasible only through methods and sentiments created in modernity' (Bendix 1997: 8). We feel however that the longing for authenticity is not only an orientation into local history and is more than a pre-modern process. The search for self-determination may also consist of an idealized vision of geographically other (distant) cultural spaces.

We therefore suggest that the idea of authenticity is embedded in the ongoing project of modernity and that this idea is best investigated ethnographically in the

sense of descriptively integrating human subjects and the stakes to which they are oriented in local moral worlds. Above all, authenticity is a fundamental expression of reflexivity. The production of cultural stories for characterizing the authentic object, which, like its provenance are often manipulated by traders, consumers, craftsmen and heritage officials, are what Appadurai calls mythologies (1995: 48). The cultural adjustment of an individual's lifeworld, following the experience of an unsatisfactory cultural situation (Warnier 1996: 17), counter-, or alternative movements, are all products of conscious reflections on the inappropriate character of the present dominant norms and values of social life.

Politics of authenticity constitute another modern strategy of authentication (see Appadurai 1995: 56ff). This involves nation-states, meta-state formations and socialities. Nation-states are powerful systems producing normative systems of authentic forms of life, national ideologies and of authentic material culture. We however do not understand the modern nation-state as a monolith, covering all aspects of social and cultural life of a given society. In order to analyse its ramifications in the context of authenticity, we follow James Ferguson's and Akhil Gupta's concept of the spatialization of the state: its characteristics may be considered to be in which social, economic, cultural, or political fields the state is intervening and how, where it leaves the spaces for other socialities or institutions to act (Ferguson and Gupta 2002). We have already mentioned a major task of the state in the formulation of national culture. But in this realm, political parties, culture associations, legally acknowledged minority groups and other stake-holders are active as well. The age of globalization has actually brought new challenges, to which the state has to adjust its representation as an authentic, particular social formation. The disciplining power of the state has well been analysed. In many situations, however, the state must rather act as a broker between various interest groups. It is determining so far how these socialities may articulate their interests for self-determination in asymmetrical power relations. In education, laws and regulations regarding intercultural teaching and learning may be considered as such a social field.

Further, the nation-state is producing, regulating and protecting tangible and intangible cultural property. By doing so it determines specific goods as such, but it also includes the circulation and flows of these latter within its territory and beyond its borders. Artworks, which are considered as national culture (property), may for instance not be exported, or at least their export has to be negotiated with state agencies. Restitution of cultural property also belongs to this sphere of activity, including objects of colonial exploitation, like the famous Benin bronzes in museums in Europe and North America, which were taken by the British 'Punitive Expedition' (1897), while in Germany and Austria, for instance, the restitution of cultural property involves items stolen during the Nazi regime.

Thus, cultural heritage constitutes another field, where state institutions have to assume activities of protection, conservation, documentation and exhibition. These institutions do not just take care of historical sites or monuments. All forms of historical and present cultural creations may be included in their agenda, for example, film and photography. In most of these heritage activities, the state is obliged to interact with transnational organizations. These latter may force states to adopt new,

protective, legal requirements . UNESCO long ago put the theme of authenticity on its agenda. ICOMOS, UNESCO's 'International Council on Monuments and Sites' has launched in 1994 the NARA Document on Authenticity. Authenticity thereby appears as those values attributed to cultural heritage within the cultural contexts to which they belong (Lemaire and Strovel 1994, §11). It is noteworthy that the various paragraphs of the document deal less with cultural purity or with a bounded, separated cultural entity, but rather with the diversity of a locally authenticated heritage within a pluralistic framework. More revealing is UNESCO's 'Universal Declaration on Cultural Diversity' (2002), which affirms that culture is subject to change in time and space and that cultural diversity is 'a source of exchange, innovation and creativity'.[10] Both the NARA-document and UNESCO's declaration are placed in the context of present-day flows of peoples, commodities, technologies and images.

The Structure of the Volume

The debate is launched with the paper of Jamie Saris. He offers a rereading of Edward Sapir's intriguing essay 'Culture, Genuine and Spurious', in pursuit of a definition of authenticity that might prove more anthropologically relevant than those that have gone before. Connecting Sapir's thinking to the problem of alienation, he argues, allows us to re-conceptualize authenticity outside of stale metaphors of purity and violation. Such a re-conceptualization allows us to come to better address the role of the market and the circulation of commodities. In his ethnographic example, following two periods of political struggle in Ireland that coalesced around the attachment of discrete class fragments to particular objects – middle-class interest in Irish-themed jewellery in the mid-nineteenth century and what we might label underclass elements' attachment to horses in urban and suburban environments in late twentieth- and early twenty-first century Dublin – Saris applies Sapir's notion of genuine culture, which he defines as a sense of individual access, if not control, over the means of cultural value production, as a way of thinking about the simultaneity of cultural and political struggle. Authenticity, then, emerges as a quality of experience with respect to an object or a life-episode. It is best contrasted with alienation and fetish.

Rajko Muršič rejects the term authenticity altogether, and rather focuses on the politics of authenticating and its consequences. The key problem, according to him, is that it may not be possible to think of authenticity without (social) exclusionism. Muršič mentions examples of authenticating exclusionism in music, especially rock and its roots, and, briefly, in anthropology. In the first case authenticity is inseparable from racism, in the second it is inseparable from culturalism (or nationalism). He considers the discourse of authenticity in both cases as essentializing, establishing the grounds for the essentialist notions of culture, nation and race. He proposes to abolish the notion from academic discourse insofar as the notion of authenticity has a political, manipulative character and is accompanied by a seemingly unproblematic use and therefore belongs to other seemingly non-problematic, essentializing notions that support regimes of exclusion and latent violence.

The second section of the volume opens on reflections of so-called moral discourses of authenticity. Lawrence Taylor analyses the search for authentic wilderness in Arizona's Sonora Desert of the American West. He sees it in the context of a larger struggle over the meaning and moral valence of the landscape involving national organizations dedicated to the preservation and proper use of wilderness environments. Taylor calls this contention a moral geography. This notion refers to a kind of social/cultural practice, rather than a passive cultural tradition or condition of the land itself, and draws on three disparate theoretical and disciplinary traditions, the critical geography of Lefèbvre, Harvey, and Soja, further Becker's notion of moral entrepreneur and his contemporary ethnography.

In these moral geographies, the role of authenticity is signaled in popular discourses as authentic wilderness, authentic Christians and authentic (real). In these the term authenticity carries a moral dimension. Taylor concludes that the lone pilgrim is the ideal person to experience wilderness. Here, the pilgrimage represents a moral geography that seeks inward authenticity in outward journey.

Jean-Pierre Warnier suggests the notion of a moral economy of authenticity. The first point of his argument is that there are two dimensions of authenticity, that is, politics and economy and he concludes that there is a political economy of authenticity. There is, however a moral economy of authenticity, that results from the fact that the quest for authenticity is pervaded with moral issues concerning forgery, truthfulness, good and evil, right or wrong. Warnier's contribution is based upon field research he has done with students in the region of Franche-Comté, in north-eastern France. Taking the example of the blood sausage of Mortagne, he shows that over the last thirty or forty years, the moral economy of the quest for authenticity triggered a process of quasi-ethnogenesis and definitely a process of invention of traditions in the region, which include various other contexts. Warnier ends with a few theoretical points regarding the question: 'Why the quest for authenticity at the end of the twentieth century and the early twenty-first?'

Jorge Grau Rebollo scrutinises some of the repertoires of typical Spanish souvenirs. Some of these images are also part of the 'Spain' brand abroad and some are displayed on tourist-aimed websites. Some of these so-called cultural icons were actually also made up inside Spain, as an exaltation of a notion of Spanishness as a moral distinctive trait. Grau Rebollo asks what these Spanish essences actually consist of, how and why certain images have become so closely associated to an essence of a whole country. He therefore has a twofold purpose. On one hand, Grau Rebollo exposes contradictions of the representation of certain authentic cultural icons. On the other, he deals with mainstream Spanish cinema as a fundamental cornerstone in the process of shaping, spreading and even contesting essentialist national values. Grau Rebollo concludes that some authenticities may be no more than the result of an intentional distortion. He suggests stressing and analysing not only that deformation, but the underlying reason for it: how and why an item is selected and afterwards presented in a particular way.

The third section is placed under considerations of the academic conceptual use of the notion, the investigation of the criteria used for its use and social practices of

collective discourses. Inger Sjørslev considers the notion as an analytical concept and not only a concept of different emic discourses to be dealt with anthropologically. In doing so, she both seeks to deconstruct authenticity as a discursive formation and at the same time realizes that this does not make the search for that, which is covered by the term authentic meaningless. It cannot be used from the outset to determine whether things are essentially authentic or not. She aims to move the idea of authenticity away from its Western linking, out into sociality, the collective and (outer) form. Sjørslev deals with these issues in the context of the ethnographic example of Brazilian *Candomblé*, a religion sustained by sociality, which is reflected mainly in the practice of ritual possession, while at the same time celebrating the individual. She aims at illuminating three points about what makes things authentic. First, form and content, in *Candomblé* illustrated most clearly in the phenomena of possession; second, authentication processes in relation to material objects as illustrated by the fetish, and, third, the characters of the sociality in ritual performance as pointing towards a subjective experience of authenticity.

Paul van der Grijp questions whether we should reject the notion of authenticity altogether as purely ideological. Authenticity is a slippery concept for anthropologists and is usually presented in emic rather than etic terms. The use of the notion of authenticity is indeed particularly doubtful when applied to peoples from non-Western cultures that have adopted and adapted elements of modernization and have become 'less traditional' and thus 'less authentic'. Van der Grijp's approaches the topic by looking first at contemporary art production in the Polynesian kingdom of Tonga and local ideas about authenticity, and, second, at Primitivism in Western art and the set of ideas related to it. In doing so, he deals with the authentic, the natural and the exotic respectively, and the way they overlap. Van der Grijp contents that art (e.g., Orientalism, Japanism, Primitivism) has become the laboratory par excellence to cope with this alienated feeling in its different manifestations, which drives people to search for authenticity either elsewhere, in other cultures, or in the social and professional margins of our own society, in nature or even in our own subconscious.

Andre Gingrich differentiates between two uses of the notion: first, it is used by several groups in the world we interact with; second, it is also a term regularly used by some academic fields outside anthropology. Gingrich's own use of authenticity is kept to the term's local and wider 'expressive' meanings that is, to some indigenous and public discourses. He discusses decorated wooden pillars and mural paintings from southwestern Saudi Arabia. While there is a seemingly smooth continuity inherent to the unchanged patterns of Hijazi wooden decorations, those bright industrial colours to the outside and inside of Asiri walls seem to indicate recent ruptures and upheavals in Asiri families and in fact, in local social life at large. Gingrich interprets these differences as communicating a fairly smooth process of Hijazi integration into the Saudi kingdom, as opposed to a relatively tumultuous and dramatic process of Asiri integration. Gingrich argues that these processes of integration into national Saudi statehood, and into the transnational and global forces of a Sunni Islam in its *Wahhabi* variant, represent an appropriate perspective in order to understand, i.e., deconstruct and reconstruct continuity and discontinuity in, what is seen as authentic folk art.

Marcus Banks questions in his paper what visual inauthenticity might look like. He starts off with considering the varied meanings and implications of authenticity for anthropology when it comes to a consideration of the visual image. Banks relies on the distinction between nominal and expressive authenticity as proposed by Denis Dutton (2003). Whereas most of his paper deals with the nominal dimension, the relevance of expressive authenticity will be considered at the end of his contribution. With respect to photomechanical images, he separates two aspects to nominal authenticity: The authenticity of the image-as-object; and the authority of the image content. In respect to expressive authenticity, Banks asserts that, in all the cases he mentions, the representations created are hybrids or fusions of a western-colonizing technology and changed indigenous notions of the self under techno-political domination. Thus, coming back to his initial question, what might be expressive inauthenticity, Banks concludes that given the historical and ethnographic evidence, it is unclear how the idea of establishing authenticity in the abstract is helpful to anthropology. In investigating the issue, revealing ethnographic understandings are discovered, not least the criteria by which we as observers consider the truth claims of images.

The papers of the last section finally categorically reject any genuine dimension of culture and emphasize encounter, the contact out of which images of authenticity are produced. Roy Dilley's story is one of hybridity, of *métissage* and of dialogic relations. His meaning of authenticity is an emergent quality engendered by a series of generative social relations, here, relationships of knowledge production and the cultural and political struggles entailed within that production. Key social processes in Dilley's analysis are colonial knowledge practices and the diverse ways of knowing that are implied by them. The construction of ethnographic and other forms of knowledge within colonialism cannot be divorced from the political contexts in which these forms of knowledge were created, or from the purposes to which they were put. Dilley's focus is upon knowledge practices and upon some of the products of those knowledge practices by considering the colonial officer Henri Gaden's ethnographic photographs of peoples and places within West Africa. The quality of authenticity arises in the matrix of a cultural and political struggle over the means of production of cultural value.

Judith Okely's presentation is a critique of culture as resting on isolation, which has influenced notions of authenticity. Instead, objects are transformed as cultural artefacts through opposition and encounters with the Other. She considers the Gypsies a prime example of selective creativity: they are brilliant *bricoleurs*. Gypsies, she asserts, survive by learning and fulfilling various needs of the sedentary population. They recycle the *gorgios'* rubbish, while the latter seek exoticism from a once nomadic group, who are credited with mysterious powers, re-consume these objects as personalized and 'hand-made' Gypsified objects. Ironically, many of these hawked goods are not valued within the group itself. While non-Gypsies are sold such real Gypsy objects, the Gypsies select and commission from the larger society alternatively valued material objects, which they transform into symbols of separate ethnicity. Thus on each side of the ethnic divide there are contrasting uses and interpretations of material objects.

Finally, Thomas Fillitz scrutinises expressive authenticity. In doing so, he connects images social actors have of societies and cultures, which drives them to search for specific representative objects. Considering discourses about contemporary art of Africa, his main hypothesis is that cultural regimes affirm a power of display, of a making visible within the global art world or of negating visibility, and hindering the public to see and experience such other works. Fillitz argues that authenticity refers to a construction, to cultural classifications, which are dynamic and changeable. What may be labelled authentic contemporary artistic expression has as referent the context of African post-colonial modernities and forms interconnections with many different cultural fields. These latter cannot be reduced to binary dichotomies between tradition and modernity. The question is one of articulating Afrocentric modernities as differentiated from European/North-American modernity. The contemporary quest for authenticity thus becomes, in the end, a matter of cultural diversity.

We would like to end these remarks to emphasize that the analysis of the uses of authenticity should be positioned within the framework of transnational complex networks. This however enhances how we look at different processes and discourses, constituting interconnections with transnational organizations, or with more local forms of socialities, such as cultural expressions, or claims of minority groups. In the early twenty-first century, the modern state operates in these contexts as agent of control, of subjugation, of production of new normative systems, but as well as intermediate or cultural broker among the negotiations between various social groups which are connected to it. Another aspect worth noting is becoming evident, the reference to diversity. Authenticity is most of the time linked to the idea of a cultural core, to the essence of a thing. In the recent past, maybe as a consequence of globalization flows, we witness strategies of producing authenticity and of processes of authentication, which are rather embedded in creative activities of social agents in selecting cultural spheres where to articulate their longing for 'being-true-to-oneself'. Authenticity then is more related to the production of the cultural stories in particular fields, within which the gaze into past times is but one option.

The particular anthropological approach, common to all contributions to this volume, is the central focus on people and their activities in the various cultural settings around the globe, who are reflecting and producing a division between authenticity and its opposite.

Notes

1. The efforts that marketers make to connect sale items to movie events, to bestow authenticity, are easily dismissed as simple hucksterism in most academic discourse. The ideological weight of terms like authentic for modern advertising is almost impossible to overestimate. This trend is most obvious in the production of authentic but technically impossible items, such as light sabres from the Star Wars series. These are produced according to exacting blueprints and even more exacting confirmation of this production process (Brandweek 2006). Anthropology engaged similar issues in the 1990s, especially in the debate concerning the relationship of national simulacra to real history (e.g., the exchange between Handler (1986), Gable and Handler (1996) and Bruner (1994) in the U.S.A.

Jackson (1995) goes over some of the same issues in her analysis of a political struggle between settlers and Amerindians in the north-west Amazon region of South America).
2. We borrow this notion from Jean-Pierre Warnier (2001), who defines this body motricity as a 'sensory, affective, motor-conduct;'; see also Marcel Mauss, who characterizes such body masteries in particular social spheres as specifically culture-determined (1936).
3. Eduardo Archetti has analysed the cultural specificity of Tango for Argentine masculinities (1999). For authentic dance in general, see Lindholm (2008: 88–97).
4. It is worth reminding that Ruth Benedict had already postulated in *Patterns of Culture* (1935) that members of cultures were combining apparently incongruent elements.
5. See Appadurai (1995: 38).
6. Personal observation in October 2008.
7. The Austrian DAC (*Districtus Austriae Controllatus*) is a certificate allocated in sixteen wine-producing districts to only one particular wine, which is determined as specific for that region.
8. See Bhabha (1994); Bensmaïa (1997); Spivak (2002), et al.
9. Parts of it are called entertainment culture as well.
10. UNESCO. 2002. 'Universal Declaration on Cultural Diversity', Article 1, p.4.

References

Amit, V. 1999. *Constructing the Field. Ethnographic Fieldwork in the Contemporary World*. EASA Series. London and New York: Routledge.
Amselle, J-L. and E. M'Bokolo (eds). 1999. *Au Cœur de l'Ethnie. Ethnie, Tribalisme et État en Afrique*. Paris: La Découverte, Poche.
Appadurai, A. 1995. 'Introduction: Commodities and Politics of Value'. In A. Appadurai (ed.), *The Social Life of Things. Commodities in Cultural Perspective*. Cambridge: Cambridge University Press. Pp. 1–63.
_____. 1996. *Modernity at Large: Cultural Dimensions of Globalization*. Minneapolis and London: University of Minnesota Press.
Appiah, A.K. 1992. *In My Father's House: Africa in the Politics of Culture*. Oxford: Oxford University Press.
Archetti, E. 1999. *Masculinities. Football, Polo and Tango in Argentina*. Oxford and New York: Berg.
Barth, F. 1989. 'The Analysis of Culture in Complex Societies', *Ethnos* 54(3–4) 120–42.
Bascom, W. 1976. 'Changing African Art'. In N.H.H. Graburn (ed.), *Ethnic and Tourist Art. Cultural Expressions from the Fourth World*. Berkeley: University of California Press. Pp. 303–319.
Bhabha, H.K. 1994. *The Location of Culture*. New York and London: Routledge.
Bendix, R. 1997. *In Search of Authenticity. The Formation of Folklore Studies*. Madison, Wisconsin: University of Wisconsin Press.
Benedict, R. 1935. *Patterns of Cuture*. London: Routledge.
Benjamin, W. 1963. *Das Kunstwerk im Zeitalter seiner technischen Reproduzierbarkeit*. Frankfurt-am-Main: Suhrkamp Edition.
Bensmaïa, R. 1997. 'The Phantom Mediators: Reflections on the Nature of the Violence in Algeria', *Diacritics* 27(2) 85–97.
Berman, D. 2009. *The Politics of Authenticity: Radical Individualism and the Emergence of Modern Society*. New York: Verso.
Bourdieu, P. 2003. 'Participant Objectivation', *Journal of the Royal Anthropological Institute* 9(2) 281–294.
Bruner, E. 1994. 'Abraham Lincoln as Authentic Reproduction: A Critique of Postmodernism'. *American Anthropologist* 96(2) 397–415.
Castaneda, C. 1975. *The Teachings of Don Juan: A Yaqui Way of Knowledge*. New York: Pocket Books.
Clifford, J. 1996. *The Predicament of Culture. Twentieth-Century Ethnography, Literature, and Art*. Cambridge, MA and London: Harvard University Press.
Clifford, J. and G. Marcus (eds). 1986. *Writing Culture. The Poetics and Politics of Ethnography*. Berkeley: University of California Press.

Comaroff, J. and S. Roberts. 1986. *Rules and Processes: The Cultural Logic of Dispute in an African Context*. Chicago: University of Chicago Press.

Cornet, J.F.S.C. 1975. 'African Art and Authenticity', *African Arts* IX (1) 52–55.

Dutton, D. 2003. 'Authenticity in Art', http://www.interdisciplines.org/artcognition/ (Access 14 September 2005). (Original in *The Oxford Handbook of Aesthetics*, ed. by J. Levinson. New York: Oxford University Press).

Eagleton, T. 1990. *Ideology of the Aesthetic*. Malden, MA and Oxford: Blackwell.

Errington, S. 1998. *The Death of Authentic Primitive Art and Other Tales of Progress*. Berkeley: University of California Press.

Evans-Pritchard, E.E. 1976. *Witchcraft, Oracles, and Magic among the Azande* (Abridged Edition). Oxford: Clarendon Press.

Fabian, J. 1983. *Time and the Other. How Anthropology Makes its Object*. New York: Columbia University Press.

Ferguson, J. and A. Gupta. 2002. 'Spatializing States: Toward an Ethnography of Neoliberal Governmentality', *American Ethnologist* 29(4) 981–1002.

Fox, R.G. and B.G. King (eds). 2002. *Anthropology beyond Culture*. Oxford and New York: Berg.

Gable, E. and R. Handler. 1996. 'After Authenticity at an American Heritage Site', *American Anthropologist* 98(3) 568–578.

Gingrich, A. and M. Banks (eds). 2006. *Neo-Nationalism in Europe and Beyond. Perspectives from Social Anthropology*. Oxford and New York: Berghahn Books.

Hammersley-Houlberg, M. 1976. 'Collecting the Anthropology of African Art'. *African Arts* IX (3) 15–19.

Handler, R. 1986. 'Authenticity', *Anthropology Today* 2(1) 2–4.

Hannerz, U. 1992. *Cultural Complexity. Studies in the Social Organization of Meaning*. New York: Columbia University Press.

———. 1996. 'Kokoschka's Return. Or, the Social Organization of Creolization'. In U. Hannerz, *Transnational Connections*. London and New York: Routledge. Pp. 65–78.

Hegel, G.W.F. 1986. *Vorlesungen über die Ästhetik*. Frankfurt-am-Main: Suhrkamp Wissenschaft. Vols: 13–15.

Hervik, P. 1994.'Shared Reasoning in the Field. Reflexivity beyond the Author'. In K. Hastrup and P. Hervik (eds), *Social Experience and Anthropological Knowledge*. London and New York: Routledge. Pp. 78–100.

Hobsbawm, E. and T. Ranger (eds) 1983. *The Invention of Tradition*. Cambridge: Cambridge University Press.

Hymes, D. (ed.). 1972. *Reinventing Anthropology*. New York: Pantheon Books.

Jackson, J. 1995. 'Culture, Genuine and Spurious: The Politics of Indianness in the Vaupés, Colombia', *American Ethnologist* 22(1) 3–27.

Jackson, P. 1999. 'Commodity Cultures: The Traffic in Things', *Transactions of the Institute of British Geographers* 24(1) 95–108.

Keesing, R. 1994. 'Theories of Culture Revisited'. In R. Borofsky (ed.), *Assessing Cultural Anthropology*. New York: MacGraw-Hill. Pp. 301–310.

Lemaire, R. and H. Strovel (eds). 1994. 'The NARA Document on Authenticity', ICOMOS. http://www.international.icomos.org (Access 6 June 2006).

Leiris, M. 1988. *L'Afrique Fantôme*. Paris: Gallimard.

Lévi-Strauss, C. 1967. 'The Sorcerer and His Magic'. In J. Middleton (ed.), *Magic, Witchcraft, and Curing*. New York: The Natural History Press. Pp. 23–42.

Lindholm, C. 2008. *Culture and Authenticity*. Malden, MA and Oxford: Blackwell Publishers.

Malinowski, B. 1984. *Argonauts of the Western Pacific*. Long Grove, Illinois: Waveland Press.

Marcus, G. 1995. 'Ethnography in/of the World System: The Emergence of Multi-sited Ethnography', *The Annual Review of Anthropology* 24. 95–117.

Mauss, M. 1950. 'Les techniques du corps'. In M. Mauss, *Sociologie et anthropologie*. Paris. *Journal de Psychologie* 363–386.

Mayberry-Lewis, D. and J. Howe. 1980. *The Indian Peoples of Paraguay: Their Plight and Their Prospects*. Special Report 2. Cultural Survival, Inc.

Miller, D. 2008. *The Comfort of Things*. New York: Wiley and Sons.

N.N. 2006. 'META: This Light Saber Slashes Skeptics', *Brandweek*. 05 June. http://www.allbusiness.com/marketing-advertising/branding-brand-development/4671449–1.html (Access 5 June 2006).

Price, S. 1989. *Primitive Art in Civilized Places*. Chicago: University of Chicago Press.
Reich, W. 1971. *The Invasion of Compulsory Sex Morality*. New York: Farrar, Straus and Giroux. Rorty, R. 1979. *The Mirror of Nature*. Princeton, NJ: Princeton University Press.
Sahlins, M. 1994. 'Good Bye to Tristes Tropes. Ethnography in the Context of Modern World History'. In R. Borofsky (ed.) *Assessing Cultural Anthropology*. New York: MacGraw-Hill. Pp. 377–394.
Sahlins, M. 1999. 'Two or Three Things That I Know About Culture', *Journal of the Royal Anthropological Institute* 5(3) 399–421.
Schildkrout, E. and C.A. Keim. 1998. 'Objects and Agendas: Recollecting the Congo'. In E. Schildkraut and C.A. Keim (eds), *The Scramble for Art in Central Africa*. Cambridge: Cambridge University Press. Pp. 1–36.
Schildkrout, E. 1998. 'Personal Styles and Disciplinary Paradigms: Frederick Starr and Herbert Lang'. In E. Schildkrout and C.A. Keim (eds), *The Scramble for Art in Central Africa*. Cambridge: Cambridge University Press. Pp. 169–192.
Selwyn, T. (ed.). 1996. *The Tourist Image: Myths and Myth-Making in Tourism*. Chichester: Wiley.
Sieber, R: 1976: 'Forgeries without Forgers', *African Arts* IX (3) 22–24.
Silverstein, M.J. and J. Butman. 2006. *Treasure Hunt. Inside the Mind of the New Global Consumer: Shopping Habits of the New Global Consumer*. New York: Portfolio Penguin.
Spivak, G.C. 2002. 'Resident Alien'. In D.T. Goldberg and A. Quayson (eds), *Relocating Post-colonialism*. Malden, MA and Oxford: Blackwell. Pp. 47–65.
Steiner, C. 1995. *African Art in Transit*. Cambridge: Cambridge University Press.
Stocking, G.W. 1989. *Romantic Motives: Essays on the Anthropological Sensibilities*. Madison, Wisconsin: University of Wisconsin Press.
Stocking, G.W. (ed.). 1985. 'Objects and Others: Essays on Museums and Material Culture', Madison, Wisconsin: University of Wisconsin Press.
Thomas, D. 2000. *Skull Wars: Kennewick Man, Archaeology, and the Battle for Native American Identity*. New York: Basic Books.
Trilling, L. 1971. *Sincerity and Authenticity*. London: Oxford University Press.
Turner, V. 1969. *The Ritual Process. Structure and Anti-Structure*. Ithaca, New York: Cornell University Press.
Taylor, C. 2003. *The Ethics of Authenticity*. Cambridge, MA and London: Harvard University Press.
Turner, T. 1989'.Kayapo Plan Meeting to Discuss Dams', *Cultural Survival*. http://www.culturalsurvival.org/publications/csq/csq_article.cfm?id=00000213–0000–0000–0000–000000000000andregion_id=8andsubregion_id=25andissue_id=25. (Access 15 December 2003).
UNESCO. 2002. *Universal Declaration on Cultural Diversity. A Vision, A Conceptual Platform, A Pool of Ideas for Implementation, A New Paradigm*. Cultural Diversity Series 1. Paris: UNESCO.
Warnier, J-P. 1994. 'Introduction. Six objets en quête d'authenticité'. In J-P. Warnier (ed.), *Le paradoxe de la marchandise authentique. Imaginaire et consommation de masse*. Paris: L'Harmattan. Pp.11–31.
____. 1996. 'Introduction. Les processus et procédures d'authentification de la culture materielle'. In J-P. Warnier and C. Rosselin (eds), *Authentifier la marchandise. Anthropologie critique de la quête d'authenticité*. Paris: L'Harmattan. Pp. 9–38.
____. 2001. 'A Praxeological Approach to Subjectivation in a Material World', *Journal of Material Culture* 6(1) 5–24.
Willett, F. 1976. 'True or False?' *African Arts* IX (3) 8–14.
Wulff, H. 1997. *Ballet across Borders: Career and Culture in the World of Dancers*. Oxford: Berg.

PART I

Authenticity and Authenticating

Chapter 1

Revisiting 'Culture, Genuine and Spurious': Reflections on Icons and Politics in Ireland[1]

A. Jamie Saris

Introduction

The concept of authenticity has both defined and dogged anthropology from its foundation as a discipline. With roots in both the Romantic Movement and the largely Germanophone critique of the Enlightenment, the concept drew strength from the seeming triumph of its opposite: a disenchanted, deracinated modernity. For most of the history of anthropology, these worries tracked on at least two levels, which often, but did not necessarily, overlap: (1) the problem of living authentically: being true to oneself, which especially worried the Romantics in the nineteenth century[2] and (2) a concern for human relationships within different collectivities, in other words, a concern about the types and qualities of connections between individuals, especially those that were now possible in the modern moment.[3] The assumption was, of course, that face-to-face relations, natural ties to kin and home and land, perhaps especially their larger analogues at the level of the nation-state, were fraying or even disappearing under the relentless individuation of subjects in modernity. It became easy, then, to fuse a sense of personal authenticity, a subject-centred sense of wholeness, with a more social sense of genuineness in the culture at large. It also became easy to see the contradictions between a mode of production that melted all that was solid into air and the complaints of classes thrown up by this process that eternal principles were being promiscuously destroyed (Berman 2009).

The lure of this concept for a discipline, that, by the late nineteenth century, had claimed, as its proprietary interest, small-scale societies, often in exotic places, was altogether predictable. The apocryphal incidences and occasional embarrassments that this sensibility has evolved for anthropology are almost too numerous to mention: from road-to-Damascus humanistic conversions in the field to stripping the clocks

and other European trade goods from Kwakiutl Long Houses before snapping photographs of authentic lifeways, to list merely some quasi-mythologized elements of Franz Boas's illustrious career (Stocking 1994). It is this sensibility that became the object of Fabian's scathing critique, concerning the denial of coevalness between the ethnographer and his or her Other (Fabian 1983, see also 2000). The strong form of this critique challenges the very condition of the possibility of collective patterns of meaning that are not epiphenomena of either unique individual creativity or the impersonal machinations of political economy. The weaker form of the argument simply avoids much discussion of the problem.

I wish to enter this knotty problem through the work of Edward Sapir. Of course, few anthropologists have not had to read Sapir (at least as an honoured ancestor) as part of their graduate training. His contributions to various branches of the emerging science of anthropology in the first half of the twentieth century are too numerous to list. He was amongst the most talented theorists of language of his time, for example, as well as being a fine fieldworker, a brilliant social theorist and an important public intellectual.[4] He both help to found (and then trenchantly critique) the Culture and Personality School in the United States.

Of all of Edward Sapir's contributions, however, his article, 'Culture, Genuine and Spurious' (1949), seems to bear most directly on our topic. This work has tended to be read as something of an enigma over the last few decades: an important piece, to be sure (at least judging from the number of reading lists on which it still appears), but one hard to square with the discipline's current scepticism about setting itself up as an arbiter of what is authentic, or even valuable, here, there, or anywhere else.[5] Those who know something of Sapir's biography sagely connect it to his artistic temperament: a musician by avocation, he also wrote and published poetry in some of the leading literary periodicals of his day, as well as producing a lot of art criticism (Darnell 1990). Ironically, this way of drawing the connection between Sapir and this work, however, allows 'Culture, Genuine and Spurious' to be sidelined as a significant contribution to the current debate on authenticity: a *cri de cœur* of a poetic soul, rather than the finished product from the analytical brain of a great scholar. Thus, even Bendix's book-length treatment of authenticity in folklore studies (1997) largely sidesteps Sapir or this article. I want to offer what I hope will be a useful re-reading of this piece, showing that the way that Sapir develops some of the themes in his argument suggests a way that we can move beyond some of the sterile antimonies that plague debates about authenticity or the lack of it.[6] I then try to work this reading through some of my own data on how certain objects and images have appeared in specific cultural-political struggles in Ireland.

What Does Sapir Mean by Genuine and Spurious?

There can be no doubt that 'Culture, Genuine and Spurious' is a sustained reflection on authenticity: its conditions of possibility and the many hurdles that it faces to be actualized in the lives of real people and real groups in concrete social-historical

circumstances. Those familiar with the context of American anthropology during this period will recognize that one of the evident targets of this piece was Lowie's diffusionist 'shreds and patches' dismissal of any type of pattern in culture. In other words, Sapir is expressly critiquing the claim that any sense of the 'hanging-together' of the meanings a subject experiences within a context is the result of 'secondary realization', an explanation generally composed of some combination of special pleading, forgetting and outright falsehood (1929, 1937). Sapir addresses this issue by moving away from a deracinated history of ostensibly discrete traits into a carefully constructed argument of how culture (in the singular) can be genuine or spurious, authentic or inauthentic from a subject-centred perspective, and, in turn, how selves can be genuine or not, depending on the nature of their interactions with meaningful forms within specific cultural contexts.

To begin with, then, I want to point out how Sapir fuses the two levels I outlined above. A genuine culture, he argues, produces genuine selves (and vice versa). On first reading, then, his argument conveys a very romantic sense of how badly most modern societies provide for the possibility of individual and group authenticity, and how especially badly current American society fares by this measure (see also Darnell 1990). At this level, the argument looks disappointingly derivative, on the one hand, from a continental tradition of critiquing modernity that by the early twentieth century, was already firmly embedded in sociology thanks to the work of Weber (the iron cage), Durkheim (excessive individualism flowing from the increasing division of labour) and Simmel (the tragedy of culture), and, on the other, from various philosophical and psychological authors, from Wilhelm Dilthey through William James, who had been making seemingly similar points, again, sometimes decades beforehand. Even Sapir's justly respected scholarship: his many references to, say, Periclean Athens or unspecified groups in Native North America, or, indeed, his adopted North American society are uncharacteristically general, lacking the detail that proves so rhetorically powerful in so many of his other pieces.

On closer inspection, however, Sapir's argument reads less like a romantic elegy on the loss of authenticity in the modern world and more a reflection on the relationship between an individual's psychic economy and various other systems, such as the material economy and certain types of 'cultural' production, that are experienced as external to the self.

> So long as the individual retains a sense of control over the major goods of life, he is able to take his place in the cultural patrimony of his people. Now that the major goods of life have shifted so largely from that of immediate to that of remote ends, it becomes a cultural necessity for all who would not be looked upon as disinherited to share in the pursuit of these remoter ends. No harmony and depth of life, no culture, is possible when activity is well-nigh circumscribed by the sphere of immediate ends and when functioning within that sphere is so fragmentary as to have no inherent intelligibility or interest. Here lies the grimmest joke of our American Civilization. The vast majority of us, deprived of any but the most insignificant and culturally abortive share in the satisfaction of the immediate wants of mankind, are further deprived of both

opportunity and stimulation to share in the production of non-utilitarian values. Part of the time we are dray horses; the rest of the time we are listless consumers of goods which have received no least impress of our personality. In other words, our spiritual selves go hungry, for the most part, pretty much all the time. (Sapir 1949: 101)

It seems to me that much of Sapir's later work on culture and personality, as well as his contribution to theory-making in psychiatry, is interestingly foreshadowed in his laying out the problem in this fashion. We can also see how his radical understanding of linguistic structure as being individual or social solely as a function of perspective and research interest is predicted here, as culture's status as internal or external in this argument is a function of the subject's experience of alienation from its value production, not as a quality in culture itself, or even in the context, per se. This sense is nicely captured in the seemingly repetitive use of the word 'share' in this quote. Its use as a verb sandwiches its deployment as a noun: we wish to 'share' in the production of cultural value, but we know that our 'share' in the ownership of the means of this production is vanishingly small. Or, to put it another way: people produce their cultural relationships (clearly not in a time or place of their own choosing) which are then either experienced as owned or controlled by them (genuine), or as something somehow done to them (spurious).

From this perspective, 'Culture, Genuine and Spurious' starts to look less like the reflection of an anguished poetical soul and more a sophisticated analysis of the relationship between production and alienation. Indeed, to the extent that Sapir is connecting a mode of production (including cultural production) with specific types of widely shared alienation, it echoes certain contemporary trends in Marxist literary theory, such as the work of Georg Lukács, who in 'Reification and the Class Consciousness of the Proletariat' (1923) predicted that this sense of extreme alienation was going to be an increasingly central part of modernity, insofar as the experience of being proletariat (that is, alienating one's labour power as the main means of gaining money and so articulating to the economy) was becoming universalized.

To put my argument in its strongest form, then, we could usefully read Sapir as endeavouring to liberate a notion of alienation from the crude sense of material production in which the interpreters of Marx had mired it (those whom Gramsci will be critiquing in a few years time), and to develop a model of authenticity based on the sense of ownership (or a feeling of having a share in) the means of cultural production. This reading of Sapir's argument belies the notion of an unreflexive relativism supposedly then at large in American anthropology, as current (middle-class) American culture comes out as especially spurious in Sapir's analysis, but not simply as a relationship of lack of economic privilege. Thus, the examples that Sapir chooses for his alienated (perhaps straw-) man and woman are, not surprisingly, connected to the market, one from the great well of alienation that Marx found, the proletariat (Sapir's example of the telephone girl), but the second comes from the bourgeoisie, a sort of standard average factory owner, whose economic privilege is contrasted both with his cultural paucity and his shrunken potential for self-realization. Note the 'we': all of us (with a few exceptions) are alienated from the means of cultural production, just as in

the material economy we have (almost universally) seen the means of production slip from our control. In all these examples, then, culture and self have little to say (even worse, they actually lie) to each other subjects feel themselves to be passive recipients of received cultural forms rather than active cultural creators.

In the Market for Authenticity

Somehow, then, the market and modern property relationships are bound up with authenticity.[7] Indeed, authenticity seems to be strongly threatened by the market whenever they meet. This is scarcely surprising, given the history of the terms describing inversions of authenticity – fake, spurious and kitsch, among others – all of which can serve as descriptions of products found at the lower end of the mass market (see Saris 2005). I believe that Sapir's connecting of genuine selves and genuine culture through production, however, allow us to formulate a more useful definition of authenticity than the one forever threatened by the violation of a penetrating market economy. This reworking pivots on how Sapir discusses the nature of a genuine culture. Genuineness or authenticity is neither a state, nor simply a relationship between objects. Like alienation or fetish, these terms denote the quality of the relationship between a human subject and a product of human labour, in this case a cultural product. For Sapir, a subject either shares a sense of ownership towards a cultural form that her material-spiritual labour has helped to make, or she feels that these forms are external, if not actually oppressive. In turn, genuine cultural forms are experienced as internal resources, democratically shared, if not actually popularly owned, while still being available to creative individual ends. The past is of critical interest here.

> And, for the time being, those other of us who take their culture neither as knowledge nor as manner, but as life, will ask of the past not so much 'what?' and 'when?' as 'where' as 'how?' and the accent of their 'how' will be modulated in accordance with the needs of the spirit of each, a spirit that is free to glorify, to transform and to reject. (Sapir 1949: 110)

Culture (note the singular) comes and goes precisely as this 'how' varies. This issue of control, then, is central to my rereading of 'Culture, Genuine and Spurious' and my subsequent argument. This emphasis forces us to confront the specificity of, say, reproduction, alongside the complexity of the market, even the mass market, in the promulgation of cultural forms. As I argue below, certain types of reproduction, even mass production, can indicate and instantiate just such a desire for control, while making a certain sense of ownership a potential personal and political reality. The metaphor of (especially external) culture as an object or possession: concentrated in certain high artefacts but quantifiably in other objects has too long a political history to yield to a simple deconstruction (even one as sophisticated as Handler 1986, 1992), but Sapir's sense of 'how' might be a way of moving this discussion forward. Ownership in the modern capitalist sense, for example, ill reflects how individuals

orient themselves to meaningful products, especially at critical historical junctures, nor does the concept, because of its modern resonance of alienable possession, encompass the precise sense of how subjects actually struggle to be connected to such products. The fixed nature of capitalist ownership (something is owned or it is not) also fails to reflect the temporal nature of this process, whereas Sapir's 'how' has this sense built into it. Sharing, however, gives a much better sense of this issue. In other words, this sense of sharing is a process, needing regular regeneration. Thus, one era's genuine form can be experienced as spurious by another, because of the feeling of being alienated from its production both temporally and socially, rather than simply experiencing it as being owned by someone else. But, in all these cases, the sense of democratic control, the harnessing of cultural labour in pursuit of individual creative ends is at the core of our analysis.

Horses and Jewellery in Ireland

To illustrate these points, I want to examine the production of two different icons of Irish tradition during politically contentious times:'Irish-themed' jewellery in the mid-nineteenth century and the struggle over the ownership of horses in certain Dublin neighbourhoods that peaked towards the end of the twentieth century. I make no comment on any issues of hybridity in Ireland, or, indeed,on any other tradition. Instead, I start with the simple observation that jewellery and horses, in two different historical circumstances existed, as both icons and indexes that were experienced by a wide variety of subjects, internally and externally, as denoting things Irish: and that, despite surface dissimilarities, 'Irish' possessed similar valences in both contexts. Thus, the motifs that appear on jewellery for sale on O'Connell Bridge are experienced by seller, buyer and passerby as Irish, whatever the history of similar motifs in similar examples of material culture, say, in the *La Tiene* culture in Central Europe. At the same time, other collectivities, other nations, use the horse to carry meanings about their cultures, but certain representations of the horse have historically (and continue to have) great resonance for things Irish. My argument is that these things are fought over precisely because of their relationship to a self-produced tradition that becomes an object for reflection (and indeed struggle) at critical historical moments.

Jewellery

In May 1853, somewhere between one and four years (depending on the historian) after the Great Famine in Ireland had killed one million Irish people and forced another million into ships bound to North America, England and Australia, leading elements of Dublin society opened a World's Fair in the capital. I have explored some of the conflicted symbolic terrain in other publications (e.g., Saris 2000a), but, for my purposes in this essay, I want to look at some of the self-consciously cultural

productions associated with this exhibition, especially the widespread success of Irish Jewellery associated with this exhibition and its older, larger sibling, the London World's Fair of 1851.

At the time, it was widely acknowledged by the organizers, the critics and the public at large, that the core of the exhibition was the Antiquities Court, which contained the Celtic and early Christian-era treasures that had built up in the past century of dilettante collecting and amateur archaeology. For an organization that wanted also to demonstrate an Irish facility for modern production methods, however, this dominating presence of the past needed to be produced at least as a promise of the future of better economic development. Their innovative solution to this dilemma was to emphasize the technical craftsmanship of these ancient pieces.

> Even in the lowest utilitarian point of view, some of the beautiful objects of Irish manufacture which the hall for Antiquities presents, may well occupy a place in juxtaposition with the triumphs of modern handicraft. The Brooches, Croziers, Crosses, and Shrines, which are there exhibited, are credible as specimens of workmanship independent of the great historic interest that they possess. (The Exhibition Expositor and Advertiser 1853. VI: 1)

The point that the authors of this illustrated newspaper for the exhibition did not develop is that their collection, at least the jewellery part of it, had already become modern, at least in a certain sense. The centrepiece of the jewellery section of the Antiquities Court was the Tara Brooch, today, one of the most recognizable icons of Ireland in the world. The 1840s had been marked by some spectacular archaeological finds, in which jewellery figured prominently. These treasures had been copied for elite purchase in a small-scale way, but, in 1850, the Tara Brooch (not discovered on the famous hill, by the way) eclipsed all other finds.

This treasure was at least found in County Meath (the county which contains the Hill of Tara), but, some distance away on the coast, by the children of a peasant woman, probably a family in some distress, who were forced to forage for socially less-valued food from coastal resources. After some misadventures (it was nearly melted down for its metal content), the brooch was purchased by a local watchmaker, who sold it for a very handsome profit to George Waterhouse, an English jeweller who had moved to Dublin in 1842 and subsequently had become one of the best-known jewellers in the capital, (McCrum 1993: 38f; Waterhouse and Co. 1872: 7f).

The piece is genuinely impressive, a 3.5 inch (9cm) gilded bronze pseudopenanular brooch, with a pin of about 9 inches (23cm). The workmanship on the artefact is sublime, with extremely fine floral and animal designs, decorated with amber and silver. Mr Waterhouse immediately set to work copying it, originally in full-size, which suited a fashion for large shawls at the time, but also in smaller versions, which became increasingly popular as a decorative accessory.

In this process, Waterhouse was following what had become an almost routine cycle of moving archaeological finds into purchasable products. By the time of the

exhibition of 1853, for example, sixty variations (generally reduced in size) of five recently discovered brooches reputedly made from 'the mineral products of Ireland' were available for purchase in Dublin. Waterhouse had two marketing insights that bear on our discussion of authenticity, however. First, he published a booklet, giving a historical background to each item, thus connecting the copy to the authenticity of the original, a ploy that was soon copied by his competitors (Dunlevy 2001: 18). He also made a point of publicly showing the original, authentically recharging his copies, as it were. In the event, the Great Dublin Exhibition was a watershed in the widespread marketing of modern, craft-produced jewellery in the Celtic style (McCrum 1993). Queen Victoria herself purchased no less than four copies of the Tara Brooch and numerous copies of other Irish antiquarian jewellery as souvenirs of her visit.

The role of the Tara Brooch in Irish self-confidence is hard to overestimate. Different creeds and classes agreed on its significance, even when they agreed on little else. Certain individuals, such as George Petrie, one of the founders of the Irish Archaeological Society (1843) developed this theme on the discovery of the Brooch as a sort of watershed, when reflecting on the development of the Society on its ten-year anniversary.

> And lastly, I would fain refer to the preservation of this valuable memorial (the Tara Broach) of the ancient art of Ireland, as an important result of the efforts made by the Academy to illustrate the past history of our country, and place it on a solid basis. I shall not easily forget, that when, in reference to a similar remain of ancient Irish art, I had first the honour to address myself to this high institution, I had to encounter the incredulous astonishment of the illustrious Dr Brinkcley, which was implied in the following remarks; "Surely, sir, you do not mean to tell us that the Irish had any acquaintance with the arts of civilized life, anterior to the arrival in Ireland of the English?" Nor shall I forget, that in the scepticism which this remark implied, nearly all the members present very obviously participated. Those, at least, who have seen our museum, will not make such a remark now. (Ornamental Irish Antiquities 1853: 9f)

Petrie's Unionist sensibilities were not affected by his excitement over such an Irish index of civilization. Indeed, one can read a lot of cultural politics over the next fifty years in Ireland as working out the political ramifications of this widespread agreement that such jewellery (amongst other objects) were our 'Ancient Irish Culture' in concentrated form. In particular, the issue of how the Union with Britain was going to be affected by the massification of interest in Irish productions of things Irish was something that was going to become increasingly contentious as the century progressed. Thus, in a surprisingly brief time, during a ten-year period when Ireland was the site of one of the greatest disasters in modern history, a set of older objects and motifs became firmly associated with modern Irish culture, indeed as some of its most authentic exemplars. These objects and motifs became ever more central to a process of political separation over the course of the next few decades.

These tensions were also central to the Dublin World Fair. The main funder of the Dublin exhibition, William Dargan, for example, made his fortune in the railway boom of the 1830s. His success under a colonial regime did nothing to cool his

ardour for an independent Ireland. Ironically, he funded an imperial display par excellence, a world's fair, to explore the ways that Ireland might eventually politically separate from Britain. The meanings associated with any part of this Exhibition, then, were complex. Queen Vicotria, for example, visited the exhibition, and was so impressed with it and Dargan that she provoked a minor crisis by offering her Nationalist subject a peerage, which he publicly refused because, frankly, he did not want to be her subject. This needless conflict did nothing to slow down her shopping spree, the royal patronage ironically emphasizing both the desirability and the other-than-British quality of this jewellery to the Dublin middle-class.

Far from being destructive of authenticity, then, a combination of a specific mode of production in concrete social-historical circumstances, crucially after a social crisis, throws up both evidence of a tradition, but, more importantly, the technological means, the classes and the discontent for a variety of subjects to feel connected to that tradition, whose members find it available for their creative production of self, through the pursuit of individual fashion and taste. The widespread availability of objects bearing these motifs, then, becomes both a means of sharing in cultural production and changing the nature of one's share in the productive process itself (for a similar case with respect to folk music in America, see Bendix 1997: 144ff). These intersections in time and place become one of the conditions of the possibility of the Gaelic Revival, an artistic flowering in a variety of fields in the latter third of the nineteenth century.

Both the market and the state are intimately intertwined with this example and certain forms of reproduction (if not mechanical ones per se) are central to this phenomenon. The point of these reproductions is to allow concentrated bits of Ancient Irish Culture to wander directly into the various individual self-construction projects of members of the middle-classes of the second city of the empire. Thus, rather being the limits of genuine culture

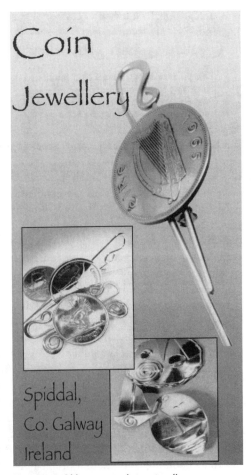

Figure 1.1: Old money made into jewellery.

or authentic experience, the market is central to it in this instance and subjects can engage such market products in creative, even surprising ways. The sense of authenticity and genuineness that I have derived from Sapir at least allows for a much more sophisticated treatment of this phenomenon, than that allowed by the metaphors of purity and violation. In Sapir's sense, the material bases for the 'how' of the life of culture, in this instance, are these reproductions. Their ability to be incorporated into the sort of self-fashioning that we refer to as taste and style also becomes a political assertion of control against something that is experienced as coming from outside.

I think that this process can be demonstrated by another form of jewellery that now enjoys some popularity amongst individuals who style themselves culturally conservative in present-day Ireland.

The motifs, borrowed from this earlier moment, to mark that seemingly most fungible of material items – metal tokens of a currency, as belonging to a nation-state – are recycled (only again after their monetary value has been lost) as distinctive aspects of an authentic national culture, after currency of another seemingly even more homogenizing kind, the euro, is introduced.

Who Gets to Drive a Symbolic Vehicle?

The role of rurality and rural life in depictions of Ireland has been investigated extensively (see Gibbons 1988, 1996, among others). In broad form, it shares many similarities with other European national depictions, evidencing a suspicion of modernity in general and urban life in particular (Helias 1978; Saris 2000b). The role of what one might call the rural horse has been especially important in very different representations of Ireland, able to condense ideas of everything from the cheerful fecklessness of the gentry to the lack of mental agility of the Irish peasant for nineteenth-century observers, but most Anglo-American observers would see something typical in a postcard depicting a working horse as part of a family farm in rural Ireland. This depiction has its urban counterpart, stressing the use of the horse in a set of traditional economic practices that are slowly fading away – such as horses hauling coal or milk in a slightly run-down cityscape.

I want to focus instead on an apparently paradoxical production of horse images that grew in importance throughout the 1990s, as part of a political struggle in some of the poorest areas of Ireland. This is the horse produced not as a survival of an earlier mode of production, but as a public display of play and leisure. This horse was also opposed in some sense to the modern, but owing more to the way that this is done west of the Missouri River rather than west of the Shannon. And, far from signalling a sort of steady-state idyll, a nostalgic waning of tradition under the waxing star of modernity, this horse highlighted current conflicts about class and the control of commons.

This relatively new relationship to horses flowers in several neighbourhoods around Dublin in the 1990s, at a time of widening economic and social inequalities and a booming youth heroin problem. My work on this phenomenon occurred mostly in Gallanstown, Cherry Orchard, part of Ballyfermot, a western suburb of

Dublin, commencing just after horses became a significant political issue in 1997, in the wake of legislation that effectively rendered every horse in the capital illegal (1996). It continued into 2000, then sporadically thereafter,[8] and in some respects is continuing at present as I am still actively researching neighbourhoods with drugs issues, which have a historical consciousness of having been recently estranged from horse ownership.

The so-called Horse Protest occurred in places like Cherry Orchard and was conflicted at several levels. First, by the mid-1990s, doing badly in modern Ireland was made more difficult both by a society that was clearly rapidly enriching itself and by how the generation of wealth was being understood at an ideological level. The Celtic Tiger was constructed as the making good of the sacrifices of previous generations in Ireland (conveniently near a round-number year, 150, commemoration of the Great Famine). At the same time, many people who both run and comment on Irish society were re-conceptualizing poverty in terms of particular spaces and specific populations, substituting what we might call an ecological model of poverty for a moral one. Thus, the notion that 'we as a society have poor members' pretty much gave way to the idea that 'there are poor communities in our environment'. This ecological model of poverty encourages erstwhile citizens to think of themselves as connected to weakly interacting collectivities, and, ultimately, I have argued (Saris et al. 2002b) to think in terms of national parks containing the dangerous forces of the socially excluded. In most places where this thinking has taken hold, these preserves come complete with socially designated rangers, such as specially trained police and social welfare officers. To this extent at least, then, Ireland developed an 'underclass' in the 1990s, in the sense that this phrase is used in North America and to a lesser extent England, that is, an ideological configuration of poor populations connected to specific areas, with supposedly distinct lifeways and values, who then could be held substantially responsible for the perpetuation of their own misery (see Wilson 1987; Dalrymple 2001, among many others). As often as not, this underclass exists at the suburban fringe of Dublin as opposed to its rapidly gentrifying core. The exotic nature of these areas and populations was further highlighted by the fact that some of the natives rode bareback.

Of course, horses had traditionally been important vehicles for both people and meanings in many areas in Dublin (Saris and Bartley et al. 2000a). A few families in such areas, for example, have a long tradition of horse ownership, indeed, as recently as the late 1980s, horses were still used commercially in a limited way. As the 1990s heroin wave grew in intensity, however, many local youths became interested in horse ownership, as one of the few positive aspects of living in Cherry Orchard. By the mid-1990s, however, there were legal movements afoot to drastically curtail horse ownership in the greater Dublin area. Since the end of 1996, with the passing of very harsh legislation that effectively rendered every horse in the capital illegal, a horse protest, including everything from raising media awareness of this issue to battering the enforcers of the new regulations, has been ongoing in this area, as well as other poor neighbourhoods in the Irish capital. In other works, our team has explored some of the ways that horses have been used by various local forces to both stake a claim to ownership of specific spaces

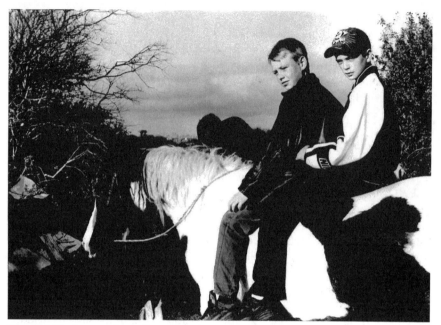

Figure 1.2: Two boys on a horse. Picture Jamie Saris.

and to contest the lack of respect and spoiled identity that they feel are projected upon them by mainstream society (Saris and Bartley et al. 2000a).

Foreign and domestic observers had long highlighted the phenomenon of urban/suburban horse ownership in the Greater Dublin area. Films, like *Crushproof* and *The Commitments* (as well as other Roddy Doyle novels that have reached a mass market beyond the island), for example, have made the urban horse one of the peculiar, quasi-ethnic features of Dublin working-class areas. It is the surprise at seeing a horse in a poor urban setting (and the further surprise of how non-plussed the natives are about encountering such animals in flats or apartment block lifts) that indexes the exotic quality of this working class population for middle-class audiences in Ireland and for most audiences abroad. In this picture, horses are constructed as preeminently traditional objects, quaint survivals at odds with the modern world. Here, tradition means something past its time, out of place, and, crucially, economically useless. It is precisely this irrationality of horse ownership that guarantees both a fleeting authenticity to life in these areas, while pointing to their inevitable decline.

It is important to keep in mind, however, that the internal homogeneity of horse owners was very easy to overstate. One could, for example, have found in Cherry Orchard animals that look dispirited and underfed as well as beasts that are maintained at near-dressage quality. Any acquaintance with the neighbourhood of more than a few days standing, moreover, provided ample evidence that, as late as the mid-1990s some elements of the neighbourhood, such as mothers with young children, found such large animals roaming around or being ridden hard to be something of a

hazard. Nonetheless, the crisis that the new legal framework around horses created, and the seizures it produced, paradoxically encouraged an interesting effervescence around horses and horse ownership. More and more, one heard from horse owners in Cherry Orchard that anything to do with horses was a traditional practice, 'Horses have always been here', 'This is the way we do things', and the like became standard responses to any outsider – researcher, journalist, or enforcer of the new regulations.

Thinking Traditionally

Clearly, while we have different issues of power and representations in this situation than in our discussion of jewellery, the idea of tradition is invoked in both contexts. In the nineteenth century case, we have relatively semi elite class fragments circulating images and reproductions amongst themselves. In the twentieth-century case, the means of reproduction (in at least two senses) rapidly leave local hands, and meaningful spaces within the representations of what was going on in places like Cherry Orchard, were never locally controlled.

First, the horse herds had to be built up in the 1990s, through breeding and purchase, generally from Travellers (an indigenous nomadic group in Ireland), to whom many folks in Cherry Orchard can be quite racist. It is also easy to elicit stories about how criminal connection allowed certain expensive thoroughbred lines to come to Cherry Orchard through temporary horse rustling and appropriation of stud services. Growing the herds was made easier by the swathes of waste ground that then surrounded areas like Cherry Orchard, which provided space to corral the animals, enjoy riding them and even to organize informal horse shows. The widening base of interest in horses was also indirectly facilitated by the heroin boom in these areas, as young people who wanted nothing to do with heroin, could still buy hashish from local dealers in these out-of-the-way places (and, indeed some dealers were themselves keen horsemen). Thus, a *modus vivendi* was rapidly worked out, where young people could interact freely in a leisure setting, with locally respected individuals with access to recreational drugs, but still be able to refuse heroin.

However, both the horses and the waste ground were attacked at the same time, as new legislation rendered almost all city horse ownership illegal, while Dublin City Council began to dispose of their newly valuable land to various developers. Most of the more politically-aware horse owners articulated the sentiment that this was not an accident, as such ground had become very valuable very quickly, and, through the quirks of Irish law, some of the owners might have been able to have claimed rights in usufruct to the land, whose purchase would have had to be negotiated as part of the transfer of ownership, delaying the development and making the transfer of land into private hands more expensive.

The people's representation of this conflict is what I found most interesting, as it is here that we see some sense of the struggle between classes over meaning-production.

C. If you look back on the history, the only people that ever owned horses was rich people, you know, and for people in urban areas to own horses, you know, you're not supposed to 'come up in life' when you live in an urban area or you live in a council/corporation estate. You're not supposed to raise above em ... any expectations of, you know of anything. ...

B. It's like the penal laws ... What was it that if an Irish peasant had a horse that was more valuable than a Lord the Lord was entitled to confiscate the horse and take it from you regardless of value.

I. Buy it for a set fee: the value of the horse, actually anybody not a member of the Established Church.

B. Under a fiver wasn't it, it couldn't be worth a value over five pound or you paid a fine.

I. Yes, they'd take it from you.

A. It's being used again as a measure, but now there's two things, wealthy people have them. But it also, its not appearing in the middle-class areas, it's appearing in areas which are, if you like, places like North Clondalkin, Fettercairn, even around town ...

I. Where else in Dublin? In Ballymun?

A. Everywhere, Ballymun ... it's interesting that both extremes in a sense in terms of status varies you know. Like really wealthy areas down the country have it, while other areas like ...

B. It's upsetting the balance of relativity in our country ... I'm sure middle-class people are saying, look, how can these people have a horse, and we haven't, and we're middle-class. So it's upsettin' the balance of relativity, they're coming out of their stations ...

Very briefly, two broad tendencies developed from this ferment. The first, which still continues, is a sort of external aestheticizing of the everyday lives of children and horses, that is, that the animals are a ray of sunshine, a source of 'happiness in the midst of bleakness', or they serve as the means of luring potential 'young criminals' onto more socially useful paths. None of these portrayals, however, question the structural relationships that developed such a situation. The aestheticizing impulse begins early in the development of the Horse Protest, with the publication of *Pony Kids* (1996), a sumptuous coffee-table volume by the English fashion photographer, Perry Ogden. His main technique in the work is a fine-grained black and white photograph, with the boy and horse isolated from their surroundings by a white sheet.

This trend is continued within Ireland in iconizing certain Dublin neighbourhoods as 'ghettos' in the way that this term is used in other parts of the Anglosphere, especially the United States. This usage masterfully fuses an understanding of poverty and one of culture, while deliberately neglecting political economy (see Saris et al. 2002). By the late 1990s, this new extension of the term ghetto had developed to become commonplace amongst in Irish punditry, and 'urban cowboy' – with a connotation of a young man on a horse being out of place, out of time, a bit wild and dangerous, with little respect for the safety and security of others – had become

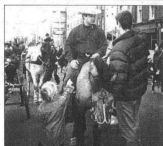

Figure 1.3: The Horse Protest: Eddie Kershaw in front of Mansion House.

one of the more exotic features defining 'ghetto culture' in Dublin.⁹ extension of the term ghetto had developed amongst Irish punditry. This expression owed a lot to the uses of the term in other parts of the Anglosphere, especially the United States, particularly in its masterful fusing of poverty and culture, while neglecting political economy (see Saris et al 2002). In turn, these trends provided relatively novel means for authentic self-fabrication and political display. In other words, as the style of urban cowboys becomes more recognized as belonging to an underclass, it became more available for individual appropriation and modification. Thus, we see (what looks in retrospect to have been) the high point of the Horse Protest in the late 1990s, a sort of theatrical raid on the Dublin City Council ('Corpo') building (Mansion House) by a local activist, Eddie Kershaw. The urban cowboy now looks as if he could ride through Dodge City as easily as Dublin.

Yet, this display never moves beyond street theatre. There were scattered incidences of assaults on the enforcers of the new law, and occasionally seized horses were liberated by their owners from state custody, but, over the next few years, these neighbourhoods loose the fight to keep horses, save in specially designed (and state-provided) stables, aimed more at job-training than enjoyment and recreation. As importantly, they also lose the symbolic control of the local meanings of the horse, which is then (re)presented to them as the index of (future) community success rather than a locally-owned means of signifying 'our' tradition or something that is a local source of shared enjoyment and a common resource for various locally-meaningful projects of self-fashioning.

Conclusion

In our first example, the really interesting question is what is the condition of possibility of judging the value of an item connected to an authentic Irish tradition (see Saris 2000b) for various processes of fashioning cultures and selves. This, it seems to me, is another way of getting to Sapir's distinction between genuine and spurious. This moment was itself a very important cultural and political juncture, as it assumed the production of cultural objects and narratives by Irish men and women for an Irish audience, who themselves had some power in a hierarchical social structure. This was precisely the enduring success of the Gaelic Revival: the collecting and/or manufacturing of Celticana became an activity valued for itself. From this point, even the seemingly most kitsch object could potentially become a part of what Hroch (1993) correctly points out as what national consciousness is in fact conscious of: the shared historical experience of a group of human beings. It was also at this point as well that such material and symbolic items became available to coherent common sense schemas, potentially motivating political action (see also Darnton 1984: 9–74). This sense of ownership establishes a middle-class-led Irish tradition, one that can still, at least for some subjects, genuinely engage the world in a creative way.

We see a similar set of issues in the situation with horses in poor neighbourhoods in Dublin, but with very different material relationships to both the state and the market and different levels of control over hegemonic ways that meaning is produced. In the first instance, the means of cultural production are at least, in part, materially controlled by the same class that is trying to make or reclaim a tradition. In the second, this control is the very object that has to be struggled over. In both cases, we see a similar appeal to a tradition, which becomes the raw material for both self-fashioning and further (novel) elaboration of that tradition. Sixteenth-century penal laws and the late twentieth-century Corpo, then, can be connected within the same historical imaginary, both of which are fought most effectively on horseback. The loss of horses, then, was experienced by many owners in Cherry Orchard as a return to a passivity and cultural silence that they feel is desired by those who hold power over them: in other words, as a denial of their right to share in the production of non-utilitarian values. Instead they are forced consume what they are given: stables to house 'their' horses, at least those that the state will let them keep, and their interest in the animals is validated, not through their self-narrated connections to everything from the Ulster Cycle of Celtic myths to the Elizabethan reconquest of Ireland, but through a middle-class hope that it might keep (at least some of) them out of trouble, or provide their otherwise unemployable youth with some job-training, or, indeed, just shut them up.

This sense of who sets the terms of the debate, who defines the stakes and how accessible these answers are to a subject's psychic economy is where Sapir's insight is most useful. It is, perhaps, best seen in the difference between *Authentes*, the Greek for self-made/self-fashioned (and, indeed, one who acts with authority, including authority to kill) versus the Latin root of *feitiço* in Italian, meaning 'skillfully contrived' or 'artificial' in the sense of 'done with artifice'. It is Marx of course who formalizes

the early anthropological use of the latter term to describe how the products of humans can be experienced by humans as having power over them.

Sapir's understanding of genuine and spurious culture deals with this same relationship with respect to public meanings, both in the sense of how widely they are owned and how accessible are their means of production. The 'how' in the way that meaningful products are experienced in our examples is determined by a subject's relationship to a cultural-material product within a concrete social-historical context. In other words, one's activities produce and reproduce not just a material environment, but a meaningful one as well. Indeed, for humans this is one and the same. Different subject positions are thrown up in this process and political struggle is, often, if not exclusively, about the struggle over these means through such positions. Meanings are indeed produced by subjects, but not just as they please, not at a time and place of their own choosing. Sapir's essential point is that there exists a basic need for self-fashioning which exists alongside specific, historically-situated means of producing and reproducing a given social-material environment. This need is an impetus to struggle over the means of making meaning and it is what imbues human politics with its specificities: in other words, power is always meaningful and meanings are themselves a place where power is struggled over and specifically reproduced. 'Culture comes and goes' in Sapir's sense because the opportunities for people to realize that they are, in fact, producers and to use this realization to produce self-consciously occurs only at specific times and is almost always the very stuff of political struggle.

Notes

1. I wish to sincerely thank my Research Assistant, Scotty McLoughlin, who laboured on the sources for this article with industry, imagination and insight. Chandana Mathur read an embarrassingly rough version of this piece and provided some very useful feedback. Finally, Rob Moore provided invaluable assistance with some major revisions in my argument. Any mistakes and omissions are, of course, my own.
2. The most clear-eyed modern version of this exhortation is provided by Trilling (1972), see also Taylor (1991).
3. The third main sense of authenticity, that of establishing the provenance and authorship of certain material objects. is explored in chapters 4, 5, 6, 7, 11, and 12.
4. For relevant literature on Sapir, see Darnell 1990.
5. 'Culture, Genuine and Spurious' was first published about ten years after Sapir earned his Ph.D. under Franz Boas, during his second major academic appointment (based in Canada), and some years away from the writings about language, culture theory and psychiatry, that were to make him world famous. Sapir reworked and considerably lengthened the article through three iterations over five years, first in *The Dial* (then a journal of political commentary on the cusp of becoming a very important literary journal in the 1920s), then *The Dalhousie Review* (an important criticism periodical) and finally, considerably expanded, it was accepted by *The American Journal of Sociology*, probably the premier English-language social science publication of that time.
6. See *Hermanaut* 15 for a special edition dedicated to 'Fake Authenticity'.
7. Clearly, one cannot refer to authenticity and the market in the first half of the twentieth century without mentioning Benjamin's 'The Work of Art in the Age of Mechanical Reproduction' and the Frankfurt School more broadly. The relationship between use value and exchange value becomes complex in capitalism because of technical considerations (Benjamin 1936), in terms of concentration of ownership of the means of production (Adorno's 'Culture Industry' (1978)), with profound

implications for the effect consumption has on art and authenticity. Benjamin, in particular, argues that art's aura encourages certain sorts of reproduction and exchange while fomenting the destruction of tradition. More disturbingly, Benjamin predicts that the capitalist concentration of the means of such reproduction, especially film, will distract the masses, without altering property relations, while providing a means of aestheticizing politics that will inevitably feed mass support for fascism. In other words, as the means to share in cultural production becomes ever more restrictive, the sorts of shares on offer to the masses become not just abortive but politically dangerous.

8. So seriously did Dublin Castle take this insult that they agitated for a Special Act of Parliament to deny the popular desire to name the newly opened National Gallery (1864) after Dargan, whose core collection was the Fine Arts Department of the 1853 exhibition. Dargan won the long game, however, as it is his statue that greets visitors to the Gallery to this day.

9. Ironically, this was also the era of the "cowboy" builder in much of Ireland – tradesmen who inflated their credentials, took money for several jobs simultaneously, ignored best practice and building code regulations, and delivered, not surprisingly a very sub-standard product. While these working class men would have come from more respectable backgrounds than their urban cowboy counterparts, there was more than a hint classism in their depictions as "cowboys", as the building boom in the Celtic Tiger made a lot of tradesmen very well-off very fast, surpassing the pay of the credentialed middle class.

References

Adorno, T. 1978. 'Culture Industry'. In A. Arato and E. Gebhardt (eds), *The Essential Frankfurt School Reader*. Oxford: Blackwell.

Bartley, B. and A.J. Saris. 1999. 'Social Exclusion in Cherry Orchard: Another Side of Suburban Dublin', In A. MacLaren and J. Killlen (eds), *Dublin: Contemporaries Trends and Issues for the 21st Century*. Dublin: Geographical Society of Ireland. Pp. 81–92.

Bendix, R. 1997. *In Search of Authenticity: The Formation of Folklore Studies*. Madison, Wisconsin: University of Wisconsin Press.

Benjamin, W. 1936: *The Work of Art in the Age of Mechanical Reproduction*. http://www.marxists.org/reference/subject/philosophy/works/ge/benjamin.htm

Berman, D. 2009. *The Politics of Authenticity: Radical Individualism and the Emergence of Modern Society*. (Revised Edition). New York: Verso.

Darnell, R. 1990. *Edward Sapir: Linguist, Anthropologist, Humanist*. Berkeley: University of California Press.

Dalrymple, T. 2001. *Life at the Bottom: The Worldview That Makes the Underclass*. London: Ivan R. Dee.

Darnton, R. 1984. *The Great Cat Massacre and Other Episodes from French Cultural History*. New York: Vintage Books.

Dunlevy, M. 2001. *Jewellery. Seventeenth to Twentieth Centuries*. Dublin: National Museum of Ireland.

The Exhibition Expositor and Advertiser. 1853. VI.

Fabian, J. 1983. *Time and the Other: How Anthropology Makes Its Object*. New York: Columbia University Press.

____. 2000. *Out of Our Minds: Reason and Madness in the Exploration of Central Africa*. Berkeley: University of California Press.

Gibbons, L. 1988. 'Coming Out of Hibernation? The Myth of Modernity in Irish Culture'. In R.

Handler 1986. Authenticity. *Anthropology Today* 2(1) 2–4.

____. 1988. *Nationalism and the Politics of Culture in Quebec*. Madison, Wisconsin: University of Wisconsin Press.

Helias, P.-J. (trans. J. Guicharnaud). 1978. *The Horses of Pride: Life in a Breton Village*. New Haven: Yale University Press.

Hermenaut 15. 'Fake Authenticity', http://www.hermenaut.com/i15.shtml.

Hroch, M. 1993. 'From National Movement to the Fully Formed Nation: The Nation-building Process in Europe'. *New Left Review* 198: 3–20.

Kearney, R. (ed.). 1989. *Across the Frontiers. Ireland in the 1990s*. Dublin: Wolfhound Press.

____. 1996. *Transformations in Irish Culture.* Cork, Ireland: Cork University Press in association with Field Day.
Lowie, R.H. 1929. *Culture and Ethnology.* New York: Peter Smith.
____. 1937. *The History of Ethnological Theory.* New York: Holt, Rinehart and Winston.
Lukács, G. 1923. *Reification and the Consciousness of the Proletariat.* http://www.marxists.org/archive/lukacs/
McCrum, E. 1993. *Commerce and the Celtic Revival: Victorian Irish Jewellery.* Eire/Ireland. XXVII (4). Pp. 36–52.
Ornamental Irish Antiquities. 1853. Second Edition. Dublin: Waterhouse and Co.
Ogden, P. 1996. *Pony Kids.* London: Jonathan Cape.
Sapir, E. 1949. 'Culture, Genuine and Spurious'. In D. Mandelbaum (ed.), *Edward Sapir: Culture, Language, and Other Writings.* Berkeley: University of California Press. Pp. 99–118.
Saris, A.J. 2000. 'Culture and History in the Half-Way House: Ethnography, Tradition, and the Rural Middle Class in the West of Ireland'. *Journal of Historical Sociology* 13(1) 10–36.
____. 2005. Reconsiderando los Estereotipos: Imágenes de Irracionalidad en la Obra del Columnista del Irish Times, John Waters. *Revista de Antropología Social* 14: 281–309.
____. 2011. "The Addicted Self and the Pharmaceutical Self: Ecologies of Will, Information, and Power in Junkies, Addicts, and Patients" In In J.H. Jenkins (ed.), *Pharmaceutical Self and Imaginary: Psychopharmacology in a Globalizing World.* Santa Fe, NM: School for Advanced Research on the Human Experience (SAR). Pp. 209–229.
Saris, A.J. and B. Bartley. 2002a. 'Culture and the State: Institutionalising "the Underclass" in the New Ireland', *City* 6(2) 167–191.
____. 2002b. 'The Arts of Memory: Icon and Structural Violence in a Dublin "Underclass" Housing Estate', *Anthropology Today* 18(4) 14–19.
Saris, A.J., B. Bartley et al. 2000a. 'Horses and the Culture of Protest in West Dublin'. In M. Peillon and E. Slater (eds), *Remembering the Present: Irish Sociological Chronicles.* Volume II. Dublin: Institute for Public Administration. Pp. 117–130.
____. 2000b. 'Imagining Ireland in the Great Exhibition of 1853'. In G. Hooper and L. Litvack (eds), *Ireland in the Nineteenth-Century: Regional Identity.* Dublin: Four Courts Press. Pp. 66–86.
Stocking, G. 1994. *The Ethnographer's Magic and Other Essays.* Madison, Wisconsin: University of Wisconsin Press.
Taylor, C. 1991. *The Ethics of Authenticity.* Harvard: Harvard University Press.
Trilling, L. 1972. *Sincerity and Authenticity.* Harvard: Harvard University Press.
Wilson, W.J. 1987. *The Truly Disadvantaged: The Inner City, the Underclass, and Public Policy.* Chicago: University of Chicago Press.

Chapter 2

The Deceptive Tentacles of the Authenticating Mind: On Authenticity and Some Other Notions That are Good for Absolutely Nothing

Rajko Muršič

If there are any human activities that incorporate authenticity in the very moment of their appearance (and disappearance), they are music and dance.

Whenever we speak (or write) about music, we lose ourselves in the opacity of the simplest words. Playing and listening to music, and the experience of dance and rapture, sound and silence, bring words to their limits: and beyond. No other magic than music can conjure its experience (see Muršič 2003).

Whatever kind of music we experience, if it has any meaning to us, we may easily become seduced to conceive it as ours. If it is music presumably inherited from our ancestors, or if it is music that reflects the soothing quality of our landscape, or the spiritual essence of our people, it is, in one word, authentic. The idea that music authenticates social experience is rather trivial. But if we generalise the idea that there are practices that authenticate experience, we have to consider the opposite situation: the falsification of social experience through inauthentic practices. In the following discussion I shall try to show that the notions of authenticity and inauthenticity are deeply problematic and fallacious.

There are various notions we take for granted without questioning. These notions are typically used in both daily life and academic jargon. When we are dealing with notions which are not only pregnant with meaning but at the same time charged with value, things can become problematic. In these times when everything solid is ineluctably melting into the air, the notion of authenticity is widely used to define that which is resisting. However, this resistance is not necessarily liberating.

The use of charged notions without establishing any critical distance from their daily use can become problematic as soon as the notion is used on a daily basis as an excuse for suppression, repression, prevention and cleansing. In different contexts,

understandings of authenticity have been used to prove ancient rights to land, or as the constitutive basis of national formations, or as the unquestioned kernel of any recognisable social group. Therefore it is difficult to find any use of the notion of authenticity that does not provoke harm either as an agent of homogenisation or as a tool of exclusion. Its draconic variants may be observed in racism, nationalism and all the other kinds of exclusivism. Without the notion of authenticity, it is very difficult to understand culturalism and millenarism.

We can easily follow its use in present-day popular culture, where solid matters are constantly and radically evaporating into the thin air of yesterday's fashions, influencing socialness in a very uncertain and specific way. Walter Benjamin showed us how the infinite reproduction of works of art affected the whole society: the peak of modernity was aestheticized politics. Without the division between the authentic and 'inauthentic' experience of modernity, this would not have been possible. Marching Nazis, fascists, communists, racists and culturalists would not have been possible without the rise of modern popular culture that is rooted no longer in ritual but in politics (Benjamin 1968).

In this essay I will critique the notion of authenticity using some examples in popular music, where the issue of authenticity is omnipresent in the discourses of fans and critics, musicians and academics. Following these examples, I will try to expose the ambiguous meaning of the term in relation to music and social processes in general and its significance in the formation of various kinds of exclusivism. The key problem is that it might not be possible to think of authenticity without (social) exclusiveness.

The main focus of my criticism will be based on the fallacy of taking the results of social processes as simply given and more important than the (social) processes in which they are created. I will follow not only Marx's criticism of commodity fetishism (1986: 39–82) and Keesing's criticism of reification of culture (1990), but also recent discussions of human agency, subjectivity and processualism (Archer 1996; Barth 1997; Wagner 2001; van Loon 2002; Rapport 2003; Carrithers 2005). This means, to give a couple of examples, that we have to discuss, if not replace in our conceptual vocabulary, not only identity but identification, not only corporeality (or simply body) but embodiment, not only spatiality (space/place) but spatialization, essentialization instead of essence, and, finally, processes of authentication instead of merely analysing authenticity.

To make the point clear, I shall use some examples of authenticating exclusivism in music, especially rock and its roots, and, briefly, in anthropology itself. In the first case authenticity in popular music is inseparable from racism (even if it appears in the form of positive racism in the sense that, for example, only Afro-Americans can rap authentically). In the second case it is inseparable from culturalism (or nationalism), i.e., the belief that there is an authentic tradition of a people. In both cases the discourse of authenticity is an essentializing discourse, establishing grounds for essentialist notions of culture, nation and race. With regard to authenticity, the 'rock 'n' roll nation' is no more essentialist than any other nation.

Authenticity in Music: Folk, Roots, Revival and Industrial

What is more authentic, more genuine: old traditional songs that people occasionally sing at home, at feasts and festivals, songs they sing with formal groups at various folklore events, or fabricated and standardized commercial pop songs, or perhaps artistic solo singing? We usually do not consider pop songs to be more authentic than traditional songs; on the contrary, we believe that there are some kinds of music that are more authentic than others, merely because of their kind and not because a particular song or musical work would be essentially more authentic than other similar pieces of music. For a general, western audience, not only for music experts as described by Adorno (1986), classical music is taken as undoubtedly authentic, but its authenticity is derived from a different kind of experience and rationalization than the authenticity of traditional music. Nobody would dare to claim that all kinds of music are equally authentic. That would be the same as claiming that all kinds of music are at the same time, and in the same way, inauthentic. If music – and any other kind of symbolic practice – is intended to mean something to people, they have to appoint at least some gradation of authenticity. The range runs from complete rejection (music as inauthentic) to full acceptance (authentic music). In-between are various kinds of partial acceptance that people express in terms of acceptance of one kind of music as being more authentic than another. At best, the notion of authenticity is relational. However, would it be possible for the same gradation of authenticity in music to be acceptable for all listeners of a particular kind of or piece of music? What is authentic for some people is inauthentic for other people. But if there are at least some people who consider particular kinds of music to be authentic, then it is authentic. And if everything can be at least in one way authentic, then there is no sense in using the term. In music, we can easily show that this is so. Any kind of music, as well as any particular piece of music, is at the same time authentic and inauthentic, even for the same audience and in the same context of its social use. Some examples from traditional and popular music relativise the concept of authenticity.

A Traditional Example: Val Resia

There is an expectation that authentic music must be searched for in the most remote parts of the globe. Even in Europe we can find remote places with presumably preserved ancient traditional (or folk) music. In the times when intellectuals first were discovering the spirit of the people, remote Alpine valleys were considered as given cultural preservation areas. The Russian scholar Izmail I. Sreznevski and the Polish scholar Jan Baudouin de Courtenay discovered the Resia Valley in the Italian Alps with its Slavic-speaking population and presumably preserved ancient language and culture as early as the 1840s and 1870s. In this valley, with a population of less than one thousand five hundred living in seven villages (more Resians live in diaspora), the Resians would gather at the main annual feast in August and dance to their music performed on violin (*citira*) and smaller double bass (*b[r]unkula*) (see Strajnar 1988).

Their music and the local dialect are considered to be the most characteristic part of their heritage and identity. They still sing songs that are long forgotten in other nearby regions and they still dance to traditional instrumental music at village feasts. Their dialect – or language – is not (fully) comprehensible to Slovene speakers, although it is classified among western Slovene dialects (the Slovene language is divided into more than thirty-five dialects, some of them mutually almost incomprehensible).

In the compilation of music from the Resia Valley (Resia 1997) we find very interesting vocal, instrumental and vocal-instrumental music examples recorded in the field, mostly at village feasts. But one of them is totally different from the others: it is a modern folk song (Rezija, singer: Rino Chinese, 1981). Which music is more authentic, the old or the new?

If there are good reasons to believe that particular pieces of music are older than others, it is perhaps reasonable to consider older tunes and songs as more authentic. However, in this particular case it is worth knowing that the Resian musicians had already established a folklore group (it is now called *Gruppo folkoristico val Resia*) by the late 1830s! One of the recent traditional music examples, recorded at a village celebration in 1996, is rhythmically performed in the characteristic old 5/4 meter (3/4 + 2/4). However, the melodic structure of the tune is different from the structure of the old tunes. They are based on a characteristic melody, which is repeated several times in the root key, then transposed to the third, and later transposed back to the initial key. Now, despite the preserved transposition pattern, the melody is played in a call-and-response manner, which is more characteristic of the composition style of popular music derived from Afro-American traditions. So, is the tune indeed so old, traditional and authentic after all?

Some Central European ethnomusicologists still claim that each nation/people/ethnic group has its own characteristic songs and music (cf. Strajnar 2001 on Slovenia and a critical overview in Bohlman 1991). Although they admit that particular songs, melodies, tunes, dances, instruments and ideas were borrowed from other people and social strata, they consider their appropriation and separation to be the raw material for the classification of folk music.

The idea of folk culture (and folk music) came with the rise of modernity: 'Folk culture included the nation's inalienable ingredients and was due to preserve the common, the distinctive, the very special of the nation' (Koestlin 2001: 160). The idea of embedded authenticity in folk music, combined with the idea that authenticity was a quality of the most cultivated art, was only possible when making a clear-cut distinction with pop songs. Folk music was conceived as authentic in contrast to popular music (Strinati 2004: 36). The first scholars and researchers of popular culture conceived of it in terms of mass culture and critically rejected it (see Rosenberg and White 1965; During 1993), because it was not seen as authentic culture. On the contrary, with its mass production, cheap price, overall availability, short duration and lack of deep meaning, the products of the culture industry, i.e., films, popular songs, popular literature, fashion, advertisements, food, and so forth, were seen as fabricated and alienated. Since they were mediated by the mass media, they had lost the authentic human touch.

Only when we observe and study mass culture ethnographically, from the perspective of the daily life of various groups of people, does it become clear that mass culture is very important (see Williams 1996) in late modernity. The products of mass culture may be used in unprecedented ways in the hands of ordinary people. They can gradually become a means of counter-hegemonic resistance (see Hall and Jefferson 1975). When observed from below, from the ethnographic point of view, mass culture is not massive at all: it is an ordinary part of present-day life. And in that sense, it is much better to use the term popular culture (preserving the Latin meaning of the term *populus*).

After the first ethnographic and sociological studies were done (e.g., Becker 1951) and with closer observations of popular music and its social impact, it became clearer that it was not possible to confirm any simplifying and stereotypic notions of mass culture. Live popular music and music consumed in many different social settings were far from being simply fabricated and standardized, producing only standardized consumers to serve the capitalist machinery (Adorno and Simpson 1990). In defining their social boundaries, its protagonists took it as authentic. As a matter of fact, the social practice of authentication became the crucial factor in defining social boundaries within complex (post)modern society. How, then, can we reconcile Adorno's sharp criticisms of inauthentic standardization in popular music and spontaneous processes of authentication among its standardized listeners?

To discuss this issue, it would make sense to begin with a definition of inauthentic music. Can we in fact find any inauthentic music? If there is music and there is at least someone who fully accepts it, then by definition there is no inauthentic music. Inauthentic music is thus *contradictio in adiecto*. As far as the social experience of music is concerned, the criterion of authenticity is of no use (see Muršič 1996). Although music is clearly a social phenomenon, it may not – and cannot – be constrained either to particular social strata (the elite) nor to any other closed group of people (folk), for any music is in its essence 'people's music' (Keil's term; see Keil and Feld 1994: 197ff.) and its authentic appeal cannot be totally confined. At the utmost, the term authenticity is not only a relational term, but is based on self-establishment, a conceptual oxymoron.

To make the point clearer, let me discuss the authenticity of one of the most well-known rock songs. The story of the song *'Louie Louie'* will bring to the fore some further dimensions of the term.

A Modern Example: *Louie Louie*

The rock anthem 'Louie Louie' is among the three most widely covered songs in the history of popular music: The Beatles' *Yesterday* has been recorded in more than three thousand versions, Gershwin's *Summertime* in more than two thousand five hundred versions and *Louie Louie* in more than two thousand versions (Predoehl 1999). Among the groups that made a recording of the song are The Beach Boys, Black Flag, The Fall, The Flamin' Groovies, Iggy and the Stooges, The Kinks, The Maytals, Mo-

torhead, Robert Plant, Otis Redding, The Sisters of Mercy, Ike and Tina Turner and Frank Zappa. However, not many people, even very well-informed rock fans, know the history of the song.

Who wrote the song? What is its original version? Which version of the song is the most authentic? Is it the first recorded version by Richard Berry and his band the Pharaohs, that of the Kingsmen, Iggy Pop, or, for that matter, any of the known and unknown thousands or perhaps millions of its anonymous performances? The answer is rather easy: each is authentic and none of them is authentic at the same time.

Richard Berry, a black singer and songwriter, wrote the song in the years 1955–1956. Curiously, Richard Berry borrowed almost all the ideas (including the famous riff) for the song from various artists of his time. He borrowed the riff from Rene Touzet's *El Loco Cha Cha*, the idea for lyrics from Chuck Berry's *Havana Moon* (which was itself derived from Nat King Cole's *Calypso Blues*) and the mood from *One for My Baby* by Johnny Mercer and Paul Weston and his Orchestra (cf. Love That Louie 2002). And he never denied it. He did not even think that the song had hit potential and planned to release it as a B-side of a single. The song was not completely unnoticed, but still went into oblivion until it was re-discovered when it became a huge national hit seven years later with the Kingsmen's number two single on the charts.

In the meantime, the song actually survived in oral transmission. How? It is a long and surprising story. *Louie Louie* was composed by a black artist and recorded by a black (rhythm and blues) group, was later appropriated, became appreciated among pub musicians and was played at all kinds of parties, gained its appeal because of its transmission from the black to the white milieu. Even if the song itself can not substantiate a widespread myth of originality, its destiny confirms the standardized myth of rock and roll: that rock is basically music stolen from Afro-Americans, cleansed and harmlessly repackaged for the white audience by white artists. The authentic roots of 'white' rock are 'black' (see, e.g. Cohn 1969; Gillett 1996). When the song became a hit, it provoked concerns among the white audience, so it became a matter of federal investigation (FBI) because of its supposedly problematic lyrics. Even if it was not obvious (the group which made it a hit song in 1963 was white), the black roots of the song were obviously too threatening for conservatives. Its authenticity was thus successfully demonstrated. Anything that is attractive to some and incomprehensible to other people may be seen as a threat. And exactly such responses are needed to facilitate ongoing processes of authentication.

Let me briefly present the story of the writer and the song (I use Predoehl's biography of 1999). Rhythm and blues singer and songwriter Richard Berry was born in 1935 in Extension, Louisiana, but he lived all his life in Los Angeles. In the late 1940s he started as a doo-wop singer. Later on, he sang in locally known groups, the Flamingos, the Flairs and others. He wrote *Louie Louie* in 1955–6, but released it as a single on Flip Records in 1957 with the group the Pharaohs. Initially, he intended to use his song, which he had written backstage (!) as the B-side of the single *You Are My Sunshine*.

Berry's version of the song did have some success in the Los Angeles area. However, because he needed money for his wedding, he decided to sell the publishing

rights to the song. 'Yet somehow, instead of fading into obscurity, *'Louie Louie'* was adopted by countless American bar bands and became especially popular in the Pacific Northwest region' (Predoehl 1999). Later it became a veritable party anthem. Barry partly regained his rights only in 1986, eleven years before his death, therefore the story of his stolen treasure, although it was actually sold, finally had a kind of a happy ending. He was admired, respected and became wealthier, because in 1992 he got a substantial amount of money from the publishing company Windwest Pacific when he sold the rights again.

What is so authentic in this story? Everything and nothing. Although Richard Berry was not considered a star, he was still perceived as 'authentic' in the stardom manner of popular music and popular culture in general. Let me leave aside for a while the modus black authenticity (and white inauthenticity), which I will later show as an (inverted) variant of racism. The discussion of authenticity in popular music and popular culture would not be complete if we did not discuss the most alienable possible form of authenticity in popular culture, stardom.

Stardom and Performance of Authenticity in Popular Music

Being authentic is a paradoxical demand of stardom. On the one hand, the popular music star has to be different from ordinary people and move in spheres that are far beyond their reach, while on the other hand, s/he has to preserve the human touch. The star is partly a mythical hero and partly the next-door neighbour. S/he is a mediator between the world of mundane experience and the world of glamour. It is not a coincidence that the term cult describes profane admiration in popular culture. The Latin verb *colere* has many meanings that are still preserved in words for cult and culture: to work on land (cultivate), to honour with worship, to protect, to inhabit (see Williams 1988: 87). Authenticity in popular culture and popular music is a result of authenticating processes we may describe as cults or profane cults.

In popular culture, especially in some kinds of popular music (jazz, rock, rap), the demands of authenticity are easily detected. Nobody can afford to be accused of 'committing the ultimate crime of "inauthenticity"' (Pattie 1999, n.p.). The consensus opinion of popular music scholars was that authenticity was derived from white musicians' and audiences' discourse of authenticity derived from 'black music and its intimate relationship with the lived experience of its audience' (Pattie 1999, n.p.; see Frith 1996). Authenticity was derived from black musicians' originality and white appropriation of their works. But what is real, what is the realness, the real thing in popular music, remains a mystery. What is popular and authentic is built and shaped on a very subtle – or apparent – interplay and intertwined opposition of public and private. According to the fan literature, authenticity is a necessary quality of stardom, insofar as it 'guarantees the authenticity of the other particular values a star embodies … It is this effect of authenticating authenticity that gives the star charisma' (Richard Dyer quoted in Pattie 1999, n.p.). The star should not only be real, but s/he has to embody realness. Therefore, adds Pattie, 'all qualities associated with performance'

are the signs of authenticity, which means, according to Richard Dyer, 'genuineness, spontaneity, immediacy, etc'. (quoted in Pattie 1999, n.p.). These qualities

> have to be demonstrated; they have to become clearly visible to an audience. The unstated paradox contained within this formulation is not that an audience accepts as real that which is patently unreal; rather it is that an audience accepts reality, or authenticity, as a performance, without necessarily accepting that its status as performance invalidates it as a true expression of the star's authentic self. (Pattie 1999, n.p.)

Therefore we are dealing with belief. Both the audience and the performer(s) have 'faith in the act' (Pattie 1999, n.p.). Its ground is a belief 'that the music contains within itself a pre-existing truth, and that it is the task of both performer and audience to rediscover and re-express that truth' (Pattie 1999, n.p.).

This is why it is conceivable to imagine authenticity in all kinds of popular music, even in the most mass mediated glamorous pop: both performers and the audience may – or must – believe in the song and this is all that counts in such a perfect feedback loop. But at the same time there should be another, more exclusive way, based on originality, sincerity and a more elaborate attitude in the whole way of life. We can find this attitude in rock, where the music supposedly does contain a pre-existing truth, which both performer and audience must rediscover and re-express. In rock music performers and audience conceive of the music as a medium – or a basis – for providing 'the ultimate validation, the ultimate proof of authenticity. It is as though the music itself contains, beyond the meanings attached to a particular chord structure and rhythm, a single set of lyrics or a specific delivery, the ability to organize the audience's and the star's perception of it as inherently truthful' (Pattie 1999, n.p.).

Regarding the most trivial forms of pop music, what is kitschier than Elvis's Graceland? In 'the heartland of American Kitsch', a screaming fan and an Elvis impersonator may both 'believe in the song: their belief is strong enough to transcend their surroundings and to unite them in an almost religious moment of revealed truth' (Pattie 1999, n.p.). But we have to be cautious: it is nothing less than the truth that is at stake here. A very good reason for worship! Here is where modern profane cults and worshipping of the stars occur and where the worshippers are striving to reach the aura and power of the stars' magical appearance. Not all admirers are worshippers, but fandom has a lot to do with veneration or admiration. In one of a very few scholarly analyses of fandom, Matt Hills defines fandom as 'any devoted media consumption as well as non-media-based passions, enthusiasms or hobbies which may have led to specialist media consumption' (Hills 2002: 83). Devoted or passionate consumption in popular culture is derived from belief that one can gain authentic fulfilment of his or her needs. This belief is only possible if there is a possibility to distinguish right from wrong.

Whenever we are dealing with authenticity, we are in the field of belief (in truth-as-authenticity). Essential elements of religiosity are thus an inevitable part of modern profane life: it seems that religion will indeed never 'go away' (Lacan 2006). Where for example did the truth of rock come from? It was derived – or inherited

– from blues, i.e., from Afro-American music. No coincidence. With his songs that were later taken as the core rock repertoire for many white rockers, black blues singer Robert Johnson made a myth of himself. The same has happened with jazz. Not only that white jazz musicians who have borrowed their basic repertoire from black jazz musicians were persuaded that only black jazz musicians are capable of playing true jazz, they further developed another strategy of self-confidence within their own community: we who know – and live – the (authentic) truth are much more valuable than other worthless squares. Howard Becker was the first to describe and analyse such an attitude in his classical (and first sociological) study of professional jazz and dance musicians and their self-segregation in the late 1940s (Becker 1951). The same goes for rock and its central myth of 'rock as an authentic, and authenticating language' (Pattie 1999, n.p.).

Othering with Music and Identity-Making

There is a widespread communal myth about the power of music, which is supposed to have a mystical power to speak and to speak truthfully, about the lives and experiences of those who listen and of those who play. Music relies on the whole individual experience and at the same time transcends the experience and intentions of any individual performer. It also provides a shared language that allows performers and fans to communicate. If we consider rock as more than just a specific musical style and more than a specific series of performance conventions, it must itself become an icon, 'a prize to which both the performer and the audience aspire' (Pattie 1999, n.p.).

So, how does it happen that a performance that is by definition – like any other play – considered a pretension, if not a fake, happens to become a source of authenticity, a vehicle of authentication? It is a matter of performing musicians creating a balance between 'the performance of authenticity [and] the practice of authenticity', as reflected in the band's musicians and the fans' idea of the music as it exists at that particular time (Pattie 1999, n.p.).

Situated performance is of utmost importance for the miracle of authenticity to occur on the axis of performance and its counterpart, experience. A music event (concert) is a multi-structured event comprising design, performance, experience and ritualistic repetition. What comes out, no matter where one might experience it – e.g., Kanazawa, Japan, or Krakow, Poland, where I did fieldwork on popular music venues – is 'performed communion' (Pattie 1999, n.p.). When the band and the audience become one, they not only turn performance into experience, but also radically transcend their subject-positions in something doubly negatively a new communion. Total identification with the performers sometimes brings the fans into extreme forms of ecstasy and catharsis. But even if the audience observes the performance from a distance, the majority of attendees, if not all of them, get attuned to a new feeling of togetherness, achieving a shared but at the same time exclusive structure of feeling. Profane experience of the performance is a ritual-like experience from which individual identity as social identity is derived (Frith 1996: 275). Symbolic commo-

nality is literally performed. Performed communion is a result of both individual and collective experience and it is at the same time staged and authentic. These ecstatic events of individual involvement and inclusion into communions at the same time delimit communions at their frontiers: the same communion rituals draw maps of exclusion. That means, in general, that any experience of authenticity is at the same time a building block of a social exclusion. To put it precisely: (belief in) authenticity is a necessary condition of social differentiation between us and them.

Everybody must have had heard from true rockers (or true metal fans, or true jazz enthusiasts, etc.) that only true rockers can know what it is all about in rock. We, the others, are too ignorant, indeed, too 'square', to know. If we observe the blogs and internet forums of true fans, we can easily see that fans mainly – through endless debates and mutual persuasion – strive to define and delimit true (rock, metal, jazz, etc.) from false.

Music is – like any other symbolic act – a tool of differentiation. In music, debates of true and false, genuine and fake, good and bad are usually rather harmless exercises in symbolic social delimitation. It is far from being so when the notion of authenticity is taken as validating the most horrible examples of social exclusivism, e.g., nationalism, racism, sexism, etc. Nationalism is constructed from the ideology of pure nationhood, a belief in the Nation, the imagined *Volk* (Eriksen 2002: 104), derived from the ancient roots of a people, their control of a land, and shared (authentic) history and culture. Stable and genuine 'national homogenizing "authenticity" (Bendix 1997) ..., seen as the "own," was the pivotal point when the Modern Age began approximately 200 years ago' (Koestlin 2001: 160). Racism is built on the idea that there are hereditary characteristics of human populations and that pure and authentic genes will become spoiled and destroyed by mixing. It is 'about exclusion through devaluation, intrinsic or instrumental, timeless or time-bound', and 'underlying racialism, not unlike nationalism, is an abstract presumption of familialism' (Goldberg 2004: 214). Sexism is derived from an idea of an authentic male and female. Both, 'race prejudice and discrimination, like sexism, assume biologically ascribed behavioural characteristics alleged to be inborn and unchanging' (Lieberman and Kirk 2004: 144). Among rightist populist parties in some European countries, there are ideas about differentiating citizens into autochthonous and allochthonous (Schippers 2007).

To understand differentiation derived from such notions, it is necessary to understand processes of identification. Both identification and differentiation stem from the same symbolic practices. The results of identification are subjectivities in both the active and passive sense of the term 'subject'. Authentication is one of the cornerstones of identification. Popular music is a good example of its scope.

Authentication in popular music comprises three elements, 'loss of control, unpremeditation, and privacy' (Pattie 1999, n.p.). Loss of control on stage is a very important part of a successful performance. These are the crucial moments of any successful popular music performance where the musicians literally get lost in performance. These moments cannot be staged. They differentiate between professional performance and excellent experience. When musicians get lost, the audience follows.

These are the moments of communion. There have to be an element of spontaneity, no matter how the performance is planned, and an emotional effect is only possible if an individual shares the experience with the performers. There is a transformation that is later 'replaced by transfiguration' (Pattie 1999, n.p.). Playing live, musicians are communicating directly with the audience. No matter what kind of experience it is, all individuals involved put meaning into the event, thus establishing various kinds of commonalities. Simon Frith writes that music 'constructs our sense of identity through the experiences it offers of the body, time, and sociability, experiences which enable us to place ourselves in imaginative cultural narratives' (Frith 1996: 275). Sometimes it may happen, in more or less obvious ecstatic situations, typically involving dance, that the audience would merge with the music group, 'in the contradictory, inherently dialogic way' (Pattie 1999, n.p.).

However, in making the miracle possible, the activity must not be chaotic. The musicians and the audience follow a scenario of the event and both perform their roles within parts of the performance. They play and sing songs that are known to them. The best performance is thus a doubly faked event: a successful performance is 'a performance that denies that it is a performance; the moment of communion itself therefore rests upon a contradiction, in which overtly theatrical moments (the countdown, the initial disrobing/preparation) are described as though they are displays of the performer's) authentic, untheatrical self' (after Pattie 1999). Staged performance generates aesthetic, emotional and experiential effects from the inherent contradiction between carefully designed performance (e.g., the order of songs played, costume design, scenography, choreography, etc.) and unpremeditated situations provoked by the responses of the audience or by force majeure. If the performance is carefully designed in advance and professionally executed, it is considered authentic. However, in the moments when unpremeditated situations occur, these moments are considered more authentic than the staged performance. If they are experienced as the common achievement of the audience and the performers, they may become considered as the only authentic moments of the performance. This is how a staged performance can be transformed into inauthentic experience. This contradiction relies on the key power of music – and any other kind of ritual activity – that the meaning of music is obscured and open to any possible interpretation. Music identity is at the same time real and fantastic (Frith 1996: 274). This inherent ambivalence and openness to any kind of interpretation is the true power of authentication processes in music.

Simon Frith observed that in pop we are drawn, individually, into 'affective and emotional alliances' with the performers and other fans. We 'absorb songs into our own lives and rhythm into our own bodies' (1996: 273). At the same time, following John Blacking, Simon Frith writes that music is collective: 'Music, we could say, provides us with an intensely subjective sense of being sociable. Whether jazz or rap for African-Americans or nineteenth-century chamber music for German Jews in Israel, it both articulates and offers the immediate experience of collective identity' (ibid.). There are a plenty of contradictions being resolved in music performance: individuality versus collective, performance versus experience, theatricality versus spontaneity, construction and authenticity. Nobody controls the situation: 'the performer does

not entirely control the event: the audience is not entirely constructed by their place in the event' (Pattie 1999, n.p.). Rock music and a rock star rest 'on the contradiction between the constructed and the unpremeditated, and both rely for their ultimate validation on the open, dialogic, unfinalisable status of music as a performed language' (Pattie 1999, n.p.). There is no inherent contradiction between individual and collective identity, because it is 'necessarily a matter of ritual: it describes one's place in a dramatized pattern of relationships: one can never really express oneself "autonomously"' (Frith 1996: 275).

At the first sight it seems that the spurious notion of authenticity does not have anything to do with othering. Steve Jones writes that popular music is 'firmly rooted within realist practice', … (the) "culture of authenticity" associated with modernism'. (Jones 1999, n.p.) The power of rock comes, according to Lawrence Grossberg, from identity crisis (see Grossberg 1992). Using the words of Vivian Sobchak, popular music 'creates a "here" that can be transported anywhere' (in Jones 1999; n.p.). With this music may become a threat or a tool against oppression (Lipsitz 1994), especially if people enjoy it more than anything else.

In the mind of conservatives, music is treated as a threat to society. In Plato's *Republic* we find the famous warning that we have to protect ourselves from novelties in music, otherwise the whole order of the state may be threatened (Plato 424d–424e). But it may at the same time be used as a tool of education and sociality or as an accepted way of common expression. In both ways, the power of music is derived from the observation that only 'the Others' can enjoy it.

We have all heard (or even claimed) many times that only black people can play proper blues, jazz, reggae or rap, that only true Gypsies can play Gypsy music, whatever it is, that only Jews can play proper *klezmer*, that only pristine peasants can sing, play and dance properly to folk music, and that only polite and well-educated people can play and understand classical music. We, the civilized, essentialise the position of the Other that is supposedly capable of direct, non-mediated enjoyment. We cannot do it anymore. The categories for the description of such music of the Others are widespread and similar. Serbs in Vojvodina, for example, defined Gypsy musicians as 'explicitly sentimental and passionate; at moments ardent, tempestuous, frenetic and at moments melancholic, mild, painful'. All these are forbidden fruits of 'the Other' (van de Port 1999: 298).

Conclusion

The conviction that the others are indeed different in their spiritual essence and existential core is the most common result of belief in authenticity. The Other is allowed to be authentic, natural; s/he is supposed to be the representative of the lost ideal of Eden and innocence. *Bons sauvages* are eternal rambling zombies of authenticity. For quite a long time, ethnographers did not doubt the authenticity of ethnographic experience and accounts:'The posited authenticity of a past (savage, tribal, peasant), serves to denounce an inauthentic present (the uprooted, *évolués*, acculturated)' (Fa-

bian 1983: 11). But there are gaps between words, things and human beings. Uncritical 'identity thinking' is based on unjustifiable 'unification between representation and authenticity' that 'is achieved when the difference between being and language ceases to exist' (van Loon 2002: 91). Authenticity is thus just a magic word that makes this unification possible. At the same time, it is a magic tool that prevents the emancipation of the Other.

Perhaps this is a reason why 'the designation of peoples and places', as Beth Conklin argued, often leaves 'little room for intercultural exchange or creative innovation, and locates "authentic" indigenous actors outside global cultural trends and changing ideas and technologies' (quoted in van de Port 2006: 445).

The notion of authenticity is deeply rooted in an understanding of natural or given differences. The old dichotomies between the modern and the primitive, or between 'the civilized self and the uncivilized other' (Escobar 1994: 223) are still alive and well. In popular music, the roots and authenticity of particular styles are still very important issues, although 'the criteria of originality, roots, community and authenticity can be deployed as marketing strategy' (Strinati 2004: 37; cf. Jones 1999). Many of us have taken it for granted that only black people can play proper blues, jazz, reggae or rap, that only Gypsies can play Gypsy music, only Jews can play *klezmer*, only peasants can play true traditional music and only cultivated people can play classical music. Sometimes we would use the expression that someone 'was born an excellent musician'. Such born musicians have their music 'in their blood'. This is how we naturalize the position of the other who is capable of direct, non-mediated, authentic enjoyment.

And what is the difference between such notions of natural gifts spread among particular populations and the notion of race as identifiable by biological boundaries, consisting of homogeneous individuals, their culture derived from their biology, and ordered hierarchically (Lieberman and Kirk 2004: 138)? Even if admiration of natural musicians and their music is based on passionate enthusiasm for black popular music among their white fans, it is still a form of racism. It may be inverted racism, but it still is racism.

In popular music, as well as in other spheres of present-day cultural creativity, it can be easily seen that the notion of authenticity, with its manipulative character and seemingly unproblematic use, belongs to other essentializing and naturalizing notions that support regimes of exclusion and latent violence. It is, therefore, time to abolish it altogether, with other similar notions that are good for absolutely nothing.

References

Adorno, T.W. 1986(1962). *Uvod v sociologijo glasbe*. Ljubljana: DZS.
Adorno, T.W. and G. Simpson. 1990. 'On Popular Music'. In S. Frith and A. Goodwin (eds), *On Record: Rock, Pop, and the Written Word*. London: Routledge. Pp. 301–314.
Archer, M.S. 1996. *Culture and Agency: The Place of Culture in Social Theory.* Revised Edition. Cambridge: Cambridge University Press.

Barth, F. 1997. 'Economy, Agency and Ordinary Lives', *Social Anthropology* 5(3) 233–242.
Becker, H.S. 1951. 'The Professional Dance Musician and his Audience', *The American Journal of Sociology* 57: 136–144.
Benjamin, W. 1968. 'The Work of Art in the Age of Mechanical Reproduction'. In H. Arendt (ed.), *Illuminations*. New York: Harcourt, Brace and World. Pp. 221–252.
Bohlman, P.V. 1991. 'Representation and Cultural Critique in the History of Ethnomusicology'. In B. Nettl and P.V. Bohlman (eds), *Comparative Musicology and Anthropology of Music: Essays in the History of Ethnomusicology*. Chicago: University of Chicago Press. Pp. 131–151.
Carrithers, M. 2005. 'Anthropology as a Moral Science of Possibilities', *Current Anthropology* 46(3) 433–456.
Cohn, N. 1969. *Pop from the Beginning*. London: Weidenfeld and Nicolson.
During, S. (ed.). 1993. *The Cultural Studies Reader*. London and New York: Routledge.
Eriksen, T.H. 2002. *Ethnicity and Nationalism: Anthropological Perspectives*. London: Pluto Press. Escobar, A. 1994. 'Welcome to Cyberia: Notes on the Anthropology of Cyberculture', *Current Anthropology* 35(3) 211–231.
Fabian, J. 1983. *Time and the Other: How Anthropology Makes Its Object*. New York: Columbia University Press.
Frith, S. 1996. *Performing Rites: On the Value of Popular Music*. Oxford: Oxford University Press.
Gillett, C. 1996. *The Sound of the City: The Rise of Rock and Roll*. London: Souvenir Press.
Goldberg, D.T. 2004. 'The End(s) of Race', *Post-colonial Studies* 7(2) 211–230.
Grossberg, L. 1992. *We Gotta Get Out of this Place: Popular Conservatism and Postmodern Culture*. London and New York: Routledge.
Hall, S. and T. Jefferson (eds). 1996. *Resistance through Rituals: Youth Subcultures in Post-War Britain*. London and New York: Routledge.
Hills, M. 2002. *Fan Cultures*. London and New York: Routledge.
Jones, S. 1999. 'Seeing Sound, Hearing Image: "Remixing" Authenticity in Popular Music Studies', *M/C: A Journal of Media and Culture* 2(4). http://journal.media-culture.org.au/9906/remix.php. (Access 6 November 2006).
Keesing, R.M. 1990. 'Theories of Culture Revisited', *Canberra Anthropology* 13(2) 46–60.
Keil, C. and S. Feld. 1994. *Music Grooves: Essays and Dialogues*. Chicago: University of Chicago Press.
Koestlin, K. 2001. 'The Art of Producing Meaning and Sense'. In Z. Šmitek and B. Brumen (eds), *Maps of Time/Zemljevidi časa*. Ljubljana: University of Ljubljana. Pp. 157–169.
Lacan, J. 2006. 'Triumf religije', *Problemi* 44(3–4) 5–20.
Lieberman, L. and R.C. Kirk. 2004. 'What Should We Teach about the Concept of Race? Reflections from the Field', *Anthropology and Education Quarterly* 35(1) 137–145.
Lipsitz, G. 1994. *Dangerous Crossroads: Popular Music, Postmodernism and the Poetics of Place*. London: Verso.
Loon, J. van. 2002. 'Social Spatialization and Everyday Life', *Space and Culture* 5(2) 88–95.
Love That Louie. 2002. *Love that Louie: The Louie Louie Files*. CD compilation. Compiled and Annotated by Alec Palao. London: Ace Records. Ace CDCHD 844.
Marx, K. 1986. *Kapital*. Ljubljana: Cankarjeva založba.
Muršič, R. 1996. 'A "Black Box" of Music Use: On Folk and Popular Music', *Narodna umjetnost* 33(1) 59–74.
_____. 2003. 'The Old and the Bearded'. In *Tolovaj Mataj, Stare in bradate*. Ljubljana: Sanje. CD. SAZAS SI 215. Sleeve notes.
Pattie, D. 1999. '4 Real: Authenticity, Performance, and Rock Music', *Enculturation* 2(2). http://enculturation.gmu.edu/2_2/pattie.html (Access 6 November 2006).
Plato. 1976. *Država*. Ljubljana: Državna založba Slovenije.
PORT, M. van de. 1999. 'The Articulation of Soul: Gypsy Musicians and the Serbian Other', *Popular Music* 18(3) 291–308.
_____. 2006. 'Visualizing the Sacred: Video Technology, "Televisual" Style, and the Religious Imagination in Bahian Candomblé', *American Ethnologist* 33(3) 444–461.
Predoehl, E. 1999. *A Short History of Louie Louie*. http://www.louielouie.net/06-history.htm (Access 6 November 2006).

Rapport, N. 2003. *I Am Dynamite: An Alternative Anthropology of Power.* London and New York: Routledge.
Resia. 1997. *Rezija: Canti e musiche della Val Resia/Pesmi in glasba Rezijanske doline.* CD. Nota (Udine). CD 2.31.
Rosenberg, B. and D.M. White (eds). 1965. *Mass Culture: The Popular Arts in America.* New York and London: The Free Press, Collier-Macmillan Limited.
Schippers, T. 2007. 'We Were Here First! Some Reflections on Time, Place and Identity-Building Today'. In R. Muršič and J. Repič (eds), *Places of Encounter: In Memoriam Borut Brumen.* Ljubljana: Univerza v Ljubljani, Filozofska fakulteta, Oddelek za etnologijo in kulturno antropologijo. Pp. 101–112.
Strajnar, J. 1988. *Citira: Inštrumentalna glasba v Reziji/La musica strumentale Val di Resia.* Udine and Trieste: Pizzicato.
____. 2001. 'Folk Music and Identity'. In S. Pettan, A. Reyes and M. Komavec (eds), *Music and Minorities.* Ljubljana: ZRC SAZU/ICTM. Pp. 95–101.
Strinati, D. 2004. *An Introduction to Theories of Popular Culture.* London and New York: Routledge.
Wagner, R. 2001. *An Anthropology of the Subject: Holographic Worldview in New Guinea and Its Meaning and Significance for the World of Anthropology.* Berkeley: University of California Press.
Williams, R. 1988. *Keywords: A Vocabulary of Culture and Society.* London: Fontana Press.

PART II

Moral Discourses of Authenticity

Chapter 3

AUTHENTIC WILDERNESS: THE PRODUCTION AND EXPERIENCE OF NATURE IN AMERICA

Lawrence J. Taylor

We followed Leslie, single file, stepping as lightly as we could manage on the yielding sands. We had camped the night before in this same wash, our hyper-modern, space-age tents secreted under boughs of brilliant green palo verde or gnarled tangles of mesquite twigs already in full spring foliage. This was the vast Cabeza Prieta of Arizona's Sonoran Desert: An official wilderness, and at some 840,000 acres, the largest in the 'lower forty-eight states'. There were about twenty of us in the group – a training session – learning to move through the wilderness as if we were not there. Hence the name, of both the training session and the national organization behind it: *Leave No Trace*. Of course we knew that we were leaving traces in the very sand through which we walked; at least until the next rains turned these otherwise dry streambeds into raging torrents. Although that might not happen till July or August, or even till next year. But such footprints would eventually pass. Very different, as we were pointedly told, from the effects of what the uninitiated might assume would be a less intrusive walk on the 'desert pavement' – the crusty pebbly ground that covered most of the desert floor whose subtle colours belied microscopic organisms. One crushing step from a careless sole destroys a living world that would take a thousand years to repair itself. Better to slog through soft sand, safe ground not only for walking, but also for camping, where it afforded another advantage. The wash was low, and the bending confusion of desert shrubs and small trees provided a cover that rendered each widely spaced tent more or less invisible. Another crucial feature of our lesson plan, for we were learning to protect not only the place, but also the experience. To be in authentic wilderness was to have an authentic experience, un-desecrated by the appearance of other humans (fieldnotes Taylor).

Introduction

Leave No Trace is one of dozens of national organizations dedicated to the preservation and proper use of wilderness environments in the United States. Their environmentalism – although varying in tone and vocabulary – is generally characterized by a strong moral and sometimes overtly religious idiom, one which lauds the spiritual values of wilderness and often depicts those landscapes as individually and nationally redemptive. However, in the deserts of the south-western United States such moral views of the landscape are not limited to environmentalists. Even their enemies – the advocates of progress, or the ranchers, whose cattle are perceived as the worst possible inhabitants of wilderness by many environmentalists – are likely to represent their landscapes as morally good in terms of the individual and the nation. And beyond that battle, the other, highly public war currently raging between advocates and opponents of the vast immigration carrying mainly Mexicans through this same desert land, as well depict not only their arguments, but also their landscapes as sacred and moral. The humanitarian faith-based groups venture into the desert and leave water for the undocumented migrants, thereby implying a kind of pilgrimage status for them and casting the Sonoran desert (often explicitly) in the role of the Biblical desert landscapes that tried the faith of the ancient Hebrews and Jesus. Meanwhile, for the volunteers of the Minuteman Project and the Minuteman Civil Defence Corps, who have come to this part of the world to help stop those same immigrants, the sacred landscape is behind them, in the United States vaguely conceived geographically, but more moral the further one moves from Washington and the iniquitous influences of the large cities on either coast. For them, it is the border itself that rises to crucial importance, a line that separates purity from pollution.

Another Frontier

Thus, this chapter argues, it is important to see the search for authentic wilderness in this part of the American West in the context of this larger, continuing struggle over the meaning and moral valence of the landscape: a contention which I call moral geography.[1] What all these otherwise very different perspectives on this wild desert have in common is the use of that landscape as what Lefèbvre called 'representational space' (Lefèbvre 1991): in this case representing America as Sacred Ground. The sacredness, however, is constructed in two apparently mutually exclusive ways. In one the model is pilgrimage (as in the case of the humanitarian aid volunteers putting water in the desert for migrants-pilgrims) and in the other the model is purity and danger/pollution (for those who, like the Minuteman, guard the frontier against defilement), although another kind of pilgrimage, to an edge rather than a centre (Taylor 2007a) may lay behind that sensibility. The wilderness groups, however, may hover ambiguously between these alternatives. As the name *Leave No Trace* suggests, theirs is a pilgrimage that preserves the purity of the landscape by removing all signs of human presence.

It is this intriguingly contradictory moral/religious construction of authentic wilderness I wish to explore here and through that exploration perhaps gain some insight into authenticity as a general cultural category and the dynamics of what I am calling moral geography, wherein particular landscapes gain both symbolic significance and moral valence.[2]

My notion of moral geography refers to a kind of social/cultural practice, rather than a passive cultural tradition or condition of the land itself, and draws on three disparate theoretical and disciplinary traditions.

First, there is the perspective of the critical geography of Lefèbvre (1991), Harvey (1989), and Soja (1989) that argues that space is socially produced. From that essentially Marxist angle, that production is understood as authored by state and capitalist systems. While such a process is visible, for example, in the very production of the space of the U.S.-Mexico border (e.g., Sheridan 2006), the political/moral battles alluded to above call, I think, for an analysis closer to the ground. For if the State – and certainly the U.S.A. in this historical period is the very spearhead of neo-liberal global capitalism – is producing space in these desert borderlands, two things are clear about that process. First, the various local arms and representatives of the State are not necessarily pursuing the same project in the same way. Agencies dedicated to the free movement of capital and labour obviously do not seek to hamper movement across the border, while those agencies following other mandates are dedicated to slowing at least the movement of labour in the name of security. The other observation that needs to be made, and on this both political right and left are in agreement, is that whatever its goal(s) vis-à-vis the flow of people and contraband across the border, the State is failing to halt that flow. In the realm of State public lands dedicated to the preservation or protection of Nature there is also a wide variety of policies and practices that depend not only on the level of government or agency involved (Federal or State or County, National Park Service, Fish and Wildlife, National Forests) but also the individual managers who have sometimes taken markedly different positions.

This failure, or inconsistency, of the State is often seen as not only political but moral, and the space left open is precisely that which various organized groups of Americans seek to fill, the sort of voluntary associations that have a long and particularly strong history in the United States (as de Tocqueville noted early in the nineteenth century). Their special interests are often represented in moral terms – perhaps because such organizations are, in the U.S.A., always in some way modelled on and understood as something like churches: congregations in a particular Protestant tradition. Such groups, however, do not just happen, but are rather the result of individual action.

That brings us to the second, sociological, line of theory that I wish to apply here: Becker's notion of 'moral entrepreneur' (1963). That ideal type was suggested by Becker in the context of his explanation of deviance as a category that (like space for the geographers) was socially constructed, rather than natural, through the agency of individuals who campaigned against perceived evils until by social and political process, those evils were officially labelled as such. The leaders of all the groups lining up in or travelling through the desert borderlands can be described as moral entrepreneurs. Often they are as involved in defining good as they are evil, and, given the

geographic focus of their activities, good in this case means sacred landscapes which, in turn, are fundamental to definitions of the United States: again as both geographical and moral entity.

How do such moral entrepreneurs accomplish their goals? Here, I turn to my third disciplinary tradition – contemporary ethnography – for a close-up view of the social and cultural practices of such individuals reveals the deployment of a symbolic politics that certainly features rhetorical strategies of the kind Becker and other sociologists might focus on, but also the creative use of the human body, and a vast array of powerful material, visual and other experiential elements. Among these must be counted relationship to landscape as cultural construct, which of course has long been the subject of cultural (as distinct from social/spatial) geographers, especially of those associated with Berkeley[3] but which has come been developed in a complementary but different manner by ethnographers writing about place (see especially Basso and Feld 1996). All this happens on the ground of course, but also, given the national audience being addressed, in the virtual moral geography of the popular media, including print, radio, television and the web.

What place has authenticity, the subject of this volume, in these contending constructions of space, in these competing moral geographies? How, in particular, does it figure in the production of wilderness? Its role is signalled by such important phrases in the popular discourse as 'authentic wilderness', 'authentic Christians', and 'authentic' [more often 'real'] 'Americans'. In these and several other (but of course not all) popular uses, the terms authentic and authenticity, clearly carry a moral dimension. The notion of truth – a true versus false version of place or person and especially Self – is often implied in the non-trivial uses of the term. But the absolute aspect of authenticity – that something or person or place is either authentic or inauthentic/false/fraudulent – is not always present, or if so, may be operating in a relative and enabling, rather than exclusionary way. For example, the existence of an 'authentic Ireland' in the Gaelic-speaking West (or the belief that such a place exists) at once – however contradictorily – implies that the rest of Ireland is not truly Ireland, or less authentic, but also provides the comforting assurance that the real Ireland, if not here, exists somewhere, and by virtue of its existence keeps Irishness, in which all may participate, alive.

Something of the same cultural logic applies to wilderness. That is, real, authentic wilderness is understood by some to be an absolute, essentialized condition and pure in a way that implies a kind of moral as well as environmental corruption in other, more human landscapes. Yet, at the same time, if wilderness exists in America, it may operate as an enabler in the same way that the Gaelic West does for the Irish. It guarantees a kind of moral heart in the continental beast, a redemptive landscape that can save the soul of an otherwise soulless nation.

Wilderness as an American Cultural Construct

While it is not within the scope of this chapter to review the long and complex history of wilderness as landscape and idea in American cultural history, a few critical aspects of the changing production of this natural space, and the central role of moral entrepreneurs as inscribers of such landscapes through their own movements and deployment of discursive and material representations, are important to understanding its current role in the moral geography of the West.

In his classic treatment of the history of 'the idea of wilderness' Roderick Nash (1967) began with attention to what he considered the essentially negative sense of wilderness in the ancient Hebrew case: the landscape of fear and trial that tested the faith of biblical characters from Moses to Jesus. This sense was, according to Nash, taken with the Puritans to New England, where in their 'errand into the wilderness' (see Miller 1956), the surrounding natural world was understood negatively. For Nash, thus, the problem is to explain how this essentially negative construction became, in the course of the nineteenth century, under the influence of a number of movements and individuals, romanticized. While there is no doubt that the historical changes discussed by Nash were real and important, his evaluation of what we might now call the initial Hebrew and subsequent Puritan 'structures of feeling' (Williams 1979) may underestimate the ambivalence and ambiguity of their notions of wilderness. After all, given the fearful and always testing character of God Himself, it may be more accurate to say that the biblical narrative depicts the wilderness as dangerously divine, a landscape wherein one most directly confronts Divinity, an awesome power that, unmediated by ritual structure, can potentially destroy the mortal who finds himself there. This is why prophets[4] are inevitably associated with that kind of desert wilderness, in Weberian terms a charismatic landscape.

It is this notion of wilderness, I believe, that emerges and re-emerges in Europe as the Sublime, but lives a particularly powerful life through American history, where it puts a more complex and compelling colouring on the relationship with Nature. Another element in this, what might be called Hebrew-Calvinist, construction is the combination of individual and collective experience and identity in relation to divinity/wilderness. That is, on the one hand there is the strongly collective errand into the wilderness that establishes the Hebrew (ancient and contemporary) and Puritan versions of themselves as nations on a collective mission. The Nation, in a sense, is that mission. Or, to put it another way, there is a Zionist sense of geography that is at once a challenge and a homeland. A sacred landscape, in which a people realize themselves by subduing it, but in some sense retaining its awesome character. An eternal struggle or else the moral core is lost. This is the moral sense of the frontier argued by Frederic J. Turner (who is this sense can be taken as espousing an American mythology). But both the Hebrew and perhaps more obviously the Calvinist version have their lonely sides as well, in which the individual soul finds himself in a constant state of, at least potential, doubt about his status as saved or damned, or to put it in relational terms: where he stands in relation to a God at once all too close and unreachably distant.

Life presents constant tests and every time he acts it may redefine his status in that regard. The individual confrontation with both Self and Divinity is thus a central cultural theme and the shape of pilgrimage in this context is the individual one, with Bunyan's *Pilgrim's Progress* as the model. But both the individual and (less acknowledged) collective pilgrimage is fraught with doubt and insecurity. There is a sense in which this sort of mythic nation, as chosen as it might be, has to be reconfirmed, re-performed, constantly. To put it other words, those of philosopher John McDermott, 'America is judged by what it is doing at the moment'[5] (personal communication).

Whatever the earlier, essentially frightening aspect of wilderness to seventeenth-century Americans, as Nash notes, a romantic and transcendental vision can be noted in some writers in the later eighteenth century, where the notion of the sublime provides a bridge between that earlier sense of awe before a potentially destructive divinity and the gentler version that we came to call romantic. In the United States, this sensibility reached a relatively wide public in the works of Emerson (more than Thoreau). There is no doubt that this American view of Nature was strongly shaped by an already flourishing German Romanticism. But the sense of collective mission/identity lent a centrally nationalist element to the American version. The Americanization of wilderness as well as the transition from, if not appropriation of the earlier sense of the errand is certainly suggested by a very early piece of Frederick Church which at once softens wilderness, extols the experience of moving through it and presages the movement westward of his own time.

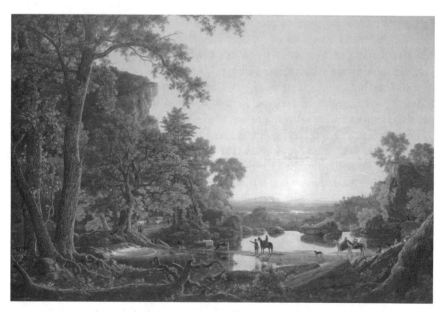

Figure 3.1: Frederic Church, 1846, *Hooker and Company Journeying through the Wilderness from Plymouth to Hartford in 1636*. The Wadsworth Athenaeum.

This aspect of American Romanticism is perhaps clearest in what was an element of popular as well as high culture: landscape painting. From British émigré Thomas Cole through the very popular Frederic Church, Edward Moran and many others (see Novak 1980), artists literally constructed Nature by composing breathtaking views from visual elements culled from disparate sites and combined to best effect. That effect, to judge by contemporary accounts, was both emotional – awe-inspiring – and moral. In this way, American landscape painting represented a new genre of religious art and like that art could be interpreted as instructive, through depicting moral examples that caused reflection, or more powerfully and magically as a mediator of the divine: as a Marian icon becomes, at the right moment and place, Mary herself. Indeed, it is in this latter sense, most often, that spectators described their experience of, for example, standing before Church's *Niagara Falls*. While equally powerful reactions to romantic landscapes might have characterized European viewers of comparable art, in the United States the nationalist dimension was very pronounced.[6] Both from within and from outside the country, the equation of landscape painting with Nature as Deity, with the United

Figure 3.2: Edward Moran, 1875, *Mountain of the Holy Cross*. Autry Museum of Western Heritage, Los Angeles.

States as Nation, was constantly made. Europe has history and America has Nature, ran the observation. Following from that, American landscape painting could command a particular moral power inherent in the divine nature it represented.

American notions of Nature and Wilderness moved West through the course of the nineteenth century and landscape painting and photography followed (or led). And in the case of painter Edward Moran (see below) and photographer William Henry Jackson, their depictions were used to argue for a certain sense of the wild West as containing a redemptive landscape that needed preservation and protection.

Insofar as these artists and their works were instrumental in the campaign for the founding of the first National Park at Yellowstone, Moran and Jackson can be considered moral entrepreneurs in the sense discussed above, and it is worth noting that whatever they said in their testimonials before Congress, it was their visual representations that no doubt exercized the greatest sway. That use of art has continued to play a crucial, perhaps the most crucial role in the representation of what after all is a centrally visual experience: the seeing of wilderness.

However, no doubt the most important moral entrepreneur in the construction of authentic American wilderness nature was John Muir (see Muir 1998 and Teale 2001). His popular accounts of the experience of wilderness were famous in his own time and had a clearly religious aspect. Most importantly, however, unlike Emerson (who demurred at an invitation to venture into authentic wilderness with Muir), he became himself the iconic role model: authentic wilderness man experiencing authentic wilderness, authentically:'It is blessed to lean fully and trustingly on Nature, to experience, by taking to her a pure heart and an inartificial mind, the infinite tenderness and power of her love' (cited in Austin 1987: 17).

Here, the persona of lone pilgrim in a promised land also recalls images of former prophets in direct contact with a far from gentle, indeed awesome, nature. This figure hewn in the divine wild image has been re-embodied and re-enacted by major and minor individuals ever since, like Edward Abbey (1968, 1989). Under Muir's influence this private pilgrimage into divine nature entered the very public sphere and took on the political combat aspect that has since that time defined it. Beginning with the famous Hetch Hetchy[7] dam controversy, environmentalism took its public shape as contest with a real and imagined enemy.

But if political in its aims and actions, it is no accident that the wilderness movement has sometimes been called a cult. And if its religious roots are Protestant (combining Calvinist asceticism with a Baptist hope for rebirth) then there have always been elements reminiscent of the Catholic use of both saints (or are they more like Old Testament prophets?) in the form of such figures as John Muir and Edward Abbey, and more importantly, of images and mediation. It was as if the painters and photographers were pilgrims to inaccessible shrines from which they brought back a piece of the holy place in the form of images. To stand before this image was to have a nearly direct experience of the power it captured and represented. But such images were soon followed by the mass-produced versions: the many form of prints and reproduction that end up finally as coffee table books and calendars. Such images and the task they are meant to perform are of course ironically positioned in relation

to wilderness, depending as they do on the very technological world they are meant to condemn. More subtly, such images from the outset propose authenticity and authentic experience as a relative rather than absolute value. That is, looking at photographs, paintings, prints gave an authentic experience, but not as authentic as being there. This is very like the way images and statues of saints operate in domestic settings, where they are seen as authentic mediations but as mediations distanced from a more powerful version which is closer to the most authentic version and so on. In the contemporary world, this is how cosmopolitanism deals with authentic artefacts as well as images; they at once establish the cultural credentials of the owner (cultural capital) but also put him/her in potential touch with what lies beyond the mediation. In the case of Eliot Porter photographs, for example (all the way down to Sierra Club calendars) they identify the owner as well as putting him in touch – however attenuated – with what lies beyond. Especially if the owner has in fact gone on pilgrimage to such places, in which case these can serve as mementos of that experience.

This role of such objects and images as mediators of the wilderness cult followed from their primary role in the actual production of wilderness, an episode in the larger task of the cultural production of Nature: already afoot in Romanticism (which established the rule of the visual image) but suitably altered in course of nineteenth-century America to take on western and nationalist themes, as well as absorbing (rather than replacing) the rugged Puritan notions of suffering pilgrimage of an isolated wandering soul. It is not surprising that this mediatory function should also continue to operate in the increasingly pervasive therapeutic sensibility that so characterises contemporary American culture, itself a kind of softening, neo-romantic, model of personal (especially psychological) transformation. That is, when the wilderness itself was unavailable or overwhelming, lesser, often gentler versions, in the form of national parks and even visual representations, could be used to achieve therapeutic results.

Public Space and Public Property

The constantly contested role of Nature as both intrinsically American in its natural state and yet defining America through its transformation in the name of progress is perhaps better understood as an aspect of settler colonialism. From the outset, American land was at once a symbol and a commodity and its acquisition in the great westward expansion of purchase and conquest – Louisiana, the Mexican War, the Indian Wars and the Gadsden purchase[8] – guaranteed a role for the Federal government more or less unprecedented globally. Huge areas of land were delivered into the hands of the State, who could both underwrite growth and progress through sale and the enabling of speculation and development of every kind and – as the idea took hold towards the end of the nineteenth century when the western frontier seemed no longer limitless – reserving areas as National Parks, Forests and Monuments. This policy at once fostered individualist notions of self and property (as process of self and nation construction) and national redemptive zones, the moral soul of the nation as a single entity and as a collection of free individuals.

Earlier in the century the cult of domesticity in the East had made for a balanced moral opposition between the woman, home, garden and park on the one hand and the masculine, urban, city on the other. By the end of the century, the Nation as a whole could be writ in terms of this larger, land-based opposition of civilized East and wilderness West. In both cases, it is important to note, even though there might be struggle and opposition between these ideals, they could also be mutually enabling. The fact that the cutthroat businessman returned to the moral purity of wife and home, or took a lunchtime stroll through Central Park, allowed an untroubled routine of competition in office and marketplace. Likewise, the nation as a whole could continue on the path of progress, development and untrammelled individual accumulation, as long as the opposite sort of national landscape, in this case untrammelled nature, continued to exist somewhere. Clearly, the contemporary perspectives, political and personal therapeutic have done nothing to upset this balance. As much as the environmental groups have fought and continue to fight against the interests of extractive and industrial capital and have attracted the support of numbers of zealots whose primary identity comes from that struggle, the mass of membership and considerable financial support has not come from the working classes or mountain men, but rather from the professional middle classes. It is they who have supplied the hundreds of thousands of supporters who donate time and votes on particular issues and are very likely to continue to live in the competitive, immoral world of consumption and accumulation, where every object is commoditized. Their participation in authentic nature is typically restricted to short or extended visits the experience of which does not lead them to reject the 'real' (in that other sense of the term!) world.

The most powerful solidification and, indeed, essentialization of the notion of wilderness came, as things do in America, with a formal legal definition, through the efforts of less literally charismatic moral entrepreneurs like Walter Zahniser who was instrumental in passing the act. The wording of the act retains all the moral flavour of the structure of feeling from which it issued:

> (c) A wilderness, in contrast with those areas where man and his own works dominate the landscape, is hereby recognized as an area where the earth and its community of life are untrammeled by man, where man himself is a visitor who does not remain. An area of wilderness is further defined to mean in this chapter an area of undeveloped Federal land retaining its primeval character and influence, without permanent improvements or human habitation, which is protected and managed so as to preserve its natural conditions and which (1) generally appears to have been affected primarily by the forces of nature, with the imprint of man's work substantially unnoticeable; (2) has outstanding opportunities for solitude or a primitive and unconfined type of recreation; (3) has at least five thousand acres of land or is of sufficient size as to make practicable its preservation and use in an unimpaired condition; and (4) may also contain ecological, geological, or other features of scientific, educational, scenic, or historical value.[9]

Clearly, the act marked a crucial moment in the ongoing battle over public land, ensuring at least a legal foothold for the pro-wilderness forces, giving a moral per-

spective the force of law. But yet more useful legal teeth were provided by the 1973 Endangered Species Act:

> The purposes of this Act are to provide a means whereby the ecosystems upon which endangered species and threatened species depend may be conserved, to provide a program for the conservation of such endangered species and threatened species … (Endangered Species Act of 1973 [16 U.S.C. 1531–1544, 87 Stat. 884], as amended: Public Law 93–205)

While the language of this act is not as overtly moral as that of the Wilderness Act, of course the very term 'endangered' clearly sounds an alarm in this regard and the act does define that unhappy state as the inevitable outcome of progress and development. But even the apparently scientific and hence neutral term ecosystem has turned out in practice to be loaded. As Sayre (2002) notes in his exemplary exploration of the case of the endangered masked bobwhite quail of southern Arizona, there is always an arbitrary choice of an often imagined pristine ecosystem, which efforts to protect endangered species often take the shape of re-establishing. It works like this: every endangered species depends on a probably fragile or already destroyed ecosystem that, despite more sophisticated views nearly any biologist would have, is rhetorically assumed to have been in a natural steady state that the Federal government needs to re-establish. This is then used to justify the eviction of ranchers, even of Native Americans, and the establishment of a Federal-managed pristine ecosystem.

Back in the Desert

The moral geography of wilderness groups continues to operate at the two levels defined and promoted, by means of words, images and indeed physical movement, by more than a century of moral entrepreneurs. On the macro, national level, this involves legal and representational battles. First, with perceived enemies with their rival perceptions and plans for the landscape, and, second, with those who have failed in duty to protect the sacred landscape from these same enemies. On the micro, personal level, the transformative experience of an encounter with the authentic wilderness continues to be central.

All this is evident on the Cabeza Prieta Wildlife Refuge, where *Leave No Trace* pilgrims where making their very careful way through the delicate desert: for it is also a ground over which legal battles were and are being regularly fought. The refuge comes under the authority of *Fish and Game* whose rangers are sworn to protect wilderness by means of a variety of measures most of which have to do with keeping vehicles of any description (as symbolically inappropriate as they are actual dangers to the environment) off designated wilderness zones. Those citizens who view the desert as a vast sandbox playground through which they would like to bounce on the all-terrain vehicles are not happy with the restrictions imposed by such designations. But equally, if not even more, unhappy are the wilderness groups, who generally feel that

any Federal agency never does enough (how can they?) to protect the environment, or the purity of wilderness as such. Under the latter rubric, for example, pitched and highly emotional battles are fought over the placing of water in the desert in order to help such delicate species as the Sonoran pronghorn antelope to survive periods of drought. Extreme wilderness advocates oppose such actions as too manipulative, a human interference with the natural, and generally – with no apparent sense of irony – back up this view with massive lawsuits. For well-funded and highly professional legal campaigns are the actions by which such groups protect nature from culture. In fact, the rangers in the Cabeza often lamented that so much of their time was taken up amassing information in response to legal queries from wilderness groups that little time remained for maintaining and protecting the refuge.

But it is the Endangered Species Act, as noted earlier, that offers the greatest legal leverage for those desirous of using it. The decision to designate any creature by this label is a social/legal as much as biological one that may involve at the very least an arbitrary fixing of both time and space. Thus, for example, the Sonoran pronghorn mentioned above – whose official population is something under one hundred animals in the Cabeza and neighbouring lands and a few hundred more south of the Mexican border – is frozen in time as a species although it is arguably a variant or subspecies since it can still successfully interbreed with the very numerous American pronghorn. Other creatures that may be numerous in Mexico are designated endangered on the basis of their specifically U.S. population, a rather ironic classification of natural but national environments. But if irony is what you are looking for, you can find no better American example than just north of the Cabeza in the vast 'Barry Goldwater Firing Range' a tract divided between the U.S. Marines and Air Force in and over which the fighter jets that have seen action over deserts far away are nearly all trained. On any given morning, well before the full light, a very young woman with a degree in biology would head out into the wild rock and sands of the Crater Range or the upper Growler Valley armed with night-vision binoculars. If she saw a Sonoran pronghorn or two she would call in the central command and a bombing run to that sector would be redirected. As it turns out, the pronghorn favour freshly bombed ground where water may be closer to the surface.

In the case of the military the redirection is temporary (although still rather remarkable), but for ordinary citizens and other government agencies the reports of sightings of endangered species can spell the end of whatever had been going on there. Large tracts of public land may be closed to all recreation, for example, and ranchers, whose livelihood in this region depends on the use of vast areas leased from the Federal Bureau of Land Management, can be dispossessed by the cancelling of leases held, in some cases, for well over one hundred years and otherwise guaranteed by the Taylor Grazing Act of 1932. While the desire to protect such endangered species may well be genuine, the campaigns waged by many environmental groups to disappropriate ranchers are based in a pervasive belief that as much land as possible should be returned to a pristine, balanced, self-regulating ecosystem, and second, that cattle are the absolute worst enemy and greatest impediment to that goal. If one doubts the moral dimension of this perspective, listen to the words of one local

activist who, when asked about the possible preservation or even representation of ranching as a local cultural tradition replied, 'The Nazis had a culture too, it doesn't mean it should be preserved!' Such aggressive confrontation rests on an assumption of moral rectitude that defines some others as failures, in the case of Federal agencies, or evil, in the case of all those with competing ideas about the use of such lands. Indeed the very existence of such wilderness groups depends on what may be described as a fairly pervasive American view of the Federal government as incapable of acting morally. In this case, those who should be watching over the landscape are not and hence need to be replaced from the ground up. Ironically, this view of Federal agencies is typically shared by the designated enemies of the wilderness groups, the ranchers. They also share a sense of the primacy of an individual experience generated by a relation with the landscape. Of course, wilderness advocates see this relationship as diametrically opposed to their own: in their case a relation based in a notion of common property (of the nation, or at least those deserving members of the nation) whose individual instantiation is by definition ephemeral and hence neither adds nor subtracts anything from that landscape; rather they 'leave no trace'. Ranchers, these same wilderness advocates would argue, enjoy a relationship based in private property always linked to a notion of consumption and the extraction of profit, a physical and moral destruction or contamination of an actual, or potential, sacred landscape. Interestingly, many family ranchers agree with that definition of large, corporate cattle-raising enterprises, but are increasingly prone to picture themselves quite differently, stressing a kind of familial indigenousness, a tie to and love of the landscape that is both deep and intimate, that leads naturally to a custodial, rather than consumptive role. They are inclined to joke about being endangered species themselves: an element of diversity in the landscape that merits preservation. Such discourse is of course viewed cynically by their enemies as simply tactical, but perhaps the self-fulfilling prophecy character of such arguments should not be discounted. A different identity and experience of the landscape might be under construction.

The Experience of Authenticity

As for the wilderness pilgrim, although he may take part in such collective sorties in these imagined pristine environments as that with which we began, the lone pilgrim is the ideal experiencer of wilderness. But what kind of experience is involved? Among the individuals walking through the desert with *Leave No Trace*, one can find traces of the Hebrew Calvinist, the romantic, the adventurous late nineteenth-century reprise of Calvinism and even the modern, or postmodern, therapeutic quest. The respective strength of these traces or layers, all available in public symbols and discourses, of course varies with individuals. One meets them all, from the combative, piss-drinking, macho to the simperingly spiritual pilgrim. In all cases, such authentic individual experience is rooted in shared worlds of words and images that are themselves the products of two centuries of moral entrepreneurs. Ironically, the social production of wilderness as spaces 'without humans or their artefacts' has certainly been achieved

through aggressive social action in the public arena and the extensive use of human artefacts from paintings to calendars to websites, to tents and backpacks of space-age materials. An authentic experience mediated by myriad objects and representations.

The particularity of one version of this culturally constructed place and person is perhaps best illustrated by a recent sacred journey. A locally prominent wilderness advocate in Tucson read the account of a Mexican guide who, in the early years of the twentieth century, had become lost and nearly died after several days of wandering through the desert. A terrifying experience for the Mexican but not – to judge by his own account – one he saw as necessarily morally improving. The American wilderness man, however, set out to reproduce the journey, testing himself at the height of the brutal summer, drinking his own urine, nearly dying as well, but coming away with far greater moral fibre and authority than he possessed at the start of the pilgrimage. I would argue that such a perspective, if not uniquely American, belongs to at least one central strand of the American search for authenticity that conjoins a bruising contact with divinity, romantic nationalism and the postmodern quest for therapy. As a form of pilgrimage, it is a movement towards the edge (see Taylor 2007a), geographically and emotionally: a moral geography that seeks inward authenticity in outward journey.

Notes

1. The term has been used loosely and variously by a number of historians and geographers, but I would like to give it a more precise and hence hopefully useful definition that takes a processual perspective: the practice of ascribing both symbolic and moral character to particular landscapes (see also Taylor 2007a for a fuller discussion of the general model).
2. This is part of a much larger project based on ethnographic research with all the groups mentioned above. Three other articles (Taylor 2007a, 2007b, 2010) have so far appeared, and a book manuscript is in preparation.
3. Among the most prominent of these is Yi-Fu Tuan. Of particular relevance to the present topic is the work of his student Graber (1976) and the more recent works of Cronon (especially Cronon 1995, where the essay of Olwig offers a perceptive intellectual history and critique of the notion of nature and park and that of Cronon, a cultural analysis of the notion of wilderness in America complementary to that offered here).
4. In very different societal contexts, of course, figures like shamans or even lone warriors may likewise be associated with such dangerous natural places, wherein the power to fight or to cure may be found.
5. In another sense, however, it might be argued that America is understood by both its present and its future – or as a representation of a possible future for everyone – a global future, whether good or bad.
6. When a landscape is politically contested it is also likely to have these moral, nationalist foci. To take two European examples, there are the dramatic western landscapes of Ireland given national/mythological constructions less in painting than in poetry and prose. Then there is the contemporary landscape of the Balkans, where contested homelands (e.g., in Kosovo) gain hugely important nationalist understandings.
7. Hetch Hetchy dam. There is still a movement dedicated to restoring this 'second Yosemite', (see www.hetchhetchy.org/).
8. In 1853 the United States purchased that part of the current State of Arizona not ceded by the treaty that ended the Mexican American War. The purchase was ratified by the Congress in 1854.

9. Public Law 88–577, 78 Stat. 890; 16 U.S.C. 1 1 21 (note), 1 1 31–1136. 88th Congress, p. 4. 3 September 1964. An Act to establish a National Wilderness Preservation System for the permanent good of the whole people and for other purposes. This Act may be cited as the 'Wilderness Act' (I 6 U.S.C. 1 1 21 (note).

References

Abbey, E. 1968. *Desert Solitaire: A Season in the Wilderness.* Drawings by Peter Parnall. New York: McGraw-Hill.
____.1989. *A Voice Crying in the Wilderness (Vox Clamantis in Deserto): Notes from a Secret Journal.* New York: St Martin's Press.
Anderson, Benedict. 1991. *Imagined Communities. Reflections on the Origin and Spread of Nationalism.* London: Verso.
Austin, R.C. 1987. *Baptized into Wilderness: A Christian Perspective on John Muir.* Atlanta: John Knox Press.
Becker, H. 1963. *Outsiders: Studies in the Sociology of Deviance.* New York: Free Press.
Benton, L.M. and J.R. Short. 1999. *Environmental Discourse and Practice.* Oxford. Blackwell.
Cronon, W. (ed.). 1995. *Uncommon Ground: Towards Reinventing Nature.* New York: W.W. Norton and Co.
Cronon, W. 1995. 'The Trouble with Wilderness; Or Getting Back to the Wrong Nature'. In W. Cronon (ed.), *Uncommon Ground: Towards Reinventing Nature.* New York: W.W. Norton and Co.
Feld, S. and K. Basso (eds). 1996. *Senses of Place.* Santa Fe: School of American Research Press.
Graber, L.H. 1976. *Wilderness as Sacred Space.* Washington, DC: Association of American Geographers.
Harvey, D. 1989. *Condition of Postmodernity: An Enquiry into the Origins of Social Change.* Cambridge, MA: Blackwell.
Lefèbvre, H. 1991. *The Production of Space.* Oxford: Blackwell.
Miller, P. 1956. *Errand into the Wilderness.* Cambridge, MA: Harvard University Press.
Muir, J. 1998. *A Thousand Mile Walk to the Gulf.* New York: Mariner Books.
Nash, R. 1967. *Wilderness and the American Mind.* New Haven, CT: Yale University Press.
Novak. B. 1980. *Nature and Culture: American Landscape and Painting, 1825–1875.* Oxford: Oxford University Press.
Olwig, K.R. 1995. 'Reinventing Common Nature: Yosemite and Mount Rushmore – A Meandering Tale of a Double Nature'. In W. Cronon (ed.), *Uncommon Ground: Rethinking the Human Place in Nature.* New York: W.W. Norton and Co.
Sayre, N.F. 2002. *Ranching, Endangered Species, and Urbanization in the Southwest: Species of Capital.* Tucson: University of Arizona Press.
Sheridan, T.E. 2006. *Landscapes of Fraud: Mission Tumacácori, the Baca Float, and the Betrayal of the O'Odham.* Tucson: University of Arizona Press.
Soja, E. 1989. *Postmodern Geographies.* London: Verso.
Taylor, L.J. 2007a. 'Centre and Edge: Pilgrimage and the Moral Geography of the U.S./Mexico Border'. In 'Displacing the Centre' (special issue ed. with V. Bajc and J. Eade), *Mobilities* 2(3) 383–393. http://www.informaworld.com/smpp/title-content=t724921262-db=all-tab=issueslist-branches=2 - v22.
____. 2007b. 'The Minutemen: Re-enacting the Frontier and the Birth of a Nation'. In R. van Ginkel and A. Strating (eds), *Wildness and Sensation: An Anthropology of Sinister and Sensuous Realms.* Amsterdam: Spinhuis Publishers.
____. 2010. 'Moral Entrepreneurs and Moral Geographies on the U.S./Mexico *Social and Legal Studies* 19(3) 299–310.
Teale, E.W. (ed.). 2001. *The Wilderness World of John Muir.* New York: Mariner Muir.
Turner, F.J. 1996. *The Frontier in American History.* New York: Dover Books.
Williams, R. 1979. *Politics and Letters: Interviews with New Left Review.* London and New York: Verso.

Chapter 4

The Moral Economy of Authenticity and the Invention of Traditions in Franche-Comté (France)

Jean-Pierre Warnier

In order to introduce my contribution, I will make four points:

(1) A moral economy of authenticity. Amongst other things Rajko Muršič points out in his chapter that, if you scratch on the surface of the quest for authenticity, you quickly uncover political implications. He said they were mostly of an objectionable nature.

The point I want to make is that, when you scratch on the surface of the quest for authenticity, you also quickly uncover economic implications. Authenticity means wealth and money. Think of an authentic Vermeer as against a fake one. If you add up together these two dimensions of authenticity, that is, politics and economy, you come to the conclusion that there is a political economy of authenticity. I also think that there is a moral economy of authenticity because the quest for authenticity is pervaded with moral issues concerning forgery, truthfulness, good and evil, right or wrong. I am here alluding to the work of B. Berman and J. Londsdale (1992), two historians of Africa, who made an extensive and most relevant use of this notion.

(2) Franche-Comté. My case study will be the region of Franche-Comté, in north-eastern France, just along the Swiss border. It coincides more or less with the Jura Mountains. I will try and show that, in Franche-Comté, over the last thirty or forty years, the moral economy of the quest for authenticity triggered a process of quasi ethnogenesis and definitely a process of invention of traditions.

(3) A story of authentic blood sausages. My concern with authenticity emerged in the 1990s following an unexpected encounter with a trivial story of blood sausages. The story is this: every year, Université Paris-Descartes organizes an intensive training

session of one week for the anthropology students. It takes place in the spring. We usually come back to the same place two or three years in a row until, by a kind of slash and burn process, we decide to let a given place lie fallow, and migrate to a new one. In 1992, the session took place in the small town of Mortagne, about 150 km south-west of Paris, some five thousand inhabitants at the time.

Mortagne has a gastronomic specialty, which is the 'authentic' blood sausage. If you want to purchase an authentic sausage, you buy one with the Mortagne label. During the training session in ethnographic field research in Mortagne, in 1992, one of our female students chose to study the tradition of sausage manufacture in Mortagne. Her name is Catherine Gilbert (1994). There was a lot to be studied: an antique fraternity of men dressed in fifteenth-century velvet gowns, chains and medals around the neck with mediaeval titles like *Grand Maître* (great master), *Tabellion* (clerk or secretary), *Maître des cérémonies* (master of ceremony), Chancelor, etc. The fraternity, called *Confrérie des Chevaliers du Goûte-boudin de Mortagne* (the fraternity of the knights who taste the blood sausage of Mortagne) organizes a yearly contest of the best blood sausage with about six hundred competitors coming from around ten different countries, including Germany, no doubt Austria, the West Indies. There are awards of various kinds for the winners and the delivery of certificates. Parallel to this contest, there is also a contest of the bigger eater of sausage. In 1993, the winner ate nearly one kg of sausage, measuring 1.25m in length.

All this looked quite authentic at face value. That is, it looked like an old, well-established tradition, dating back to a time when there was no mass consumption of standardized industrial products, when food production was still scattered among thousands of artisanal producers in small regional centres. One would not have been surprised to learn that the fraternity was in fact an ancient guild that had been abolished, like all corporations, by the Revolution and revitalized under the new forms of the modern associations. It claimed to be authentic anyway, that is, the actors themselves endeavoured to make people believe that they indeed maintained an antique tradition. The word authentic was extensively used.

What Catherine Gilbert found out, however, was that it all dated back to 1963. Nineteen sixty-three! The antique fraternity had been founded just about thirty years before the investigation done by Catherine Gilbert. Yet, no one in Mortagne tried to hide the fact although everybody contributed to the show of authenticity. The members of the fraternity gave a hearty welcome to Catherine and opened up all their archives to her. No wonder: an anthropologist coming from the Sorbonne to study the blood sausage in Mortagne was a God-given certificate of authenticity. There were even articles in the local newspapers.

What happened in the early 1960s is this: like all French (and presumably European) small towns, Mortagne had been a local marketplace and an urban centre of the third or fourth order. It had a fair, which used to take place every year at Carnival, before the beginning of Lent, usually about March. In the late 1950s, with the fast modernization process of French agriculture and the development of public and private transport, the fair experienced a sharp decline. People took to attending the shopping centres of the larger towns like Le Mans.

A few people in Mortagne decided to react. A couple of them proposed to associate the fair with a contest focussed on gastronomy: definitely something that could appeal to French patrons. The mayor of the town proposed the blood sausage. Although blood sausages had been produced everywhere in France, he had heard that, in the past, Mortagne had a good reputation for that produce. The city council decided to organize a fraternity to supervise the contest. Along the contest of the best sausage, the contest of the bigger eater was organized by the more popular sections of the city. It was, however, constantly disavowed by the fraternity as vulgar.

Altogether, at the beginning, it seems to have been a kind of tongue in cheek business. They made no bones about the fact that it was new. It was a construct. At the same time, they claimed it was fully authentic since blood sausages had indeed been made in Mortagne since times immemorial, as everywhere in the country. Fairs, feasts, banquets and guilds existed since the Middle Ages, as did carnival and joking. Joking and laughter were part of the trick. For example, the first *Grand Maître* to be elected by his peers was the surgeon of the local hospital. People took to making innuendos regarding the nature and origin of the blood used in making the sausages and about their unique taste.

Anyway, it worked beyond expectations. The decline of the fair was checked. Between 1960 and 1990, more and more people attended the contest. Mortagne is now known everywhere as the world capital of the authentic blood sausage and makes good business with it. Authenticity has exchange value on the market.

(4) The market for authenticity in the 1990s. This could have been the end of my story. But it is not. In the following years, as we moved the field research training session to the town of Besançon, the question of authenticity exploded to our face. The quest for authenticity, the way the latter is constructed, the procedures for authenticating a given produce provided the themes of many enquiries by the students, ending in the publication of two edited books (Warnier 1994, Rosselin and Warnier 1996).

In the wake of those two publications, I will now deal with three issues: first, the region of Franche-Comté, second, some aspects of its history relevant to the quest for authenticity, and, third, a few theoretical points regarding the question 'why the quest for authenticity at the end of the twentieth century and the early twenty-first'?

The Region of Franche-Comté

Once we had moved the field research training session to Besançon, we noticed many things that reminded us of the authentic blood sausage of Mortagne. Besançon is the capital town of what used to be the royal province of Franche-Comté and is now the capital of one of the twenty-two administrative regions of France since the law of regionalization of 1982. The phenomenon of authentication took place in Franche-Comté on a much larger scale, however, and in a much more diversified way than in Mortagne.

There was not only one produce but many of them: smoked produces (the ham of Luxeuil, the sausages of Montbéliard and of Morteau, the smoked ham of Haut Doub), cheeses (Mont d'Or, Bleu de Jex, Bleu du Haut Jura, Comté, Cancoillotte, Morbier), wines (vin jaune, Château Chalon, AOC Arbois, Etoile, AOC Côtes du Jura), spirits (kirsch de la Marsotte, kirsch de Fougerolles, anis de Pontarlier). All of them were certified by labels, authentication procedures and antiques fraternities, sometimes as recent as the one in Mortagne. Authentication procedures are extremely diversified, but, as an example, one could take the feast of the *biou* performed in the town of Arbois: at the time of grape picking, in October, the fraternity of Arbois men manufacture a *biou* which is a huge grape, by assembling hundred of real grapes. It is one metre high, weighing some 100kg. It hangs from a pole carried around town by several men in procession with banners and music. It consists in a scenography of local traditions addressed to tourists, specialized journals of eonology, local newspapers and national magazines. It is the kind of event that could be covered by *The National Geographic* or its French equivalent *Geo*.

All the produces of Franche-Comté were presented as being authentic produces, typical of this region and of no other. They fitted into a general category, well-known of all French consumers, called *produits de terroir*, that is, the product of a given locality, a particular, bounded, stretch of land, with specific soil and climatic properties resulting in a unique produce that cannot be produced, but only faked, anywhere else.[1] The question of *terroir* translates on a much more local scale. Even in Burgundy, you cannot grow a Volnay wine on Savigny-les-Beaunes *terroir*, four kilometres away, neither could you grow a Savigny on the *terroir* Nuits-Saint-Georges.

There is an official repertory of such produces. It is the inventory of the *Produits de terroir et recettes traditionnelles* of Franche-Comté (1993) that I would gloss as 'produces of the soil and of the traditional cooking recipes'. It is just one volume of a series covering all the French territory under the heading of an inventory of the culinary heritage of France. It is elaborated and published by the very official National Committee for the Cooking Arts, made up of delegates from five ministries (Culture, Agriculture, Education, Tourism, Health and Social Security), of renowned chefs, business men and women from the agricultural and food businesses, and qualified personalities like scholars and researchers. It seeks academic recognition. It funds ethnographic research. It organizes cooking contests. Its sophisticated list of criteria of authenticity would be worth investigating. Let me just name a couple of them: for a produce to be considered as traditional, its production must have been carried on continuously since the time which antedated the industrialization of agriculture, that is, roughly, half a century. Also, there should be tangible evidence that the produce has been assigned for a long time to a particular locality in Franche-Comté.

There are institutions and procedures of authentication:

- The Committee for the promotion of regional produces (founded 1994), which conforms both to the local traditions and to European regulations;
- The *Label régional Franche-Comté*;
- The *Indication géographique protégée* (protected geographical origin);

- The most famous of those certifying institutions, founded 1934, is the *Institut National des Appellations d'Origine* which delivers the *Appellation d'origine controlée* (controlled label of origin);
- There are many other institutions delivering labels of quality, or origin, or authenticity;
- There is a regional contest of the best chefs called *Tables régionales de Franche-Comté* delivering a label that restaurants can put on their doors or in touristic guides;
- There are fraternities and associations. For example, in Morteau, the *Confrérie des Chevaliers Porte-cheville*.

The processes of authentication are articulated with the most sophisticated high technology. Example: the famous Louis Pasteur was born in Franche-Comté. He had a house in Arbois. The wine producers of Jura have a museum in a château, not far from the house of Pasteur and of his monumental statue on one of the town squares. This château is called Château Pécaud. In the building, there is a permanent exhibit on wine, the vineyard of Arbois, winemaking traditions, tools that were used before the modernization of agriculture, etc. In the same building (actually a fifteenth-century castle, with round towers), there is a high tech laboratory and a tasting room, which is as modern, high tech and disinfected as a surgical theatre. The visitors are told that the producers of Arbois work hand in hand with *Institut Pasteur* in Paris, on enzymes, fermentations, organoleptic properties of the wines, etc. The message is clear: thanks to modern high technologies, you can make sure that the miracle of age old authentic traditions will not be spoiled by some vile enzyme.[2]

This brings me to the cultural and architectural heritage of Franche-Comté and the question of museums and monuments: the Museum of Comtois architecture in Besançon (scores of authentic farmhouses disassembled *in situ* and rebuilt in a park near Besançon, showing all the different styles of peasant architecture), the Peugeot museum, the eighteenth-century utopian salt factory at Arc-et-Senans built by the architect Claude-Nicolas Ledoux, the museum of toys at Moirans, the museum of wine at Arbois, the workshop and museum of Comté cheese at Tréport, etc.

Such institutions are witnesses to the process of museification of things, buildings and folklorized traditions. This needs comments since it is a feature of French history dating back to the early years of the French Revolution when the populace began looting and destroying churches, monasteries and aristocratic mansions. This raised the following question: are these monuments witnesses to a hated political regime that should be destroyed, or do they belong to the national heritage that should be maintained and protected? The Latin notion of *patrimonium* was used in that context. The Assembly engaged in a sophisticated debate and decided that such monuments were part and parcel of the French national identity and should be preserved. The remains of those that had been destroyed were collected and deposited in seven *dépôts lapidaires* that would translate as something like stone deposits. Together with royal collections, they are at the origin of French contemporary practices behind museums, conservation and the inventory of national heritage. The Revolution engaged into

an inventory of the national monuments that developed into a systematic cultural policy throughout the nineteenth and twentieth century. This tradition is part and parcel of a much larger phenomenon including annual fairs, religious feasts around given saints, fraternities, feasts of the harvest, like the feast of the *biou* mentioned earlier, etc. Further, prominent men (and women) born in Franche-Comté, like Victor Hugo, Louis Pasteur, or the painter Courbet are mobilized for the construction of a regional identity supposed to fit with the territory, the landscapes and a kind of *Volkgeist* particular to the region.

The quest for an authenticity fostering a regional identity is tightly connected with mass tourism focussed on three main targets. First, senior citizens from Northern Europe: Germany, Belgium, Luxemburg, the Netherlands. During the four successive years when the field research training session stayed in and around Besançon, we met busloads of them being herded to regional produce shops, local museums, restaurants. For the more sophisticated, there were wine-tasting and appreciation sessions with local producers and, of course, purchase. This is based on a tourist infrastructure of hotels, skiing and trekking resorts (including with sled dogs), restaurants, tour operators. Second, parents in their forties with children, from all over France and northern Europe, who can be offered summer or winter vacations in mountain or skiing resorts in magnificent natural landscapes, plus cultural activities and discovery of an authentic regional identity and customs. Three, the local youth: in the1960s, at a time when there was an appeal for modernization and industry, school children were taken by their schools to visit factories and workshops. Nowadays, they are taken to museums and cheese producing farms to be initiated in Franche-Comté identity.

Last but not least, there is a significant production of books, magazines, pamphlets, touristic and museum guides and derived products such as postcards, posters, T-shirts, to sustain the local invention of an authentic regional identity.[3]

Dating the Invention of Franche-Comté

The embodiment of the authenticity of such a regional identity is explicitly related to history. What the consumers of authentic products ask for is an uninterrupted tradition reaching as far back into the past as possible. Continuity is one of the criteria that has to be fulfilled by a given regional produce or a regional cooking recipe to be included into the inventory of the gastronomic heritage of Franche-Comté. Heritage is history. This is why it is worth looking into the history of Franche-Comté and its identity. It emerged as a specific unit in the fifteenth century. It was attached to Burgundy until 1493. At that date, it was attached to the Habsburg dynasty until 1635. When Charles V abdicated, it became a Spanish dominion, administered from the Netherlands and Belgium, and, as such, a land considered by the French crown fit to be appropriated at the expense of Spain, which had nothing to do in that part of Europe after the collapse of the Empire of Charles. From 1635 to 1678, the army of Louis XIV conducted an extremely destructive and violent series of campaigns to appropriate the province. The latter kept its status as a Province of the French crown,

with its own parliament, until the Revolution, enjoying more than a century of peace and relative prosperity. However, it had no particular identity of its own, contrary to the neighbouring Alsace, or other French provinces like Britanny. The Revolution wiped out the royal province as an administrative unit and replaced it by the much smaller *département*, which was carved in such a way that the return trip to any point in the district could be done on horseback from its capital town in less than one day. The province of Franche-Comté was divided up into four *départements*: Haute Saône, Territoire de Belfort, Doubs and Jura.

All traditions must have some historical origin, a kind of starting point. The argument of E. Hobsbawm and T. Ranger (1983) about the invention of tradition is that certain historical contexts trigger a process of reformulation of local traditions. Specifically, Hobsbawm and Ranger bring forth the fact that in nineteenth-century Europe, nationalist competition fostered the invention of regional identities propped against specific practices, ways of dressing, material culture, etc., designed to enhance regional identities in a national context.[4]

Regarding nationalism and regional diversity as enriching the one and indivisible Republic, Franche-Comté, however, did not rank very high in that respect. It had nothing to offer that was really specific to it, and, besides, the division into four administrative districts was a success and none of them claimed to have much in common with the other three. The forty years between the end of the Second World War and the 1970s were not conducive to anything looking like the search for lost regional identities. France was more in the mood for modernization and industrialization in which another, futuristic, kind of authenticity could be desired and found. This drive was highly successful in the four districts of Franche-Comté, which actively participated in post First World War European economic development with the automobile, railway and heavy metallurgical industries. During that period, almost nothing was done to foster a regional identity in this region.

The tide began to turn in the small rural towns in the 1960s, with the modernization of agriculture, as it did in Mortagne, and even more so in the 1970s, with the oil crisis and the beginning of the economic difficulties resulting in mass unemployment, delocalization and the decline of national industries. This is when the products of *terroir* became an alternative for local economies experiencing a lasting crisis. This trend was definitely encouraged by the 1982 regionalization law. Its purpose, of course, was not to restore the old royal provinces, but to create larger administrative units than the small district at a time when people could telephone and travel by car and train, instead of on horseback. Its second purpose was to grant a modicum of autonomy from the centralized administration residing in Paris.

As a region, Franche-Comté had a number of economic assets: a strong industrial tradition in a few manufacturing centres, gorgeous landscapes mostly in the Jura mountains, with vast forests and forest-derived activities (the manufacture of furniture, toys, musical instruments, tobacco pipes, etc.) and with grassy areas suitable for dairy cows and cheese production. It had a lot of streams and water and was equipped with hydroelectric power plants right from the beginning of the twentieth century. Tourism is also an asset and, until the mid-twentieth century, Franche-Comté, with

its harsh winters, had developed a lot of cottage industries in farmhouses during the winter months like small mechanic, clocks and watch manufacture, furniture.

As I said, it has no striking identity of its own. In 1994, just at the time of the invention of a new Comtois identity, a book by Mr Perron was reprinted, 'The Franc-Comtois People, Their National Character, Their Customs and Habits' (my translation, 1994; first published 1892). At that time, in the wake of Romanticism and regional nationalism, local intellectuals all over France tried to invent something that could look like a local *Volkgeist*. For example, Mr Perron writes: The Franc-Comtois people is 'jealous of its freedom, suspicious and cautious, prone to contradiction and to being stubborn, touchy and rough, shy to the point of being wild, never in a hurry, superstitious'. That is, nothing that could not be said more or less of any European peasantry at the time, when there were real peasants. These are plain vulgar stereotypes. Not to speak of the generalization (all Franc-Comtois are like that). It is *Volkgeist* and national character at its worst. Obviously, the book was a complete failure. However, it is worth noting that it was reprinted in 1994, just at the time of the invention of a new Comtois identity. Let me add that the local language is French, if only with a slight regional accent.

Yet, despite the fact that there is not much in local history to support a local authentic Comtois identity, what has been taking place over the last twenty or thirty years on the background of the invention of French provinces is a multifaceted attempt at producing such a thing as a *Volkgeist*. This needs analysis and perhaps some attempt at explaining why it happened at that particular time, in that particular place and under that form.

Why the Quest for Authenticity?

I now wish to elaborate my argument concerning the invention of a Franche-Comté identity, i.e., the quest for authenticity as quite a widespread phenomenon in contemporary societies. Over the last few years, it seems to me that three lines of enquiry have developed, depending on the scale of the data at hand: the global level, the level of the nation (in that particular case France) and the local level (Franche-Comté).

At the global level: I refer here to the work of Appadurai (1990 and 1997). Appadurai takes notice of the globalization of a number of flows on which we have accurate statistics, figures and maps: flows of commodity, media, finance and demographic ones. The result of those flows is the worldwide drift of what he calls unmoored goods, news, people, cultural items, etc. This, in its turn, triggers two kinds of phenomena. First, there is not a single human being who is in a position to have an adequate representation of these fluxes on a global scale. Yet, every human being needs such a representation, for example when s/he is confronted with unmoored goods intruding into the local group he belongs to. As a result, people produce imaginary landscapes of the global flows: mediascapes, financescapes, ethnoscapes. Second, unmoored things, migrants and commodities, as well as decontextualized news or cultural items have to be domesticated and locally moored. Together with the globali-

zation process of flows, all over the world, people and states implement procedures to produce locality and assign things, people, capital, etc., to the local. The politics of heritage and of authenticity are part of that drive since they predicate authenticity on locality and on the continuity of the cultural heritage. They often rest on what Appadurai, following some American political scientists, call the *primordia*, that is, the land, the language, the imagined identities, the local traditions.

This argument is far from being new. One finds the same line of argument in a tradition that runs from Marx to contemporary anthropological and sociological writings on the State as a device aimed at enforcing closure, the production of locality, with local domains. For example, Bayart (2004) stresses the fact that the State is not the cause of international exchanges at large. It does not produce the conditions of international exchanges and flows. It does not come before them but after. The development of long-distance trade, of matrimonial and diplomatic exchanges, intrudes into localized societies and creates the need for the domestication of foreign things and people and their assignment to locality.

What Appadurai stresses, however, is that the globalization of flows creates contradictions and divergence in the global cultural economy, especially by fostering a divorce between the State and the Nation. Bayart, however, contends that the processes of globalization reinforce the State and especially State boundaries: there is more and more pressure to establish control at the borders, especially of migrants and illegitimate trade, and to enforce surveillance and security within the limits of the national borders.[5]

The global argument provides a rationale that explains the quest for authenticity. It contends that one of the ways to domesticate unmoored things and people and to assign them to a locality, is to create things, traditions, heritage that are genuinely local, or, in other words, authentic. The globalization process, all over the world, has gone hand in hand with the politics of heritage on a worldwide scale, from UNESCO to the smallest African kingdom or European village. The museification process of the planet is part and parcel of this worldwide phenomenon. In that respect, the production of a Franc-Comtois regional identity is a means to produce locality, to assign people and things to it, and to create an inside and an outside with clear criteria of belonging or not belonging.

At the national level of France: Here, the relevant reference is a vast body of literature on mass consumption, most prominently the publications of CREDOC (an acronym for *Centre de Recherche et de Documentation sur la Consommation*; Research and Documentation Centre on Consumption). It is a private research organization founded after the Second World War. It has statistical series on household consumption for the last sixty years. It shows that, from the early 1960s onwards, with the development of mass consumption, the budget of French households has split into two easily identifiable parts: the larger part is devoted to purchasing standard quasi-generic goods. This is basically what people put in their trolley when they do their shopping at the local supermarket. The smaller part is devoted to the purchase of goods on specialized markets with a high potential for the production of identity: antiques, *produits de terroir*, labelled produces. This is the market for the authentic. It helps producing heritage, tradition and identity.

Fischler (1990) calls OCNI (*objets culinaires non identifiés*; non identified culinary objects) the unmoored food items we find on the shelves of the supermarket or in the fast food restaurants. The consumer cannot do without them. They are cheap and welcome. But they create a need and a desire for the authentic, the identified, the food item that can be traced back to a local farm or a given *terroir*. Franche-Comté has been in a position and has had the will to respond to that kind of demand. In other words, the market for the authentic produce is part and parcel of the development of mass consumption. There is an economy of identity and authenticity, because there is a market for it. But, being connected to household consumption, to food, health, welfare and the self, it is pervaded with moral issues about what is allowed or not, decent or not, positive or negative, good or bad, acceptable or not. It is a moral economy.

There is another important point in such debates about the moral economy of authenticity. It results from I. Kopytoff's analysis of the 'social biography of things' (1986). Starting from the analysis of slavery, Kopytoff dismisses any attempt at giving a definition of a slave or slavery. At the same time, he stresses that the enslavement process takes place along a continuum extending from the person included in a kin group at one end of the continuum, to, at the other end, the alienable commodity cut off from any personal context or kin group.

Similarly, I would like to stress that the authentic is more on the side of the personal, the inalienable possession, heritage, and descent, and that the inauthentic is more on the side of the alienable possessions, the market, exchange, alliance. This is an argument, which is developed in the two edited volumes which I have already alluded to (Warnier 1994, Rosselin and Warnier 1994). Along the same lines of thought, I have tried to summarize the semantics of authenticity in the previous paragraph. Accordingly, in contemporary societies, the consumer is caught into a paradox or a double bind: he wants to acquire 'authentic' products or things. However, really authentic things are those that come to you by heritage, that are included into the realm of personal and intimate, domestic things. They are usually close to the body. If one does not have them and wants to acquire them, the best and probably the only way to obtain them is by purchase on the market, which is in principle incompatible with their status as authentic things. The paradox is resolved by all the procedures, which are devised to produce something unique, localized, customized that can be traced back to a known place, and by means that tend to overcome the smell of money attached to them by some other, more wholesome, perfume.

From the mid-1960s onwards, the number of procedures of certification exploded. The crises of mad cow disease, of avian flu, etc., also increased the need for traceability and reliability, and therefore for the identified, the authentic. The construction of authenticity rests on the use or mobilization of signs that belong to systems of communication or connotation. For example, the pot of 'authentic Poligny honey' will bear a printed label reproducing a hand-written home-produced image. It is a sign, addressed to the customer, with its signifying and its signification which rest on a code made of contrasts between home-made versus industrially processed. It can be interpreted as: 'this is a hand-written label, therefore the produce his been the object

of much care in a small, genuine family farm'. Consequently, the construction of authenticity lends itself easily to a semiological analysis in terms of binary oppositions between different qualities or properties of objects, actions, consumption choices, etc. However, the signs [+] and [-] can easily be reversed. For example, authenticity can be found either in an idealized past, or in a utopian future. Both, however, are opposed to a spurious present.

In the following series of binary oppositions, I have underlined the possible reversals.

Authentic [+]	Inauthentic [-]
Genuine	spurious
Primordial (soil, language, heritage)	innovation
The enlightened future	the dark ages
The doomed future	the authentic past
Heritage	commodity
Inalienable possessions	alienable possessions (A. Weiner)
Descent	alliance
Identity	otherness
The local	the global (unmoored; A. Appadurai)
The exotic	western/modern (the Frankfurt School)
The noble savage (Ariel)	the civilized (Prospero)
The civilized (Prospero)	the savage (Caliban)
The savage (Caliban)	the civilized (Prospero)

Conclusion: Is It a Process of Ethnogenesis?

In Franche-Comté, the production of locality, the construction of an authentic regional identity, the assignment of things and people to the locality is the result of the actions of hundreds of different categories of people: the producers of cheese, wine, smoked meat; the sponsors and curators of the museums, monuments, towns and sites of historical importance; the primary and secondary education teachers; the tourists from France and from abroad, the tour operators, restaurant chefs, hoteliers and others; the State, the regional council, the city councils; the institutions that certify and produce the numerous labels of quality and origin; the associations running the fairs, the local feasts, the contests and the awards; the authors and creators of books, pamphlets, photographs, postcards, tourist guides and similar items.

Such different people and institutions act in many different ways. They are often in conflict with one another. Their actions are so diverse and complex that the scenario of a coordinated plot is totally unlikely. In my view, the only possible hypothesis to explain the consensus on the production of an authentic regional identity is to consider that all those people are submitted to a number of constraints that they share. Consequently, they tend to cope with them in similar ways. The constraints are those operating at a global level; that is, let us say, Appadurai's argument, and also those operating at the level of the consumer society as it is shaped in France by the

economic growth of the last forty years of the twentieth century. It just happens that the local resources, in Franche-Comté, point out the solutions in some sort of apparently coordinated manner.

For the people of Franche-Comté themselves, does it all amount to a kind of ethnogenesis, that is, do they tend to acquire a feeling of identity and belonging that they did not have before the regionalization law of 1982? The enquiries we conducted with the students over a time-span of four years did not yield any definite answer. However, if we follow the definition given by Max Weber of the ethnic group in 'Wirtschaft und Gesellschaft' (1922) which is predicated more on the political community than on kinship and a common origin, we would certainly agree that Franche-Comté, as a political community, has definitely produced an identity of its own and therefore tends towards something that resembles an ethnic group with a feeling of belonging among its members. Yet, obviously, it does not fulfil the criteria of the authentic ethnic group as they developed in the commonsensical perception of tribal people. But does it really matter? No, if we consider that for the anthropologist, no ethnic group is more authentic than any other because authenticity is a myth, a construct, that has to be analysed, but that has no epistemological value for the anthropologist.

I wish to make a second concluding remark: Hobsbawm and Ranger edited their book on the invention of tradition in relation to nineteenth-century European nationalisms. It is in the context of nationalist competition, they contend, that the local traditions were invented as a means of producing larger national ensembles, on the basis of a shared cultural diversity or of separating certain people from each other on the basis of such dramatic differences that a given group had to shift national allegiance, more or less on the pattern of the dispute between France and Germany over Alsace and Lorraine. This is the nationalist context of the production of authentic traditions. In the second half of the twentieth century and the beginning of the twenty-first, the context of the invention of traditions has changed. It has much more to do with the globalization processes at work in consumer societies, and with consumption as a domain that allows the production of personal and group identity, than with nationalist competition. The case of Franche-Comté is not an isolated one. It has helped me to underscore a worldwide phenomenon.

Notes

1. When the Americans began to produce wines for the national and world markets, their references were the best-known European wines. They tried to imitate them. They pretended to produce Bordeaux or Burgundy wines on Californian land. In a sense, these wines were fakes since they were produced according to exogenous criteria. Nowadays, American wine-makers do not pretend any longer. They produce genuine Californian wines that are highly competitive as such on the world market.
2. At the same time Franche-Comté is a centre of modern and high technology. It is the homeland of the Peugeot family and its factories at Sochaux and Montbéliard, of Alsthom and heavy metallurgy which manufactures the fast trains (TGV, Talys, Eurostar), turbines for nuclear power plants, diesel engines for liners and all the railway equipment of the national railway company.

3. For example the book *Franche-Comté* (1988) with chapters on the natural environment, history, art, literature, language, economy and folklore.
4. This was exported to Africa and all over the world by the European colonial empires.
5. Friedman and Rowlands (1977) have developed the same argument in their epigenetic model of the production of the State.

References

Appadurai, A. 1990. 'Disjuncture and difference in the global cultural economy', *Public Culture* 2(2) 1–24.

———. 1997. *Modernity at Large*. Minneapolis. University of Minnesota Press.

Bayart, J.-F. 2004. *Le gouvernement du monde. Une critique politique de la globalisation*. Paris: Fayard.

Berman, B. and J. Londsdale. 1992. *Unhappy Valley. Conflict in Kenya and Africa*. London: James Currey, 2 vols.

Friedman, J. and M.J. Rowlands. 1977. 'Notes towards an Epigenetic Model of the Evolution of Civilisation'. In J. Friedman and M.J. Rowlands (eds), *The Evolution of Social Systems*. London: Duckworth. Pp. 201–278.

Gilbert, C. 1994. 'L'invention d'une tradition: le boudin de Mortagne'. In J.-P. Warnier (ed.), *Le paradoxe de la marchandise authentique. Imaginaire et consommation de masse*. Paris: L'Harmattan. Pp. 35–48.

Hobsbawm, E. and T. Ranger (eds). 1983. *The Invention of Tradition*. Cambridge: Cambridge University Press.

Kopytoff, I. 1986. 'The Cultural Biography of Things: Commoditization as Process'. In A. Appadurai (ed.), *The Social Life of Things*. Cambridge: Cambridge University Press. Pp. 64–91.

Fischler, C. 1990. *L'Homnivore*. Paris: Odile Jacob.

Franche-Comté. 1988. Paris: Christine Bonneton Editeur.

Franche-Comté. Produits de terroir et recettes traditionnelles. 1993. L'inventaire du patrimoine culinaire de la France. Paris: Albin Michel et Conseil National des Arts Culinaires.

Perron, Dr 1994. *Les Franc-Comtois. Leur caractère national, leurs mœurs, leurs usages*. (first published 1892, publisher unknown).

Rosselin, C. and J.-P. Warnier. (eds). 1996. *Authentifier la marchandise. Anthropologie critique de la quête d'authenticité*. Paris: L'Harmattan.

Warnier, J.-P. (ed.). 1994. *Le paradoxe de la marchandise authentique. Imaginaire et consommation de masse*. Paris: L'Harmattan.

Weber, M. 1922. *Wirtschaft und Gesellschaft*. Tübingen: Mohr.

Chapter 5

'OH, THAT'S SO TYPICAL!' DISCUSSING SOME SPANISH 'AUTHENTIC' ESSENTIAL TRAITS

Jorge Grau Rebollo

Introduction[1]

This paper could very well have been entitled:'Typically Spanish' (or 'How Many Learned to Stop Wondering and Hate the Stereotype'), after Stanley Kubrick's celebrated film *Dr Strangelove, or How I Learned to Stop Worrying and Love the Bomb*.[2] The film script was based on Peter George's novel 'Red Alert' (U.S. title, since George's work, under his pseudonym Peter Bryant, was first published in 1958 under the title 'Two Hours to Doom').[3] According to some sources, the original novel dealt with the threat the world faced before an accidental nuclear war. While Dr Strangelove plays a key role in the movie, this character did not actually appear in the novel. He was invented by Kubrick and Terry Southern for the film adaptation, thus creating the story anew. Nevertheless, Strangelove has become one of the film major landmarks, being less and less important whether he really existed in the film's (story) past. Sometimes, however, it is this particular past, which must be evoked in order to prove a sort of genetic link with a given form of ancestry that may confer the hallmark of authenticity.

For instance, in 'The Predicament of Culture' (1988), James Clifford recalls how in 1977 the descendants of the Wampanoag Indians living in Mashpee were requested by the Federal Court in Boston to prove their identity. In order to establish a positive link with their ancestors in the seventeenth century, and so be able to claim their lost land, New England Indians were asked to testify before the Court. Clifford states how historians, anthropologists and sociologists also took part in the process and how notions like tribe, culture, community or ethnicity were thoroughly discussed. 'It seemed to me that … it was a crucial experiment of cross-cultural translation. Modern Indians, who spoke in New England-accented English about the Great Spirit had to convince a Boston jury of their authenticity' (Clifford 1988: 8).

In the following pages I will try to invoke a seeming paradox, although one that operates at a very different level and in many senses. Throughout academy we can find different examples of how authenticity is debated. What makes something authentic, representative or genuine is certainly a thorny, multifaceted question. Here I examine Spanishness by considering how certain images and values are currently associated worldwide with traditional Spain or the typically Spanish – even though these traits are openly contested by many Spaniards (for various reasons).

However, I will not focus on the theories of symbolism, the cultural construction of identity(ies) or even semiotics. Rather, I will use those examples to pose a more fundamental issue: how, under particular circumstances and always in specific contexts, do certain icons or ideological statements become associated with the true nature of social groups or even entire states? I will endeavour to use the kitsch tourist market and certain assumptions about authenticity in film to illustrate the following paradox: that certain products and themes that brand Spain as a tourist destination and a particular place in the global imagination are often those that many Spaniards find far from the truth.

Authenticity and Refraction

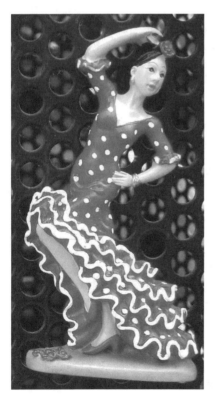

Figure 5.1: *Bailaora* magnet. Picture Jorge Grau Rebollo.

According to the Anholt Nation Brands Index,[4] Spain ranks eleventh for most reliable country-brands.[5] A quick browse over the internet also provides an impressive number of reasons to visit, and spend some money in this country. There is not, of course, a total discrepancy between how Spaniards would like to be seen abroad and how they are actually seen, but – and this is the issue of this paper – there is sometimes a clear divergence between, for example, what the tourist is offered as a typical Spanish gift and what this object really means for wide sections of the population. What is perhaps more interesting is how these objects came to represent certain notions of Spanishness.

If we take a closer look at such discrepancies we may find intriguing paradoxes. For instance, say you stroll along *La(s)*

Rambla(s), probably the best-known avenue in Barcelona,[6] on a summer afternoon. There, in the oppressive heat, you will find a number of news-stands and souvenir shops offering the visitor a wide variety of typical items to prove to those at home that s/he has indeed been to Spain. Some of these popular souvenirs include dancer dolls (*bailaoras*) armed with fans and castanets, black twisted sculptures of raging bulls, broad-brimmed wicker hats or, why not, nostalgic postcards of an old big albino gorilla.

But the repertoire of Spanish authenticities is not limited to certain specific items. According to many travel guides, tourist websites and travel information sources, there are also certain traits and customary behaviours that are considered the Spanish way of life and are worth being aware of well in advance of visiting the country. These stereotypes include the hot-blooded passionate Spanish character, the amazing readiness of Spaniards of all ages and conditions for fiesta, not to mention the world-famous post-lunch nap: the *siesta*.

The crucial aspect to analyse, however, is not the material object (or character trait) itself, but the social and cultural dimensions of such objects (and traits); that is, the different ways in which they are selected, culturally shaped and presented as the epitome of certain cultural values and attitudes. It is precisely at this moment when the notion of authenticity arises. As Appiah has posed:

> The concept of authenticity, although often dissociated from its roots in the relation of reader or writer to society, is one that can only be understood against social background. It is the fact that we are social beings, after all, that raises the problem of authenticity. The problem of who really I am is raised by the fact that's what I appear to be, and although it is essential to the mythology of authenticity that this fact should be obscured by its prophets, what I appear to be is fundamentally how I appear to others and only derivatively how I appear to myself. (Appiah 1992: 76).

Thus, it is the distance between what something (supposedly) is and how it is presented that becomes relevant for the analysis. These two entities, the thing-in-itself and the thing-as-represented, may not be exactly the same, although they are necessarily connected. In fact, it is difficult to analyse one as totally independent from the other. In his award-winning film *Ethnic Notions*, Marlon Riggs showed how certain stereotypes are linked to existing referents, but they may be intentionally manipulated by powerful shapers (managers) of such stereotypes. In the end, what is perceived as real and authentic is not the thing-in-itself, but the thing-as-represented that is, its intentional distortion. Even one single background may deliver different shapes and types when represented. All of them, someone may say, likable; but none of them absolutely true.

If we assume, as someone cleverly wrote, that there is always a certain distance between what the speaker says and what the listener wants it to mean, we should add a third dimension in our analysis: (1) the original source (reality, whatever that may be), (2) its perception/representation, and (3) the process by which the latter emerges from the former. In accordance with Derek Paget (1998) I suggest that representational processes do not always accurately reflect reality. If we take mainstream cinema

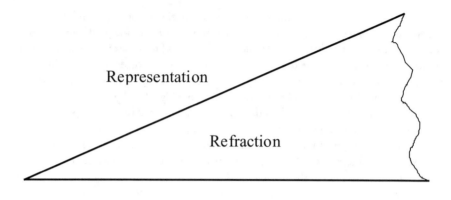

Figure 5.2 : Refraction as intentional distortion. Diagram Jorge Grau Rebollo.

as an example, we find that filmic situations are often referred to as fictional, implying not faithful to reality. Nevertheless, following here Paget's distinction between fiction and *faketion,* I think that it is a mistake to consider film purely as a mirror of reality. We sometimes hear that feature or fiction films are not useful as documentary sources, since they are not considered true mirrors of reality as, supposedly, documentary films are. But no film is a mirror, in my opinion, since a mirror returns the same beam of light that it was shone upon it. Instead, film is penetrated by that beam of light (an ideological and theoretical beam, if you wish) and returns it to us slightly different from its original shape. It has become something new but not so different it can be considered unconnected to its source (reality). In this sense, filmic texts do not reflect reality, they refract it. They act as a prism, an ideological prism let's say, that, for example, allows its creators to present something in a way that could be read as some sort of reality, while, at the same time, it is clearly perceived as a distortion of that reality.

By refraction, then, I mean the process by which a given event is shaped, coded and embedded into a specific visual and material form. The moral notions of good or evil, for instance, are by their very nature, intangible. They do not take any specific form, do not inhabit any particular place nor refer to any precise behaviour. But when, for some reason, it is necessary to show how a respectable woman should not behave, the cinematic repertoire is rich in reifications of appropriate (good) and inappropriate (evil) attitudes. We can find examples in cartoons (the white, healthy, polite, blonde cowboy versus the black, slim, unshaven, rude bad cowboy; the wide-open eyes looking straight to the audience versus the half-closed eyes glancing to the side of the screen), in U.S. Hollywood films under the Hays Code or in Berlanga's or Bardem's films in 1950s and 1960s Spain.[7]

Such processes can also be applied to the past and its careful re-creation. Terry Smith shows how visual regimes of colonization deal with practices of obliteration, symboliza-

tion and aestheticization. By these, Smith means, among other things: a) the erasing of the habitus, imagery or the viewpoints of a given population, b) the transformation of 'the world of experience by treating selected parts of it, or certain relationships in it, as a representative of an abstract idea (such as beauty) or of an ideological tendency …' (Smith 2002: 484) and c) 'to subject the world to processes of representation' (ibid.). In conclusion, 'The visual regimes of colonization then, always involved a triangulation, a simultaneous crossing of the three perspectives: calibration, obliteration and symbolization' (ibid.). Thus, purpose and intention become crucial issues in the analysis of representation. And representation itself is exposed as an historical context-related activity largely intended to delimit abstract notions or ideologies.

But, returning to the aforementioned stages of reality, all three of them are intimately connected and the process of the transformation of 1 into 2 (that is, 3) appears as a context-related procedure. And if we must deal with context, we necessarily must also deal with intention.

In 'Ways of Seeing' (1977), John Berger stated that the relationship between what we see and what we know is never settled. And because of this unsettlement we should, as Banks (2001) suggests, not only analyse what an image is or how it is portrayed, but also why it exists in precisely this way. And in doing so, we must be aware of the cultural specificity of the shaping process. As Banks himself put it: 'Within any particular sociocultural environment, we may learn to associate certain visual images with certain meanings, but these are normally highly context dependent and often transient' (Banks 2001: 10). Furthermore: 'All visual forms are socially embedded and many visual forms that sociologists and anthropologists deal with are multiply embedded' (1977: 79).

In this embedding process, as in refraction, intention plays a major role. Something is represented in one way and not another for certain reasons. And in shaping one particular representation, fidelity to the referent is a highly controversial point. For instance, the decision of how a given fact is going to be summarized and presented (as newspaper cartoonists do daily, for example) involves a complex sequence of progressive selections: what is the key element in the event? How can it be quickly understood? How can fictional characters be representative of their authentic referents? And furthermore, what is the (so-called) authentic nature of the event – what does its truthfulness rely on?

Of course we know how dangerous it can be to look for simple explanations or single dimensions of social representations of any kind. And I would never suggest that there is only one possible interpretation. Surely quite a lot of people of all age and condition would certainly agree. But when we take a closer look at cartoons, jokes, adverts and so on, the question always arises: Why are some images or ideas persistently associated with the same referents, as if there is some sort of objective correlation?[8]

Returning to the case of Spanishness, it is impossible for me to develop an in-depth analysis of the three stages of the representation process here; it is even problematic to properly analyse the third dimension, but I can at least expose the question and invite a critical reflection upon it.

In the following pages I would like to highlight some of the contradictions inherent in the alleged representativeness of certain cultural icons. I would also like to point to mainstream cinema as having a fundamental role in the process of shaping, spreading and even contesting truly national values (that is, dealing with film situations as cultural context refractions),[9] sometimes come to be understood as major culture traits.

'Typical Spanish'?

There are many possible sources from which to prospect information on Spanish authenticities, I have selected two for my purpose in this paper. First, we quickly browse through different open-access websites. Most of them are aimed at tourists and offer information about the country or representative items for sale. Second, we approach mainstream cinema as an example of how certain notions of authentic Spanishness are purposely channelled. Both provide a good repertoire of appointed representations and also invite us to reconsider how the line between referent and representation often gets blurred.

First Axis: Tourism and the Typical-Gift Market

In his article on the Nation-building process of nineteenth-century Spain, Álvarez Junco summed up what, at that time, were regarded as Spain's most representative qualities. Although they might have been seen as stereotypes even at that time, they were nevertheless bound to certain ideas of Spanishness:'Spain was a country of strong passions, brave people, banditry, blood and sun' (Álvarez Junco 1996: 23). At the beginning of the twenty-first century, still some facile overviews are reported about the country:

> Every day – unless you happen to live in mist-shrouded Galicia – the sun shines. Tobacco and beer are cheap, and the optic, that Pecksniffian contrivance that ensures you get not a drop more than your one-sixth of a gill, is quite unknown … In this country, you actually have to tell the bartender when to stop pouring spirits into your glass. (Chris Steward, 'Why You Should Visit Spain in 2006', The Sunday Times, online edition, 15 January, 2006)[10]

And also about its inhabitants:

> This is one view of Spain: families big and close, children indulged; the people noisy, anarchic, sometimes quixotic … They take long and late lunches, respect the siesta when they are in the countryside, dine when most of their neighbors in Europe are thinking about bed. They start horse races at 11 P.M. – bleary-eyed children in tow – think nothing of Madrid traffic jams at 3 A.M., and enliven the discotheques towards

dawn. And don't forget the passion of bullfights ... It used to be said that Madrid had 300 taverns and only a single bookshop. It now has some 600 bookshops, but at least 23,000 of the more than 150,000 bars in the country. (Barry James in the International Herald Tribune, 10 January, 1992)[11]

Both these quotations were extracted from larger texts in which a counter vision is also provided, a vision which pleads for the true nature of both Spain and Spaniards to be recognized, and which, by opposing the distorted one, brings reliability back to its rightful place. Actually, this alternative vision may be read as closer to the truth. Nevertheless, in both the full texts, these passages are supposed to fit a distorted but somehow more extended stereotyped knowledge. And this latter information is reinforced by images that allegedly capture Spanish mood and nature.

Such images can easily be found in souvenir shops scattered throughout Spain's tourist hotspots. There, you can get a piece of authenticity at a reasonable price. Furthermore, when travelling abroad, Spaniards may frequently enter shops, restaurants, pubs and so on where their national identity is advertised in the form of gigantic bulls or *flamenco* dancers. Sometimes interesting combinations can be found. For example, in some European cities, leaflets, websites and posters invite customers to

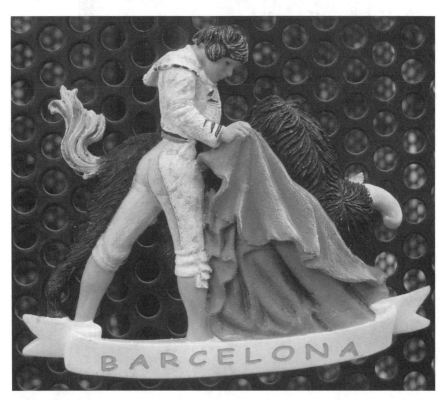

Figure 5.3: Bullfight as souvenir. Picture Jorge Grau Rebollo.

taste Spanish meals under the nicely decorated symbol of a bull. Interestingly, many Spanish cities and villages have declared themselves against bullfights, and in numerous others, much of the population finds this question controversial, to say the least. Nevertheless, bull figurines are widely advertised and sold in many gift shops.[12]

Despite the fact that many Spaniards feel overtly uncomfortable at the sight of wounded bulls, Spain is persistently associated worldwide with this activity. Either in

Figure 5.4: *Torero* and *Bailaora* costumes. Picture Jorge Grau Rebollo.

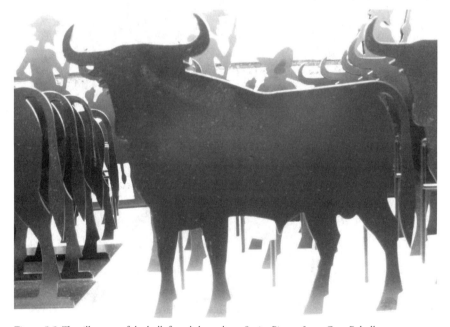

Figure 5.5: The silhouette of the bull, found throughout Spain. Picture Jorge Grau Rebollo.

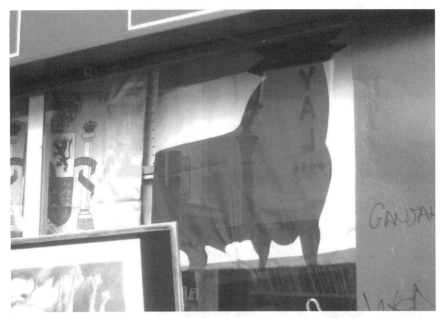

Figure 5.6: Flag and bull: two national icons embodying a new one displayed at many news-stands in tourist locations. Picture Jorge Grau Rebollo.

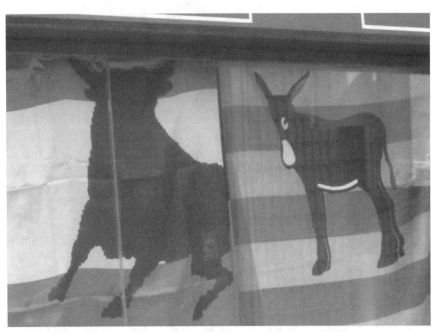

Figure 5.7: The Catalan donkey on a starred Catalan flag next to the 'Spanish' bull. Picture Jorge Grau Rebollo.

promotional pictures or as popular gifts, images linked to bullfights are considered emblematic of the country (Figure 5.3). Furthermore, such associations are even common within the country. For instance, the picture in Figure 5.4 was taken during a popular celebration in El Prat de Llobregat (a seaside town of 62,837 inhabitants, according to the latest population figures from 1 January, 2007, situated about 10 km from southwest Barcelona)[13] in September 2008. There is no bullring in the town; nevertheless, the typical Spanish costumes: *torero* and *bailaora* are extremely easy to find.

Mainstream cinema, tourist magazines, even mass media cartoons recurrently link Spain and bullfights in an inextricable symbiotic relationship. This association is even made when events are considered from a critical point of view, like the Iraq War (see at www.cartoonsotck.com, for example, the Ed Fisher's cartoon of an enraged bull – branded with the word terrorism on its body – chasing a terrified *torero* – with the word Spain on his bullfighter costume in front of a road sign indicating that Iraq is located towards the bull's direction) or the opposition to the celebration of *San Fermín* in Pamplona,[14] where bulls are locked in the bullring after chasing people through streets.

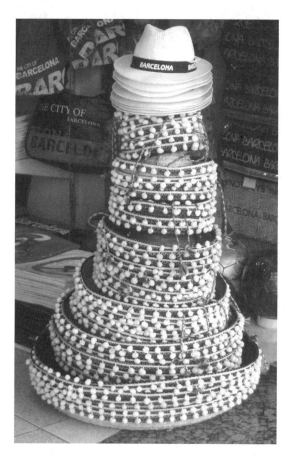

Figure 5.8: A pile of typically Mexican/Spanish hats. Picture Jorge Grau Rebollo.

But, certainly, foreigners cannot be blamed for such associations. A well-known liquor brand in Spain (now also trading non-alcoholic drinks and food) made itself famous by placing enormous bull-shape placards near major highways and roads (Figure 5.5).[15] This shape has now become a major national symbol found in postcards and flags (Figure 5.6), and has simultaneously reinforced certain alleged national characteristics (even the national soccer team is nicknamed *La Furia*, 'The Fury'). The combination of symbols (namely, the flag and the animal) becomes a powerful new symbolic referent, which is often read as an identity claim.[16] Not surprisingly, in other ideological and political instances, similar strategies are set for similar purposes, always with identity both at the background of the icon and at the forefront of the claim.

For example, Figure 5.7 depicts the Catalan donkey, a particular breed officially acknowledged as autochthonous.[17] In parallel with the symbolic use of the wild bull in the Spanish flag, sometimes a silhouette of the donkey is placed in the middle of the Catalan flag, specially in the starred version (the red and yellow stripped flag with a star inside a hoist triangle), which is characteristic of more overtly independent or nationalist sections of Catalanism. Other more radical ideological twists show both animals in controversial positions (mating or kicking each other), thus metaphorically expressing (and refracting) other political meanings.

By the same token, other apparently typical Spanish items can be selected, for example the broad-brimmed hat, actually considered representative of Mexico in Spain

Figure 5.9: A piece of folk authenticity. Picture Jorge Grau Rebollo.

(Figure 5.8), or *flamenco* as the Spanish national dance (Figure 5.9). Indeed, *flamenco* is a popular dance in Spain …as are many others. This dance is mainly associated to the Andalusian region and it faces as many supporters as detractors both there and in other autonomous regions. One interesting aspect about *flamenco* is the predominance of the Carmen-style *bailaora*. Carmen is widely considered an authentic Spanish character, which is surprising since, in George Bizet's opera, Carmen (1875, based on a previous novel by Prosper Mérimée), the title character, is a cigar-selling Gypsy. Gypsies have been (and still are largely) a deprecated ethnic minority in Spain. Gypsies, *flamenco* and racial mood have now merged to the point that *flamenco* is acknowledged as a Gypsy tradition, where Gypsy singers and dancers have been prominent over ages. In this light, the association of *flamenco* with Spanishness as a whole can seem no less than striking.

Second Axis: The Role of Mainstream Cinema

> Interpreting Images is just that, interpretation, not the discovery of their truth … Visual images do not exist in a vacuum, and looking at them for 'what they are' neglects the ways in which they are produced and interpreted through particular social practices (Gillian Rose 2011: 2, 37).

> We represent our world visually: through artefacts, still pictures, television, video, and via the typescript and layout of verbal text itself. Furthermore, visual representation is acknowledged to be increasingly influential in shaping our views of the world (Elizabeth Chaplin 1994: 1).

Representations and associations are not exclusively the result of the popular will. Many researches[18] have dealt with how hegemonic powers have taken control of cultural production in order to scrutinize and organize, which representations could or should be displayed, and, equally important, how they should be presented to the audience.

Mainstream cinema is one of the principal methods for such cultural dissemination due to its extraordinary capacity to penetrate and spread through society. As Henry Giroux suggests:

> Films do more than entertain, they offer up subject positions, mobilize desires, influence us unconsciously, and help to construct the landscape of American Culture … they not only provide multiple pleasure, but also enable me to think more critically (learned pleasure of analysis) about how power operates within the realm of the cultural and how social relations and identities are forged. (Henry Giroux 2002: 3; 15)

Some authors see film (as well as other audiovisual and graphic media) not only as an issue of identity forging, but also as a source of forgery. Rob Stone states how, after the Spanish Civil War (1936–1939):'There was not such a thing as poverty, nor adultery, nor dissidence, nor difference of any kind' (2002: 37). Such invisibilities did not

come from reality, even though they came to shape the new reality of the country.

It is impossible to carry out an extended and in-depth history of ideological embodiments and the struggle over the control of representations here. I would, however, like to highlight some of the efforts of different Spanish governments over the last century to protect audiences from disturbing and harmful film situations while, at the same time, striving to fix an idea of authentic national characteristics on celluloid.[19]

Government control over film production began in the early nineties. According to Borau (1998), censorship was officially established on 27 November, 1912, although according to some authors as Díez Puertas (2003) it had been present since 1886. In 1911, certain Catholic sections of society asked for action against the wave of pornography that hit unsuspecting audiences in cinema theatres, especially those who were under age. In 1916 a political decree was enforced in Spain to regulate any potentially offensive film. Movies were clearly perceived at the time as major ideological devices and as extraordinary tools for disseminating hegemonic values. At the same time, it could be dangerous vehicles for dissent, so it was imperative to prevent the dissemination of problematic works. Appropriate film portrayals were equally important beyond the borders, so that foreigners would view the proper image of Spain. And by the same token, foreign films had to be filtered prior to showing to prevent Spanish audiences from being exposed to indecent behaviours or ideologies. Shortly after his *coup d'état*, Primo de Rivera strengthened censorship and ordered Spanish ambassadors and consuls to protest against the distortion of Spanish realities on foreign films (see Borau 1998).

In 1942, in the midst of the post-war period, the Spanish Documentary Newsreel 'NO-DO' (*Noticiarios y Documentales Cinematográficos*) appeared under the motto:'The whole world at the reach of all Spaniards', thus claiming itself to be a window over the world, the source and provider of any significant information to Spaniards. Through film production, the new hegemonic ideology was slowly shaping a 'dominant memory' (Rodríguez Mateos 2005: 2),[20] which would also redefine whole aspects of Spanishness. Film production was then considered an excellent device to serve this purpose:

> Spain has now began to produce master films in celluloid ... We must feel joy for that from the depth of our souls, since (film) will be the messenger of good news, the herald of our historical glory, the voice and image of our spiritual and geographical landscapes, the resonance of our folklore, the radiance of our culture and faith, the immaculate lesson for our offspring, the enduring wisdom for all of us and the light of the sun in Spain, which is generously poured over all continents on Earth. (Spanish film journal, 1942; my translation)

To be considered a true Spaniard meant that s/he had to fit certain moral patterns, to think and behave properly, proper being defined in terms of the hegemonic discourse. This new recreation of national traits invoked the greatness and glory of the past, this being understood as the pillar of current existence. Certain episodes of the past were consequently magnified and permanently recited in schools, magazines and exhibi-

tion theatres. To be a Spaniard, especially for women, meant to act in a certain way, which was rooted in Catholicism and the omnipresent and enduring sense of virtue and nobility that accompanied it.

Thus, Spanish film theatres showed numerous films and newsreels ('NO-DO' was compulsory viewing before every film screening), which claimed to portray the real Spaniards and Spanish values. Patriots and anti-patriots, virtuous and fallen women, loyalists and dissident of the regime were all clearly depicted on screen. And, inevitably, certain icons were also associated with these depictions. All scripts had to contain only displayable, authorized, situations and no new representations that could be accused of enfeebling national values were allowed to find their way to the screen.

From the early 1940s to the mid-1970s, Francoism retained its grip over mainstream cinema, although the intensity lessened over the years. Nevertheless, even during the early democratic period, cinema did not lose its role as a representational device. In 1989, seven years after the Socialists were elected in Spain, a Royal Decree stated that:

> Cinema, as a cultural manifestation and reflection of the reality of the Country, deserves and needs to be fomented and assisted by society and, consequently, by the Administration of the State ... the present disposition establish a system of public funding for cinematography which ... has as its final goal to foment the realization of films which are representatives of the Spanish culture in every manifestation and way of expression. (Royal Decree 1282/1989, 28 August)

And so film today, still perceived as a reflection of reality, is left wondering what reality it is supposed to reflect ...

Conclusion

'Typical', when used as a synonym for the authentic or characteristic traits of someone, something or somewhere, is an extraordinary problematic term. Certain representations associated with an assumed authenticity are the result of a volitional process in which intention and purpose act as catalysers of their meaning. And meaning is necessarily context-related. Beyond the supposed representativeness of certain items, images or values, there lies the issue of the making process.

Both the tourist souvenir market and mainstream cinema may serve as examples of how authenticity can be summarized and boiled down to certain items, situations, sayings, etc. This is not to say, of course, that all gifts and any sort of film are, by their very nature, distorted or deceptive. But certainly they may be used as a reification of certain values or cultural traits. And such values and cultural traits are not always left uncontested by the same population they are supposed to represent.

For example, in Spain, bullfights fuel strong debates inside the country. They face as much support from certain social sections as rejection from others. Such popular gifts, as the *flamenco* dolls or castanets, are not identified as national symbols by many

Spaniards. What is often assumed abroad as symbolic of the whole country may be no more (and no less) than a regional association, which may even provoke strong repulse from other sections of society. Furthermore, symbols may sometimes be found in particular combinations in order to deliver new meaning, a sort of added-value identity (as is the case of the Spanish flag with the bull silhouette or the donkey in the middle of the starred Catalan flag). None of this is fortuitous. There is always some intention behind every image and every item. Stereotypes remain and do transform themselves to fit the changing ideological framework.

In the previous pages I have shown how authenticity is often invoked as a sign of distinctiveness, but, as Appiah (1992) has rightly pointed out, this can only be done with specific social backgrounds in mind. Exploring these backgrounds away from the context in which the authenticity claim being is made should lead us to other aspects of cultural representation, to refraction, for instance, where sometimes distortion is intentionally used as a depiction strategy.

Refracted or not, images or film situations are widely used as popular mechanisms in the reification of ideological assumptions. Mainstream cinema provides prime examples of how the filmic milieu is of strategic interest to hegemonic social structures. In the Spanish case, we find classic examples in the films produced under Francoism, and, even at the end of the 1980s, cinema was still considered a mirror of reality.

Thus, intention and purpose are key concepts in every approach to cultural production. Tourist souvenirs or popular film production are, by no means, an exception; probably no cultural manifestation is. Debates about authenticity cannot (and should not), therefore, skip this dimension.

Notes

1. I am grateful to Thomas Fillitz, Jamie Saris and Anna Streissler for their careful reading of preliminary drafts and the fruitful and valuable comments that emerged.
2. *Dr Strangelove, or How I Learned to Stop Worrying and Love the Bomb* (Stanley Kubrik, 1963). Screenplay by Stanley Kubrick, Terry Southern, Peter George.
3. http://www.filmsite.org/drst.html.
4. According to the Index website:'(It) is the first analytical ranking of the world's nation brands. Each quarter, the Index ... surveys 25,900 consumers in 35 nations. The consumers are surveyed on their perceptions of the cultural, political, commercial and human assets, investment potential and tourist appeal of each nation. This adds up to a clear measurement of national brand power, and a unique barometer of global opinion'.
 http: //www.nationbrandindex.com.
5. http: //www.ie.edu/esp/sobreie/sobreie_noticias.asp?id=417.
6. As stated in a popular tourist-guide website:'Las Ramblas in Barcelona is approximately 1.2 kilometres long with Port Vell (near the cruise port terminal) at the southernmost end and Placa Catalunya at the northern most end ... Las Ramblas is primarily pedestrianized with only two narrow one-way traffic roads which run on either side of the central Ramblas Boulevard'. http: //www.barcelona-tourist-guide.com/ramblas/barcelona-las-ramblas.html.
7. I have developed this notion of refraction and its role in mainstream cinema in Grau Rebollo 2002a, 2002b, 2005: Online resource: htpp: //www.ugr.es/~pwlac/Welcome.html. ISSN 0214–7564).

8. I take the concept of 'objective correlate' from Williamson (1978). For further discussion see also Rose (2001).
9. Of course, this is not to say that cinema is the only or even the main agency in which these stereotypes are embodied. My intention is merely to look at mainstream cinema as a major ideological device, which may sometimes be highly useful as a research document (always under specific research contexts and in the framework of particular research projects).
10. Full article available at: http: //www.timesonline.co.uk.
11. Full article available at http: //www.iht.com/articles/1992/01/10/spai_3.php.
12. http: //www.asanda.org/documentos/taurinos/ciudades-antitaurinas.htm (Access 25 May 2006).
13. http: //www.aj-elprat.cat (Access 13 July 2007).
14. See also www.cartoonstock.com to get some humorous impressions of Spain's *Fiesta Nacional* (images have not been reproduced here in respect of reproduction rights), or type *San Fermín* at popular video-sharing websites like Youtube (http: //www.youtube.com) or Google Video (http: //video.google.com) among others.
15. A map displaying the location of all remaining fences can be found at Osborne's website:www.osborne.es.
16. Spain has often been referred as *la piel de toro* (the skin of the bull) and some distinguished writers have dealt with such metaphor.
17. http: //www.gencat.net/darp/c/ramader/races/races04.htm (Access 13 July 2007).
18. Riggs (1984), Dabakis (1993), Balio (1993) Rosenstone (1993), Chaplin (1994), Gee (1995), Bartra (1997), Rosen (2001) or Shohat and Stam (2004), among many others, have dealt at different levels with this issue.
19. I am well aware that this issue is much too complicated, thorny and multifaceted to be summarized in just a few paragraphs. For a broader discussion on the topic, see also: Neuschäfer (1994 [1991]), Caparrós Lera (1992), Álvarez Junco (1996), Pérez-Perucha (1997), Ballesteros (2001), Fernández and Couto (2001), Stone (2002), Grau Rebollo (2002, 2005) or Triana-Toribio (2003).
20. This expression refers to the role that 'NO-DO' played in erasing memories of the Civil War from particular individuals, according to Rodríguez Mateos (2005).

References

Alvarez Junco, J. 1996. 'The Nation-Building Process in Nineteenth-century Spain'. In C. Mar-Molinero and H. Smith (ed.), *Nationalism and the Nation in the Iberian Peninsula: Competing and Conflicting Identities*. Oxford: Berg. Pp. 89–106.
Appiah, A.K. 1992. *In My Father's House*. New York and Oxford: Oxford University Press.
Balio, T. 1993. *Grand Design. Hollywood as a Modern Business Enterprise, 1930–1939*. New York: Charles Scribner's Sons.
Ballesteros, I. 2001. *Cine (Ins)urgente. Textos fílmicos y contextos culturales de la España postfranquista*. Madrid: Fundamentos.
Bartra, R. 1997. *El salvaje artificial*. Barcelona: Destino.
Berger, J. 1977. *Ways of Seeing*. London: Penguin Books.
Borau, J.L. (ed.). 1998. *Diccionario del cine español*. Madrid: Alianza.
Caparrós Lera, J.M. 1992. *El cine español de la democracia*. Barcelona: Anthropos.
Chaplin, E. 1994. *Sociology and Visual Representation*. London and New York: Routledge.
Clifford, J. 1988. *The Predicament of Culture. Twentieth-Century Ethnography, Literature, and Art*. Cambridge, MA and London: Harvard University Press.
Dabakis, M. 1993. 'Gendered Labor. Norman Rockwell's *Rosie the Riveter* and the Discourses of Wartime Womanhood'. In B. Mellosh (ed.), *Gender and American History since 1890*. London and New York: Routledge. Pp. 155–181.
Díez Puertas, E. 2003. *Historia social del cine en España*. Madrid: Fundamentos.

Fernández Colorado, L. and P. Couto Cantero (eds). 2001. *La herida de las sombras. El cine español en los años 40*. Madrid: Cuadernos de la Academia.
Gee, D. 1995. *Slaying the Dragon*. U.S.A. (film).
Gilmore, D.D. 1983. 'Sexual Ideology in Andalusian Oral Literature: A Comparative View of a Mediterranean Complex', *Ethnology* 22(3) 241–252.
Grau Rebollo, J. 2002a. *La familia en la pantalla*. Oviedo: Septem.
____.2002b. *Antropología audiovisual*. Barcelona: Ediciones Bellaterra.
____.2005. 'Antropología, cine y refracción: Los textos fílmicos como documentos etnográficos', *Gazeta de Antropología*. 21. htpp://www.ugr.es/~pwlac/Welcome.html.
James, B. 1992. 'In Spain, Old Values Survive the Glitz', *International Herald Tribune*, 10 January 1992.
Kubrik, S. 1963. *Dr Strangelove or How I Learned to Stop Worrying and Love the Bomb*. U.K. (film).
Mar-Molinero, C. and H. Smith (eds) 1996. *Nationalism and the Nation in the Iberian Peninsula: Competing and Conflicting Identities*. Oxford: Berg.
Neuschäfer, H-J. 1994. *Adiós a la España eterna*. Barcelona: Anthropos.
Paget, D. 1998. *No Other Way to Tell It. Dramadoc/Docudrama on Television*. Manchester: Manchester University Press.
Pérez-Perucha, J. (ed.). 1997. *Antología crítica del cine español (1906–1995). Flor en la sombra*. Madrid: Cátedra.
Riggs, M. 1984. *Ethnic Notions*. U.S.A. (film).
Rodríguez Mateos, A. 2005. 'La memoria oficial de la Guerra Civil en NO-DO (1943–1959)', *Revista Historia y Comunicación Social* 10: 179–200.
Rose, G. 2001. *Visual Methodologies*. London: Sage.
Rosen, P. 2001. *Change Mummified. Cinema, Historicity, Theory*. Minneapolis: University of Minnesota Press.
Rosenstone, R. (ed.). 1993. *Revisioning History*. Princeton: Princeton University Press.
Shohat, E. and R. Stam. 2002. *Multiculturalismo, cine y medios de comunicación. Crítica del pensamiento eurocéntrico*. Barcelona: Paidós Comunicación.
Smith, T. 2002. 'Visual Regimes of Colonization. Aboriginal Seeing and European Vision in Australia'. In N. Mirzoeff (ed.), *The Visual Culture Reader*. London and New York: Routledge. Pp. 483–494.
Steward, C. 2006. 'Why You Should Visit Spain in 2006', *The Sunday Times*, online edition, 15 January 2006.
Stone, R. 2002. *Spanish Cinema*. London: Longman.
Triana-Toribio, S. 2003. *Spanish National Cinema*. London and New York: Routledge.
Williamson, J.E. 1978. *Decoding Advertisements: Ideology and Meaning in Advertising*. London: Marion Boyars.

Websites

http://www.aj-elprat.cat (Access 13 July 2007).
http://www.asanda.org/documentos/taurinos/ciudades-antitaurinas.htm (Access 25 May 2006).
http://www.barcelona-tourist-guide.com/ramblas/barcelona-las-ramblas.html (Access 25 July 2007).
http://www.filmsite.org/drst.html (Access 4 July 2006).
http://www.gencat.net/darp/c/ramader/races/races04.htm (Access 13 July 2007).
http://www.ie.edu/esp/sobreie/sobreie_noticias.asp?id=417 (Access 23 June 2006).
http://www.iht.com/articles/1992/01/10/spai_3.php (Access 23 June 2006).
http://www.nationbrandindex.com (Access 11 July 2007).
http://www.timesonline.co.uk (Access 4 July 2006).

PART III

Authenticity: Popular and Academic Discourses

Chapter 6

IS FORM REALLY PRIMARY OR, WHAT MAKES THINGS AUTHENTIC? SOCIALITY AND MATERIALITY IN AFRO-BRAZILIAN RITUAL AND PERFORMANCE

Inger Sjørslev

From an anthropological point of view, authenticity is a puzzling concept. The everyday connotations of true, real, original, sincere, valid, historical or deep are well-known and the opposite of authentic may be thought of as false, pretending, copy, superficial, not-what-it-seems, or just new.[1]

In this paper, I want to set out from two issues related to the overall question of what makes things authentic. One is the statement that form is primary, a statement inspired by the ethnography of ceremonial speech among the Waiwai of the Amazon (Fock 1963; Sjørslev 2002). The other is the implication of the Western idea of authenticity as related to an inner core of self (Taylor 1999). By this, I aim to move the idea of authenticity away from its Western linking with the individual, content and an inner core, and out into sociality, the collective and (outer) form.

I shall deal with these issues on the basis of my work with the Brazilian *Candomblé*, an African religion of the diaspora that came to Brazil with the slaves, and which is known from back into the seventeenth century (Reis 1988). Related to the Haitian Voodoo and with the same historical roots, this is a religion that is very much thriving in modern and postmodern society. It is undergoing changes related to the individualism of modernity and to the searching for roots and the inventions of tradition related to postmodern society (Sjørslev 2001; Jensen 2002); but the worship of the African gods, the *Orixas*, in rituals of possession remains at the core of its practice (Goldman 2007). It is also characterized by magical practices and animal sacrifices related to fetish objects, and on the whole a strong dominance of practice as well as both individual and collective agency. It is crucial to my arguments that the *Candomblé* is very much a religion sustained by sociality, which is reflected mainly in the practice of ritual possession, while at the same time celebrating the individual. It thus raises questions of the

relationship between collective acts and individual beliefs, or between outer forms of expression and inner feelings. Furthermore, *Candomblé* can be regarded as a material practice in which objects and the continuous elaboration of material substance in different shapes play a key role. Materiality in terms of fetish objects, as well as aesthetics, clothes, jewellery etc., is highly significant in its practice.

The *Candomblé* is only one of several forms of the religions of African derivation found in Brazil today. There is also the *Umbanda*, which has millions of adherents and there is the newest variety of adherents to Afro-Brazilian religions, who call themselves traditionalists (Jensen 2002). The fact that there has been a movement from the syncretistic *Candomblé* via the spiritistically influenced and in many ways modernized *Umbanda* and back to what is considered a pre-syncretistic, original African religion, points towards a continuous discourse on what is authentic in relation to the African origin within the religious discourse itself. I shall come back to this later, in order to deal with the point related to the specific historical situation and the emic discourse on the Brazilian *Candomblé*. At the same time, the general questions about form and inner core may be illuminated by way of a closer look at the recent development of the *Candomblé*.

I did my main fieldwork on the *Candomblé* years back in a small town in the Federal State of Bahia, and I have worked in São Paulo with both *Candomblé* and *Umbanda* back in the 1980s. Although I have not been preoccupied continuously with the *Candomblé* over all this these years, I seem to keep coming back to it, particularly to the small town in Bahia where I stayed for the longest fieldwork period. This is also where I was initiated. While I have no intention of making this a story of the importance of going native, or to relate authenticity to intensive participation, I do have a point about the experience of authenticity as related to the sociality implied in participation, and the kind of obligations that sometimes follow anthropological work. This is a point that relates to sociality as it is observed in ritual. Since *Candomblé* is so much a religion of practice, it seemed difficult, not to say impossible, to study it anthropologically without getting oneself involved through the rituals that eventually lead to initiation (Sjørslev 1999, 2006), and, over the years, I have kept in touch to such an extent that I am considered a full member of the *Candomblé* house that I worked with most extensively. This means that I have social obligations, and I want to argue that there is a point in this that has to do with the experience of something authentic. On the whole, I take the case of the *Candomblé* to illuminate three points about what makes things authentic. First, form and content, which is in *Candomblé* illustrated most clearly in the phenomena of possession, second, authentication processes in relation to material objects as illustrated by the fetish object, and, third, the character of the sociality in ritual performance as pointing towards a subjective experience of authenticity. In dealing with authenticity in this way, I realize that I take it to be an analytical concept, and not only a concept of different emic discourses to be dealt with anthropologically as an empirical object. In doing so, I follow the kind of thinking which both seeks to deconstruct authenticity as a discursive formation, and at the same time realizes that this does not make the search for that, which is covered by the term authentic, meaningless. As Regina Bendix says, this is a search that

springs from a deep human longing, whether religious-spiritual or existential, and 'declaring the object of such longing nonexistent may violate the very core around which people build meaningful lives' (Bendix 1997: 17).

Form and Performance

Before I go further into the Afro-Brazilian religions, I shall deal briefly with the statement that form is primary. This implies going into what ritual is, and particularly what performance is.

In connection with his work on the Kaluli of New Guinea, the American anthropologist Edward Schieffelin elaborated the concept of performance in ways that illuminate the issues at hand.[2] In its anthropological theoretical meaning, the concept of performance implies something that is not pre-formed, but being formed in the process of creating (Schieffelin 1993, 1998). When people interact in ritualized or ceremonial manners (James 2003) meaning is created in the process. Performance is framed behaviour (Bateson 1972; Goffman 1975; MacAloon 1984), but in performance, we are also, as Schieffelin emphasises, dealing with the production of meaning in practice. Recent writings on how performance can be further elaborated in anthropological thinking links it to materiality by pointing to the material transformations of body, things and space in performance (Mitchell 2006).

Taking into consideration the etymological kinship between the word performance and the concept of form in itself, the point about performance is that meaning is not only being created in the process, meaning is in form itself. These ideas may point towards an idea of the authentic as founded in a consensus on form, a form which is open for all participants in an event to project or 'read' their individual meanings into it, while at the same time enabling a joint coordination in practice.

The particular statement that form is primary I have from Niels Fock, a Danish anthropologist who studied the ceremonial speech of the Waiwai of the Brazilian Amazon back in the 1950es. His empirical object was a form of chants called the *oho*. It is impossible, Fock says, to understand the *oho* ceremony without the performative perspective. The *oho* is ceremonial speech, which means that it carries its meaning in form as much as in content, or rather, if the two can be separated at all, the 'content' or the meaning as such is in the form. Form is primary in the sense that the form determines the understanding of the content in those ways implied by the concept of frame as a kind of quotation marks. As Bateson said in his famous case of the interpretation of play, the frame within which a message is given, determines the character of the message (Bateson 1972). If we continue in the perspective of Gregory Bateson, society is defined by communication, both verbal and non-verbal, and there is communication at many different levels, including none the least the kind of communication that goes on via the body and bodily practices. As a systemic thinker, strongly inspired by cybernetics, Bateson said that any kind of utterance has to be understood and interpreted in its total social context and cannot be limited to any cognitive or literal meaning of words. Utterances are framed, metacommunicated,

as in the famous example of the play of baby monkeys in the zoo, the example on which Bateson based his theory of play and fantasy. We thus have to pay attention not only to what people say or do, but just as much to the way they say or do it. Genres become important in human communication and interaction, and different genres can be found also outside those more clearly framed occasions of which ritual is the most obvious. A genre may be literal, metaphoric, pretentional or fictional. In this perspective, form reveals what must be understood by words – or deeds – in a given context (Austin 1989).³ The statement that form is primary implies that the first condition for understanding what people mean when they speak is to understand in which tone something is said (Sjørslev 2002), and a privileged place for studying this is ritual and performance. Furthermore, considering the reflexivity that accompanies ritual, which is often emphasised in ritual analysis, from Turner – and back to Durkheim – and onwards, ritual has been understood as society's way of staging itself (Fields 1995; Turner 1986).

The point about form in ritual has been further elaborated by Roy Rappaport, who thinks cybernetically about society even more than Bateson does. In his book 'Ritual and Religion in the Making of Humanity' (2000), he deals with the fundamental role of giving form, shaping, *gestalting*, and uniting form and substance as having a deep meaning in ritual, a meaning that is fundamental for the role of ritual as a marker of sociality as such. Rappaport talks about myths and tales of origin as well as the repetitive treatment in ritual of the relation between form and substance. The *Urkaos,* which is implied in most myths of origin, is counteracted or fought by way of form. Also, the human body can be viewed as that which substantiates form, when for instance in ritual it is given a special role and posture. Form is substantiated and substance in-formed, Rappaport says, when form and substance are united in ritual, and, at the same time, this is a manifestation of that human order, which is instituted in culture as the natural order. In ritual, the humanly created order of the world is expressed as if it was natural and eternal. Ritual then becomes a confirmation of the naturalness of human order and culture, which includes conventions and rules for social relations and people's interaction with each other. In short, Rappaport speaks about ritual as a matrix for society (Rappaport 2000: 324ff).

If ritual is a metacommunicative form of communication and also recreating and confirming the natural order of things again and again in a process by which it makes society reflect upon itself, we may say that reflection is somehow at the bottom of the social. As social beings, we live according to our habitus, but we also reflect upon who we are. This comes out particularly clearly in events that have a ritual or performative character and where the collectivity of social life is emphasised. Reflections may not be articulate, reflexivity is not explicit and not put down in language, or, if language is involved it is often ceremonial, but reflexivity in other forms of expression is an essential element in performative phenomena. This points towards the fact that there is a doubleness to human beingness, which should not escape our attention, neither when we are thinking phenomenologically about lifeworlds and experience, nor when we deal with that search for something which is sometimes labelled authenticity. The doubleness implies that we both live and think about living – even if, as the Danish

philosopher Søren Kierkegaard said about individual being, we live life forwards but understand it backwards. Sociality is defined by the ability to live this reflexivity, and to juggle with different forms of communication. It is defined by the ability to identify genres, to 'play the keys', and to know when which key is being played.

That form is primary does not mean – and this is emphasised by Niels Fock – that it is the most important, the most weighty, it only means that it is a condition for understanding what goes on, in which key we are talking, singing, acting or playing in a general sense. In this respect, the metaphorical key, the ironic key or the fictional key are all keys that we know how to play, some better perhaps than others, and in some cultures more eloquently than others, but nowhere in human society are people being literal and talking, singing or acting in the same key, the same genre, all the time.

In ritual, a frame is being put around what is going on; ritual creates quotation marks, which say that all that goes on within the frame is to be understood in a certain way, a certain key, which can be fiction, as in theatre, or, in religious rituals such as the *Candomblé*, a cosmology, which says that when ritual is on, the gods are real. The gods are really there within the ritual frame; cosmologies become true, as Rappaport says, and it is the frame, which makes it true and acceptable. Rituals (re)create reality, as performance creates it continuously. So, in ritual and performance we are dealing with something very basic; we are, as more than one anthropological author since Durkheim has stated, at the core of what a society is.[4]

Before I go deeper into the particular case of the *Candomblé* and further on to the implication of all this for the concept of authenticity, I shall take a brief look at ideas about authenticity in a modern, Western context.

Authenticity as a Western Concept

In his book 'The Ethics of Authenticity' the Canadian philosopher Charles Taylor (1999) gives a brief insight into the notion of authenticity as related to modernity and its malaise. Taylor goes back into European and American history and shows how the ethics of authenticity are deeply related to the idea of an inner core, a self in which the real, the sincere and the valuable is located in the inner constitution of the individual. He argues that the ethics of authenticity is something peculiar to modern culture. It rose by the end of the eighteenth century and builds on earlier forms of individualism. Authenticity is a child of the Romantic period, it is a moral concept, related to 'a voice within'. In earlier times, the individual had to connect to something outside itself, a god, cosmos, but with the concept that the Romantic period brought about, this was no longer the case. Now a human being has to connect to something within itself, an inner core, which is where sincerity and the real I are considered to be located. Taylor says that this is part of the massive subjective turn of modern culture, a new form of inwardness in which we come to think of ourselves as beings with inner depths. 'Morality has, in a sense, a voice within' (Taylor 1999: 26). The modern ideal of authenticity, then, is related to the idea of being true to oneself, but it also implies the goal of self-fulfilment or self-realization. In Taylor's interpretation of the vices of

modernity, the culture of authenticity in this sense becomes the obstacle to the community version of the authentic with its genuine social relations, and to a communitarian way of life with a social commitment, which has been lost in modern life. In modern times, the ideas of individual authenticity have been combined with the self-realization project that has created a population of self-interested, egoistic, atomized individuals, whose obligations are first and foremost to themselves and perhaps their very nearest family, and only second, if at all, to other people and society at large. I do not want to simplify Taylor's ideas to a sheer modernity critique and pessimism. They are much more elaborate than that, and he has developed his research on the Western ideas of self further in his major work 'The Sources of Self'. In this context, the point is the fact that authenticity as a Western concept has become related to the individual and to an inner core, based on the tradition of Romanticism and going back to Christian ideas of a personal self (Dumont 1985).[5]

The role of ritual in creating reflexivity, the celebration of sociality in the abstract sense, and ultimately the reflexivity about conditions of life show that it is possible to locate that diffuse, but impressive experience, which we have preliminarily termed authenticity, in something other than both the individual inner and the collective folk soul, namely a temporary event within a performative framework. The question is, whether this creates an experience, which defies essentialism without dismissing the seriousness and depth of that kind of experience that may be linked with a sense of the authentic.

The *Candomblé* ritual may be regarded as an example of the kind of reflexivity created by the joint event of individual possession and a collective, performative framework. It brings forward an experience of the real, by way of the imaginary, or in the present analytical perspective, of the authentically social by way of the cosmological, which is given shape and perceptibly illustrated by the presence of the gods, the *Orixas*. The gods are closely linked to those individuals who have been trained in receiving their individual gods. There is a complex ontology behind this and a practice of learning, which has been profoundly analysed by the Brazilian anthropologist Marcio Goldman who studied the Angola nation of the *Candomblé* (Goldman 1985; 2007). Individuality is thus not dismissed at all, the point is that the experience derives from the particular coming together of the role of the individual, who is possessed, and the collective social performance and acceptance of the key being played within the particular ritual framework.

Interestingly, we may not be so far from that Western tradition which understands authenticity as related to *Volk*, but still, with a significant difference. Herder's eighteenth-century ideas about the soul of a people, which were founded in an idea of the individual, implied that it revealed itself none the least in performances, although they might not be thus termed, but poetry was one of the privileged expressive forms in which the character of a folk soul could be identified. As Bendix says: 'The question of internalized authenticity – the authentic human experience, the exuberant search for the "soul of people," as Herder called it – is a much more complex temptation, an attractive, troubling series of attempts to pinpoint the ineffable' (Bendix 1997: 7). The complex may derive from the fact that there is a refined and intricate

coming together of form and content, inner and outer, individual and collective, subjective and common experience in ways, which may be seen as a transgression of that dichotomy as such.

We are, in a sense, back at the ceremonial speech, which is, however, to be interpreted as a particular social key, which receives joint acceptance and consensus, and not as an expression of an inner essence. So, an experience of authenticity is not necessarily – or not at all – linked to an experience of an expression of something inner. It may, as in this case, derive from the coming together of the individual and the collective, as well as of form and content. The sense of something real may derive precisely from the experience of such dichotomies being transgressed. This idea may be further illustrated by going into a particular case of a performance of the Afro-Brazilian religions, a case which can be interpreted from a constructivist approach to authenticity, or it may be regarded as an obvious example of invention of tradition; but it may also point us in another direction, namely versus that particular character of the social which leads to a subjective experience of something authentic.

Tradition and Sociality in the Performance of the Afro-Brazilian *Orixas*

Some years back I guided a group of Danish college teachers of religion on a study tour in Brazil with the purpose of getting to know the *Candomblé* and its derivatives. After having visited some of the oldest and most well-known *Candomblé* houses in the north-eastern State of Bahia and experienced various performances of possession, we ended up in the southern metropolis São Paulo, where we witnessed a most impressive and skilful presentation in a house of a group of those who call themselves traditionalists. The immediate reaction of the Danish group was that we were witnessing something, which was not the real thing, not authentic, in the same sense as what we had experienced in Bahia. The members of the group expressed it as being outward, staged, or pretending, and they likened it to a theatre performance.

I do not want to imply that we did indeed witness an inauthentic performance; my anthropological constructivist approach prevents me from that, but I want to try to look at the kind of sociality implied in this event as compared to those events we had taken part in back in Bahia, and I want to try to explain the intuitive sentiments of the onlookers.

The session we witnessed in São Paulo was a session of a recent derivative of the Brazilian *Candomblé*, a clear (re)invention of tradition represented by mainly white middle-class people, who live in the metropolis of São Paulo. In calling themselves traditionalists, they emphasize the cultivation of the African *Orixas* in ways that explicitly detaches the practice from the syncretistic and much more widespread version of the Afro-Brazilian religion that goes under the name *Candomblé*. A clear example of what Stewart and Shaw have termed anti-syncretism (1994), the *Orixa* tradition defines itself in opposition to the historically well-known version of *Candomblé* that

accepts the Catholic church as a framework for its practice, and whose main locus is the State of Bahia. A substantial number of the – altogether relatively small – number of *Orixa* cultivators, as the traditionalists also call themselves, are intellectuals; some of them are anthropologists and sociologists, who are familiar with the classical anthropological works of the first scholars of *Candomblé*, like Pierre Verger, Roger Bastide and others.

My empirical knowledge of the traditionalists is heavily based upon the work of Tina Gudrun Jensen, whose doctoral thesis presents an extensive and thorough analysis of the *Orixa* cultivators in São Paulo (Jensen 2002). The traditionalists make claims to authenticity by referring to the African past. They surpass both ethnicity and practice, in a sense, and declare the West African Yoruba religion a universalistic one, while at the same time claiming their own privileged position as knowledgeable practitioners. Articulate, literal knowledge is more important than bodily practices. This can – somewhat paradoxically – be regarded as a Westernizing trend by way of Africanization. In the self-understanding of the traditionalists, their formalized knowledge is primary to bodily form. The traditionalists have converted to, and studied, a religious tradition, which is not related to their own historical roots in any ethnic sense, but which represents in some sense Brazilian national history and identity. In her work on the self-understanding and practice of the traditionalists, Jensen shows how they are caught in several contradictions and placed in an ambiguous position in between tradition and modernity. The traditionalists of São Paulo have for the most part converted from Catholicism to *Candomblé* and further on to the *Orixa* tradition – a conversion Jensen analyses as a return to an Occidental self. The point in this connection is not that they are hereby representatives of an inauthentic version of a more historically rooted practice of the *Candomblé*. At the outset, and from an analytical point of view, the practice of the traditionalists is neither more nor less authentic than other forms of *Candomblé* practice. From an emic perspective it is considered a return to an authentic religious and ritual practice.

At the particular occasion which made me contemplate the issue of authenticity as related to the immediate experience, the audience's intuitive reaction to the traditionalists' presentation revealed that the subjective experience varies according to something which we might at the outset be tempted to call authenticity or the lack of such, but for which I think it would be wise to try to find different concepts by way of a deeper analysis of what brings forward this kind of experience.

The performance I witnessed together with the group of college teachers in the *terreiro* of a group of traditionalists at the outskirts of São Paulo was impressive in many ways. Some of the dancers were obviously considered by the audience to be extremely eloquent in their choreography, and they were elaborately dressed. The drummers and singers appeared to be well-trained, and the songs that were sung for the *Orixas* were more explicit in their African wordings than I had ever witnessed it in the more mainstream syncretistic cult houses in Bahia. This may be due to the fact that some singers had the written words of the songs printed on paper before them, something I had never seen in any other house of the African religions. The aesthetics in terms of dresses, decoration of the house, costumes of the *Orixas*, etc., were certainly as sophis-

ticated as any I had ever seen. There was no doubt that the leader of this house, who took a strong role in directing the performance, was as skilled as anyone in his performance as possessed and in the dances of the *Orixas*. I was certainly captured by the performance, which lasted for a couple of hours, as was the whole group of spectators. Yet the comments afterwards were, as already stated, comments of sceptical wonder. There were raised eyebrows, questions as to how to understand this 'show', somewhat ironic smiles and more explicit utterances of criticism like 'the dancers were excellent, but it was not as real as in Bahia', and 'wasn't this a tourist show put on for the sake of us and the other audience?' My answers to questions about the realness, sincerity and non-show like character of the other performances of Afro-Brazilian religions we had witnessed in comparison to this, revealed a reluctance to admit any difference in terms of authenticity, although my own subjective experience of this performance was not too different from what was expressed by the rest of the group.

In retrospect, I have tried to articulate the kinds of sentiments I had, and which I think the others had, and attempted to analyse their cause in terms of the character of the performance. For one thing, the majority of the dancers were white and the main dancer looked more like a young Swede than a Brazilian. But an analytical anthropological eye cannot accept phenotypic ethnicity as a course for the experience of authenticity, or the lack of such, without further reflection. More important was the way people – dancers and singers as well as audience – moved among each other and filled out the space. The social choreography was clumsy, to put it simply and – admittedly – subjectively, but it is a fact that it needed the directive steering of the master of the show, whereas at other performances in Bahia, there had been a feeling of being one body, a moving together, a feeling which included the audience, who gained a sense of being part of the whole performative body of dancers.[6] A sense of some kind of organic sociality often emerged in Bahia, with those possessed by the *Orixas* at the centre, but this feeling did not occur during the performance of the traditionalists in São Paulo. There was a 'willed-ness' to it, which may tempt one to describe the character of the joint social movement as shallower, less deep, than in the other cases. The subjective experience was that something was lacking, and it had something to do with the social habitus, the form of sociality, the way the collective moved, on the whole, the social choreography as such. This again points to the role of form in the immediate subjective impression of an authentic performance.

Possession is performed.[7] The connection with something outside the self, a god, is reached by way of certain gestures, actions and practices. It does not work in private. Its whole condition is the publicity of the performance. The authenticity of the gods that are present derives from people, from the audience who accepts them as *Orixas* for real. And the subjective experience of an authentic presence of gods again derives from the collective contribution to the performance. Performance creates a special kind of sociality which, when successful, brings forward experiences of something authentic. It is the specific kind of sociality, which in a sense also creates those gods by which the dancers are possessed. The authenticity of possession thus lies in its performance, that is how form and content, inner and outer, come together, and in the holistic integration of the possessed with the audience and the whole social context.

The Possessed and the Fetish

The practice of the self declared traditionalists in *Candomblé* illustrate a problem in the experience of something as authentic, a problem that presents a kind of paradox, which may be recognized from other contexts, namely the fact that the people who make the most explicit claim to cultivating tradition may sometimes be those who are experienced as less traditional, whereas performances that are sustained by a less self-conscious bodily and collective habitus do not call forth sceptic reactions or any experiences of the performative presentations being shallow and not based on a profound collective habitus. By saying this I do not want to imply that an experience of something as authentic depends upon it being non-explicit, nor will I suggest that some kind of innocence, and pure doing, non-accompanied by the knowledge of doing, is a precondition for an authentic experience. As pointed out by Turner, Schieffelin, Rappaport and other analysts of rituals and performative practices, such practices always imply some kind of reflection. The double character of ritual and performance lies precisely in its simultaneous doing and reflecting, it lies in the reflexivity which, while tacit and embedded in bodily practices, is still a basic element in these particular events.

In a general sense, which goes further than the particular case of the traditionalists, the Afro-Brazilian religions are well-suited to illustrate points about the character of sociality involved in performative events and the transgression of the dichotomy between form and content. A key role is played by the possessed in ritual practices. This is a role that can be likened to the role of those material objects that are termed fetishes. Let us therefore take a closer look at the possessed and the fetish.

Possession, which is at the core of the ritual practice, is a learned skill, trained through initiation (Goldman 1985). From a psychological point of view, possession may be regarded as a state of dissociation. However, from a social point of view, it is more important to understand possession as a performed role in which the acts carry the sentiments, so to speak, and which is social in a deep sense. By this I mean that it is brought forth and sustained by the joint communal agency of the audience and the whole group involved. Within the *Candomblé* ritual, possession embodies a complexity of religious and cosmological ideas, and possession shapes both individual and collective experience. The possessed person is a mediator between the social and the cosmic world, between the individual and the collective, and also, it may be added, between tradition and renewal (Sjørslev 1999). The fetish object in many ways plays a similar role.

Fetishes, in the classical sense, are things-in-themselves (Ellen 1988); they are objects that do not represent, but *are* gods (Pietz 1985, 1988; Pels 1998). They are thus not to be regarded as a form which represents some other kind of content, or as material objects that symbolize something non-present. Fetishes are 'in themselves' in the sense that their significance and meaning lie in their material form as such. The fetish is precisely that object, which transcends the distinction between the represented and the representing; the fetish is the object in which form is content.[8]

People relate to the fetish as to a human being; they feed it through sacrifices, they dress it up, and they fabricate and manipulate it. The fetish may have its own agency, but it is certainly an object *of* agency; it is as much a pretext for agency as it is a static object.[9] In Sansi-Roca's analysis of key objects in *Candomblé* he points to the need to see the role of these as a result of events. Drawing on Pietz's work on the emergence of the fetish in a historical and territorial context, he emphasises the agency of objects as related not only to social agents, but also to the circumstances like when the stone that is the *Orixa* lets itself be found and becomes the *ota*, the stone of an initiated person that grows with that person (Sansi-Roca 2005: 143–44). In the present context, I would add that while sacred objects in *Candomblé* are, as Sansi-Roca focuses on, hidden (and have hidden lives), there is also a strong public and social element in a general objectification, and there is a link between the role of the (hidden) objects and the *Orixa* objectified in the initiated person, who performs in the public rituals. This is a link that goes beyond ontology and into the construction of an authentic public performance with the sociality involved.

I would suggest that in relation to materiality, what makes things authentic is a continuous process of elaboration through human agency. Objects are acted upon and manoeuvred into people's lifeworlds by being sacrificed to. In the same vein, the possessed person, who is dressed up as a god, in its material form gains an object like character, and may be regarded as both object and subject of agency. In the transformative moment of ritual, the possessed both acts and is acted upon. Within the particular social context of ritual, this acting is what creates the authenticity of the gods.

In the Afro-Brazilian religions, fetishlike objects are given food, oil and nourishment by being sacrificed to. They are objects formed in stone, clay, porcelain or wood, but they are also gods in themselves. The fetish and the possessed both, in each their way, transgress the distinction between form and content. Their character and role is maintained by social agency and the different kinds of practices to which they are subject. Both are framed and sustained by the way people interact with them and with each other. They are sustained by the obligations implied in cultivating them as gods, and by the character of the ritual practice.

When I stated in the beginning of this article that there might be a point about authenticity which relates to the fact that I became initiated in the *Candomblé* and have kept in touch with my fieldwork site and the *Candomblé* people in Bahia over many years, I was thinking of the role of ritual practice in the continuous creation of meaning. The meaning is in the doing and the doing is not individual but social. Doing and becoming part of are thus preconditions for understanding what is going on as such (cf. Sjørslev 2006). Hopefully, this insight can contribute to an understanding of those different processes of agency that within particular social and communicative contexts create those particular kinds of sentiments that are labelled authentic.

Authenticity can never be sustained by written formulas or formalized practices that are laid down in books or recipes; or surely not by that alone. The fact that the São Paulo traditionalists performed their ritual reception of the gods eloquently, in the sense that they relied on an explicit and systematically learned practice, could not

in itself transmit a sense of authenticity. The sense of the authentic relies completely upon the character of the social practice involved. In the particular case of the *Candomblé*, to take part is to be part. As an anthropologist, I have more or less intuitively sensed that, not from the very beginning of my first fieldwork, but after giving up my initial resistance; a resistance that was to a large extent based upon the cultural idea that the inner is the real, the sincere. So, if I could not believe in the *Orixas* myself, it would not be legitimate to take part and be part. This is a way of thinking dominated by a Western cultural model, and it is not in accordance with the ideas that carry the practice of the *Candomblé*. Meaning is in the doing, doing is social, and doing is believing; or rather, it makes the question of individual belief pointless.

As a first conclusion to my attempt to point to the role of the social and the material in bringing forward an experience of authenticity, I would say that much takes place on an implicit and maybe even subconscious level, but that it is still possible to detect the elements – including the role of persons and objects – in the formation of that particular character of the social which ritual and performance implies. The anthropological aim must be to become wiser on the kinds of experience that call forward sentiments of something authentic, or the lack of such.

At the same time, it is necessary to hold the concept of authenticity out at arms length. We need to know more both about the kinds of stimuli that create certain experiences that can more or less be labelled under that concept, but also how that concept is used and misused, and thus how it can be deconstructed, opened up and held out for closer scrutiny in order to detect the (Western) cultural models that sustain it. We have to ask 'why are new-age-Gypsies so non-Gypsy-like' (Okely, this volume) and 'why are some worshippers of Afro-Brazilian religions considered so un-Afro-Brazilian?' by some people, no matter how clever and eloquent they may be regarded by others. We also have to ask how and why the concept of authenticity is an unsatisfactory anthropological concept from an analytical perspective.

Authentication through Form

I have tried to show that the experience of something as authentic has to do with the transgression of the dichotomy of form and content, as well as with practice and human agency and with the sociality implied in performance in its widest anthropological sense. It is well-accepted in anthropological thinking that in many contexts form is content. Well-known examples are magical practices when words are deeds (Austin 1989), or in political and rhetoric speech (Paine 1981). We may also remind ourselves of the famous story about Quesalid, recounted by Lévi-Strauss. Quesalid became a big shamanistic healer who was able to cure people because he learned to perform as a shaman; it was not the other way around that he cured people and therefore became a big shaman (Lévi-Strauss 1967).

As for practice and agency, I would like to suggest that authentication is a better concept than authenticity in an analytical perspective. While authenticity can be an empirical object in the sense that we need to study what is considered authentic by peo-

ple, who deal with the idea, it is not a useful concept to set out from in the analysis of what creates those events and phenomena that are thus labelled. My contention is that form is primary in the sense that authentication processes take place by way of form, and in the sense that the sociality implied in the experience of something authentic have to do with a common experience of form, which may in communicative terms be understood as the key being played. Form is form as in performative, as well as form in the more abstract sense of the character of the social relations involved and their degree of ritualization, but it is also form in the concrete sense of shaping the material into concrete objects. I would like to propose that when looking at authenticity as a process, materiality is a strong authentifier, and people elaborate the social and the material in transgressions of dichotomies between form and content, and also in transgressing the distinction between persons and things. In ritual contexts this may be seen as a kind of agency that I have elsewhere proposed to call a technology of sociality (Sjørslev 2007).

Whether a religious practice is regarded as authentic or not depends first of all upon the position of the observer. From an analytical point of view, it also depends upon power and agency, rhetoric and persuasion: as formulated by Stewart and Shaw in relation to syncretism (Stewart and Shaw 1994). As for the experiences related here, as in the meeting with the Bahian version of the Afro-Brazilian religion, the *Candomblé*, on the one hand, and the São Paulo version of this religion, the traditionalist *Orixa* worship, on the other, my contention has been that the experience of whether a performance is authentic or not has to do with the character of the sociality involved. The traditionalists were skilful and professional in their performance, but there was an instrumentality and willed-ness to it, which did not include the whole group of people in a joint social choreography based on a common habitus. In contrast, the Bahian *Candomblé* transmitted an experience of a common bodily habitus, a kind of organic social interaction.

In her important exploration of authenticity related to folklore studies, Regina Bendix says:

> After years of reading and thinking about what, if anything, could still be authentic, I saw authenticity at best as a quality of experience: the chills running down one's spine during musical performances, for instance, moments that may stir one to tears, laughter, elation: which on reflection crystallize into categories and in the process lose the immediacy that characterizes authenticity. (Bendix 1997: 13–14)

This quality of experience, I suggest, is based on a particular character of the sociality involved.

Concluding Reflections

By dealing with the agency that surrounds the possessed and the fetish, and at the same time with communication in ritual – each one of these rather large issues, which I have here labelled under the broad categories of the social and the material – I am

taking the concept of authenticity out of that context in which it plays its major role, namely Western discourse. In Western discourse, the authentic is an issue not only related to the sincerity of the individual person, based upon the idea of an inner core, it is also related to concrete materiality in the form of objects, particularly objects that have to do with history.[10]

I have advocated that in dealing with the concept of authenticity, we aim to move from inner person and static materiality to form, performance and the continuous elaboration of the material in what we may chose to call authentication processes. Such processes are important, probably essential, no matter which part of the world we deal with and whether people use the term authenticity or not. As Hannah Arendt has said, 'the reality and reliability of the human world rest primarily on the fact that we are surrounded by things more permanent than the activity by which they are produced' (Arendt 1998: 95f). The search for experiences that point in that direction, and the agency that surrounds ritual with the materiality involved, all have to do with this. It is of course not insignificant that in the cases related here, the ritual activity ultimately has to do with gods, with cosmology and permanence in a deep sense.

Form is primary in the sense that in order to be able to deal with what people do, with their lifeworlds and with different ways of being social, we have to understand which key is played, that is, which form of communication is being employed. This goes for social life in general as well as for studying ritual and performance.

In my interpretation, the authentic has to do with communication and social relations. In this respect, form and content cannot be separated. As for materiality, what makes things authentic is a continuous process of agency directed at elaboration of the material. Objects are manoeuvred into lifeworlds by incorporation, as the Gypsies do it in a very concrete sense when they transform products of mass production into authentic Gypsy symbols (Okely, this volume). In the *Candomblé* sacrificial rituals, they do it by fabricating – or forming – fetishes.

While authenticity is from an analytical point of view to be regarded as a cultural construction, that which it represents to people is still very much real. In the interpretation I have proposed here, it has to do with many things. A sense of permanence, control over one's lifeworld and trust in social relations, based upon the ability to judge the actions of one another according to their intentions, which, among other things, means being able to read the key being played correctly, or, in a Batesonian sense, to read metacommunicative messages.

As an analytical object, authenticity is unavoidable, first of all because it seems to have such strong significances in Western thinking, but also because people – Western and non-Western – engage in a range of activities, implying both sociality and materiality, which we may interpret as authentication practices. I have proposed to take a closer look at communication in social relations and the role of the material, including the fetish, in the creation of that which we term authenticity. By doing so, I realize that I may have broadened what the concept covers to such an extent that it becomes very near to being social and cultural life in general. The concept of authenticity cannot be used from the outset to determine whether things are – essentially – authentic or not. It has to be looked at as a process, and as a construction. Only

thus can we begin to unpack what it covers and is used for in different contexts. At the same time, we need to search for other terms with which to articulate the kind of stuff people use in creating trust, sincerity, rootedness and other significant elements of their individual and collective lives.

Notes

1. The etymological root of authentic is the Greek *authentikós,* which derives from *authéntës* meaning the maker of something, preferably by hand, or, ultimately murderer, the one who did it. In the present context it is significant that authenticity thus has to do with doing, or agency.
2. Victor Turner laid the ground for interpreting ritual and performance and the ideas presented here are also inspired by his works (Turner 1986), as well as by Tambiah's ideas about performance (Tambiah 1979).
3. The analysis of ceremonial speech in the Amazonian context has since been developed further (Urban and Sherzer 1986), and, lately, Wendy James has significantly given her new portrait of anthropology the title *The Ceremonial Animal* (James 2003).
4. Daniel de Coppet 1992.
5. In Bendix's investigation of the concept of authenticity, she distinguishes the Herderian tradition, which links the authentic with folklore as the soul of a people from the Heideggerian existential philosophy of *das Eigentliche* (Bendix 1997: 18f). I shall take a different route here, in aiming to transcend the individual-collective or inner-outer dichotomy.
6. It is significant that in the performances in Bahia, there is always a tacit expectation that someone among the audience might become spontaneously possessed. This expectation probably carries a good part of the common sentiment of being part of a whole. Such an expectation did not seem to exist among the audience in that particular event we witnessed among the traditionalists, but I will not rule it out that it could be present at other occasions.
7. As early as 1955, Alfred Métraux studied Haitian Voodoo and described possession as a role, (Métraux 1955).
8. The fetish is the spirit of matter, it is not matter representing a spirit. This is what was so shocking about the fetish worship that the first Portuguese colonisers met on the western coast of Africa in the fifteenth century. These fetish worshippers were pagan idolatry worshippers, not only because they worshipped false gods, according to the missionaries, but because they worshipped the material as such. The real scandal of the fetish worshippers, was that they did not distinguish between representation and the represented, or between form and content. The object was the god (Augé 1988). I am aware that I am here speaking about the fetish in another sense than in Saris's chapter. The fetish is a complicated concept, and it may very well be that it would be well-applied to a study of authenticity as Saris implies, in terms of contrasted to the authentic. Certainly in the Marxian sense, the fetishized is that which is alienated from its conditions of production, that is from relationships. But in the more classical understanding of the concept of the fetish as a religious object, it can also be related – as I am trying to do here – to those processes by which something is made authentic in a creation that implies human agency.
9. The etymological root of fetish is the Latin *factitium* which is also the root of the Portuguese word for 'to do', *fazer*. There is thus a clear etymological link between the fetish and something done or fabricated.
10. While other cultures (simplifying and generalizing terribly!) engage in ongoing processes of authentication via ritual, performance, and different kinds of elaborations of the material, in the West, we have since the time of colonization had institution for authentication, namely museums. Since the constructionist perspectives of the 1980s gained ground, museums have been termed institutions for the creation of authenticity (cf. Clifford 1988).

References

Arendt, H. 1998. *The Human Condition*. Chicago: University of Chicago Press.
Augé, M. 1988. *Le Dieu Objet*. Paris: Flammarion.
Austin, J.L. 1989 (1955). *How to Do Things with Words*. In J.O. Urmson and M. Sbisà (eds). Oxford: Oxford University Press. Pp. 1–176.
Bateson, G. 1972. *Steps to an Ecology of Mind*. New York: Ballantine.
Bendix, R. 1997. *In Search of Authenticity. The Formation of Folklore Studies*. Madison, Wisconsin: University of Wisconsin Press.
Clifford, J. 1988. 'On Collecting Art and Culture'. In J. Clifford, *The Predicament of Culture*. Cambridge, MA and London: Harvard University Press.
De Coppet, D. (ed.). 1992. *Understanding Rituals*. London and New York: Routledge.
Dumont, L. 1985. 'A Modified View of Our Origins: The Christian Beginnings of Modern Individualism'. In M. Carrithers, S. Colins and S. Lukes (eds), *The Category of the Person*. Cambridge: Cambridge University Press. Pp. 93–122. Ellen, R. 1988. 'Fetishism'. *Man*, New Series, Vol. 23, No. 2, pp. 213-235
Fields, K.E. 1995. *Introduction to Emile Durkheim: The Elementary Forms of Religious Life*. New York: Free Press.
Fock, N. 1963. *Waiwai – Religion and Society of an Amazonian Tribe*. Copenhagen: The National Museum.
Goldman, M. 1985. 'A construcao ritual da Pessoa: A Possessao no Candomblé', *Religiao e Sociedade* 12(1) 22–54.
Goldman, M. 2007. 'How to Learn in an Afro-Brazilian Spirit Possession Religion. Ontology and Multiplicity in Candomblé'. In D. Berliner and R. Sarró (eds), *Learning Religion. Anthropological Approaches*. Oxford: Berghahn Books. Pp. 103–120.
Goffman, E. 1975. *Frame Analysis: An Essay on the Organization of Experience*. Harmondsworth: Penguin.
Hughes-Freeland, F. (ed.). 1998. *Ritual, Performance, Media*. ASA Monographs 35. London and New York: Routledge.
James, W. 2003. *The Ceremonial Animal. A New Portrait of Anthropology*. Padstow: Oxford University Press.
Jensen, T.G. 2002. *In between Contradictions*. Ph.D. dissertation. University of Copenhagen.
Lévi-Strauss, C. 1967. *Structural Anthropology*. New York: Doubleday.
MacAloon, J. 1984. 'Introduction: Cultural Performances, Cultural Theory'. In J. MacAloon (ed.), *Rite, Drama, Festival, Spectacle. Rehersals Toward a Theory of Cultural Performance*. Philadelphia: ISHI. Pp.1–15.
Métraux, A. 1955. 'Dramatic Elements in Spirit Possession', *Diogenes* 3(11) 18–36.
Paine, R. 1981. 'When Saying is Doing'. In R. Paine (ed.), *Politically Speaking: Cross-Cultural Studies of Rhetoric*. Philadelphia: ISHI. Pp. 9–23.
Mitchell, J.P. 2006. 'Peformance'. In C. Tilley, W. Keane, S. Kuechler, M. Rowlands, P. Spyer (eds), *Handbook of Material Culture* London: Sage. Pp. 384–401
Pels, P. 1998. 'The Spirit of Matter: On Fetish, Rarity, Fact, and Fancy'. In P. Spyer (ed.), *Border Fetishisms: Material Objects in Unstable Spaces*. London and New York: Routledge. Pp. 91–121.
Pietz, W. 1985.. 'The Problem of the Fetish I-II'. I: *Res: Anthropology and Aesthetics* No. 13, Spring, pp. 5–17, 23–45.
Pietz, W. 1988. 'The Problem of the Fetish, IIIa. *Res: Anthropology and Aesthetics*. No. 16, Autumn, pp. 105-124.
Rappaport, R. 2000. *Ritual and Religion in the Making of Humanity*. Cambridge: Cambridge University Press.
Reis, J.J. 1988. 'Magia jeje na Bahia: a invasao do calundu do Pasto de Cachoeira, 1785. Escravidao', *Revista Brasileira de Historia* 16: 57–81.
Sansi-Roca, R. 2005. 'The Hidden Life of Stones. Historicity, Materiality and the Value of Candomblé Objects in Bahia', *Journal of Material Culture* 10(2) 139–156.

Schieffelin, E. 1993. 'Performance and the Cultural Construction of Reality', *American Ethnologist* 12(4) 707–24.
____. 1998. 'Problematizing Performance'. In F. Hughes-Freeland (ed.) *Ritual, Performance, Media*. London and New York. Routledge. Pp. 194–207.
Sherzer, J. and G. Urban (eds). 1986. *Native South American Discourse*. Berlin: Mouton de Gruyter.
Sjørslev, I. 1999. *Glaube und Bessessenheit. Ein Bericht über die Candomblé Religion in Brasilian*. Gifkendorf: Merlin Verlag.
____. 2001. 'Possession and Syncretism: Spirits as Mediators in Modernity', in S.M.Greenfield and A.Droogers (eds.) *Reinventing Religions. Syncretism and transformation in Africa and the Americas*. Lanham, Rowman & Littlefield Publ. Pp. 131–144.
____. 2002. 'Form is Primary. A Conversation with Niels Fock', *FOLK Journal of the Danish Ethnographic Society* 41: 23–56.
____. 2006. 'On Leaving the Field: Closure and Continuity as Seen through the Lens of the *Candomblé Axexé* Ritual', *FOLK, Journal of the Danish Ethnographic Society* 46–47: 11–41.
____. 2007. 'Ting og person. Bidrag til en socialitetsteknologi'. In I. Sjørslev (ed.), *Scener for samvær. Ny antropologi om ritualer, performance og socialitet*. Aarhus: Aarhus University Press. Pp. 179–206.
Stewart, C. and R. Shaw (eds). 1994. *Syncretism/Anti-Syncretism. The Politics of Religious Synthesis*. London and New York: Routledge.
Tambiah, S. 1979. 'A Performative Approach to Ritual', *Proceedings of the British Academy* 65: 113–69.
Taylor, C. 1999. *The Ethics of Authenticity*. Cambridge, MA and London: Harvard University Press.
Turner, V. 1986. *The Anthropology of Performance*. New York: PAJ Publications.
Urban, G. and J.Sherzer (eds.). 1986. *Natine South American Discourse*. Berlin: Mouton de Gruyter.

Chapter 7

A CULTURAL SEARCH FOR AUTHENTICITY: QUESTIONING PRIMITIVISM AND EXOTIC ART

Paul van der Grijp

This chapter is about the Western interest in non-Western art as well as the non-Western influences on Western art within both local and global perspectives (globalization). The major research question is: Why are we in the West so interested in non-Western art and what is, within this context, the real relationship between the Western and the non-Western world? The chapter has two major parts: (1) the contemporary art production in a particular non-Western society, the Polynesian kingdom of Tonga, and local ideas about authenticity; (2) Primitivism in Western art and the set of ideas behind, focused on the natural and the exotic. We deal here with the authentic, the natural and the exotic respectively, and the way they overlap. In this analysis, exotics are conceived of as material (art) products representing cultural otherness, and exoticism is seen as the yearning for this kind of otherness. Exoticism includes art Primitivism but, as we will see, it is much more comprehensive and thus should not be reduced to this.

Globalized Art in the Western and the Non-Western World

When the ship carrying him back from Polynesia anchored off Java, the French author Victor Segalen decided to write a book on exoticism. He wished to give the notion of exoticism an authentic meaning. He had been working in Polynesia as a naval physician for two years during which he visited the house of the painter Paul Gauguin in the Marquesas Islands, just after the latter's death. During an auction of Gauguin's last possessions in the market of Pape'ete, Segalen was able to acquire some of his paintings. These were now in his luggage. In the following years, Segalen made numerous notes for his exoticism project but he never finished writing the book he had in mind. He had intended to write about the sights, the skies, the sounds, the

smells, the exotic music, eroticism, and exotic painters such as the Orientalist Fromentin and Gauguin, the first Primitivist. According to Segalen, exoticism was in the first place a tropical phenomenon and he noted that 'there is little polar exoticism' (1986: 33; author's translation). In his analysis of the sense of exoticism, Segalen later wrote that he wanted to avoid slipping into banalities and straightaway put aside the – apparently already stereotypical – images of coconut palms and camels, pith helmets, black skins and the tropical sun. He then also set aside those who advanced such images along with the cruise ships and aeroplanes used by Thomas Cook and other travel agencies and the hurrying tourists. To Segalen, the feeling of exoticism concerned the notion of difference, of diversity, the consciousness that something is not equal to itself, the serious effort to understand the other. In the present chapter, this notion of exoticism is taken as a point of departure, although my methods and aims are anthropological rather than literary. Good anthropology does not necessarily exclude a touch of literary style, but anthropology is not – and should not be – fiction. Here, I try to understand the Western interest in non-Western art as well as non-Western influences on Western art within both local and global perspectives (globalization). Segalen's ideas on exoticism remain revealing and relevant for our leading topic of authenticity.

Here, my research question is the following one: Why are we in the West so interested in non-Western art and what is, within this context, the real relationship between the Western and the non-Western world? For me personally, this research question about the pre-supposed shared interest we Westerners have in non-Western art came to the fore in my book 'Passion and Profit: Towards an Anthropology of Collecting' (2006a). The collectibles discussed in this book are not only elitist cultural objects such as works of art (ancient, modern or tribal), books and antiques, but also non-elitist objects such as stamps, postcards, plants and other mass-produced items. My question in 'Passion and Profit' was: what moves collectors, i.e., collectors-in-general. The 'we' in my research question in this chapter (Why are we in the West interested in non-Western art?) is a partly hypothetical 'we' because, indeed, within Western societies not everybody is interested in non-Western art. The same held for my book on collectors: not everybody is a collector. However, the number of people interested in non-Western art – like the number of collectors – is still important enough to study it as a cultural phenomenon from an anthropological perspective. The phenomenon concerns not just private and public collectors (individuals and museums), but also, for example, tourists, Western and non-Western alike, who bring exotic souvenirs back home, as well as visitors to museums.[1] So, what is the drive behind all this?

This chapter has two major parts: first, the contemporary art production in a particular non-Western society, the Polynesian kingdom of Tonga and local ideas about authenticity; second, Primitivism in Western art and the set of ideas behind it, focussed on the natural and the exotic. We deal here with the authentic, the natural and the exotic respectively, and the way they overlap. In this analysis, exotics are conceived of as material (art) products representing cultural otherness and exoticism is seen as the yearning for this kind of otherness. Exoticism includes art Primitivism but, as we will see, it is much more comprehensive and thus should not be reduced

to this. Etymologically the word exoticism comes from the Greek *exôtikos* and refers to things coming from outside. Within the European literary and artistic tradition, the word refers in the first place to those things coming from a different culture and, in a more active sense, the evocation of images from faraway lands with which we are generally unfamiliar. This concerns landscapes, customs and exogenous personages that give a *couleur locale* to a story or images situated elsewhere and answers the yearning for escape and an external viewpoint in the reader, listener or observer (Buvik 2006; Laplantine 2010; Yee 2000). Thus, they are confronted with the question of the self-evidence of their own culture, by which the detour via exoticism may result in a critical reflection on one's own culture.

Dealing with the Authenticity of South Pacific Arts and Crafts

In this section, I will give some examples of living artists in the Polynesian Kingdom of Tonga. Tonga is situated in the Southern Hemisphere, north of New Zealand, east of Fiji and south-west of Samoa. Tonga consists of some 150 tropical islands and has a predominantly Polynesian population of about 100,000 people within its borders, with an additional 50,000 Tongans living overseas. Tonga is an independent nation-state that has never been colonized, but it was a British protectorate between 1900 and 1970. The ethnographic material I present here is from three recent periods of fieldwork (2003–06) in Tonga, where I have worked for the last thirty years (e.g., van der Grijp 1993, 2004). The changing context of Tongan artists is an increasingly monetized economy and mobility of persons, ideas and money. Their wood and bone carvings are now produced for a tourist market inside the country, which does not only consist of foreign tourists, but also of emigrated Tongans visiting their home country (van der Grijp 2006b, 2007). It is my aim to show some of the daily preoccupations of these Polynesian artists and, in so doing, make them less exotic, with the words of Condominas (1965) in mind: *L'exotique est quotidien*: the exotic is a daily matter.

Lopati, our first example, was born on Tongatapu, the main island of Tonga, sixty-three years ago. Since his early youth, he has been keen on drawing. His parents sent him to a technical school in Honolulu, Hawaii, but he was not really interested in mechanics and asked to be allowed to go to the Honolulu Academy of Arts, where he obtained a scholarship. So when Lopati was nineteen years old, he studied fine arts there. Returning in Tonga, Lopati was unemployed and, moreover, had no money to buy materials for oil painting as he had had in Honolulu. Nevertheless, he did manage to make a few oil paintings, but found it hard to sell them in Tonga; he sighs, 'there is no market for painting here' (personal communication, Maofanga, 2006). There was, however, plenty of wood available for free. He started working with it, carving the kinds of things he thought would be easy to sell. He never studied sculpture, but said to himself: 'what I can do on paper or canvas, I can do that on wood too' (ibid.). Thus, he became a carver and intends to remain a carver. Most of his working life, Lopati has made his living from woodcarving. He is also a carpenter and built, for example, his own house.

When he first returned to Tonga, Lopati only used hand tools such as a carpenter's chisel, a knife and a wooden mallet resembling a tapa beater.² One of his brothers, a high school teacher, saw him at work and offered him some genuine carving tools. Later, another brother, who worked at the Brigham Young University in Hawaii, bought him a chainsaw. At that time, the Tongan government hired a Maori carver from New Zealand to teach woodcarving. Tongans who wished to learn carving were invited through radio announcements to join his workshops and Lopati was one of them. When the Maori teacher saw Lopati's work, he said (at least in Lopati's memory): 'I can't teach you anything, you're already too good for me'. Lopati asked to stay anyway because the government would supply them with free tools. He was allowed to stay.

Today, Lopati insists on making art, not handicraft, and says that it feels good when he finishes a carving, especially when he takes his time and does a good job. Lopati does not believe in mass products. He tried to make them, but did not like it. For him, carving is art and should remain so:

> I want that every piece is different; I don't like copies. The wood too is different every time. I carve billfish and whales, but my favorite is octopus. I also liked to make mermaids. A difficulty with mermaids is what you do with her hands. The most natural is that she combs her hair and looks in a mirror. My daughters, however, do not appreciate me carving naked women. They don't think in terms of art, but accuse me of being a dirty old man. This is why I don't make mermaids anymore. (ibid.)

Under the dominating influence of the churches, Tonga has become very puritanical about nudity. Exposing women's breasts and even men's torsos in public is considered immoral and may be punished. Under such circumstances, especially when close family members bring pressure to bear on them, it can indeed be difficult for artists to represent the human body. Interestingly, in the Western art world, particularly in Primitivism (see below), erotic representations have served as important critiques of the cultural establishment.

Tevita, Lopati's younger colleague and a successful art entrepreneur, claims not to see any difference between art and handicraft, although he does not himself want to be considered a maker of handicraft:

> I'm an artist, a *tufunga*. Many of my fellow artists don't have a creative eye. I travel a lot and read books on art and religion. This is part of my character. I can't sleep without having read something first. My art is innovative because I read about so many things. This makes me different from other (Tongan) artists. I make contemporary art, but also realistic sculptures. I know artists who are unable to carve a whale or a dolphin. They're able to make an abstract form of it that looks like a whale or a dolphin from a distance, but they don't look real. I can also make abstract sculptures. Most artists don't do that. They make the same *tiki* (anthropomorphous carvings) again and again. (Personal communication, Popoa, 2005)

In Tonga today, according to Tevita, people are starting to recognize what art is. Previously, this was not so. In 1990, for example, he was commissioned to make a sculpture for a Tongan government department. He made a fine sculpture of the legendary Polynesian demi-goddess Hina, for which he asked 800 Tongan dollars.[3] They thought, however, that it was too expensive. Tevita replied: 'When you think it is too expensive, I will take it back home. If you buy a sculpture from me, you also buy my artistic interpretation of that legend. This is my art, I don't sell just a piece of wood' (ibid.). Ten years later, he received another commission from the same government department. He again made a fine sculpture which, this time, was well-appreciated. According to Tevita, Tongans are beginning to learn what art is all about:

> Some Tongans have a good income, but will not spend this on art very quickly, because they don't know what it is. Certain visitors from Europe or the United States, however, immediately recognize the artistic value of my work and buy several pieces at once because the price is good. (Ibid.)

Although these remarks seem to be part of Tevita's marketing discourse, I think that they also reflect a real change in Tongans' mentality towards art today. Tevita's colleague Ofa has the following opinion:

> Handicraft is part of art, like music and dancing. I think they are all part of art. I want to make replicas of ancient Tongan artefacts. Anyone with the talent to make something new in handicraft should make it according to how it comes to his mind. But as far as I know, most carvers don't, they just copy. (Personal communication, Nuku'alofa, 2003)

Feleti, Ofa's colleague in Vava'u, Tonga's northern archipelago, also does not see any difference between art and handicraft, although he is conscious of the distinction in Western eyes. Feleti says he does not conceive of himself as an artist, a point of view based on his background as a carpenter. According to Seine, Feleti's wife and business partner, art and handicraft are the same. Even when she copies the same necklace over and again, for her this would still qualify as art because she made the original design in the first place. Tomasi, another successful art entrepreneur, sees his sons' production as both handicraft and art:

> In handicraft, the example is already there from the past. In art, you deal with the creation of something new based on new ideas. I may, for example, get new ideas because of things I see in New Zealand. In Tonga, I can also get new ideas based on the history of Tonga. When I'm able to translate this in new designs in the present, it would be art. In the 1960s, when I was in primary school and there was one cruise ship coming in every week, people always sold the same things. Today, we can still sell the same things. For me that is typically handicraft. We try to make both: handicraft and art. (Personal communication, Nuku'alofa, 2005)

I hope this brief review of artists, their daily activities and their thoughts on handicraft and art in this so-called exotic society — Tonga is proud to call itself the last Polynesian kingdom — results in a de-exotization of such artists, in the sense that we feel closer to them. The following section, dealing with the construction of exoticism in Western art, however, may have the inverse effect.

Western Art Primitivism, or the Yearning of the Natural

In the previous section, I referred to the notion of art Primitivism. This is an intriguing notion, particularly when we relate it to contemporary art production in non-Western — previously called 'primitive' — societies. What is art Primitivism all about and what are its manifestations? As an artistic movement, Primitivism was a purely Western phenomenon and not the result of reciprocity with non-Western societies although, later, artists in non-Western societies such as Indonesia, China and Japan, would engage in similar directions (Zaelani 2006; Chao 2006; Shogo 2006). Primitivism covers the period from Gauguin in the 1880s until the American abstract expressionists of the 1940s, with a tail that continues today. Primitivism in Western art history does not refer to an organized group of artists, but encompasses divergent artistic reactions to (among other things) non-Western influences (Flam and Deutch 2003; Goldwater 1967; Hiller 1991). To Europeans in the late nineteenth and early twentieth centuries the peoples in many parts of Africa, America and Oceania were still considered savages. By extension they also looked for the primitive among peasants in their own societies and among children and the mentally ill. In the early twentieth century Primitivism still concerned actual artistic inspiration by non-Western art. Around 1906, artists such as Picasso and Matisse became interested in tribal art because it corresponded to developments in their own work. Among abstract painters, Dadaists and Surrealists, however, we can also distinguish Primitivist tendencies which were not reactions to tribal art, but were inspired by a primitive spirit (to be situated, for example, in the unconscious) which they considered as more fundamental and authentic.

The marker of Cubism was Pablo Picasso's notorious painting *Demoiselles d'Avignon* (1907), inspired by African sculpture which apparently triggered off forms of simplification. Originally, Picasso had called this work *Le bordel philosophique* and changed the name in *Demoiselles d'Avignon* in 1916.[4] *Le bordel philosophique* may be translated literally as 'the philosophical brothel', however, the French expression *faire le bordel de quelque chose* also means 'to make a mess out of something'. Picasso was not so much preoccupied with philosophy, but with his revolutionary painting — an 'authentic break' (Assouline 1988: 99) — he indeed turned existing artistic standards upside down. In the early twentieth century, women were still considered as more primitive and closer to nature than men, who were closer to, or even representative of, culture. This asymmetrical ideology (van der Grijp 2011a) was not just a male perspective, but was shared by many women and, indeed, has been criticized by feminists ever

since (De Beauvoir 1949; Ortner 1974; Douaire-Marsaudon 2010). The female body was thought to be less specialized, her mind more instinctive in contrast to the more rational male mind. Modesty was a high value for adult women, starting with adolescence. The lack of modesty was often seen as a sign of insufficient psychological development or as degeneration and was linked with 'savages' and children. Picasso's *Demoiselles d'Avignon* shows women who were apparently not bound by self-imposed modesty (Rhodes 1994: 62).

The masks in *Demoiselles d'Avignon* were not simply representations of exoticism in non-Western cultures, but signs of the otherness of female sexuality, which could be dangerous. Showing nudeness in paintings symbolized the unmasking of Western society. Usually, it was men who painted female nudes – thus undressing women – and as such represented the dominance of the (active) male over the (passive) female. With the exception of some of Gauguin's sculptures and woodcuts, none of the painters until then had made a real study of the composition and aesthetics of tribal art. Such art was valued rather symbolically and as a source of inspiration to make one's own art in a primitive way. The two faces on the right of Picasso's *Demoiselles d'Avignon* and in the preliminary studies for it, however, are clearly different from the three standing nudes on the left and give evidence of his familiarity with African Dan masks (Ivory Coast) and Bakota (Gabon) copper-covered guardian figures.

After having discussed this marker of Cubism, I would like to pull the various threads together here around the notion of Primitivism. Generally, Primitivism refers to something less complex or which exhibits less progress than the standard with which it is compared. Primitivism is usually defined in negative terms of what it is not, or of what it does not have: organization, refinement, technology, cultural development. Often, appreciation for Primitivism is motivated by nostalgia: the ideal world is not here and now, but elsewhere or in the past or even in the future: and with this we find the theme of the Golden Age. Primitivism in Western art in the first half of the twentieth century was, according to Rhodes (1994: 20), mainly a reaction to materialism in politics and science and to positivism in philosophy. Between 1900 and the First World War, the term Primitivism was used without reference to tribal societies, for which the term 'savage' was still in use. At the end of the nineteenth century, artists initially searched for sources of inspiration in Europe to renovate their art: mediaeval Europe, peasants, fishermen and, later, children and fools. This could also be a translation of an aversion to cosmopolitanism. Often, Primitivism implied the myth of the artist as outsider who, in this respect, expressed a kinship with other marginal groups in his own society such as the peasants, fishermen children and fools mentioned above, but also with Gypsies, circus and cabaret performers, prostitutes and criminals.

Contesting cultural conventions characterizes almost all artistic (avant-garde) currents in the twentieth century: and the twenty-first does not appear to deviate much from this pattern. This resistance can only be called Primitivism when it takes the form of a desire to artistically express less complex forms of life and, in so doing, to search for the natural, the pure and the authentic as equivalent to the simple and the primitive. In this way, the yearning for the natural may lead to the most fun-

damental characteristics of the (natural) landscape outside man, for example in the presupposed perception of – or, rather, by – animals (Marc), but also the elementary landscape of the human unconscious, via dream analysis, automatic writing or painting, psychedelic drugs and other kinds of inner or imaginary voyages. Children and women should be more spontaneous and natural than adult men and as such were considered as ideals. This longing for simplicity and authenticity was also translated into a – temporary – immersion in life of European or North American peasants or fishermen and in sojourns in foreign or exotic societies (Gauguin, Nolde, Pechstein) and in inspiration by and collection of tribal art from Africa, Oceania and indigenous America (the Fauves, Cubists and Surrealists). Primitivism is an important dimension of exoticism but, in my view, art exoticism cannot be reduced to Primitivism alone and also includes, for example, Orientalism and Japanism. Moreover, members of non-Western societies, including Oriental and far-Eastern societies, have their own forms of exoticism, often focussed on the West.

A Carved Kingfisher

Thus, why are we in the West interested in non-Western art? One answer may be: to look for something we do not find in our own society, either in our daily work and social life or in conventional Western art. The Industrial Revolution has brought employment and welfare to many, along with a strong feeling of alienation – from one's work, social relationships and even from oneself – to many more. I think that it is no accident that, since this revolution, art has become the laboratory par excellence to cope with this alienated feeling in its different manifestations via the search for authenticity either elsewhere, in other cultures (compare the art currents of Orientalism, Japanism, Primitivism), or in the social and professional margins of our own society, in nature, or even in our own subconscious (Surrealism). This search for the authentic, the pure and the natural has been translated into a yearning for the exotic in numerous forms. The central idea being that it is always better elsewhere. The here-and-now often seems to be a dreary valley, while behind the mountains the grass is always greener. However, our Arcadia may not be simply elsewhere, but it may also be located in another time, a Golden Age either in the past or in a projected future.

In everyday consumer behaviour in Western societies, there is an increasing demand for handmade products: commercial chains such as Ikea cater to this, although their 'handmade' products are mass-produced. Moreover, there is the underlying assumption that handmade would require more production time and skill than normal industrial commodities. A second assumption is that authentic handmade products are more abundantly present in the Third and Fourth Worlds than in the West. In this way, according to Pocius we become 'artefact "culture hoppers," filling our houses with our own versions of some "authentic world" and become museums "temples of authenticity," where objects are put on display, becoming symbolic pieces of an entire culture' (1997: 7–8). Often, an appeal is made from the 'gallery world of elite art' to material culture researchers and museum curators to distinguish the bad and

mediocre objects from the good and to make final judgements on authenticity. In the eyes of Pocius, however, it is not the role of the ethnologist to make statements about the authenticity of artefacts, but rather to conduct research on those who make such statements within the societies producing these artefacts. Above, we had a close look at several Tongan artists and dealers of arts and crafts. Their ideas and the corresponding artistic practices, however, are clearly the result of interaction – globalization – with the outside world. Here, I will give one final Tongan example.

Ofa, one of the artists and art dealers we met earlier, told me the following story. A woman visiting from New Zealand wanted to buy in Tonga a present for her father, a wooden kingfisher bird. She bought woodcarvings that looked like kingfishers from four different carvers, but was not really pleased with them. She asked around for someone who would be able to make a better one. Ofa heard about it and asked how much she would be willing to pay. She opened her bag, took out one of the four carvings and said:

> I paid 15 dollars for this one.
> Ofa replied: For such an amount nobody can make a good kingfisher bird.
> She again: Could you make a better one?
> I think so, but maybe my price will be too high for you.
> How much?
> 60 dollars.
> Never mind.
> Ofa asked her: Why don't you give that kingfisher there to your father?
> She: My father knows what a kingfisher looks like and will see at once that this one isn't good.
> Why do you think that 60 dollars is too expensive when I make a really good one?
> She just stood there looking at Ofa, who remarked:
> I will make one for you. You dont have to buy it, I only ask you to come back tomorrow to see how it looks like.

There was a block of wood that other carvers had used as an anvil. Ofa took a close look, saw the kingfisher (*sikota*) in it, a sacred bird in Tonga, and carved the bird out of that block. The following day, the lady from New Zealand came by and asked about his promise:

> Did you make a kingfisher bird?
> Ofa: Oh, I forgot all about it.
> She almost walked away when Ofa said:
> No, look here. I made a kingfisher, but maybe you don't want it.
> When she saw the carving, she walked around it, took it in her hands and pressed it to her bosom.
> What did you say that it would cost yesterday?
> 60 dollars.

Okay, I'll only keep enough for the airport tax and the rest of my money is yours. This came to 93 dollars. She also gave Ofa the other four kingfisher carvings and said: You may sell these to someone else, I don't want them anymore.

This is indeed a fine story about concrete interaction between people from different cultures who are brought closer together through the production and exchange of an art object. An important dimension of this interaction is not only the money involved, but also the exchange of words, of ideas on authenticity, in this case the question whether the sculpture really looks genuine. I would like to emphasize here once again, that this kind of exchange occurs not only between members of different cultures, but also between members of the same non-Western, here Polynesian, culture. As I mentioned before, about one third of the total Tongan population lives in the Western world far from its home islands. This kind of diaspora is a common experience of many peoples from the Third World. From time to time, Tongans living overseas return to their home islands to visit relatives and, then, return to their new homes in Australia, New Zealand or the Unites States and bring Tongan souvenirs back with them as presents for those who remained behind. Thus, I asked one of the artists in Tonga the following question: Why do you think that Tongans from overseas buy your products made from wood, bone, sea shell and coconut shell? His answer:

> I think that they can get the same things anywhere, but they like to buy things from Tonga and *fakatonga* (i.e., made in the Tongan way). They buy them for their friends, children and relatives overseas. They could buy these things also in America, but not in a Tongan design. Sometimes they want us to engrave a name or a few words in Tongan on it. (Personal communication, Nuku'alofa, 2006)

Tongans who live overseas, and visit the Kingdom, often wish to return home with something typically Tongan, an object embodying Tongan identity – and personalizing that souvenir with a Tongan word may be seen as means of authentification of this identity. My Tongan informant, Tomasi, also sells part of his production, in particular hundreds of bone fishhooks, to traders in New Zealand and notes that 'people in New Zealand who buy bone fishhooks and other Polynesian artefacts made in Tonga indeed think that they are made by New Zealand Maori' (ibid.). Apparently, these buyers also want something typical and authentic, maybe something ethnic, in the way that one may consume ethnic food, or put a tribal tattoo on one's shoulder blade.

Conclusions

For anthropologists (with our strong tradition of cultural relativism) authenticity is a slippery concept and is usually presented in emic rather than etic terms, as a kind of spirit of the object – with Marcel Mauss (1954) and his *hau* of the gift in mind. The people whom anthropologists study may well believe in spirits, but most anthropologists do not believe in spirits themselves. The use of the notion of authenticity is

indeed particularly doubtful when applied to peoples from non-Western cultures that have adopted and adapted elements of modernization, such as a monetary economy and capitalist relations of production and exchange, and European political systems such as democracy, and have become 'less traditional' and thus 'less authentic'. Does this mean that we should reject the notion of authenticity altogether as purely ideological? I do not think so. Concerning tribal or exotic art objects, there are at least four criteria I propose to use to distinguish authenticity: (1) that the object was actually made by the people to whom it is attributed; (2) that it was made in the time period concerned; (3) that the material from which it is supposed to be made is indeed that material; and, last but not least, (4) that the object is of artistic quality.

Thus, an eighteenth-century Tongan ivory *tiki*, i.e., an anthropomorphous sculpture, should be made by Tongans (and not by Chinese) in the eighteenth century (and not last year) and the material should be sperm whale ivory (and not elephant ivory or plastic). The last criterion, artistic quality, is a matter of cultural refinement of judgement and taste. Tribal art connoisseurs – or those who claim to be so – will notice that two of their most cherished criteria are lacking in my definition of authenticity related to their specialty. Very often, private collectors of tribal art emphasize that a mask or a sculpture had an active ritual function. An authentic mask, they say, should have actually been worn by a participant in a ritual (see Bonnain 2001; Derlon and Jeudy-Ballini 2008; Price 1989). And it should wear the traces of this, such as patina, small surface scratches and other tiny degradations. All this sounds nice, indeed very exotic. The difficulty, however, is in the proof. Someone may be able to show pictures or a video film of that mask actually dancing in a ritual, but the ritual may have been organized for that particular occasion with lots of tourists around and much money involved.

My argument is not that this would consequently be a fake ritual, but rather that the proof of a ritual function can hardly be very solid, especially when such objects are separated from their original contexts in Western museums, private collections or antiquity shops. The other criterion lacking is provenance. Must a Tongan *tiki* be made in the Tongan islands or could it be made in neighbouring Fiji, for example? In the eighteenth and nineteenth centuries, many Tongans were already living in Fiji, where they participated in the local wars. Today, as we have seen, one third of the total Tongan population is living overseas – mostly in Western countries – and some of these overseas Tongans also produce contemporary Tongan art. This kind of diaspora is a common experience for many people from Third World countries: globalization, indeed, is not only a Western prerogative. This is also a partial answer to my second research question about the real relationship between the Western and the non-Western world. 'They' (people from other cultures) are increasingly becoming a part of 'us', and 'we' – beginning with our yearning for the exotic – a part of 'them'. This dialectical relationship, however, does not in any sense exclude social inequality. Such social asymmetry and its accompanying ideology should become a major focus of anthropological and other social scientific analyses, based on meticulous empirical research as well as a critical evaluation of earlier efforts in this direction.

The most intriguing criterion for the authenticity of tribal art objects, or of any art object for that matter, may be my fourth criterion, artistic quality. I oppose artistic

quality to the (presupposed) ritual function of art objects. Apart from giving three clear – obvious – criteria to identify authenticity, defining artistic quality (my fourth criterion) in terms of cultural refinement of judgement and taste keeps the discussion open, whilst ritual function seems to be simply a matter of belief. I define (avant-garde) art in the final instance as the human exploration of the limits of thinking and practice and as the material representation of this exploration in objects, images, words, sounds and performances. In so doing, artists give form to their cultural and personal search for authenticity. Western and non-Western artists diverge in this respect. Among Tongan artists, for example, I did not hear a discourse about art as being the expression of one's inner (individual) self. In order to illustrate this, I would like to briefly return to the kingfisher made by Ofa, the Tongan woodcarver. I think that his customer, the woman from New Zealand, appreciated this particular sculpture and hugged it to her bosom not only because of its likeness to a real kingfisher, but also because she recognized its artistic qualities and felt that her father would too. In my view, this appreciation and pleasure is a genuine cultural phenomenon. This was also the case when the particular artistic qualities of Pablo Picasso's *Demoiselles d'Avignon* were recognized for the first time and when this recognition was shared with others one century ago.

Notes

1. The writing of this chapter preceded (and contains abstracts of) my book 'Art and Exoticism' (2009). For other anthropological perspectives on art see Feest (2004); Gell (1998); Marcus and Myers (1995); Morphy and Perkins (2006); Plattner (1996); Svašek (2007); on anthropology and exoticism see Affergan (1987); Bensa (2006); and Huggan (2001); and on authenticity see Adorno (1973); Benjamin (1992); Berman (2009); Cheng (2004); and Errington (1998).
2. Real tapa beaters or *ike* are made from ironwood and would be too hard for the chisel. Two days before my last visit to him, Lopati lost his mallet, so is using now a small *ike* ('but it is not good'). He always makes two or three mallets at the same time, but his children throw them at the chickens and pigs to chase them away from the fence.
3. One Tongan dollar (or *pa'anga*) was worth 0.37 Euro on 25 March, 2007.
4. This final title did not refer to the city of Avignon in the south of France, but to the Avignon Street in Barcelona where prostitutes used to exercise their profession.

References

Adorno, T.W. 1973. *The Jargon of Authenticity*. Evanston: Northwestern University Press.
Affergan, F. 1987. *Exotisme et altérité: Essai sur les fondements d'une critique de l'anthropologie*. Paris: Presses Universitaires de France.
Assouline, P. 1988. *L'Homme de l'art: D.-H. Kahnweiler 1884–1979*. Paris: Balland.
Benjamin, W. 1992. 'The Work of Art in the Age of Mechanical Reproduction'. In W. Benjamin, *Illuminations*. London: Fontana. Pp. 211–244.
Bensa, A. 2006. *La fin de l'exotisme: Essais d'anthropologie critique*. Toulouse: Anacharsis.
Berman, M. 2009. *The Politics of Authenticity: Radical Individualism and the Emergence of Modern Society*. London and New York: Verso.

Bonnain, R. 2001. *L'empire des masques: Les collectionneurs d'arts premiers aujourd'hui*. Paris: Stock.
Buvik, P. (ed.). 2006. 'L'exotisme, l'exotique, l'étranger', *Les carnets de l'exotisme 6* (nouvelle série). Paris: Kailash.
Chao, L. 2006. 'Overview of Cubism in China'. In *Cubism in Asia: Unbounded Dialogues*. Singapore: Singapore Art Museum. Pp. 170–174.
Cheng, V.J. 2004. *Inauthentic: The Anxiety over Culture and Identity*. New Brunswick, NJ: Rutgers University Press.
Condominas, G. 1965. *L'exotique est quotidien: Sar Luk, Vietnam central*. Paris: Plon.
De Beauvoir, S. 1949. *Le deuxième sexe*. Paris: Gallimard.
Derlon, B. et M. Jeudy-Ballini. 2008. *La passion de l'art primitif: Enquête sur les collectionneurs*. Paris: Gallimard.
Douaire-Marsaudon, F. 2010. 'Enfanter, est-ce bien " naturel"? Rite, représentation, fantasme de l'engendrement dans un culte polynésien', *Journal de la Société des Océanistes* 130-131: 89-104 .
Errington, S. 1998. *The Death of Authentic Primitive Art and Other Tales of Progress*. Berkeley: University of California Press.
Feest, C.F. 2004. 'Franz Boas, Primitive Art, and the Anthropology of Art', *European Review of Native American Studies* 18(1) 5–8.
Flam, J. and M. Deutch (eds). 2003. *Primitivism and Twentieth-Century Art: A Documentary History*. Berkeley: University of California Press.
Gell, A. 1998. *Art and Agency: An Anthropological Theory*. Oxford: Oxford University Press.
Goldwater, R. 1967. *Primitivism in Modern Art*. Revised edition. New York: Alfred A. Knopf and Random House.
Hiller, S. (ed.). 1991. *The Myth of Primitivism*. London: Routledge.
Huggan, G. 2001. *The Post-colonial Exotic: Marketing the Margins*. London and New York: Routledge.
Laplantine, F. 2010. *Tokyo, ville flottante: Scène urbaine, mises en scène*. Paris: Stock.
Marcus, G.E. and F.R. Myers (eds). 1995. *The Traffic in Culture: Refiguring Art and Anthropology*. Berkeley: University of California Press.
Mauss, M. 1954. *The Gift: The Form and Reason for Exchange in Archaic Societies*. London: Cohen and West.
Morphy, H. and M. Perkins. 2006. 'The Anthropology of Art: A Reflection on its History and Contemporary Practice'. In H. Morphy and M. Perkins (eds), *The Anthropology of Art: A Reader* Malden, MA and Oxford: Blackwell. Pp. 1–32.
Ortner, S. 1974. 'Is Female to Male as Nature is to Culture?' In M. Rosaldo and L. Lamphere (eds), *Women, Culture and Society*. Stanford: Stanford University Press. Pp. 67–87.
Plattner, S. 1996. *High Art Down Home: An Economic Ethnography of a Local Art Market*. Chicago: University of Chicago Press.
Pocius, G.L. 1997. 'Material Culture Research: Authentic Things, Authentic Values', *Material History Review* 45: 5–15.
Price, S. 1989. *Primitive Art in Civilized Places*. Chicago and London: University of Chicago Press.
Rhodes, C. 1994. *Primitivism and Modern Art*. London: Thames and Hudson.
Segalen, V. 1986. *Essai sur l'exotisme*. Paris: Fata Morgana.
Shogo, O. 2006. 'Cubism and Japan'. In *Cubism in Asia: Unbounded Dialogues*. Singapore: Singapore Art Museum. Pp. 185–188.
Svašek, M. 2007. *Anthropology, Art and Cultural Production*. London and Ann Arbor: Pluto.
Van der Grijp, P. 1993. *Islanders of the South: Production, Kinship and Ideology in the Polynesian Kingdom of Tonga*. Leiden: KITLV Press.
____. 2004. *Identity and Development: Tongan Culture, Agriculture, and the Perenniality of the Gift*. Leiden: KITLV Press.
____. 2006a. *Passion and Profit: Towards an Anthropology of Collecting*. Berlin: Lit Verlag.
____. 2006b. 'Precious Objects with a Natural Touch: Endangered Species and the Predilection for the Exotic'. In H.-H.M. Hsiao (ed.), *The Frontiers of Southeast-Asia and Pacific Studies*. Taipei: Center for Asia-Pacific Area Studies, Academia Sinica. Pp. 267–295.
____. 2007. '*Tabua* Business: Re-circulation of Whale Teeth and Bone Valuables in the Central Pacific', *Journal of the Polynesian Society* 116: 341–356.

____. 2009. *Art and Exoticism. An Anthropoogy of the Yearning for Authenticity*. Berlin: Lit Verlag.

___2011a. 'Why Accept Submission? Rethinking Asymmetrical Ideology and Power'. *Dialectical Anthropology* 35: 13–31.

___2011b. 'Contemporary Tongan Artists and the Reshaping of Oceanic Identity'. In E. Hermann (ed.): *Changing Contexts, Shifting Meanings: Transformations of Cultural Traditions in Oceania*. Honolulu: University of Hawai'i Press. Pp. 277–295.

Yee, J. 2000. *Clichés de la femme exotique: Un regard sur la littérature coloniale française entre 1871 et 1914*. Paris: L'Harmattan.

Zaelani, R.A. 2006. 'Image of Autonomy: Problems of Cubist Painting in Indonesia in the 1950s and the 1960s'. In *Cubism in Asia: Unbounded Dialogues*. Singapore: Singapore Art Museum. Pp. 180–184.

Chapter 8

WOODEN PILLARS AND MURAL PAINTINGS IN THE SAUDI SOUTH-WEST: NOTES ON CONTINUITY, AUTHENTICITY AND ARTISTIC CHANGE IN REGIONAL TRADITIONS

Andre Gingrich

In south-western Saudi Arabia, as elsewhere, icons of what is considered traditional folk art often serve local residents as examples of 'authentic' regional traditions. These in turn support a widely held local assumption that continuity and authenticity are synonymous: If a practice or style is thought to have a long local history, it is considered to truly represent a given cultural tradition. In this paper, I discuss connections in both terminology and ethnography that illuminate notions of continuity and authenticity in the context of regional case studies of certain architectural and design elements that are characteristic of the Saudi south-west.[1]

Anthropologists today often feel uncomfortable about such local equations of authenticity with continuity. An earlier anthropology held quite similar assumptions, but twenty-first century anthropology tends to emphasize the pervasiveness of change, rather than continuity, on the local and global levels. The meaning of authenticity itself thus comes into question. I believe that academic research in anthropology may in fact benefit from addressing, describing and explaining such local cases and conceptions of equating authenticity with continuity. To that end, I first discuss a few useful terminological and methodological tools, then apply them to a number of ethnographic cases and finally make several suggestions that may help us develop more comprehensive theoretical approaches to the theme of this chapter.

Methodology

Some notes on methodology and a few comments on the terminology of authenticity will serve as an introduction. The words 'authentic' and 'authenticity' seem to sit at a familiar intersection of different classes of terminology. One class comprises specialized academic terms. Anthropologists, for example, employ many terms and concepts that are rarely used and may not be understood by people we interact with and about whom we write. Reification, for example, a term widely used by researchers, is highly unlikely to be spoken by common people among the Roma, the Dublin poor, or the Nuer in their daily interactions. Authenticity, in so far as it is not commonly used in everyday contexts, shares some of the qualities with terms from this first class.

A second class of terms or expressions is defined by their context of usage: academic terms that are used or appropriated by special interest groups outside of academia who employ them in ways that most anthropologists would seek to avoid. Indeed, some groups with specific agendas abuse academic terms by using them in ways that contradict accepted academic understanding. Expressions like 'racial distinctiveness' or 'ethnic purity' belong to this class of terms, as would 'racial authenticity' or 'authentic nationhood'. Other non-academic uses are more benign and may even intersect with academic interests: when people from the art world – gallery owners, collectors and art dealers, for instance – reference authenticity, anthropologists may find their usage less provocative and even intellectually stimulating.

In a way, then, authenticity belongs to a wider inventory of words, ideas and concepts that are rarely used in common people's everyday lives but are instead used and contested between academics and various (other) special interest groups. Researchers thus face a challenge of positioning themselves and their academic fields within these contests of usage and meaning.

Inside the world of academic research, the term authenticity is employed most frequently in fields other than anthropology: in art history and archaeology, as well as legal studies and philosophy. It is in part through these avenues that the term has come to play a role in the anthropology of art and in legal anthropology. One could argue that authenticity, precisely because it is used in very different ways inside and outside of academia, is perfectly appropriate for use in various dialogical and interdisciplinary interactions between academic and some non-academic fields. For the same reason, however, the term requires additional conceptual elaboration before it can be considered a sound anthropological concept.

I am attracted by Jamie Saris's suggestion (this volume) that we consider authenticity in its deceptive and somewhat illusionary multisemantic meaning, which Saris conceives as being close to Marx's notion of fetish. Carl Dahlhaus, a renowned historian of music, has similarly addressed the problem of the word: 'Authenticity is a deceptive term; its nature is to be deceptive about its nature' (Dahlhaus 1976). Rajko Muršič's warning (this volume) is also useful, since he draws our attention to all those fields where applying the term authenticity may be completely inappropriate. We may have to deal with authenticity as part of the real world that we seek to analyse,

while discussing its utility for becoming an integral element in our own analytical anthropological toolkit. But we should assess the validity of a term not only in light of its positive utility, but also by its use in those spheres in which it is not appropriate. This is why I began by suggesting an identification of terminological classes in which the term's local meaning may sometimes contradict academic reasoning.

Based on terminological considerations such as these, my own (sceptical) use of the term authenticity will remain confined to its local and wider 'expressive' meanings (Banks 2001): I shall use it as a shorthand reference to some indigenous and public discourses. For the time being, I thus abstain from trying to elaborate any nominal academic significance of the term. My usage reflects the following: In public and indigenous discourses, authenticity is often seen as being intrinsically linked to notions of continuity. Often, something is considered authentic because it is understood as being a result of local continuity. The reverse holds, as well: if something is believed to be linked to a deep cultural continuity, it is likely to be considered authentic.

There is, of course, no necessary semantic and conceptual connection between authenticity and continuity. Such a seemingly logical and inherent connection may be marginal in a particular case, or it may be absent altogether. Let us consider the example of a secular urban artist from the Middle East. He or she is likely to emphasize originality, creativity and novelty in his or her work. If those qualities are conveyed successfully, art galleries, journalists, clients and scholars may respond favourably. In such a case, the works of our Syrian painter or Yemeni sculptor will be acknowledged and appreciated as expressing creativity, novelty: and authenticity. In such a case, authenticity refers to the artist's creative sincerity and originality, as part of his biographical and artistic development. In all likelihood, however, such a response to this artist's work and its 'authenticity' will not be related to any idea of cultural continuity. If the artist's work is considered to be avant-garde, then no such connection to cultural continuity will be made. In such a case, then, authenticity refers to the artist's truly original creative qualities, which, by definition, do not represent or reflect a continuous history of predecessors.

Some more widespread linkage between authenticity and continuity may be identified, however, if we shift our attention to creative works that are commonly labelled village art or folk art. Authors such as Robert Redfield and Ernest Gellner have proposed very clear-cut distinctions between folk art and elite art (Gellner 1981) and between little traditions and big traditions (Redfield 1941). Their ideas were oversimplifying, but I would argue that for the Middle East, at least, a somewhat more relative, fluid, contextualized and interactive notion of folk art continues to be not only useful but indispensable. Updated ways of conceptualizing folk art and local art have more recently absorbed such authors as Christopher Steiner (1994; Phillips and Steiner 1999) and Regina Bendix (1997, 1998). Their perspectives address the evidence that some connection between cultural continuity and artistic authenticity in the realm of folk art is acknowledged and referenced in many public spheres, even if the word authenticity itself is not explicitly used.

Several local and wider public spheres, arenas and markets interact with the production and display of folk art. Anthropology is one of these. From the inception of the discipline, anthropologists have sought to discover and document, to classify and

collect, to analyse, interpret, publicise and display folk art. Anthropology has also intervened in the very production of folk art in many different ways, ranging from stimulating a better appreciation of and increased demand for it to radically transforming and even destroying its practice.

In a theoretical and conceptual sense, anthropological thinking about continuity and authenticity in folk art has gone through three basic main eras. Many of the earliest forerunners of anthropology and some of its founding figures, saw little connection between continuity and authenticity, since they considered folk art to be the product of 'people without history', to use Eric Wolf's famous term (1982). In those early days of anthropology, folk art was seen as authentic, but only in the sense that it was perceived as the result of the ahistorical, savage, primitive, or natural status of those who produced it.

By contrast, in the era of anthropology's own metanarratives during the twentieth century, the connection between authenticity and continuity was almost universally accepted. In one way or another, most of anthropology's main traditions – evolutionism as much as diffusionism, neo-evolutionism and structuralism as much as cultural relativism or functionalism – emphasized some kind of linkage between authenticity and continuity in folk art. If we look closely, we see that most of the relevant authors recognized both continuity and discontinuity and distinguished internal from external influences. Yet in one way or another, they all put primary emphasis on cultural continuity as an identifiable quality of authentic folk art. Perhaps Franz Boas's 'Primitive Art' (1927) is the classic work that best represents that era.

The last quarter of a century, from about 1980 to the present, may be seen as a third era of anthropology, one that emphasizes postmodern and transnational reasoning. It seems to me that during this era, anthropologists are using the concepts of continuity and authenticity in new ways. Many writers on folk art have presented very good work that demonstrates how allegedly 'ancient' traditions have in fact been introduced quite recently from the outside, or have recently been invented. We should continue to pursue this extremely valuable 'deconstructive' dimension in our work on the subject. But if we understand anthropology as a cumulative and global endeavour, it is also important that we retain and appreciate a number of valuable elements from the second era of anthropological reasoning. In this context, my basic methodology argues for a dialectical approach towards both deconstructing and reconstructing possible connections between continuities and authenticity in the expressive and indigenous realms. Such a dialectical methodology also is inspired by the work of Walter Benjamin (1937): but as we shall see, the results of our investigation will require a critical re-assessment of some of Benjamin's insights.

Ethnography

I apply the methodology discussed above to the ethnography of decorated wooden pillars and mural paintings from the mountain regions in south-western Saudi Arabia (Gingrich 1983, 1991, 2007; Dostal 1983, 2007). I carried out my primary fieldwork in the 1980s and returned to Saudi Arabia on several occasions in the late 1990s and again in 2002.[2]

146 *Debating Authenticity*

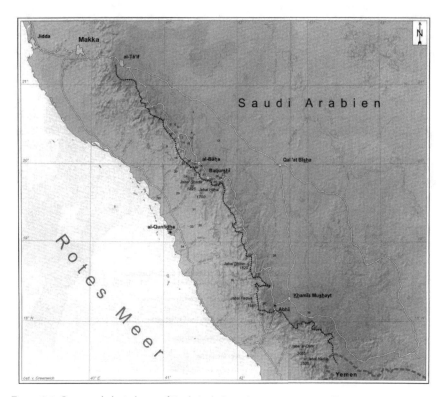

Figure 8.1: Geo-morphological map of Saudi Arabia's south-western provinces (from Dostal 2007).

The map in Figure 8.1 provides an overview of the region under consideration: the mountains along the south-eastern shore of the Red Sea, which stretch from Mecca and Jidda[3] in the north to Saudi Arabia's border areas with the Yemen in the south. Four major ecological and demographic zones may be distinguished here. First, there is the coastline along the Red Sea in the west; second, the flat, barren and very wide Tihama coastal plain; third, the mountain zones of Asir and Hijaz; and fourth, the Central Arabian steppe and desert, known as the Najd. The land rises abruptly from the Tihama plain to the mountains, which are the most densely populated part of the Arabian Peninsula, inhabited by perhaps a quarter of the kingdom's overall population of ten million people. It is the mountain zone that primarily concerns us here.

Before we examine the folk art and some of the more prominent features of the mountain region's architecture, a short regional contextualization of local architecture in general may be helpful. For historical and political reasons, the whole region displays a surprisingly rich, living inventory of nonindustrial domestic architecture. This is due, to some extent, to the fact that the region has been integrated into the Kingdom only in relatively recent, sporadic waves. Hijaz and Asir became part of Saudi Arabia's domain after the First World War and in its early decades the new Saudi ad-

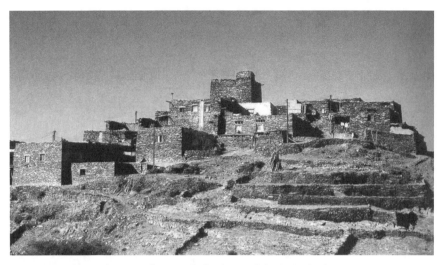

Figure 8.2: Defence architecture of a mountain hamlet in Bilad Zahran, al-Baha province. Picture Andre Gingrich.

ministration managed to establish itself at only a few formal, legal and military levels. Serious political and religious integration only began during or after the period 1934 to 1945, when the Kingdom managed to establish a more permanent administration in the region. An even later wave of economic and technological integration began in the 1970s and continues – with more recent emphasis on infrastructure and security – to this day. This late wave of economic integration, in particular, helps explain the very high profile of nonindustrial domestic architecture in the region.

Relatively distinct architectural features are found in each of the four ecological and geographic zones, but at the same time, these features have links to wider regions elsewhere. The coral stone houses along the coastline are part of a much wider sphere of coastal architecture along the Red Sea and the Indian Ocean shorelines of Arabia and East Africa. The beehive-shaped straw huts characteristic of the barren Tihama coastal plain can be found everywhere in the Red Sea plains of Arabia and, more importantly, in wide parts of East Africa. The mud-brick buildings in the Najd deserts to the east also occur throughout Central Arabia and along the Arabian side of the gulf. Finally, the tribal architecture of the Asir and Hijaz mountain highlands, with its well-defended towers and multistoried buildings (Figure 8.2), is part of a much wider zone of traditional south-west and south Arabian skyscrapers, which are found to the south through all of the Yemen and into the distant Hadramawt, near the borders of Oman.

Put in regional perspective, the only elements that are truly unique to the mountain architecture of Asir and Hijaz – the only ones that are not found among Yemeni and Hadrami skyscrapers – are decorated wooden pillars and interior mural paintings. This uniqueness is the reason decorated pillars and mural paintings are seen as key elements of authentic regional culture by many people in the region and through-

148 *Debating Authenticity*

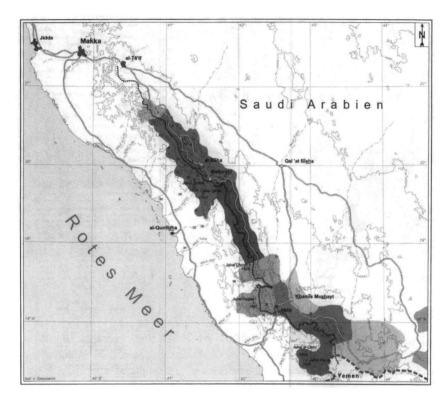

Figure 8.3: Main varieties of village architecture in southern Hijaz and Asir (from Gingrich 2007).

out the Middle East. But local residents would use terms other than authentic. They would refer to wooden pillars and mural paintings as signs of real or true (*sahih*) local culture. In this sense, most local inhabitants understand authenticity first of all as a term synonymous with 'being unique' to a region's culture: something that represents a distinctive visual marker. With the local population's increased travel into and out of their home region, they are perhaps more aware of this feature in their material cultural heritage today than they were during the 1980s: or in the 1930s when Harry Philby first reported about these pillars and mural paintings (Philby 1976).

The map in Figure 8.3 identifies the two neighbouring areas under discussion. Southern Hijaz is in the northernmost part of the map, marked in various darker shades. Asir is the largr area in the south-east, marked in various lighter shades. Two- and three-storied houses prevail in southern Hijaz, partly for complex ecological reasons. For purposes of defence, these low buildings often required the addition of extra towers (Figure 8.4). In a two- or three-storey house, the weight of the upper floors can be supported by a wooden pillar in the living room, which usually is on the second floor. Wooden pillars, therefore, dominate as an interior support element in the domestic architecture of southern Hijaz (Figure 8.5).

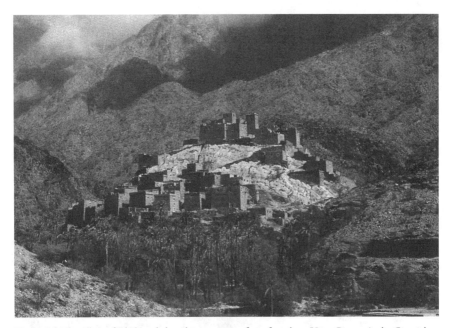

Figure 8.4: The village of Dhi 'Ayn below the escarpment face of southern Hijaz. Picture Andre Gingrich.

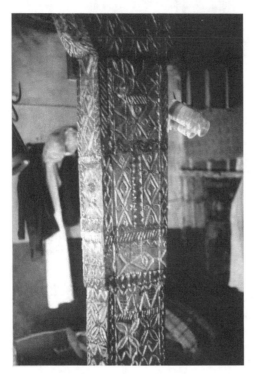

Figure 8.5: Decorated wooden pillar in a living room of southern Hijaz. Picture Andre Gingrich.

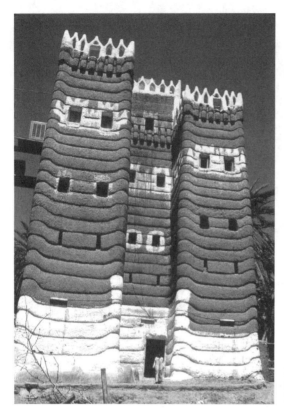

Figure 8.6: Defence architecture of a rural skyscraper in northern Asir. Picture Pascal and Marie Maréchaux.

Domestic buildings in Asir, on the other hand, are five to seven floors high. As defensive towers in their own right, these skyscrapers need no extra towers (Figure 8.6). Because the buildings are so tall, the supporting elements in the middle floors carry a burden much heavier than wooden pillars could support. In Asir, as in the Yemen, houses therefore feature not wooden pillars but interior supporting walls. The rooms in these houses that are used for habitation can be much wider and central pillars do not interrupt the internal view. These, then, are the technical conditions of construction: wooden pillars in the rooms of southern Hijaz's lower domestic buildings and wide, strong walls in the rooms of Asir's tower houses.

The allocation of room functions also follows different patterns in the smaller Hijazi houses and the tall Asiri tower houses. In Asiri tower houses with five or more floors, the rooms in which the family lives are always somewhere on the second or third floors. The lower floors are used for animals and tools, while the uppermost storey is used for sleeping rooms and the kitchen is always on the roof. Women move freely inside the house, which can be defended from all levels, including the roof, which is one of each house's most useful defensive positions. These Asiri tower houses, with their large families in residence and their good defensive installations, usually stand alone.

The lower domestic architecture in southern Hijaz, by contrast, is more difficult to defend. Extra towers are therefore a common feature. In many cases the towers are shared by several houses, which are clustered together for additional protection against attack. As in Asir, a house's ground floor is used in southern Hijaz for stables and for tool storage, but in other ways the social usage of rooms and floors differs considerably. Because the Hijazi house itself cannot be easily protected, its roof has to be fully exploitable for military purposes. A kitchen on top of so low a roof would be far too exposed and it would be an impediment when the house had to be defended. For practical, but also important social reasons, the kitchen in southern Hijaz is therefore usually found close to the ground floor and, symbolically enough, in proximity to the family's tools and animals.

Within these social contexts, we may now discuss the decorated wooden pillars of southern Hijaz and the mural paintings of Asir.

The characteristic decorative elements of the living rooms of Asir are mural paintings executed with simplicity and clarity of design. In almost every house that is more than twenty or thirty years old, one finds decorative painted patterns of two- or three-coloured stripes, the margins of which intersect in tower-shaped or crenellated forms (Figure 8.7). The colours of these painted stripes are made from a variety of plants, all of which are carefully selected by local girls and women on their weekly trips into the countryside to gather and collect wild plants of all kinds: medicinal herbs, firewood, stable fodder and so forth. Women not only gathered and collected the plants, but also produced and prepared the pigments. Even more importantly, until the early 1990s the mural paintings themselves were women's work: women of each household painted their own rooms by hand. Until a generation ago, then, the mural paintings

Figure 8.7: Mural paintings from earth colours inside a living room of Asir. Picture Andre Gingrich.

of Asir were known and appreciated unambiguously as female folk art. It was, and still is, locally known that older mural paintings had been produced by women: first by the generations who had built the house and later by women from succeeding generations who carefully repainted and repaired the older colours.

In contrast to the simple mural paintings of Asir, the decorated carvings on wooden support pillars in southern Hijaz are, by local standards, relatively spectacular and elaborate. Basically, however, they comprise four or five primary decorative elements. Again, one could find these carved decorations on interior pillars in almost any substantial village house in southern Hijaz, where they are the prominent feature of the main living room, the *diwan* or *mafraj*. The decorations on wooden pillars, however, are not the work of women from the household. They are instead produced by male specialists, who come from outside the community. These carpenter-specialists live in a few nucleated settlements in the area and they travel throughout the region to produce and repair on demand. Very few expert families thus supplied their skills and labour to many communities, which is one reason for the relative uniformity of carved wooden decoration in southern Hijaz. For centuries, most of these families of expert carpenters have belonged to low-status groups from the *Isma'ili* Shiite minority; until the mid-twentieth century, a few Jewish carpenters also were active in the trade. From the demand side of the domestic households served by the specialists, the relative uniformity of supply is matched by a prevailing interest in the real and true Hijazi wood decoration the craftsmen provided.

Having discussed a bit of the technical and social context of these forms of Saudi folk art, we may now consider a few symbolic aspects. The primary feature already has been pointed out: the two kinds of decoration are seen, above all, as typical and true indicators of Hijazi and Asiri culture, respectively. They are seen as distinctive for the respective region and in that context, for the social majority of tribal households living there. Because of this, they represent a necessity for any local tribal house and its main living room. In turn, if residents and visitors alike see those decorative elements as typical – as unique and true elements in each house – this has much wider implications, because in Arabic, 'house' (*bayt*) is synonymous with family, with origins and with honour. This leads to the question of these decorations' deeper cultural meaning.

In the 1980s and early 1990s, an average young Asiri adult would have argued that the painted walls in the home were a symbol of family honour and of the strong female presence in the family. In fact, women in Asir, as in parts of neighbouring north-western Yemen, could rely on strong cognatic elements in local kinship structure. Until very recently, women in these areas carried arms, wore no veil and had their own legal and ritual voice in local public affairs. An average Hijazi village resident, by comparison, would have argued that the decorated pillars in his or her house were also a sign of family honour, but that they stood for one's famous patrilineal ancestors. As elsewhere in Central and northern Arabia, a woman's role in southern Hijaz is much more hierarchized through an explicitly patrilineal kinship system and corresponding genealogical ideologies.

The meanings of social space in each region support these symbolic associations. In southern Hijaz, the roof is a 'men-only' zone and the kitchen is situated on the

ground floor near the animals' sphere of impurity. The living room too is a predominantly male zone and in the symbolic logic of southern Hijaz the supporting pillar in the centre of the house connects the male principles above with everything that is below them. Above, there are the local group's genealogical world of patrilineal ancestors in the sky and the men defending a house's honour from the roof. Below, on the ground floor, is the world not only of tools and animals, but closer to them, also of women and children.

If we look at Asiri mural paintings, however, we see that they decorate rooms that until very recently were used regularly by both men and women, without any gendered rules of mutual avoidance in space. The living rooms with their mural decorations are located above levels that are used for animals and tools, but the kitchen's location is much higher here, on the roof. The mural paintings thus decorate a semi-public domestic space that is both female and male and which is located below other male and female zones that are secluded from the public: sleeping rooms and, on top, a walled roof used for both cooking and fighting. Importantly, women participated in defensive fighting alongside men. In this symbolic perspective, then, Asiri mural paintings also had gendered aspects, but they represented less hierarchical gender roles: both male and female on top, close to the skies, with joint access to the property of a strong house, its animals and its land below.

This analysis helps to explain why in the 1980s, when I did my major fieldwork, most Hijazi residents associated their wooden decorated pillars with family pride, male ancestors and male honour, whereas Asiri residents associated their mural paintings (until quite recently) with family honour in which women had a widely appreciated voice of their own.

This analysis permits an additional conclusion. With both of these main versions of living room decorations, a very clear set of symbolic and social meaning provided a socio-culturally pre-defined demand structure, which the respective local 'folk artists' had to address and to satisfy from the outset. In these cases, context and socio-cultural demand therefore encouraged and to an extent required that specialized male carpenters or local female painters in each case would try their very best to make their work of art as similar as possible to those that already existed in the area. Context and socio-cultural demand thus were causal factors for the manual reproduction of this kind of rural folk art.

Authenticity and Continuity

In 1997, the Kingdom of Saudi Arabia celebrated the centennial anniversary of the modern Kingdom's foundation by King Abdul Aziz bin Saud. On the occasion of the anniversary, everything was done to enhance and transmit the image of a coherent, unified and modern Saudi Kingdom: to the international community as much as to the local population. Key centennial festivals included official political and religious ceremonies and several cultural events. In the capital city, these cultural events included a widely attended musical theatre performance of King Abdul Aziz's biogra-

phy and the opening of a major amusement park near the centre of old Riyad. In the park, typical houses from the Kingdom's major provinces had been constructed by craftsmen from those regions and local products were sold in front of each of these architectural symbols. The whole amusement park represented a major contribution to the Kingdom's overall efforts towards nation building, in this case through show business and popular entertainment.

These official efforts went quite far. Events staged in the centennial amusement park were televised throughout the country, seeming to indicate a changing climate of liberal reforms: in principle and in practice, the austere doctrine of *Wahhabi* Islam tends to be opposed to any sort of public amusement whatsoever.[4] Although some conservative theologians' circles were predictably critical of these cultural events, the general public seemed to appreciate their inclusiveness. The spectacular Hijazi and Asiri buildings in the amusement park were a major attraction and interviews with those who built them and others who lived in buildings like them in the provinces could be seen on television.

Figure 8.8: Mural paintings from industrial colours on external walls of an Asiri village. Picture Pascal and Marie Maréchaux.

Both houses at Riyad's centennial amusement park were constructed exactly like buildings in local villages in Asir or Hijaz. The builders and their teams were proud of that authenticity and one of the craftsmen even used the word authenticity, in English, during a Saudi television interview carried out in Arabic. The decoration inside the Asiri display house in the amusement park, however, differed remarkably from what I was familiar with in the 1980s. First, it lacked the older, muted mural colours and instead featured very bright blue and red pigments not only on the interior living-room walls, but also on the outside walls of the entire house. Second, no mention was made either in the centennial festival display or the related television programs about who, until recently, had been the producers of these decorations. Women were absent from the presentation.

During my subsequent visit to Asir in 2002, I learned that the bright interior and exterior decoration of the display house at the Riyad amusement park corresponded to significant local changes in Asir. Similar paintings in very bright colours appeared inside and outside many Asiri tower houses (Figure 8.8). Asiri architecture demonstrated elements of explicit change in its decoration, while Hijazi architecture did not: just as the Hijazi display building had retained the old carved wooden pillars.

The new colours on the walls of Asir's tower houses are no longer made of organic local materials, but utilize imported chemical stuff that is applied by hired male labour from Pakistan rather than by local women. In Hijaz, by contrast, the formal and decorative continuity of wooden pillars persists. The carpenters' families pass their skills and decorative patterns from one generation to the next and their clients continue to insist on traditional patterns in newly produced pillars. If we look at the socio-cultural composition of these carpenters' groups over time, however, we do see some structural change among them during the twentieth century. Specifically, the *Isma'ili* carpenters gradually gained a stronger presence in the profession after they had been resettled from their earlier place of residence in Najran and after the tiny Jewish group of carpenters had left for Israel around 1948. Despite these changes in their social organization, the carpenters' decorative work displays more continuity than change over time. A careful comparison between wooden decorations that were carved in my presence in early 1981 with another wooden decoration that featured the Hijra year 1200 (the late eighteenth century AD) among its engravings reveals that hardly any difference can be identified between the two. In fact, today's carpenters often copy older decorative patterns because their clients insist on it. 'House owners in southern Hijaz hardly want anything else but these old decorative patterns', a carpenter told me in 1981:'Even if I suggest some modern decoration, they prefer their local tradition'.

That carpenter's tale, and the related aesthetic and technical evidence, shows that continuity in regional folk art cannot be taken as a given, but has a variety of underlying factors and causes. Continuity is intentionally enhanced through the interplay of mimesis and social conformity. Mimesis, copying and manual reproduction are the intellectual devices by which the carpenters of Hijaz produce wooden decoration on new pillars in such a way that it resembles the patterns on older examples. Conformity to existing ideals of status and prestige is what informs the demands and wishes

of clients who commission these works. In the Hijazi case, then, local and regional hegemony of an existing aesthetic and symbolic order is perpetuated by house owners. In turn, these icons of a hegemonic, regional 'authenticity from below' are instrumentalized 'from above' as part of a centralized effort towards nation building.

In an inversion of this relationship between continuity and tradition, the mural paintings of Asir seem to have lost some of their earlier symbolic status in recent decades. This symbolic demise coincides with a phase of increased integration into the Saudi Kingdom and its religious ideals, which disapprove of the kind of social status held by tribal women in Asir. The old style of mural painting seems to have lost its significance hand in hand with a deterioration of women's actual status in local Asiri households. While carpenters' contractual artwork persisted in Hijaz, largely because it conformed to a regional hegemonic order and its integration into the nation, the reverse happened in Asir. Women's domestic artwork vanished together with the general lowering of women's social status and was replaced by painted decorations created by male foreigners using materials purchased on the market: signs of turbulent social changes. The resulting apparent changes in folk art on the ground were enhanced and confirmed through the television shows and amusement park presentations that celebrated national integration.

The result of all this is that Asiri mural paintings have almost disappeared today, replaced quite recently by conspicuous signs of Saudi modernity. Hijazi wooden decoration, by contrast, even in its amusement park variant, displays almost nothing but continuity. But on a national level, public discourse tends to ignore those local peoples who actually produced both kinds of decoration. Walter Benjamin insisted quite rightly on the fact that the reproduction of art works always was possible. As this analysis shows, some cases of folk art imply that its manual reproduction not only is possible, but a necessary requirement to indicate continuity and conformity.

Conclusion

Three ethnographic conclusions emerge, which will lead us back to my initial methodological argument.

First, and despite the fact that anthropological reasoning in this field tends to be critical of initiatives towards nation-building that come from above, the remarkable Saudi effort to acknowledge in its centennial festivities some of the country's internal diversity and cultural plurality is noteworthy. The televised festivalization and spectacularization indicated a significant rupture with a past in which austerity and uniformity had dominated, and the public presentation of some of the country's diversity allowed regional identification and made way for some new forms of cultural integration. Still, these official efforts left out and thus eliminated from national memory some of the groups that had contributed to the rich and diverse cultural heritage of the Kingdom: including Asiri women.

A second conclusion concerns the contrast between continuities in the decoration of Hijazi pillars and the striking discontinuities in the decoration of Asiri walls. The

bright industrial colours on the walls of Asiri domestic buildings may be interpreted as signs of recent and turbulent changes in the social life of Asir, while the seeming continuity of some two hundred years in the patterns of Hijazi wooden decorations can be seen as a sign of a smoother and less complicated process of Hijazi integration into the Saudi Kingdom (Dostal 1983). As I mentioned earlier, there were several different waves of integration in Saudi Arabia just prior to and throughout the twentieth century. Legal and military integration reached these two south-western provinces first, followed by waves of theological and political, and finally economic and social integration. These different waves came to southern Hijaz earlier than to Asir and proceeded more gradually there. It can also be argued that southern Hijaz was better prepared than Asir to cope with these processes, which were orchestrated and directed out of Jidda, Mecca and Riyad. The local patrilineal legacy of southern Hijaz, and its closer proximity to Mecca, made accommodation with the Riyad State and its *Wahhabi* doctrine both earlier and easier. In Asir, the process of integration set in fully only after the Saudi-Yemeni war of 1934, and Asir's local social and religious traditions were less well-predisposed to accepting the Saudi political and religious doctrines. Asir has experienced a number of more turbulent periods subsequent to 1934.[5] Thus, I suggest that we can see the appearance of bright new mural colours on the inner and outer walls of Asiri houses during the 1990s as visual signals and symbols of these changes: they point not only at new aspirations and new prosperity, but also at hidden feelings of anger and resentment.

This leads to my third, and more methodological, conclusion. I have pointed out that local discourses in southern Hijaz represent carved wooden pillar decorations as truly authentic symbols of regional culture, and that Hijazis insist that these forms of decoration continue to be basically the same. In Asir, on the other hand, local notions insist that mural paintings are an authentic part of local culture as well, but Asiris now feel that these mural paintings have to change whenever necessary. In both of these cases, the results of integration into national and transnational spheres of Saudi statehood and *Wahhabi* Islam have supported and enhanced certain elements of local continuity, but they have left others out. Nation building and religious integration thus enhance, reinforce and upgrade some conspicuous, widely appreciated local factors of continuity and of locally perceived authenticity, but in a very selective manner. In fact, symbols were selected and reinforced for the purpose of televised presentations precisely because local people identified with them. Regional notions of identity thus build on notions of visual authenticity as versions of selective continuity. In turn, visual authenticity as selective continuity then becomes core material for the wider processes of nation building in a globalized world.

These processes of integrating traditional Hijazi and Asiri architectural design motifs into national Saudi statehood – and into the transnational and global forces of Sunni Islam in its *Wahhabi* variant – indicate an appropriate and indispensable perspective that allows us to understand (that is, to deconstruct and reconstruct) continuity and discontinuity in what is seen as authentic folk art. In the age of globalization, these versions of folk art continue to be manually reproduced, for hegemonic purposes as much as they indicate distinctiveness and deviation. The perspectives on

integration that were discussed here are national, transnational and global. A methodology of dialectically combining deconstruction with reconstruction is well-suited for such conceptual orientations that are informed by transnational and global theories in anthropology.

Notes

1. I would like to thank Thomas Fillitz (University of Vienna) and Jamie Saris (National University of Ireland: Maynooth) for their helpful editorial comments and suggestions and Johanna Gullberg (Stockholm), Jan Grill (St. Andrews) and Marcus Banks (Oxford), who provided valuable inspiration and discussion for this paper during and after the Sokrates Intensive Programme. Copy-editing assistance was provided by Joan O'Donnell (Santa Fe). In addition, the help of Andrea Belassoued, David Mihola and Sarah Kwiatkowski (all University of Vienna) in preparing the visual materials is gratefully acknowledged. Financial support for field research and assistance was granted by the Austrian Science Fund and the Austrian Academy of Sciences.
2. The original fieldwork was part of a cooperative project between the Department of Archaeology at King Saud University and the Department of Social Anthropology at the University of Vienna. The project was funded by the Ministry of Higher Education of the Kingdom of Saudi Arabia and by the Austrian Science Fund. A 2002 re-study was funded by the Austrian Science Fund's Wittgenstein prize and was carried out as in cooperation between the Austrian Academy of Science's Institute for Social Anthropology and the Faculty for Social Sciences at King Khaled University of Abha, Asir.
3. With due apologies to the experts, the current text uses a simplified transliteration of Arabic terms and refers to Anglicized versions where possible.
4. The term *Wahhabi* is a reference to the doctrine's founder, Muhammad Abd al-Wahhab. Its followers, however, prefer to call this path of Sunni Islam *Tawhid*, or Unitarian.
5. The recent phases of Asir's integration into the Saudi Kingdom include such highly diverse factors as militant sectarianism (visible through local participation in the *Juhayman* revolt of 1400 H. and in the 11 September, 2001 terrorist attacks), on the one hand, and one of the most open-minded and energetic governors of the Kingdom, whose regional administration has enhanced infrastructure, health services, education, and even more importantly, civil participation, on the other. (For a discussion of an earlier phase of Asir's integration, see Gingrich 2000).

References

Banks, M. 2001. *Visual Methods in Social Research*. London: Sage.
Bendix, R. 1997. *In Search of Authenticity: The Formation of Folklore Studies*. Madison, Wisconsin: University of Wisconsin Press.
———.1998. "Authenticity', "Fakelore", "Folklorismus"'. In T. Green (ed.), *Folklore: An Encyclopaedia of Beliefs, Customs, Tales, Music, and Art*. Santa Barbara: ABC-CLIO. Pp. 72–5, 275–77, 337–39.
Benjamin, W. 1968. 'The Work of Art in the Age of Mechanical Reproduction', in H. Zohn (trans.), *Illuminations: Essays and Reflections,* New York: Schocken. Pp. 217–252.
Boas, F. 1927. *Primitive Art*. Oslo: Oslo Institute for Comparative Research.
Dahlhaus, C. 1967. 'Zur Dialektik von "echt" und "unecht" '. *Zeitschrift für Volkskunde* 63. Pp. 36–57.
Dostal, W. 1983. *Ethnographic Atlas of Asir. Preliminary Report*. Sitzungsberichte der philosophisch-historischen Klasse Bd. 406. Vienna: Verlag der Österreichischen Akademie der Wissenschaften.
———. (ed.). 2007. *Tribale Gesellschaften der südwestlichen Regionen des Königreiches Saudi Arabien. Sozialanthropologische Untersuchungen*. Veröffentlichungen zur Sozialanthropologie Band 8, Sitzungsberichte

der philosophisch-historischen Klasse Bd. 732. Vienna: Verlag der Österreichischen Akademie der Wissenschaften.

Gellner, E. 1981. *Muslim Society.* Cambridge: Cambridge University Press.

Gingrich, A. 1983. 'Traditional Architecture'. In Walter Dostal, *Ethnographic Atlas of Asir. Preliminary Report.* Sitzungsberichte der philosophisch-historischen Klasse Bd. 406. Vienna: Verlag der Österreichischen Akademie der Wissenschaften. Pp. 74–124.

____.1991. 'Das Haus als Praxis und Vorstellung. Ethnologische Thesen zur Methodologie der Hausforschung am Beispiel südwestarabischer Erhebungen'. *Mitteilungen der Anthropologischen Gesellschaft in Wien* CXXI. Pp. 9–75.

____.2000. 'Trading Autonomy for Integration: Some Observations on Twentieth-Century Relations between the Rijal Alma' Tribe and the Kingdom of Saudi Arabia'. *Études Rurales* 155–56, Juillet–Décembre, 75–92.

____.2007. 'Wohnarchitektur im südwestlichen Saudi Arabien: Lokale Zeugnisse historischer Interaktionen mit Nachbarn, Herrschern und Fremden'. In W. Dostal (ed.), *Tribale Gesellschaften der südwestlichen Regionen des Königreiches Saudi Arabien. Sozialanthropologische Untersuchungen.* Veröffentlichungen zur Sozialanthropologie Band 8, Sitzungsberichte der philosophisch-historischen Klasse Bd. 732. Vienna. Verlag der Österreichischen Akademie der Wissenschaften. Pp. 207–406, 576–613, 630–37, 676–82.

Philby, H. St J.B. 1976. *Arabian Highlands.* New York: Da Capo.

Phillips, R.B., and C.B. Steiner (eds). 1999. *Unpacking Culture: Art and Commodity in Colonial and Postcolonial Worlds.* Berkeley: University of California Press.

Redfield, R. 1941. *The Folk Culture of Yucatan.* Chicago: University of Chicago Press.

Steiner, C.B. 1994. *African Art in Transit.* Cambridge: Cambridge University Press.

Wolf, E.R. 1982. *Europe and the People without History.* Berkeley: University of California Press.

Chapter 9

TRUE TO LIFE: AUTHENTICITY AND THE PHOTOGRAPHIC IMAGE

Marcus Banks

> Whenever the term 'authentic' is used… a good first question to ask is, *Authentic as opposed to what?* (Dutton 2003)

Towards the end of this paper I shall consider what visual *in*authenticty might look like. To start off however, it is necessary to consider the varied meanings and implications of authenticity for anthropology when it comes to a consideration of the visual image.

This is not the place to consider the role of the visual image within the discipline more widely. A variety of anthropologists writing from within the sub-discipline of visual anthropology have sought to justify the role played by visual images both within the course of anthropological investigation and in analysis.[1] For the purposes of this paper I take these arguments as given and consider instead whether there are any special problems of authenticity arising out of a reliance on visual (as opposed to, say, literary) representations. To do so, I consider a number of case studies and evaluate their approach to authenticity in the light of other, non-anthropological perspectives.

The bulk of ethnographic information we have today rests upon written representation: the classic ethnographic monograph. Writing, as form of language encoding, and more importantly as a purely symbolic system of representation, allows a potentially infinite range of expression through which to convey the lives of others – from the purely fraudulent [and hence, presumably, inauthentic – see Parkin 1985 (for a fictional example)]. to the purely honest and objective. But most anthropologists would challenge the ability of writing / language to convey a purely objective ethnographic account and since the so-called "crisis of representation' in the 1980s[2] the discipline has become used to the idea that all written accounts are representations, not unmediated transparent presentations of fact.

It is thus perfectly possible to 'fake' an ethnographic account in writing, to cynically present a wholly inauthentic presentation of an entirely faked ethnographic

'truth'. The slight surprise is that there are so few (documented) examples: the faking of ethnographic evidence is surprisingly rare and confined largely to examples that do not claim to come from the heartlands of academic anthropological enquiry in the first place (e.g., Morgan 1994).[3]

Equally, the presentation of false or inauthentic ethnographic evidence in visual form is rare in the twentieth century, a far cry from the images of cannibal butcher's shops and suchlike that accompanied travellers' accounts from the eighteenth and early nineteenth century. In the late nineteenth and early twentieth centuries the apparent objectivity of the camera's eye presented itself to anthropology as a scientific tool that could firmly underpin the scientific credentials of the discipline. Even though the value of the photomechanical visual image to the anthropological enquiry diminished over the course of the twentieth century, its evidential status – resting on presumptions of authenticity – was rarely if ever questioned. The problem in the mid-twentieth century was that the kind of evidence the photographic or filmic image was presumed to provide was increasingly not required.[4]

What is Authentic?

But before going on, the concept of authenticity needs to be unpacked. The philosopher Denis Dutton introduces a useful distinction between nominal and expressive authenticity. Nominal authenticity is acquired and confirmed through identification or confirmation of origin (or authorship, or provenance): the thing is really what it claims to be, verified by 'appeal to external sources' (Dutton 2003). This is, on the surface at least, the common-sense everyday understanding of the term. Expressive authenticity is, by contrast, verified by the thing itself, a fusion of object and representation: things are true to their own nature.

I will consider the relevance of expressive authenticity at the end of this paper; for the moment, with respect to photomechanical images at least, there are actually two aspects to nominal authenticity that need to be separated.

The first is the authenticity of the image-as-object; the combination of light, lens and chemically coated celluloid (or, in digital photography, charge-coupled devices) means that (with some rare exceptions) something that is recorded on film (or written to memory) really took place before the camera and leaves traces of image creation. Consequently, the authenticity of the image-object and, it is thought, the image-subject, can be verified by external criteria (the type of paper, the composition of the chemicals, edge-codes and other inscriptions on the object)[5] and sometimes provenanced by a quasi-forensic process.

Consider, for example, Figure 9.1, a reproduction of one of the famous *Cottingley Fairy* photographs. These images were produced in 1917 by young cousins Elsie Wright and Frances Griffiths, who borrowed Elsie's father's camera to take photographs of fairies they claimed they played with near their home in Cottingley, a village near Bradford in northern England. This particular image, produced from a 1917 glass-plate negative, was authenticated in 1920 with the others as being 'entirely

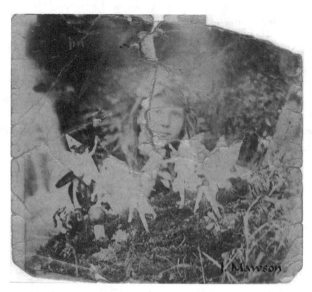

Figure 9.1: A reproduction of a contact print taken from the original glass-plate negative of 'Frances with the fairies', July 1917, taken by Elsie Wright. Photograph courtesy of Brotherton Collection, University of Leeds, England.

genuine unfaked photographs of single exposure, open-air work, show(ing) movement in all the fairy pictures … they are straight untouched pictures':[6] that is, the nominal authenticity of the object is tested and found to be robust. The fact that the test mixes the putatively verifiable (open-air, single exposure) with the unverifiable (movement, fairies) is not the point: the verification of the glass-plate as object bleeds unproblematically over into the photograph as representation.[7]

In fact, I know of no instances of this kind of nominal authority being faked in this way for ethnographic images and indeed I do not know of any for other genres of photography of the early period. For one thing, there is unlikely to be much in the way of a financial incentive. In this sense, the world of ethnographic photography – and, in due course, film – is quite different from the fine art world, with its van Meegeren-forged Vermeers and Tom Keating-forged Samuel Palmers.

The second aspect of nominal authenticity as applied to images is the authority of the image content. The *Cottingley Fairy* photographs have, to modern eyes at least, inauthentic image content (fairies do not exist) and although there are not many instances of deliberately faked content in ethnographic photography, it does exist although it would perhaps be fairer to refer to it as misleading rather than faked content. A classic example is the ethnographic film director requesting indigenous people to remove their Coca-Cola T-shirts before he begins to film. While the *Cottingley Fairy* photographs were deliberately faked (by Elsie Wright and Frances Griffiths) issues of authenticity in ethnographic photography usually hinge on unconscious cultural stereotyping or assumptions about 'primitiveness', such as the romantic 'end of an era' aspect to Edward Curtis's photographs of Native Americans. Much the same is

true of ethnographic film: I know of no faked ethnographic films (in the sense of falsification of the nominal authority of the material object) and the nominal authority of the image-content is normally challenged on the grounds of unconscious cultural bias or ignorance, rather than wilful deceit.

Authenticity and the Aura

In its earliest days photography was renowned for its authenticity: Fox Talbot's *Pencil of Nature* that faithfully reproduced what was before it. But this claim to authenticity is only with reference to the object of representation: as Benjamin says, 'from a photographic negative, for example, one can make any number of prints; to ask for the "authentic" print makes no sense' (1936 §IV).[8] In constructing his argument against fascism, Benjamin is keen to demonstrate that mechanical reproducibility destroys the magico-religious aura of unique forms, thus linking authenticity, authority and singularity. Unfortunately, his claims do not apply beyond particular metropolitan and western understandings of representational practice (even if there).

Clare Harris for example, in a discussion of photography in and of Tibet, points out that photography doesn't function for Tibetans in the way it does for Westerners: for example, photographs of dead lamas are deemed to be presences, not absences: the lamas are in some senses reincarnate in their images (2004: 144f). More specifically, Dalai Lamas such as the Thirteenth knowingly worked with photographers (in this case, Charles Bell) to create what Harris calls certificates imbued with the aura of themselves that spread their fame and influence far beyond their immediate surroundings (2004: 143). Similarly Gabriel Hanganu, in a discussion of the social life of a photographic object representing an orthodox pilgrimage site in Romania during the socialist period, notes that the understanding of icons in the theology of the Orthodox Church assumes divine presence (aura) to be multiply present, no matter how many 'copies' exist (2004: 156).

To some people at least, then, photomechanical reproduction does not automatically cause the loss of aura, nor a consequent loss of authenticity: authenticity is subject to cultural interpretation.

The Authentic Indian Photograph, the Authentic Indian Film and the Inauthentic Film of 'Indians'

I now wish to present three examples to show how some of the ideas above play out in actual ethnographic or historical contexts. The first concerns the ways in which western viewers judge the authenticity of images made by ethnographic subjects; like the second, it draws upon materials from India, my own regional area of interest, although in this first example I rely heavily on the work of Christopher Pinney (especially 1992 and 1997).

The earliest images taken in India of quasi-ethnographic intent fitted into the 'races and types' genre of photography, as British administrators sought to map and document this highly diverse society (see Pinney 1992). While some of these images may today seem distasteful in their apparent objectification that renders individual men and women as mere signs of 'types', there is nothing inherently inauthentic about such images. Yet despite the co-option of photography to the project of Colonial surveillance (as it would be understood in a Foucauldian frame of analysis) Indians quickly took to the camera, with photographic studios opening at first in Calcutta and Bombay in the 1850s and throughout the country within a couple of decades (Pinney 1997: 72). Understandably, studio portraiture rather than 'races and types' was the preferred photographic genre for Indians who chose to stand or sit before the camera, but it could be argued that this was a less authentic form of image-content, given that such static posed imagery was more distinctive of a western representational mode than an Indian one.

One argument against such an interpretation is provided by the art historian Judith Gutman, who holds that traditional stylistic and formal properties of pre-photographic and pre-cinematic Indian visual forms were carried through to the age of the camera (Gutman 1982). The idea of visual flatness, especially a shallow depth of field and lack of strong diagonal composition, has also been identified as a pre-photographic Indian visual trope by historians of early Indian cinema (e.g., Chabria 1994: 3). Such an approach (re)confers nominal authenticity on images made by Indians for Indians, but at the same time implies that the transmission of stylistic form happens automatically and without interruption: but equally, also automatically, lacking any agency. Yet Pinney claims that this approach also condemns early Indian photographers to be mere patients of tradition ('hyperbolic essentialization of an Indian alterity' as he puts it: 1997: 95) and, drawing upon examples of personal rather than studio photography, demonstrates that for some Indians at least photography became a mode by which traditional forms (of life, not merely painting) could be explored in conjunction with the modern: represented by the medium of photography itself.

I will return to Pinney's criticisms of pre-photographic stylistic continuity below; for the moment, the point to note is that both Pinney and Gutman assert the authenticity of early Indian photographic image content, but for different reasons. For Gutman, authentically Indian traits are carried through into this new form; for Pinney, image subjects are being true to themselves as they seek to engage creatively with the new medium.

For my second example, I wish to move forward a few decades and examine some of the questions above with reference to the moving image in India. As with still photography, Indians were early adopters of cinema. Film arrived in India (in the form of a programme of short films from the French Lumière brothers company) in 1896 – only months after first unveiling in Paris – and the first fragment of apparently Indian-made film dates from the late 1890s (showing buildings along a river, possibly in Calcutta or Varanasi, filmed from a moving boat).[9]

Although there are written records that attest to other early films, unfortunately, due to climatic conditions as well as a pervasive sense of the ephemerality of cinema

(cultivated by Lumière brothers themselves) almost none of this material survives. The first extant film (and that only a fragment) is from 1913 when D.G. Phalke, the so-called 'father of Indian cinema' released his first film, *Raja Harishchandra*: a mythological epic. Phalke's creation was not an entirely autochthonous development of course, but stimulated by the colonial encounter. When Phalke saw a Christian missionary propaganda film, *The Life of Christ* (in late 1910 or early 1911) he is reported as saying:'… while *The Life of Christ* was rolling fast before my eyes I was mentally visualizing the gods: Shree Krishna, Shri Ramachandra, their Gokul and Ayodhya … Could we, the sons of India, ever be able to see Indian images on the screen?' (Chabria 1994: 8). Within a very short space of time, commercial film studios were established in Bombay and elsewhere in western India that in due course evolved into the juggernaut that is modern Bollywood.

During early years of the twentieth century various British visitors to and residents of India were also filming the country and its inhabitants as they saw it, but in the form of documentary or actuality productions rather than dramatized shorts or features. As the century wore on and as the Second World War got underway, the Government of India and various parastatal agencies also began to produce films, often for educational or propaganda purposes.

In general these British films, especially the amateur ones, skid across the surface of Indian social life: when not filming tiger shoots, children playing with the servants, or scenes of famous buildings such as the Taj Mahal, the British home and amateur movie makers tended to follow a rather circumscribed agenda. Key themes are found

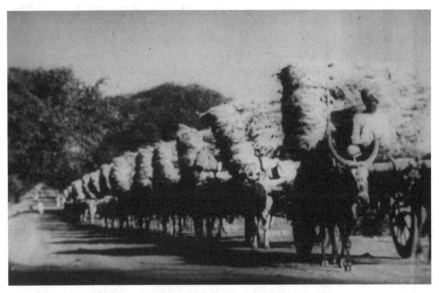

Figure 9.2: A frame still from the Crown Film Unit production *In Rural Maharashtra* (1945), a film about agricultural production in India during the Second World War. Note the strong diagonals and vanishing-point perspective in the image. Photograph courtesy of the National Film and Television Archive, Pune, India.

over and over again in the amateur films, including a quasi-ethnological interest in rural life (e.g., Figure 9.2) and activities (especially different techniques of ploughing and irrigation) and women. Indian women seem to be constant source of fascination to the largely male filmmakers, in part perhaps because they were far less visible in public space and so the filmmakers took whatever shots they were able. This results in numerous shots of women at wells, or washing clothes in rivers, or travelling by foot or cart on their way to the fields or to country fairs. In these films, once the women are aware of the gaze turned open them, they try to evade it: by pulling their veils or saris more tightly over their heads, or simply by turning and walking away.

There is however a neat and surely not coincidental flip-side to this in the treatment of women within Indian-made dramas. Indian filmmakers in the colonial period were, for the most part, uninterested in documentary and actuality filmmaking. Phalke himself shot some scenes of pilgrims at a *mela* (a religious fair or festival) and of workers at a brick factory, but these scenes seem more like camera tests than footage for a project. One reason for this lack of interest is purely commercial: the British amateurs generally had private means to support their film recording of famous buildings or rural life, the Government of India provided State funds for propaganda documentaries on childcare or tourism, but Indian filmmakers were – as in Hollywood – businessmen, they had to use their cameras to provide revenue.

For example, the archives of the Bombay Board of Film Censors contain correspondence between the Board and a Gujarati filmmaker-entrepreneur, Manchershah Bilmoria. In 1934, Bilmoria wrote to the Secretary of the Home Department in the regional Government of Bombay: 'We desire to take a cinema film of the proceedings of Congress Meeting [that is, the nationalist pro-independence party] to be held in Bombay next month, but before we do so we would like to know whether the picture will be passed for exhibition in India, because [if] there is no chance of its being passed for exhibition we do not desire to undergo expenses for nothing'.[10] Thus, fear of censorship allied to purely commercial pressures (cinema is expensive to produce) constrained the ways in which Indians represented themselves to themselves.

Yet some scholars have claimed that the treatment of women in the commercial dramas – mythological and other, such as light comedies or social dramas – provide an insight into Indian self-representation, not only images of who pre-Independence Indians are (or were thought to be in pre-colonial times) but who they could be (e.g., Rajadhyaksha 1994). If documentary and actuality film forms were commercially and politically closed avenues for Indian filmmakers, the crowd-pleasing dramas of early Indian cinema must be the repository of authentic images of pre-Independence Indians representing themselves. In this view, Phalke's attributed words: 'Could we, the sons of India, ever be able to see Indian images on the screen?' take on a new significance. He speaks not only for a desire for authentic (self) representation, but for social and political freedom. Under the yoke of politically motivated censorship Indian filmmakers were then forced to find spaces where an authentic and possibly nationalist self-representation could be performed. The answer lay most strongly in mythological dramas and in the domestic space. The representation of women in early Indian-made feature films is seen by one branch of modern scholarship as a

repository of coded nationalist sentiment. Like Margaret Thatcher's Conservative government in Britain in the 1980s, the British in India limited their involvement in Indian society (by and large) to the public space: they stopped short at the bedroom door, as it were. Consequently, modern scholars of Indian film claim that the domestic space of Indian society remained largely uncolonized and that its depiction (typified in the representation of women in Indian feature films as ideal wives and mothers) provided a space for the depiction and exploration of 'pure' – that is nationalist – Indian representations.

Returning briefly to the earlier discussion of early Indian photography, what we see in that case as well as in the case of colonial-period Indian filmmaking is not, as Judith Gutman and other art historians would argue, images of Indians by Indians that derive authenticity from stylistic continuity with pre-photographic artistic practices, but rather – as Pinney notes – a series of political negotiations around the new technology of the camera that rest upon who has the right to make what images of whom (1997: 96). Authenticity is fought for, not simply revealed.

I now wish to turn away from Indian and British attempts to seek to represent the authentic Indian, to a final discussion of a very different kind of 'Indian' authenticity: that of the misnamed Amerindians of South America (the misnaming itself could be a very profitable starting point for a discussion of authenticity). In particular, I want through the brief consideration of a modern ethnographic film to consider some of the issues involved in authentically representing post-colonial peoples.[11]

The 1990 film, *From The Heart of the World: The Elder Brothers' Warning* (Ereira, 1990), concerns the Kogi people, a group that lives in largely self-imposed isolation in the Sierra Nevada mountains of Colombia. The remnants of the powerful pre-Colombian Tairona civilization, the Kogi and two related groups have retreated up to the tops of the mountains. The essentially feudal society consists of a large number of serfs who cultivate the soil and a smaller number of *mamas* or priests who spend their days meditating and practicing divination. The film however is not a classic ethnographic one, at least inasmuch as that means a gritty, grainy style reflecting the filmmaker's closeness to the film subjects and intimate participation in their lifeworld. 'From the heart of the world' has very high production values, immediately evident in the swelling orchestral soundtrack and use of aircraft or helicopter shots at the film's start and progressing on with the use of Royal Shakespeare Company actors dubbing the spoken words of the Kogi subjects. In some ways the film seems more like a liberal-romantic Hollywood fiction production [for example, John Boorman's *Emerald Forest* (1985): although this is actually a British production] than an ethnographic film. But is it authentic? And if so, in what way?

The Kogi certainly have an apocalyptic cosmology – perhaps as result of the trauma of the Conquest – and see themselves as 'Elder Brother' to the rest of the world ('Younger Brother'); one reviewer acknowledges that this gives the film an exotic appeal: their message of global disaster being one that chimed (and still does) with audiences in the 1990s as the environmental movement grew. But the same reviewer also notes that there are some ethno-historical inaccuracies in the film and that Ereira overstates his claims to be the first to have filmed the Kogi (Taylor 1993: 220).

More surprisingly, the film's anthropological consultant – Graham Townsley – notes that film is disliked by many ethnographic filmmakers, who find it overblown and florid, not adhering to the minimalist canons of observational film style. He says:'Many (anthropologists) expected me to be somehow irritated or embarrassed by the film's high rhetorical style and the way it wears its romantic mythology of the primitive on its sleeve' (Townsley 1993: 223). However, he goes on to say that the Kogi *mamas* were extremely pleased by the film: its over-dramatic narration and vivid imagery exactly suited the drama of their apocalyptic message:'They certainly did not want a film that would be seen by few and then disappear, like most ethnographic films, with little or no trace. They wanted a big audience and they wanted it to stick in the mind' (1993: 225). In fact, through carefully chosen representatives, the Kogi actually do have contact with Euro-Colombian society (and, increasingly, with European indigenous rights activists and other politicized Amerindian groups) and know about television, cinema and the power of the media. As Townsley notes (1993: 225), the absence of rhetoric in minimalist observational film, is not a hallmark of authenticity, although the gritty, true-to-life feel may give that impression. Authenticity, as the suggestions of the Indian film scholars noted above indicate, can be carefully crafted and pre-meditated; it is not inherently spontaneous and innocent.

Conclusion: Expressive Authenticity

In some ways the issue of authenticity can be very easy for anthropologists to deal with, using the favourite tool of cultural relativism: one person's inauthenticity is another's authenticity: we may think that if Amerindian indigenous peoples wear Coca-Cola T-shirts, or if English traveller-Gypsies have *gorgios* make their traditional painted wagons for them then they are being inauthentic, but if these same people think that they are being authentic while doing these things, if they appropriate these items of material culture and make them their own, then so they are (see Okely, this volume). Heuristically, this is a closed argument: authenticity is whatever the subjects of scrutiny claim to be authentic.

Even in a more technical sense, authenticity can easily be established: once the facts of the broader contextual narrative are fully known, then nominal authenticity can be withheld, granted, or transferred. Returning to the world of fine art forgery for a moment, as Dutton notes (Dutton 2003), there is an interesting twist to the story of the famous Dutch forger of Vermeer paintings, Han van Meegeren. During the First World War van Meegeren sold a 'fake' Franz Hals, *Laughing Cavalier*, to Hermann Göring. After the war he was put on trial for selling national treasures to the enemy. In order to prove his innocence, van Meegeren painted an 'original' Vermeer painting (*Jesus among the Doctors*) to prove his innocence to the court, to prove that he had in fact tricked Göring. At a stroke (or several brush strokes) a fake Vermeer became an authentic van Meegeren.

At the start of paper I mentioned two forms of authenticity identified by Dutton: the one I have dwelt most on is what he calls nominal authority. This relates largely to

art historical work, such as establishing the authenticity of Vermeer paintings and my main concern in the paper has been to demonstrate that this needs to broken down still further into two components when it comes to visual, and particularly photomechanical, images: the nominal authority of the image-object and the nominal authority of the image-content. But I have said almost nothing about Dutton's other form of authenticity, derived from philosophy, expressive authenticity: the notion that something or someone is true to itself, an essentially moral rather than technical matter.

This is what Pinney is seeking in his analysis of the Jaipur Maharaja, Ram Singh, photographs (Pinney 1997: 83ff). Ram Singh is exploring the relevance, or perhaps the goodness of fit, between a traditional image – the pious king, the fusion of temporal and spiritual power – in a new techno-political context; he is seeking the truth of his self in a new world. The same is true of the 'father of Indian cinema' D.G. Phalke and other makers of the early Indian mythological films and also of the Kogi *mamas*. In all these cases the representations created are hybrids or fusions of a western-colonizing technology and changed indigenous notions of the self under techno-political domination.

If this is so, we should ask, following my opening use of the Dutton quotation: what is or might be expressive inauthenticity? It can certainly be seen in most amateur British attempts to film India in the colonial period, films, which impose a narrative (servile labour, timeless traditional ways, mysterious femininity, happy colonial subjects) and a style (deep focus, strong perspectivalism) on Indian subjects. In general these images are not true to anyone's lives: they are certainly not true to the lives of the Indian subjects represented, but they are not even true to the lives of the British filmmakers, who present these home movies as documentary truths about how India is, yet which are more consonant with a view of how British subjects were taught to perceive India.[12]

Thus, given the historical and ethnographic evidence available to us, it is unclear how the idea of establishing authenticity in the abstract is terribly helpful to anthropology. Yet in investigating the issue, revealing ethnographic understandings are discovered along the way, not least the criteria by which we as observers consider the truth claims of images: the *Cottingley Fairy* images look like unsurprisingly obvious fakes to us today, yet were fervently believed in by some at the time: the eyes that viewed them then belonged to people worried about increased anomie and alienation, about the loss of faith and the loss of childhood innocence. Although Elsie and Frances revealed at the end of their lives that the pictures had been fakes (the fairies were illustrations from a picture-book, carefully cut out and mounted on hat pins), Frances maintained to her deathbed that she and Elsie really had seen fairies by the stream in Cottingley: the photographs were attempts to recreate rather than fake that experience. If true, then in one sense the *Cottingley Fairy* photographs are no more inauthentic than the grand orchestral scoring and panoramic, carefully lit photography of Ereira's *From the Heart of the World*. In both cases, and in the early Indian photographs and mythological films, we see the representation of a form of experience, which is authentic not only for creators, but also for those around them and those who view those representations.

Notes

1. As a sample I would suggest Banks and Morphy (1997) together with Taylor's review (1998) which challenges the approach taken but not the value of the project, as well as the many contributions by Pink (e.g., 2006) and Ruby (e.g., 2001). See also Banks (2001, Chapter 1) and Banks (2007, Chapter 1) for summaries of the many arguments in favour of a visualist approach.
2. The classic references on this, two decades on, are still Clifford and Marcus (1986) and Marcus and Fischer (1986). However, the trend towards questioning – written – ethnographic authority began at least a decade earlier (e.g., Asad 1973) as did the first indication of calls for anthropological reflexivity (e.g., Ruby 1982).
3. Interestingly, and after much outcry, Morgan's account of life with the 'real people' Aborigines is now listed as a 'novel' (e.g., on amazon.com)
4. This is not the place to rehearse these historical developments; for more detail see Banks 2001: Chapter 2; more interpretation, see Edwards 2001.
5. Such external verifications are more complexly configured for digital photography and video, but they exist, not least in the physicality of the storage media – CDs, SSD cards, magnetic tape and so forth. Unique identifiers, such as date, type of cameras, etc., may also be encoded within the image files themselves.
6. The opinion of Henry Snelling, a contemporary photographic expert.
7. See Banks 2001: 51 for more on the Cottingley images.
8. There is another, more specific way in which the notion of 'the authentic print' is quite meaningful. The market in fine-art photography is one in which consumers must be persuaded that some prints are more authentic than others, e.g., true to the photographer's intention. As a consequence, there are also faked fine art photographs: modern prints from original negatives on old paper, purporting to have been printed by the photographer him- or herself: there are known cases involving Man Ray and Ansell Adams images.
9. Copies of all the Indian-made films described below are held at India's National Film and Television Archive in Pune, along with some Government of India productions; the amateur British and other foreign productions are held in a variety of archives in the U.K., including the National Film and Television Archive in London and the Centre for South Asian Studies in Cambridge.
10. Home (Political) Department, 1934, File 178, held now at the Maharashtra State Archives, Mumbai. Much background information in this section derives from these archives.
11. The shift in continental focus at this point in my argument is unfortunate, but reflects the available material. Contemporary Euro-American interest in 'primitiveness' and especially in 'primitive wisdom' and its relation to environmental activism is now very much focussed on the indigenous communities of the Americas. The closest Indian equivalent would be the inhabitants of the Andaman and Nicobar Islands but for a variety of reasons these are largely off-limits to filmmakers.
12. This is of course a sweeping generalization and some films manage to break the mould. Charles Hunter's 1920s amateur film, *Glimpses of India: Home Life,* held at the Centre for South Asian Studies, Cambridge, explicitly acknowledges the filmmaker's point of view, presenting the images as those that 'you', the imagined visitor to the Hunter family home in Dehra Dun in north India, are being shown as a tourist-visitor by Charles and his family. Equally, some of the Government of India propaganda films, such as A.B. Rao's *Woven with Affection* (1943), a documentary on wool production and blanket manufacture (copy now held at the Indian National Film and Television Archive), are explicit in their depiction of a new kind of Indian, one fully signed up to the Allies' war on fascism.

References

Asad, T. (ed.). 1973. *Anthropology and the Colonial Encounter*. London: Ithaca Press.
Banks, M. 2001. *Visual Methods in Social Research*. London: Sage.
____. 2007. *Using Visual Data in Qualitative Research*. London: Sage.
Benjamin, W. 1936. *The Work of Art in the Age of Mechanical Reproduction*. www.marxists.org/reference/subject/philosophy/works/ge/benjamin.htm (Access 23 February 2009).
Boorman, J. 1985. *The Emerald Forest*. Christel Films (film).
Chabria, S. 1994. 'Before Our Eyes: A Short History of India's Silent Cinema'. In S. Chabria and P.C. Usai (eds), *Light of Asia: Indian Silent Cinema 1912–1934*. New Delhi: Wiley Eastern. Pp. 3–24.
Clifford, J. and G. Marcus (eds). 1986. *Writing Culture. The Poetics and Politics of Ethnography*. Berkeley: University of California Press.
Dutton, D. 2003. 'Authenticity in Art'. In J. Levinson (ed.), *The Oxford Handbook of Aesthetics*. New York: Oxford University Press. Pp. 258–274.
Edwards, E. 2001. *Raw Histories*. Oxford: Berg.
Ereira, A. 1990. *From the Heart of the World: The Elder Brothers' Warning*. Elstree: BBC (film).
Gutman, J. 1982. *Through Indian Eyes: Nineteenth and Early Twentieth-Century Photography from India*. New York: Oxford University Press.
Hanganu, G. 2004. '"Photo-Cross": the Political and Devotional Lives of a Romanian Orthodox Photograph'. In E. Edwards and J. Hart (eds), *Photographs Objects Histories: On the Materiality of Images*. London and New York: Routledge. Pp. 148–165.
Harris, C. 2004. 'The Photograph Reincarnate: the Dynamics of Tibetan Relationships with Photography'. In E. Edwards and J. Hart (eds). *Photographs Objects Histories: On the Materiality of Images*. London and New York: Routledge. Pp. 132–147.
Marcus, G. and M.M.J. Fischer. 1986. *Anthropology as Cultural Critique: An Experimental Moment in the Human Sciences*. Chicago: University of Chicago Press.
Morgan, M. 1994. *Mutant Message Down Under*. New York: Harper Collins.
Parkin, F. 1985. *Krippendorf's Tribe*. London: Collins.
Pink, S. 2006. *The Future of Visual Anthropology: Engaging the Senses*. London and New York: Routledge.
Pinney, C. 1992. 'Underneath the Banyan Tree: William Crooke and Photographic Depictions of Caste'. In E. Edwards (ed.), *Anthropology and Photography, 1860–1920*. New Haven and London: Yale University Press in Association with the Royal Anthropological Institute, London. Pp. 165–173.
____. 1997. *Camera Indica. The Social Life of Indian Photographs*. London: Reaktion Books.
Rajadhyaksha, A. 1994. 'India's Silent Cinema: "A Viewer's View"'. In S. Chabria and P.C. Usai (eds), *Light of Asia: Indian Silent Cinema 1912–1934*. New Delhi: Wiley Eastern. Pp. 25–40.
Ruby, J (ed.). 1982. *A Crack in the Mirror: Reflexive Perspectives in Anthropology*. Philadelphia: University of Pennsylvania Press.
____. 2000. *Picturing Culture: Explorations in Film and Anthropology*. Chicago: University of Chicago Press.
Tayler, D. 1993. '*From the Heart of the World* (film review)', *Visual Anthropology* 6(2) 219–221.
Taylor, L. 1998. 'Review of: "Rethinking Visual Anthropology – Banks, M. and Morphy, H."', *American Anthropologist* 100: 534–537.
Townsley, G. 1993. 'Comment – "Lost Worlds Found: Advocacy and Film Rhetoric"', *Visual Anthropology* 6(2) 223–26.

PART IV

Entangled Spaces of Authenticity

Chapter 10

QUESTIONS OF AUTHENTICITY AND LEGITIMACY IN THE WORK OF HENRI GADEN (1867–1939)

Roy Dilley

Initial Reflections of the Concept of Authenticity

The questions of authenticity I wish to consider in this paper are closely linked to the concept of legitimacy. Both ideas are a function, I will argue, of social and political processes that occur within a specific cultural milieu and are not to be viewed in an essentialist or a decontextualized manner. As Jean-Pierre Warnier argues in his chapter, authenticity is a value, indeed a sign-value. And like all signs, it can carry both positive and negative loads. The pursuit of these symbolic loadings and the generation of value around them, involves the examination of key social processes within tightly defined contexts.

What I regard as the key social processes in this analysis are colonial knowledge practices and the diverse ways of knowing that are implied by them. Colonial knowledge practices in West Africa developed as part of a much larger process of the definition of French colonial political policy and its implementation in the region. The construction of ethnographic and other forms of knowledge within colonialism cannot be divorced, therefore, from the political contexts in which these forms of knowledge were created, or from the purposes to which they were put. In other words, knowledge is intimately linked to power and the ideas of authenticity and legitimacy that are attached to forms of knowledge and its representations must be seen too as part of this power play within the colonial project.

I argue below that certain forms of knowledge production and types of knowledge product are liable to be construed as authentic and legitimate for specific actors at specific times. These actors are variously situated in time and space and from their locations they are provided with a perspective that views types of cultural product through a lens of authenticity. As subject positions shift over the course of history

with respect to the workings of politics and to the struggles in which individuals are involved, so the construction of what is viewed as authentic becomes redefined across time and space.

The subject matter I consider below does not focus centrally on the production or the examination of material artefacts per se, a topic around which a good deal of debate over authenticity has taken place. My primary focus is instead upon knowledge practices and also upon some of the products of those knowledge practices. One such range of products comprises Henri Gaden's ethnographic photographs of peoples and places within West Africa. These photographs were taken under very specific conditions and for specific purposes, from Gaden's point of view. They were nonetheless co-opted and harnessed to further French colonial native policy in West Africa and these representations were seen to capture images that were later useful to the colonial propaganda machine. Over time, however, the sign-value of these photographs has been redefined, for they become for us, situated at a different moment in history, objects that open a window onto another world. They carry a sense of authenticity that is construed from our particular social perspective.

One way in which ethnographic photographs were harnessed to the emerging policy of colonial native administration in the late nineteenth and early twentieth centuries was with respect to the French *politique des races* in West Africa. This policy involved the classification of local populations along racial lines and once achieved, different kinds of policy were pursued according to what was considered appropriate for each of these races. Local groups were classified as to whether they were 'black' or 'white', sub-Saharan Sudanese or Moors and Berbers of the Sahel or Sahara. They were either non-Muslim or Muslim, susceptible to education and development or not as the case may be. Ethnographic photographs indicating the diversity of peoples of West Africa served the purpose in this context of providing a physical representation of the racial types as defined by French policy. This is a kind of nominal authenticity that connected a representation to an object, which was itself the subject of colonial enquiry.

The argument I present here finds echoes in the analyses of both Gingrich and Saris (this volume). Gingrich suggests that authenticity is an emergent property arising from the tension between continuity and change that operates within a specific cultural context. As the relative dynamic between continuity and change shifts over time, or even from one context to another, so the construction of authenticity takes on different forms as a consequence of these dynamic social processes. Authenticity is not a stable concept, but one that is the outcome of social relations. In a not dissimilar manner, Saris sets into relationship the concepts authenticity, alienation and fetish, arguing that each denotes a quality of experience of the link between a human subject and a cultural product of human labour. The quality of authenticity arises, therefore, in the matrix of a cultural and political struggle over the means of production of cultural value.

Specifically, my argument involves an examination of the shifts over time of colonial knowledge practices, of the kinds of knowledge generated by those practices and of the purposes to which that knowledge was put. As a consequence, the quality or sense of authenticity and the processes of legitimacy changed too. I regard the

processes of construing authenticity as epiphenomenal or as surface events arising from the underlying social practices of knowledge acquisition. Authenticity is, therefore, an emergent quality engendered by a series of generative social relations: in my case, relationships of knowledge production and the cultural and political struggles entailed within that production. My story is one of hybridity, of *métissage* and of dialogic relations. The fixing of elements as authentic at any one moment is simply that: the momentary capturing of elements that are themselves fluid and transitory into a form that appears as static and stable. Once fixed, those elements dissolve, only to be fixed again in another combination at a later date, as the consequence of underlying and contested social and political relationships.

Colonial French West Africa

This chapter focuses on the issue of knowledge practices among French colonial officers and administrators in West Africa and in particular on how one specific officer and administrator, Henri Gaden (1867–1939), developed an understanding of a region previously unknown to him. The story of Henri Gaden's engagement with the peoples and landscapes of West Africa is not one of the simple accumulation of knowledge of an unknown area and its inhabitants; it also implies the problem of ignorance, the flip-side to knowledge. To talk of knowledge without recognition of the potential of ignorance is like speaking of velocity without a conception of distance. The word 'ignorance' in English implies two different meanings: 'the fact or condition of being ignorant; a want of knowledge (general or specific);' and in verbal form the meaning of 'to refuse to take notice of; not to recognise, to disregard intentionally, to leave out of account, to shut one's eyes to' (Oxford English Dictionary). One cluster of meanings, therefore, describes a sense of the limits to knowledge, the lack of knowing in some general or specific way. The second meaning involves intentionality, the direction of attention, a sense of agency and of an agent's consciousness.[1]

Knowledge and ignorance, therefore, are mutually constitutive. This may seem to be an obvious point, but I hope to indicate some of its implications for an anthropological examination of colonial knowledge practices within West Africa. The specific question I am raising, therefore, is this: what is the place of ignorance with respect to constructions of knowledge practices within French colonial administration and policy in West Africa? And to what extent are notions of authenticity connected to these practices and their products, which constitute themselves a contested arena of social and political struggles within the colonial enterprise?

The last few decades of the nineteenth century saw the end of French military expansion in West Africa and the beginnings of the establishment and consolidation of a colonial apparatus aimed at the control of territory and the ordering and surveillance of local populations. It also involved an individual, Henri Gaden, who grappled with the problem of making sense of his immediate West African experiences. His career included the posts of military officer of various ranks and then his appointment

as a colonial administrator. I take this individual life as a prism through which may be viewed in detail the complexities of, and tensions among, diverse colonial knowledge practices. These complexities are apprehended through Gaden's engagement with local populations, with the landscapes they inhabited and with the languages they spoke. Gaden's increasing participation in civil administration from 1910 onwards is another dimension of this engagement.

Gaden: A Personal Transformation

Henri Gaden signed up for the French colonial army in 1894, having attended the military academy of *Saint Cyr*, one of the two most prestigious academies in France (Figure 10.1). During his second tour of duty in 1896, Gaden was engaged in operations against some of the last leaders of resistance to French annexation. Military conquest reached a symbolic conclusion in French Sudan with the capture of Samory Touré in 1898, during a campaign in which Gaden himself played a significant part (Figures 10.2 and 10.3).[2]

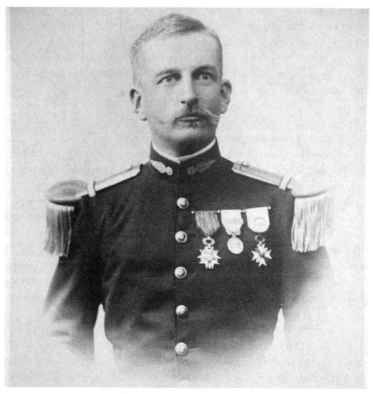

Figure 10.1. Henri Gaden as a young man and colonial officer early in his military career. Archives municipales de Bordeaux, copyright cliché A.M. Bordeaux.

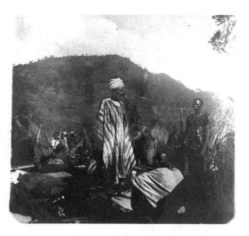

Figures 10.2. and 10.3. Two images of Samory Touré, taken by Gaden, the second of which was immediately after his capture by a detachment of troops led by Gaden at the camp of the resistance leader near Nzo, West Africa, September 1898. Archives municipales de Bordeaux, copyright cliché A.M. Bordeaux.

Popular illustrated news publications of the colonial period carried first-hand accounts by officers engaged in the operation and Gaden himself produced an account of his role in the much-lauded defeat of Samory (Gaden 1899). He was also the first to take photographs of him immediately after the rebel's capture in the bush camp and these were widely used in later colonial publications. These photographs were taken as a record of an historic event, but they also became part of military propaganda to bolster enthusiasm at home for the success of the French colonial mission in West Africa. The seeming authenticity of the first-hand verbal accounts and the visual images of French military success acted as props to support a sense of national pride. These same artefacts some one hundred years later took on another sense of authenticity when they were exhibited in Bordeaux in 2001 in a display of Gaden's photographs in his natal city.[3] Now the symbolic value they carried was of the artistry and standing of Gaden the photographer, whose images spoke to the idea of an authentic visual window onto a series of colonial events now distant in time and space from the contemporary viewer (see Figure 10.4.). They were authentic souvenirs of the period, which the viewer might capture in a nostalgic gaze. Their authenticity was constructed for the western observer through the tension played out within a dynamic of continuity and change in the relationship between Europe and the peoples of Africa.

Gaden later became a key figure in colonial government on his appointment in 1920 to the Governorship of Mauritania, then one of the last territories to be pacified and controlled by the French. After his retirement in 1927, he remained in St Louis, Senegal, the seat of the Governor, to live out his twilight years conducting eth-

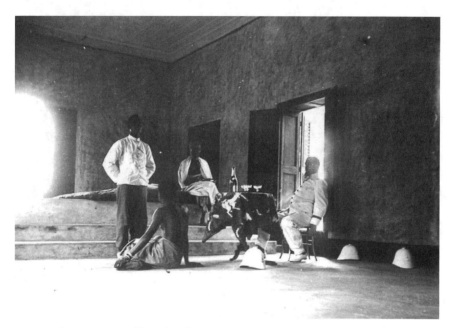

Figure 10.4. A scene captured by Gaden of the interior of a colonial building with a French officer, champagne glasses, attendants and a local woman. No date or location given but probably taken after the Samory campaign. The juxtaposition of these diverse and striking images in the scene no doubt appealed to Gaden's sense of irony.

nographic and linguistic research, surrounded by his Senegalese family and his West African wife by an indigenous 'country' marriage: *mariage à la mode de pays*.

This brief outline of a career contains a story of personal transformation. The figure of a young military officer, replete with nineteenth-century bourgeois prejudices about Africa and Africans, is recast in new form by the end of his life. In his latter days, he was regarded as a respected figure of authority, of learning and stature in the eyes of his adopted community. He lived with his West African partner, Coumba Cissé in St Louis until his death. With her, he adopted in about 1920 a young *métis* boy, Amadou Aïdara otherwise known under his baptismal name as Henri Michel Gaden, who was probably the son of one of Coumba's female relatives and a Moor of the Aïdara clan. The couple also fostered a number of local children from St Louis, one of whom, now in his eighties and known to his friends as Doudou Gaden, is still alive in Dakar today.

Gaden's initial encounter with Africa on 30 October 1894 did not augur well. He describes in a letter to his father the following scene on arriving in the port of Dakar:[4]

> Finally, we dropped anchor (in Dakar) at 6.30, on a dark night. The odour of the negro can be smelt from the port itself, and when a horde of canoes invaded us, a bunch of grubby blacks climbed aboard. The smell became awful. I have however almost be-

come used to it already ... Horrible hot night, no air and a stifling temperature. The old Sudanese who were with us could not recall similar temperatures. You can see I have started off well. Today the heat is again stifling ...

The blacks are decidedly a dirty race; above all those here, terribly lazy and indolent that one must berate them firmly in order to get something done. This colourful and dirty crowd is rather remarkable. All of them well-clothed, however, in unbelievable boubous, in obnoxious rags. The women with their babies on their backs, straddled around their waists, their bare heads nodding around, are quite remarkable. (30 October 1894: CAOM, 15 APC/2)

On 14 December 1894 he writes again to his father:

The blacks are completely insensible to good deeds, which they take as a sign of weakness. A case of mores. The respected chief is one who administers blows and chops off heads, advisedly, of course. My groom is never as careful, never cleans the bridle, or saddle, as well as when I administer to him a kick somewhere or other. (ibid.)

He was not, however, insensitive to what he saw around him, nor uncritical of the so-called civilizing mission of colonialism. A few months later in January 1895 he recounts, again in a letter to his father, a snippet of ethnographic insight and critical commentary:

Anyway, the society is sharply divided into castes; warriors, cultivators, smiths, weavers, leatherworkers, praise-singers, and there is no need of rules to guarantee their privileges. A black believes himself to be dishonoured if he takes on a trade other than that of his father ... And here are the people whom we have the pretence to civilize!

Or again, when describing a meeting with the illustrious Fama Madamba,[5] with whom he dined well – a meal apparently washed down with champagne and a 'rather good Bordeaux' – Gaden comments that despite the chief's enormous palace, surrounded by high walls and flanked by large towers, there was absolutely nothing inside it. 'No more cleanliness or order than among the last of his captives'. He adds, nonetheless, that 'Madamba is mightily interesting on the country, which he knows profoundly, its history, its uses, its languages. Eight highly interesting days were passed with this man'. (1 January 1895: ibid.)

Gaden chose not to shut his eyes to this encounter with Madamba, nor did he when making his ethnographic observations on caste separation. Indeed, by overcoming the temptation to ignore, he allowed himself the opportunity to apprehend the ignorance inherent in the French civilizing mission. His initial dismissive attitudes towards those around him were also gradually weathered away by successive encounters with the people of the region.

By the end of his life, Gaden had mellowed into a man of stature in the eyes of his adopted countrymen. By 1926, a French journalist described in the column *Sil-*

houettes coloniales, published in *Le Midi Colonial et Maritime*, remarkable scenes he witnessed at the Governor's residence in St Louis:

> From all points in Mauritania, from the near Trârza to the distant Adrar, they come on camels to submit their grievances or proclaim their vows to the great chief of St Louis, whom they all venerate for his uprightness and equity ... The prestige of M. le Gouverneur Gaden over the Maures and Toucouleurs is considerable. (Silhouettes coloniales, 26 December 1926)

In what ways had Gaden come to know West Africa and its populations? In what ways had he engaged with those around him and with the cultures he encountered? A onetime racist colonial novice with an unshrinking severity and judgemental eye had undergone a remarkable personal transformation. It was, as it were, André Gide's *Amyntas* in reverse: a transformation from distance and disdain to intimacy and engagement. The story of transformation in the life of an individual person is only one small part of a broader canvas of colonial endeavour and engagement with the other.[6]

Empire of the Unknown

Ignorance was an uneasy bedfellow of the colonial enterprise. The military and colonial mission was predicated on a claim to superior knowledge of various sorts: scientific rationalism, technological mastery of arms and machines, economic know-how

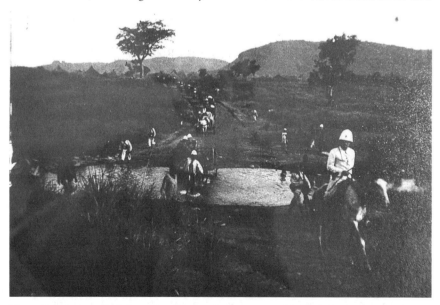

Figure 10.5. A picture by Gaden of French colonial troops moving through the West African bush, 1897–98. Archives municipales de Bordeaux, copyright cliché A.M. Bordeaux.

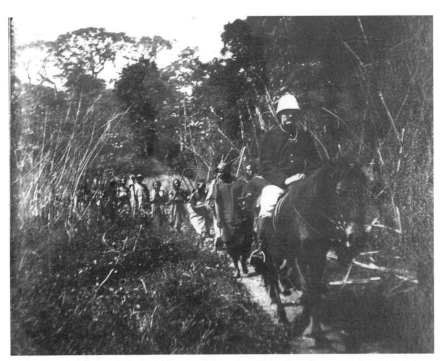

Figure 10.6. A picture by Gaden of French colonial troops moving through the West African bush, 1897–98. Archives municipales de Bordeaux, copyright cliché A.M. Bordeaux.

about the exploitation of resources for industrial production and so on. It was also fuelled by a sense of intellectual and moral progress, by developments in education and religious understanding and by the civilizing mission of an enlightened European power. Yet lurking behind this pretence of mastery was a sense of ignorance, of not knowing. Ignorance was a function of not knowing as well as 'shutting one's eyes to' aspects of local culture that challenged preconceived ideas and deep-seated prejudices.[7] These ways of not-knowing related to specific and important domains. The first of these was the environment and landscape, the geography and topography of regions yet to be annexed. The second was the people who populated these landscapes; it included too the languages they spoke (Figures 10.5, 10.6 and 10.7.).

The physical landscapes colonialists encountered were apprehended as imaginative spaces, into which at times figures and motifs from familiar European surroundings were used to make sense of an alien environment. These were landscapes of beauty and nostalgia. For example, Gaden writes to his father in November 1894:

> 'We left Kayes the day before yesterday. The train journey is certainly interesting. We travelled through superb places. The country is very mountainous, table-like mountains the sides of which are precipitous, resembling those of the valleys in Spain'.

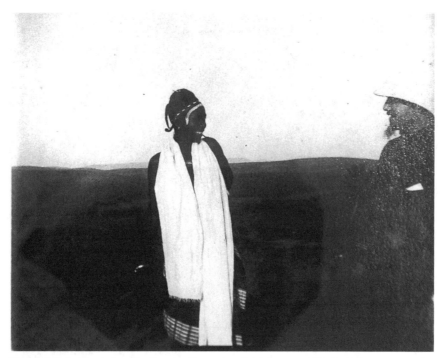

Figure 10.7. A girl at Beyla with a French officer, n.d. probably between 1897–99. Archives municipales de Bordeaux, copyright cliché A.M. Bordeaux.

At other times, they were also inchoate landscapes of fear. Gaden writes in January 1895 of the Niger bend that this is a 'country of incoherence' where 'the morrow is never certain'. These intimidating spaces were inscribed by *lieux de mémoire*, sites of memory evoking conflicts and armed engagements, disasters or triumphs over adversaries. These *lieux de mémoire* are constantly evoked in officers' discourse. For instance, Gaden reports in December 1894 that: 'We camped near to Dio, which pillaged Gallieni's mission in 1881'. The landscape was thus an object of knowledge, around which the shadow of ignorance with all its ghastly and grizzly consequences hovered with menace. These landscapes were endowed with moral qualities too, for the sites of memory were inscribed with characters that spoke of wrongs to be righted and hurt pride to be restored; they spoke too of personal and collective emotional turmoil, of anger and resentment, and of the necessity of revenge for fallen comrades-in-arms.

In his letters home to his father, Gaden frequently complains about the lack of information available at colonial residences, forts and outposts. Colonial reports on neighbouring territories were not available, few maps were produced and even fewer were to hand. His father in Bordeaux, Gaden pointed out, would probably be more informed than he about the local situation in West Africa.

When not engaged in military operations, Gaden was charged with a responsibility for ethnographical and geographical missions. His beautifully hand-drawn maps,

the detailed itineraries, compass readings and spatial coordinates noted in his diaries, all attest to a dedication on Gaden's part to the crucial task of plotting virgin territory. Devising supply routes and carving out lines of communication were indispensable aspects of colonial penetration. Mapping, surveying and the physical description of localities were the tools by which the military confronted not knowing the geography of the region.

The price of this sort of ignorance was high. It was a topic of conversation among officers, who counted the immediate costs of ignorance, saw at first-hand its consequences, and discussed the resulting loss of prestige in defeat for the French nation. Military patrols died in unmapped corners of territory, men got lost and were never seen again. For example, the shadow of the massacre of Capt. Bonnier's mission some years earlier was cast darkly across the landscape. Gaden refers to this incident in his letters home, saying that 'vengeance for the affair has never been taken', that 'our [French] prestige suffers terribly because of it' (14 December 1984).

'Not-knowing' the landscape could have disastrous consequences for the physical and mental well-being of French troops. To stray off the map was to enter tortuous territories where officers might lose their lives or go out of their minds.[8] A notorious affair was etched deeply into the consciousness of colonial officers and administrators. Voulet and Chanoine's 1890s mission, from what was then called the Soudan, to meet up with two other exploratory French forces at Lake Chad had profoundly troubled all who came to know of it. These two officers, in command of a unit of Senegalese troops, became deranged en route through the Soudan. Suffering from delusions of grandeur, they had proclaimed themselves kings of the Soudan, committing atrocities against local populations in their march towards Lake Chad. They were cut short only once their Senegalese troops mutinied leaving the two officers dead. This was too late, however, to stop them killing Capt. Klobb at the head of a small contingent of troops, sent to relieve them of their duties by the Governor General on hearing of the mission's atrocities.

The ethnographic project was equally crucial to the success of the colonial mission. Knowledge of local society was as significant as knowledge of the landscape. Indeed, as General Gallieni had advised, the realizing of a good ethnographic map is at least half the work of pacification. Gaden was charged with this role immediately on his arrival. Indeed, the mapping of the region's peoples and the writing of ethnographic accounts eventually became his life-long obsession once he had moved into civil administration and then retirement.

Language, the command of vernacular tongues, was another problematic area of ignorance. Colonial officers were suspicious of an over-reliance on native interpreters and translators, for they were anxious to have an immediate ear on local discourse and exchange. The *École Coloniale* in Paris only started teaching African languages some decades later in the early twentieth century. Officers such as Gaden, after a military training at *Saint Cyr*, had little or no language instruction in African tongues. The *Bureau Arabe*, established in Algeria for the training of officers and officials in Arabic and North African culture had an impact only later in the Sudan, to where its methods were imported many years after Gaden's introduction to West Africa.

Officers such as Gaden learnt in situ the languages necessary for colonial government and administration. Always keen to get hold of any published works on local vernaculars, Gaden nonetheless honed his own linguistic skills through local studies of language in Bandiagara, Zinder, Chad and St Louis. He emerged over the course of his life as an important linguist of *Pulaar* or Fulfulde, among other languages. The image that captures the experiential form of learning on the spot is the *broussard*, the practical man of action living in the bush. Until the next generation of college-educated men arrived in West Africa, the *broussard* was a kind of ideal type of colonial officer: he was an unencumbered bachelor willing to spend time alone in remote up-country stations; a person whose knowledge was acquired by means of immediate, sensory experiences. The *broussard* absorbed by a process of osmosis of practical adaptations to the climate and territory, he picked up a *savoir faire* to deal with local conditions that could not be matched, it was argued, by other ways of learning. There was no explicit methodology taught to officers to explain how this process of osmosis was to occur in the bush, that is how officers were to absorb the lessons that their postings to remote locations might teach them.[9] Someone like Gaden, however, developed his own idiosyncratic method by which the lessons of the bush could be integrated with his own carefully crafted methodical techniques for topographical and ethnographical mapping, linguistic research and so on. His intellectual curiosity, whetted by his early encounters with individuals and local groups, was in addition a continual spur to his endeavours.

In parallel with the concept of the *broussard* was the ideological notion of the 'mystique of action', a romantic ideal developed by military men such General Lyautey, who proclaimed the glory, virtue and sense of self-fulfilment to be gained from active military service. Together these two ideas – the *broussard* and the mystique of action – were the well-springs of Gaden's motivation for his early West African encounters. The practical expression of these ideals, along with his own methods of putting them into practice, led to him gaining an immediate experiential, bodily and sensory knowledge of place and population.

By the 1920s a new generation of trained, professional colonial administrators were graduating from the *École Coloniale*. Graduates of the Paris-based École were trained in African languages, ethnology and culture before being posted overseas (Cohen 1971). Gaden's contempt for this new breed of official, expressed in his later years, is all too evident: they had no bush experience, no knowledge or understanding of local cultural complexities, no feel for the place or its people. Furthermore, these new recruits were reluctant, it was claimed, to take on long and arduous postings to distant stations. Many of them were now also accompanied by their French metropolitan wives on their tours of duty to West Africa. This concession was regarded in some quarters with ambivalence. The accusation was made that officers were unwilling to be parted from their families – who lived in the relatively cosseted surroundings of Senegal's coastal towns – and serve the colony in the manner their elders expected. Their ignorance was apparent to Gaden and others like him. He complained specifically about the series of functionaries sent out to replace him after his retirement; and claimed that, for example, seditious Islamicist literature, circulat-

ing in Dakar in the 1920s, had to be sent to Paris for translation and interpretation. Such were the levels of ignorance and subsequent incompetence in Gaden's view. These claims of ignorance by him must be set within a context of political, ethical and personal transformations, since they can be read too as strategic and individually motivated accusations that carry a moral burden.

Changes in Colonial Context

A different set of knowledge practices had been developed for this new generation of colonial administrators; by means of different ways of knowing, the new recruits threatened the older methods of experiential learning. Moreover, new knowledge practices were developed in relation to the problem of political control in Mauritania. Until the early 1920s, France had been anxious to secure a narrow belt in the southern part of Mauritania, in order to protect its economic and strategic interests in St Louis and the Senegal River basin. Towards the end of the decade, the new Governor General of *Afrique Occidentale Française* (A.O.F.) insisted on pacifying the rest of the territory in order to link up with French interests in Morocco, Algeria and the rest of the Maghreb. Lines of communication needed to be secured and the pillaging and raiding by Moorish groups had to be stopped. The vision of uniting the French territories in West Africa and in the Maghreb generated all kinds of mad-cap schemes, such as the unsuccessful attempt to build a trans-Saharan railway: a project that was eventually buried in the shifting sands of the desert. This vision of unity was part of a colonial programme seeking mastery and control, not only over local populations but also over the natural elements of an extreme environment. Its practical advantages were defined in terms of uninhibited communication of man-power, goods and services between discontinuous spheres of influence, the pacification of pockets of local resistance to achieve stable colonial law and order: a practical consolidation and a symbolic manifestation of French imperial might.

One of the new techniques of knowledge was to rely increasingly on surveys, listings and estimations of wealth in livestock and men-at-arms of groups of Berbers and Moors who had not submitted themselves to French dominion. Knowledge thus became formalized and was represented on standardized forms to be filled in and lodged in individual files held in colonial offices. Individuals or collectivities of local populations were assigned to one of two conceptual categories of person, namely, those of *dissident* and *notable*. *Notables* were those willing to submit to French rule and *dissidents* were those who opposed it, for whatever reason. Under the new colonial regime, these categories became rigid, crystallized and essentialized with respect to the individuals and groups they purported to describe.

Gaden's use of these categories in his reports differs significantly. In his hands, they appear to be much more fluid, relative and contingent classes, whose membership depends upon circumstance, not on something approaching innate and fixed human qualities attributed to enemies or friends. Gaden's discursive, descriptive and ethno-

graphic style of reporting political affairs is progressively replaced by the formulaic and ordered style of the new arrivals. To his superiors, Gaden was guilty of excessive tolerance and indulgence, verging on a derogation of duty of a high-placed colonial officer. He was eased into early retirement by the Governor General, but did not go quietly. His critical voice continued to be heard until his demise in 1939. Gaden's policy of 'domestication' or 'taming' (*apprivoisement*) in Mauritania was discredited by the late 1920s and the 'politics of the sugar-loaf' that he espoused were abandoned.[10] France succeeded in connecting its West African territories to those in the Maghreb. But at what cost? This was Gaden's constant refrain.

One major plank of Gaden's construction of knowledge in this colonial setting was derived, it could be argued, from his bourgeois Bordelais upbringing. Gaden's family roots lay in Bordeaux, in particular among immigrant German families who had established themselves as wine merchants in the late eighteenth century. By the mid-nineteenth century, the Gadens, together with other German families, had founded important trading houses, whose members had become influential in the city's commercial, political and cultural life (Espagne 1997).

A recurring feature of his early letters to his father are Gaden's observations on the West African environment as a treasure house of commercial possibility. He describes levels of commerce in specific towns, the types of commodities on offer, what agricultural produce was abundant in the areas he travelled through, and so forth. These details were to be passed to other members of his family who had mercantile interests in France and West Africa. Furthermore, the Gadens were linked through affinal ties to the Devès family, originally Bordeaux merchants, who had later set up business in St Louis dealing in gum arabic. The St Louis Devèses had established a strong commercial base in the town and emerged over succeeding generations as an influential *métis* family in the local community.

Gaden's mercantile background was central in forming a strategy he pursued in his dealings with West Africans. What became known as the 'politics of the sugar loaf' emerged from reciprocal exchange relations Gaden developed with key local informants and *notables*. For him, knowledge was akin to a commodity, an article of commercial traffic, to be exchanged with those he considered worthy: namely local scholars, Muslim clerics, oral historians, praise-singers and the like. That is, those who offered insights into the country, its history, its literature, languages and cultures. These commodities were exchanged to promote and cement relationships. They were articles of trade for this son of a Bordelais mercantile enterprise, but they were also tokens of an emerging set of personal and professional relations whose social and symbolic density increased over time.

For example, he was drawn into an intimate relationship with Cheikh Siddiyya, known by some as the co-founder of modern Mauritania (Robinson 2000). In exchange for ethnographic data on religion and customary practice, or for information on kinship relations among specific clans, as well as for political intelligence, Gaden arranged for books in Arabic – religious texts, dictionaries and suchlike – to be imported from Paris or the Lebanon. These books, together with other gifts, were presented to the Cheikh as part of a system of personal reciprocal exchange. In other

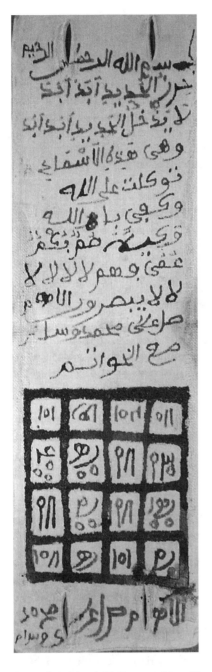

cases, Gaden organized the official papers and permissions for, as well as helped finance the expenses of, the pilgrimages of local Muslim leaders to Mecca.

An intriguing piece of evidence of Gaden's relations with local experts is a starched white detachable European shirt cuff that can be found among his papers in the Colonial Archives lodged in Aix-en-Provence (a photograph of this cuff is presented here as Figure 10.8). The cuff is inscribed with Arabic text and a magic square incorporating a series of numbers, and together these form a local Islamic talisman.[11] The purpose of this particular talisman is to protect the wearer from penetration by metal, whether that be a sword, bullet and so forth. One can only surmise that this was written for Gaden by one of his local contacts and was intended for him to wear to provide protection in the course of his daily activities. No note or any form of explanation is attached to this archive piece and so we are left with the only option of speculation about its origins, etc. This item, however, speaks to us today in all sorts of ways: it could be taken as an authentic artefact that reveals the kinds of intimate relationship Gaden created with local experts; by contrast, for the colonial officers of his time, this object would have represented the kind of indulgence and over-intimacy that eventually compromised Gaden and his political strategy. From one perspective, the cuff might represent a form of authentic engagement with ethnographic realities of West Africa; from another it is a piece of mystical mumbo-jumbo that represents Gaden's gullibility.

Reciprocity formed a central plank of Gaden's policy of domestication in Mauritania; a policy driven by an intellectual and

Figure 10.8. A detachable European shirt cuff inscribed with an Islamic amulet to protect the wearer from injury by metal objects, from Gaden's archive in Centre des Archives d'Outre-Mer, Aix-en-Provence (15 APC 1(7), item 117), n.d. Picture by Roy Dilley from Centre des Archives d'Outre-Mer, Aix-en-Provence.

personal engagement with the Other that was predicated on the idea of mutual benefit and advantage. Domestication was, moreover, a specific strategy within a much broader framing of French colonial policy at the end of the nineteenth century. This involved a shift from an earlier phase of assimilation to one of association, which resembled something akin to the British policy of indirect rule (Conklin 1997). This policy was championed with much enthusiasm by Gaden, among others.

Political changes in France after the First World War, together with the appointment of a new Governor General to A.O.F, led to the abandoning of the experiment with the policy of association and to a reassertion of a militaristic strategy in Mauritania. Gaden's 'politics of the sugar loaf' was attacked by the new administration. Furthermore, his kinship ties to the Devès family became a liability, for specific family members took a prominent stance against French colonial policy in St Louis. The final straw for Gaden's career was the accusation that French weapons, whose serial numbers could be traced to St Louis, were found in the hands of dissident groups of Moors. The suspicion was that Gaden was implicated in the affair in some way, perhaps through some of the contacts of the Devèses who were known to be trading with these groups.

The nadir of French prestige and confidence in relation to its Mauritanian policy came with the Reine and Serre episode in 1927. These were two French aviators whose aeroplane, plying the route between St Louis and Casablanca, came down in the Spanish controlled West African territory of Rio de Oro. The protracted negotiations for the release of the two men from groups of dissident Moors, and the humbling realization that a ransom would have to be paid for them, was the final nail in the coffin of the pacific and mediated policy of domestication. The powerlessness of the French position in this affair was seen by the Governor General as a direct consequence of the over-tolerant and indulgent attitude Gaden had adopted during the seven years of his Governorship of Mauritania.

Reflections

This is a brief and truncated version of a period of around fifty years of French colonial history in West Africa, viewed largely through one man's experience during that period: the transformations he underwent as a military officer, colonial administrator and ethnographer, and as a human being entangled in intimate personal relations with a variety of local characters. A number of conclusions can be drawn this. First and most generally, attributions of ignorance by French colonialists towards local practice and custom were often condemnatory and brutal; they were frequently cast in racist and evolutionary terms. In addition, attributions of ignorance by local interpreters towards French policy and conduct are also apparent in correspondence and official documents. This is hardly surprising. The situation calls to mind Hobart's observation that attributions of ignorance entail moral judgements – in this case, judgements issued by both parties to the encounter. Moreover, claims to ignorance are to be seen as being as much confrontational as they are dialectical.

By the turn of the twentieth century, most of the major military campaigns in the Soudan were over, and the last significant figures of colonial resistance were either captured or dead. The subsequent development of a broad, functional system of administration shifted attention away from military conquest and towards a civil structure whose aim was to achieve order through other means. Strategies of arms were no longer the primary recourse for colonial intervention, for now greater emphasis was placed on ethnographic documentation, linguistic research and an engagement with the practitioners of local knowledge.

The first and most urgent knowledge practices of colonialists during the military phase had been intimately related to the necessities of gaining the upper hand over local adversaries. They comprised mapping and topography, establishing lines of communication to outposts of French annexation, basic information on local populations, their resources and military capabilities. Colonial concerns about ignorance lay squarely in the domain of securing domination through might: a military might be founded upon a limited scope of knowledge governed by the dictates of an expansionist colonial enterprise.

The establishment of a civil colonial administration that lay beyond the control of purely military men became the priority in the early decades of the twentieth century. Henri Gaden fitted neatly with the new requirements of civilian government: he had military credentials but was sensitive to and well-versed in the complexities of local social organization. His ways of knowing had been formed in numerous ways: disciplined by the formal techniques of military necessity, moulded by the practical experience of living in the bush, informed by his initial ethnographic and linguistic enquiries, and motivated by personal and family imperatives. Gaden's Governorship of Mauritania from 1920 coincided with a shift in colonial policy from assimilation to association, specifically in relation to the territories north of the Senegal River. This allowed him to develop as part of his official strategy a range of knowledge practices aimed towards a new set of objects of enquiry: local understandings of social and cultural relationships; the connection between modes of livelihood on the margins of the desert and in the Sahara proper, on the one hand, and local ecological constraints and practical adaptations to the environment on the other. Moreover, the social relations he created with religious and political leaders, with local intellectuals and cultural interpreters, expanded the compass of colonial networks in ways not imagined a generation earlier. A shift had occurred too in the burden of 'interpretative labour', in Graeber's terms (2006), from the subordinate local to the dominant colonialist, whose aim was now to administer through a more informed sense of what indigenous custom and practice was all about. The structures of inequality shifted from a military to an administrative mode and with it the 'lop-sided structures of the imagination' balanced themselves more evenly. Gaden's burden of interpretative labour was made possible by his intimate engagement with local knowledge practices. This moment of mutual engagement was not to last long, however. New knowledge practices were given political legitimacy and the old were pushed to one side, rejected as failed attempts to further the French cause.

Both confrontation and dialectic are apparent, therefore, in this examination over time of shifting colonial knowledge practices. Each claim to knowledge cast a shadow

of ignorance not only over the lands of West Africa, but also across the tiled floors of the Governance itself. Different ways of knowing engendered different modes of ignorance and these were set in opposition one with another once colonial policy was put into practice. The extent to which at specific moments colonial policy was informed by an understanding of local knowledge and its practitioners is another dimension in the dialectic of the colonial encounter. The colonial project was not a monolithic exercise of power and knowledge, but was a highly nuanced affair in which attributions of ignorance, claims to knowledge and the pursuit of power were ever-present.

Authenticity: A Reprise

I have tried to indicate within this complex historical picture how certain products of knowledge and indeed certain aspects of knowledge practices themselves, were viewed as variously authentic and even legitimate or not at specific junctures. The value placed upon these signs depended upon the social location of individual actors who apprehended them and upon the broader framework of the colonial project in which they were placed. But there is another view through the lens of authenticity of the life of Henri Gaden. This perspective draws on what might be called expressive or existential authenticity and refers to the problem of how to live authentically by 'being true to oneself'.

There are at least two ways of apprehending authenticity from this perspective: one is through Charles Taylor's discussion of the idea of authenticity as related to the inner depths of the self; a second is through Sartre's idea that an inauthentic act is one that betrays one's responsibility for behaving in a manner that is true to oneself, that is to act in bad faith. Arguably this perspective of 'being true to oneself' presupposes a concept of self that is both unitary and coherent; that object in respect of which an act can be untrue. It presumes too a life project or individual trajectory through history that is consistent with a unified self. This view is problematic in a number of regards. My story, by contrast, touches upon the way in which the colonial experience fractured an individual's sense of self, for in the extreme that experience took officers 'out of their minds' (Fabian 2000). I have no evidence that Gaden went out of his mind and perhaps his letter writing to his father was a kind of cathartic and integrative exercise he used when confronted with the heart of darkness. What is more certain is that Gaden experienced a sense of disjuncture between the self that had been crafted as the consequence of a life-time's engagement with West Africa and his Senegalese family in St Louis, on the one hand, and that self which had been fashioned in the early years of his Bordeaux upbringing, his bourgeois natal home and his education and military training, on the other. The Islamic talisman inscribed upon the detachable cuff of a European shirt, found in Gaden's archive in Aix-en-Provence (Figure 10.7), speaks of a set of possibilities that might indicate this disjuncture: namely, the extent to which he participated in local religious practices. This is certainly a moot point among those Senegalese today, who retain memories of him: some of them

claim he possessed powers of a Muslim mystic, others deny this. This artefact, and the debate within the local community, suggests the possibility of a quite profound reorientation of his ideas over the course of his lifetime in West Africa.

Just prior to his retirement, Henri Gaden was in correspondence with his old friend and military companion, Henri Gouraud, and together they discussed what options were open to him. Gouraud advised that he should return to France for a retirement on his beloved coast of the Gironde, south of Bordeaux, from where he could continue his researches, be affiliated with academic institutions and their scholars in Paris, and perhaps gain for himself some sort of wider national recognition. Gaden was obviously disquieted by the choice he had to make, but eventually he chose Senegal and his adopted home, where he died in December 1939.

The two possible futures lay before him in 1927, and if that moment of decision had turned out differently, would we have asked which act was truer to himself? Which one was the more authentic? For his Senegalese family and neighbours he had acted authentically, being in touch with that new emergent self, the product of a life-time of experience in Africa; for his French companions in the *métropole*, had he denied his true self in an act of bad faith that betrayed who he really was? Perhaps we will never actually know. Be that as it may, these varying attributions of authenticity do tell us something: they are the consequence of individualized perspectives cast from different locations on a single human life. Moreover, the forces that generated such attributions, and the sense that a notion of authenticity might itself be salient and desirable as an explanatory frame for social actors, are all consequences of social and political relations that span across space and time, a matrix of relations that constituted part of French colonialism. In the search for meaning in a life observed from afar and lived in such vastly differing circumstances in Africa and Europe, the question of authenticity arises as a function of the tension among the relations of continuity and change perceived to be present within a single biography.

Questions of legitimacy and authenticity run through the many layers of this analysis, from considerations of forms of colonial knowledge practice, through the historical and contemporary constructions placed on photographic images taken in the nineteenth century, to the course of an individual life and the decisions that formed it. Each of these sets of processes is susceptible to being configured through the lens of authenticity. And that sense of authenticity is nothing more than the product of a dynamic of social and political relations operating variously over time and space.

Notes

1. Hobart (1993) adds another dimension to this discussion of ignorance and knowledge. Ignorance, he continues, 'differs in degree and kind according to the presuppositions of different knowledges' (1993: 21). 'Ignorance, however, is not a simple antithesis of knowledge', he tells us. 'It is a state which people attribute to others and is laden with moral judgement' (1993: 1).
2. Henri Gaden wrote extensively about his early encounters with West Africa in a series of letters to his father, a body of correspondence that starts in 1894 and continues for the next fifteen or so years. These letters are held at Centre d'Archives Outre Mer, Aix-en-Provence, in 'carton 15 APC 2'.

His letters home in September 1898 describe in detail how a company of colonial troops, of which Gaden was a part, tracked Samory's forces through the bush, eventually capturing the resistance leader in a surprise raid on his camp.
3. See the catalogue of the exhibition: *Henri Gaden: Photographe*. Bordeaux: Éditions Confluences, 2001.
4. The following quotations are taken from letters written by Henri Gaden to his father and all the translations from French are mine.
5. Madamba, a Wolof, was a retired employee of the Post and Telegraph service, to whom Archinard had given a small state, populated by captives taken from Ahmadou Tal of Nioro.
6. Whether this change in Gaden's outlook came by way of a moment of epiphany or was the result of a more gradual and incremental process is the subject of further research. The kinds of factor that may have brought about this transformation include: his 'country marriages' to local women, the birth of his children by his wives, his increasing engagement with local intellectuals, and the developing strains with his colonial peers and contemporaries.
7. Conrad described how the ideological distinction between civilized European society and the 'heart of darkness' became meaningless once men were confronted by unknown territories that threatened and overpowered their sense of self and disoriented their moral compass. As Said has noted:'the heights of European civilization could instantaneously fall into the most barbarian practices' (2001: 6).
8. The extension of empire into previously uncharted regions of West Africa brought French colonialists and military officers to confront the extent of their own ignorance, the limits of knowledge, and the make-up of their own moral universes. They had to confront too the potential of their own power that could be unleashed in remote regions beyond the ken of the imperial centre; they had to grapple with motivations and urges normally submerged by the weight of civilized pretence. The dialectic between ignorance and knowledge does not register, therefore, on one dimension alone: an encounter with the unknown stirs human passions and desires, whose consequences reach beyond the intellectual search for knowledge or the imposition of political order.
8. See Fabian (2000) for a study of the effects of the European experience of the encounter of Central Africa on the mental equilibrium of explorers and travellers.
9. Dr Barot's 'Guide pratique' (1902) was perhaps the nearest Gaden's generation of officers would have come to receiving an explicit set of practical tips and advice on conduct in the colonies, but this publication appeared a little late for them and some years after their introduction to West Africa. It contains, for example, guidance for officers and others on which kinds of women (by ethnicity, race, etc.) should be chosen to ensure loyal companions and faithful concubines in the bush.
10. The 'politics of the sugar loaf' involved the provisioning of local leaders and groups to keep them sweet and loyal to the French cause.
11. See Dilley 2004 for details on Muslim talismans.

References

Barot, Dr. 1902. *Guide pratique de l'Européen dans l'Afrique Occidentale à l'usage des militaires, fonctionnaires, commerçants, colons et touristes*. Paris: Flammarion.
Cohen, W. 1971. *Rulers of Empire: The French Colonial Service in Africa*. Stanford: Hoover Institution Press.
Conklin, A.L. 1997. *A Mission to Civilize: The Republican Idea of Europe in France and West Africa, 1895–1930*. Stanford: Stanford University Press.
Dilley, R.M. 2004. *Islamic and Caste Knowledge Practices among Haalpulaaren, Senegal: Between Mosque and Termite Mound*. Edinburgh: Edinburgh University Press (for the International African Institute).
Espagne, M. 1997. 'Les Allemands de Bordeaux au début du XIXième siècle: l'exemple des familles Gaden, Meyer, Klipsch'. In G. Merlio and N. Pelletier (eds), *Bordeaux au temps de Hölderlin*. New York: Peter Lang. Pp. 53–77.

Fabian, J. 2000. *Out of Our Minds: Reason and Madness in the Exploration of Central Africa*. Berkeley: University of California Press.
Gaden, N.J.H. Letters to his Father. *Carton 15 APC 2*. Centre d'Archives Outre Mer: Aix-en-Provence.
Gaden, H. 1899. 'Le capture de Samory'. *A Travers le Monde* 8, 25 février. Pp. 57–60.
Gide, A. 1988. *Amyntas*. New York: The Ecco Press.
Graeber, D. 2006. 'Beyond Power/Knowledge: An Exploration of the Relation of Power, Ignorance and Stupidity', *The Malinowski Lecture*, 25 May. London School of Economics and Political Science. Website: www.lse.ac.uk/collections/LSEPublicLecturesAndEvents/pdf/20060525–Graeber.pdf. (Access 10 August 2006).
Hobart, M. 1993. 'Introduction: The Growth of Ignorance?' In M. Hobart (ed.), *An Anthropological Critique of Development*. London and New York: Routledge.
N.N. 1926. 'Le Midi Colonial et Maritime', *Silhouettes coloniales*, 16 décembre.
Robinson, D. 2000. *Paths of Accommodation: Muslim Societies and French Colonial Authorities in Senegal and Mauritania, 1880–1920*. Oxford: James Currey.
Said, E. 2001. 'The Clash of Ignorance', *The Nation*, 22 October.

Chapter 11

CONSTRUCTING CULTURE THROUGH SHARED LOCATION, *BRICOLAGE* AND EXCHANGE: THE CASE OF GYPSIES AND ROMA

Judith Okely

Theoretical Overview

This chapter addresses the vexed link between place and culture and the age-old presumption that cultural authenticity depends on a spatial as well as bounded isolate. As a student of anthropology, I recall world maps being placed on a board with marked places for peoples and their cultures. This may have had the intentions of expanding horizons, but it rooted culture, implying that it was defined by geographical location. While presented as the ideal, yet this is rarely what the anthropologist encountered in practice, although s/he may have felt obliged to invent and create cultural isolation in the field locality. Malinowski is an early example. His *Diary* (1967) revealed his daily encounters with non-indigenous traders, administrators and the influence of missionaries (Okely 1973, 1996). Yet such persons and cultural, political and economic influences were rendered near invisible or marginalized in his final public texts.

Despite the presumptive ideal of cultural and geographical isolation and fieldwork in a bounded location, many later anthropologists reveal leakages and problems of boundaries. Indeed both Leach (1954) and later Barth (1969) confronted and explored the creation of cultural boundaries where geographical isolation is not the causal explanation for separation and cultural distinctness.

While raising interesting questions about location, Gupta and Ferguson rest their iconoclastic arguments on a caricature of most previous fieldwork (1997). They seem to suggest that, long after Malinowski and well into the mid-1990s, anthropologists stayed in their one enclave presenting the ethnography as geographical isolate to the neglect of movement, migration and transnational changes. This straw or mud hut

version has long been inappropriate. The fixed link between geographical place and culture has been increasingly questioned even for sedentarized peoples (Olwig and Hastrup 1996). Those most likely not to have fallen into spatial trap were anthropologists studying Europe and other native anthropologists studying their own localities. They have had to confront the cultural variability and instability of culture(s) in place. Europeanist anthropologists, like minorities, have long ago lived the paradoxes of inhabiting geographically familiar but socially, unfamiliar contexts. The boundaries and divisions are lived and recognized as constructed.

Gypsies are a case study of the new interest in hybrid, border cultures. The focus on a minority in a Western context confronts the presumption of isolation as explanation for authenticity of culture. I, for one, hit the field a few miles from London in the 1970s and occupied a caravan in the arc lights of major motorways (Okely 1986, 1996 chapter 1). Fieldwork among the Gypsies was never a physically, let alone culturally, bounded place. Even the camps were open to non-Gypsy intrusion. They were demarcated in so far as only I and the Gypsies slept there. Fieldwork consisted as much of routes traversed by everyone else and in public non-Gypsy places such as house-dwellers' doorsteps, government offices and courthouses. When the subject of Gypsies appeared on television, word went round the camp and companions turned on their generator-driven sets in their trailers. They were thus open to and knowledgeable of the cultural representations of themselves as other in the non-Gypsy controlled mass media.

The field for the anthropologist was also a mental, imagined locale created by the people she was with and that included non-Gypsies. It could not become a permanent encultured space. Next week the patch of land could be abandoned, then fenced off, piled with council rubble or turned over by diggers. The field as place could thus be dug up, dumped upon and obliterated. Thus Gypsy culture for stigmatized and persecuted nomads was created from contrast and difference, if not conflict.

Gupta and Ferguson should, nevertheless, be applauded for assisting in destabilizing the classical linkage between place and culture, recognizing that 'anthropology appears determined to give up its old ideas of territorially fixed communities and stable, localized cultures, and to apprehend an interconnected world in which people, objects and ideas are rapidly shifting and refuse to stay in place' (Gupta and Ferguson 1997: 4).

For centuries, the Gypsies have been economically and politically intertwined with a wider sedentary economy and polity (Okely 1983, pp. 49–65). They provide a special example of culture as created in shared territory and which involves daily, ubiquitous encounters with non-Gypsies and their powerful representatives. In the last resort it is the non-Gypsies who hold the power, with potential for persecution.

At the same time, non-anthropologists, especially linguists concerned with Gypsies, or Gypsiologists, held fast to the sedentarist mythical charter which privileged an Indian origin going back to 10,000 A.D. (Okely 1997). They have sought to legitimate Gypsies in the light of a primordial, self sufficient and bounded whole. This freezes them in a mythical past as well as place. It colludes with rather than challenges the politically dominant non-Gypsy ideal of culture as place and geographical isolate. It also continues an Orientalist tradition, which privileges exoticism from which mod-

ern transformations are seen as dilutions and even contamination. The implication is that everything after the alleged departure from the mysterious and still contested exact Indian region is a loss of purity of culture.

The Gypsies refer to non-Gypsies or their Other as *gadjes* or *gorgios*. Silverman (2007) discusses how Roma musicians have themselves responded to the largely *gadje* interpretation of Roma/Gypsy by constructing for *gadje* consumption an Indian origin and alleged linear trail of similar orientalized 'Gypsy' music, regardless of the obvious dissimilarities. This was influenced by the film *Latcho Drom* (1993) a 'staged documentary which traces the musical diaspora from India to Spain' (Silverman 2007: 339). This has in turn encouraged promoters to make their Gypsy performers reenact such presumptions and conceal any musical instruments, costume or music which do not fit the *gadje* exoticized and presumed commercial potential.

The renewed focus on India parallels the burgeoning investment by displaced persons in imagined places and homelands. Some Roma representatives approached institutions such as UNESCO emphasizing Indian migration although regrettably Gypsies or Roma are likely to be more recently and regularly displaced as nomads in localities closer to their current abodes. I suggest the greater problem is the Gypsies' contemporary displacements rather than any centuries-old and mythical displacement from one alleged, unremembered, ancient homeland. Here also the Indianists have proclaimed their belief in a once-isolated cultural homogeneity.

The questions raised by research on Gypsies lock into what have now been recognized as mainstream concerns. Phillips and Steiner (1999) have drawn attention in subtle degrees to the problematization of hybridity in the discussion and collection of art and artefacts from non-Western cultures and locations. There is the notion of the pure and unadulterated object but indigenous creativity and ingenuity in confrontation with new forms and mass reproduction and external market demands. Their discussion of non-Western peoples and production focus on cultures, peoples and groups, which nonetheless are presumed to have been self-contained before any colonial/capitalist encounter. There is less discussion of the interrelationship between adjoining non-Western cultures.

Clifford notes:

> It is increasingly clear … that the concrete activity of representing a culture, subculture, or indeed any coherent domain of collective activity is always strategic and selective. The world's societies are too systematically interconnected to permit any easy isolation of a separate or independently functioning system. The increased pace of historical change … forces a new self-consciousness about the way cultural wholes and boundaries are constructed and translated … What is hybrid or 'historical' in an emergent sense has been less commonly collected and presented as a system of authenticity. (Clifford 1988: 231)

Phillips and Steiner explore this in relation to art (1999). The contributors to Gupta and Ferguson's 'Culture, Power, Place' (1997) trace 'ways in which dominant cultural forms may be picked up and used – and significantly transformed in the midst of the

field of power relations' (Gupta and Ferguson 1997: 5). They emphasize the 'sometimes ironic political processes through which cultural forms are imposed, invented, reworked and transformed ... Rather than simply a domain of sharing and commonality, culture figures here more as site of difference and contestation' (ibid.).

Ortner suggests that rather than 'banishing the concept of culture ... the issue is one of reconfiguring this enormously productive concept for a changing world' (Ortner 1999: 8). One imperative is to 'welcome the ethnographies and histories of "borderlands" of zones of friction (or worse) between "cultures" in which the clash of power and meaning and identities is the stuff of change and transformation' (ibid.). A second imperative is to

> emphasise the issue of meaning-making (ibid.). ... Even if as many thinkers now claim, there are fewer and fewer in the way of distinct and recognisable 'cultures' in the contemporary world ... the fundamental assumption that people are trying to make sense of their lives, always weaving fabrics of meaning, however fragile and fragmentary, still holds. (Ortner 1999: 9).

In fact we already have in the Gypsies or the Roma a centuries-old tradition of interlocking cultures between the Gypsies and non-Gypsies. Rather than being confronted with a sudden change, Gypsies have changed all along, through time and space. They are both an example of culture with 'distinct and recognisable' aspects (Ortner ibid.) in the borderlands and an example of continuous meaning-making in the face of a dominant encircling system with the greater political and economic power. This is inevitable, given the Gypsies have not inhabited a separate place nor geographical location, let alone a bounded political entity for centuries, if ever.

Instead, we should look at Gypsy, Traveller or Roma cultures as a complex and pioneering form from which refugees, migrants and emergent minorities might themselves seek to devise creative strategies. Gypsy culture inhabits and constructs its internal coherence alongside or in opposition to other dominating cultures; in the same geographical and political space. For example, the Gypsies' animal classification which deems some ritually polluted such as the cat and others special, such as the hedgehog, is constructed in part on the Gypsies' recognition that *gadjes* or non-Gypsies value the former and ridicule or ignore the latter (Okely 1983: 91–104). Their case has long destabilized the classical notion of culture as a geographically bounded entity grounded in place as isolate.

Michael Stewart, studying the Vlach Gypsies in Hungary (1997), suggests how, instead of a culture located in a mythical homeland of Indian origin, the Gypsies create an alternative and imagined autonomous space in song, horse dealing activities, communality, commensuality and speech. Anthropologists are increasingly alert to the ways in which the colonized have mimicked their colonisers. Previously, it was thought that this was mere deference, when in fact it was defiant reinterpretation and subversion (Taussig 1993). Gypsy culture inhabits and constructs its internal coherence alongside or in opposition to other dominating cultures; in the same space. Gypsies have created their own semi-autonomous cultural space. There may be cor-

respondences between what both Gypsies and non-Gypsies each see as their own culture(s). It should not be concluded that these have the same meaning for the different groups of Gypsies, Travellers and non-Gypsies.

The Gypsies have been creative *bricoleurs* (Lévi-Strauss 1966, Okely 1983); selecting from wider surrounding systems and inverting the meaning in line with their own interpretation. The apparent similarities are neither simplistic copying nor merely a result of influence by the majority systems on a supposedly passive minority. The Gypsies have both rejected and selected with finesse and aesthetic sensibility. Out of this creative process Gypsies have in turn given back and added new form to the surrounding dominant or other cultures. Gypsy, Traveller and Romany culture(s) take on semi-autonomous coherence. They are not archaic remnants disappearing under the hegemony of non-Gypsy systems, which forever confronts the ethnic minority.

I contend that Gypsies have for centuries provided a pioneering example of cultural coherence with continuing insider appropriations and constructions. These are then redefined on their own terms. Such reconfigurations at the same time have been dismissed as mere hybrid or passive imitation. Gypsies have continuously created and recreated their cultural autonomy with notions of authenticity in the midst of others' space and cultures. Authenticity does not lie in an imagined sedentarist place but in the Gypsies' historic ingenuity and inventive originality in the shadow of the ever present dominant other.

Gypsy culture is created through contact, sometimes conflict and specific exchange. Gypsy culture is one emerging from ever present and changing culture contact rather than a former isolate allegedly undermined by contact. Theirs is a culture created from and through difference.

Musical Examples of Hybridity

In Kertèsz-Wilkinson's study (1997), she argues that the Vlach Gypsies in Hungary make their own culture by dancing to a Hungarian tune and style, yet with 'Romanised steps and movements'. On a broader level it could be said that the Gypsies dancing to the non–Gypsies' tune, yet on their own terms, symbolises exactly the Gypsies' cultural and social predicament. The Gypsies subvert the dominant form in novel ways often invisible to non-Gypsies looking for pure and authentic, untouched cultural forms.

In a project I have overseen on Romungro Gypsy music making in Hungary with Kertèsz-Wilkinson as the researcher, it is illuminating that she initially found it considerably more difficult to gain access to the Romungro as opposed to the Vlachs. The former only speak Hungarian whereas the Vlach also speak Romanes, a Gypsy language. The presumption among many outsiders and doubtless some anthropologists was that it would be easier to gain access to a group not marked by a separate language. Yet the absence of a separate language points to the greater need for a group to create less obvious and constructed boundaries and barriers. The shared language between the non-Gypsy researcher, a native Hungarian speaker, was no proof of greater cultural

assimilation as might have been the presumed belief. In fact a shared language was all the more deceptive. The cultural boundaries were more subtle (Okely 2002). Similarly Carol Silverman (2007) has exposed how Balkan Roma on tour, especially in the U.S.A. create exotic so-called 'Gypsy' music in line with the expectations of the non–Gypsy marketing priorities and the stereotyped expectations of the audiences.

Exchange and Transformation of Objects with Opposing Authenticity

Gypsies also create difference through objects, which cross the borderlands. Some are sold or exchanged by Gypsies for non-Gypsy consumption. Others are selected, commissioned and purchased from non-Gypsies for Gypsy internal cultural elaboration. The former are used by Gypsies to enhance their exotic difference from non-Gypsies and to make financial gain from the transaction. The latter, through financial purchase from non-Gypsies, are used to create and affirm an autonomous cultural space for Gypsies. Thus a form of 'Gypsy culture' for non-Gypsies is invented partly through objects. This verges on pastiche. At the same time, but for different purposes, an alternative Gypsy validated culture, separate from non-Gypsies and often unknown to them, is created by Gypsies. I explore how this is enacted through objects. Gypsies select and acquire but which they then transform the meaning from that associated with or understood by the dominant society.

The circulation of goods and practices between Gypsy and non-Gypsy is highly significant but highly selective. As a group with nomadic non-sedentarist traditions, few material objects are made among themselves. Granted, nomadic pastoralists of the Middle East have made their own tents and weave carpets from their animals' wool. Unlike other nomads, whether hunters and gatherers or pastoralists, there can never be even the semblance of economic self-sufficiency for Gypsies. Engaged continuously in relations with others who have the economic infrastructure to produce goods, Gypsies have made use of those objects on their own terms rather than deciding to hand-make them themselves. There are some goods or objects, which they select and acquire because they have the potential to be transformed into expressions of their own values. It is no matter that these are made by the 'enemy', who interpret them for their own purposes.

Trivia

There is renewed interest in material culture, at least after an extended lull in British social anthropology. Museums established their own separate traditions of dealing with objects. Paradoxically, Malinowski's famous monograph 'The Agronauts of the Western Pacific' (1922) was devoted almost entirely to the circulation of two types of objects. Malinowski was keen to explore the wider context in which to Western eyes some apparently banal armbands and necklaces were exchanged across islands and after hazardous sea journeys, all without barter-like value. He emphasized how these

precious objects were utterly useless although highly prized and the subject of endless myth making through individual histories.

More recently ethnological museums have confronted in creative ways the problems of display and interpretation of seemingly dead things. They have begun to problematise the very choices and acts of display for different viewers (Phillips and Steiner 1999). Similarly the display of so called 'Gypsy cultural objects' identified in the same 'home' territory as the museum and curators raises problems about the criteria and contradictions in collections usually brought from afar (O'Hanlon and Welsch 2000, Gosden and Knowles 2001, Hendry 2005, Junghaus and Szekely 2007).

Here the Gypsies pose intriguing questions. On a number of occasions in talking to art connoisseurs and others, I have been informed that one major proof that Gypsies have 'no culture' is that they have no distinct material objects of their own. Non-Gypsy collectors cannot seek out and accumulate things like carpets for which other nomads are celebrated. There are some collections of Gypsy caravans and the occasional rare museum, e.g., in Reading, England and in Poland. But the records do not suggest that the wagons were always made by Gypsies. Instead, they were commissioned from non-Gypsy specialists, with the paintings completed by some Gypsy artists, but also by non-Gypsies. David Smith, a non-Gypsy art teacher, was often asked by Gypsies to paint their wagons.

Faced with this lack of exotic, museum collectable objects, over the years, I have found myself collecting apparently banal or trivial objects from my encounters with Gypsies. At the same time, these could not be placed in glass cases as aesthetic or immediately exotic objects. They could in no way act as trophies as researchers are increasingly depicting nineteenth century collections by Western explorers (O'Hanlon and Welsch 2000). I have always been impressed when visiting some Norwegian anthropologists' homes where each had their illuminated glass cabinet in their living rooms displaying as proof of their 'having been there' (Clifford and Marcus 1986) beautiful objects from either South-East Asia or South America. I could not do quite the same. But intellectual history moves on: seemingly banal if not trivial objects and detritus have come into their own.

Attfield is indicative of this growing interest in what she calls 'the material culture of everyday life'.

> In spite of the all embracing attempts to integrate 'commercial art' and industrially mass-produced products in the 'new art history' of the eighties, its subsequent re-categorization as visual culture failed to consider its materiality and the most distinctive qualities which make design different from art in its relationship to the everyday, the ordinary and the banal. (Attfield 2000: 3)

She regrets that 'the model of design history … disregards the social life of things that unfolds beyond the initial commodity stage'. In addressing the 'the physical embodiment of culture' she discusses the notion of authenticity and originality. The latter is a concept foreign to trade practices, which depend on repetition. Yet she argues for the 'role of domestic things in materializing the construction of self-identity' (2003: 5-7).

Similarly, I argue that in the case of the Gypsies, we find some mass-produced objects which in several contrasting ways embody forms of identity; either the perceived identity of Gypsies among non-Gypsies or the Gypsies' own usually hidden self-identity. It is not so much that the objects can necessarily be restricted to everyday life, rather they take on meaning in the very exchange across the cultural and ethnic divide. That is they take on an exotic form in the transaction. They may be seen by the Gypsies as trivia in their own circles but with potential for transformation when exoticized by them for non-Gypsy consumption. On the other side, non-Gypsy manufacturers or salespersons may not know the ethnic significance and transformation of objects, which they themselves sell to Gypsies.

While considering objects as embodiments of culture and identity, Attfield does not consider ethnic identity and exchange across boundaries. The exchange between Gypsy and non-Gypsy is crucially concerned with ethnic contrast. This is also different from the Trobriand *kula* circulation of objects. Although the *kula* takes place between potentially hostile islands, there is a shared and agreed value placed on the necklaces and armbands. This contrasts with the differing and often unshared values placed in the objects exchanged between Gypsy and non-Gypsy.

Material Objects in Gypsy-*Gadje* Exchange as Contrasting Categories of Culture

Those presented and imaginatively transformed in transactions initiated by Gypsies and sold to *gadjes*. They are often used as mediators for the act of fortune telling. Such objects may be partly hand-made by Gypsies or mass manufactured in *gadje* factories, but transformed by presentation into exotic goods for *gadje* eyes and beliefs. Such objects may not in fact be considered real or meaningful goods in terms of the Gypsies' own ethnic less visible values. Second, those goods which the Gypsies select or commission and purchase or acquire from *gadjes* and which they transform as signals of their own ethnic values, especially in relation to pollution beliefs and daily habitus (Bourdieu 1982).

Objects Created as 'Real' Gypsy for Gadje, not Gypsy, Consumption.

(1) 'Hand-made' objects

In the earlier folklore writing and still in popularist texts it is asserted that 'traditional' Gypsy occupations were based often on their handicraft skills. Gypsies have hand-made wooden clothes pegs. I encountered only one such person who did this as long ago as the 1970s and I was sold some in the 1990s in Hull. Other objects sold on the doorstep which approximate to the authentically hand-made are wooden or paper flowers (see photograph in Adams, Okely et al. 1975: plates 6 and 7, pp. 217; 248). I have examples of wooden chrysanthemums carved skilfully from sticks and then dyed. These I acquired in the 1970s. But I have not seen any since.

Then there were the wax flowers: made of melted wax in a rose-like shape placed on sticks. I was taught by a Gypsy fellow-hawker how to make such objects when I went calling with her. When I asked my Gypsy fellow-hawker 'Surely those privet leaves on the sticks will die?' She answered 'It won't matter, we'll be gone'. She, as Traveller on the move, had little interest in the long-term life of such transient objects. When we had some left over, these were never used as display within her or neighbours' trailers. These hand-made objects had no value for the Gypsies' own display and consumption.

Since my earlier fieldwork, when accompanying the Gypsies, and now as anthropologist, at the receiving end as house-dweller, I have been sold paper flowers made from either lavatory paper or paper handkerchiefs. They were wired to freshly cut privet with healthy green leaves. I have retained these objects but cannot display them in a lit cabinet like my Norwegian anthropologist friends as trophies of my professional authenticity. Long since, the leaves have died and droop, as in fact we would expect real flowers to do. I suggest that, in contrast to the wax flowers I once made with my Gypsy work partners, there is an added irony in the paper flowers. Made from lavatory paper for unmentionable bodily cleansing, they have been re-presented by Gypsies as ornaments and objects of beauty for *gadje*, but not for Gypsy interior space.

The Gypsies recognized the importance of presenting objects to *gadjes* as the product of a specialized craft. One Gypsy woman described how when she went hawking, a major item was lace: 'We say we made it ourselves but we get it by the yard in Noggingham' (i.e., Nottingham).

Years before tourism privileged the cultural authenticity of native hand-made crafted cultural objects, the Gypsies were aware of the advantages of selling authenticity in the guise of ethnic products. Now mass global tourism exploits and indeed recreates or invents the notion of local and indigenous authenticity for the sale of items to outsiders. The following example presents the ultimate paradox of an Asian woman assisting Europeans in the production and sale of local European authenticity.

For example, in 2001 in Bruges which sells its image as home of a special lace, I discovered that the bulk of this is imported from Taiwan and recycled as the 'authentic locally hand-made' product from this iconic beautiful European town. Thus lace, like culture, was authentic if associated with traditional place, although in practice now bogus.

The creation of indigenous authenticity for external consumption has indeed a longer history than mass tourism. Daniel Miller (1987) also describes how image construction has operated in the oriental style of cloth. Researchers at London's Victoria and Albert Museum, at first presumed that some distinctive textile was 'made in the original style of a group of people' (Miller 1987: 123) but in fact it evolved over time in response to the taste of the British at that time. 'There emerged a style embodying an image of what the European consumers thought the Indian manufacturers ought to be making' (ibid.). Thus Orientalism was objectified (Said 1978).

Similarly, the Gypsies through trial and error have evolved their own exoticism to please the *gadjes* who also have their own idea of what a true Gypsy embodies. The objects usually play on a specific contrast. As Miller suggests, 'the object may lend

itself equally to the expression of difference, indicating the separate domains to which people or aspects of people belong' (Miller 1987: 130).

(2) Fortune-telling and 'gold' charms

Lace selling and hawking for Gypsy women are often an entrée for fortune telling. For the latter, one Gypsy woman who did not indeed tell fortunes explained to me:'You have to look Gypsified; put on gold earrings and say "cross my palm with silver or paper money nowadays"'. Thus she was fully aware that being exotic entailed a performance.

In 'Own or Other Culture' (Okely 1996) I have explored how fortune-telling, like the selling of ostensibly hand-made lace to the *gadje*, is asymmetrical in knowledge. Generally, the Gypsies do not believe in the supernatural powers accredited to them, although they recognise that character reading skills and long-term experience are required. The Gypsies are in effect giving good psychotherapy. But they do not engage in fortune-telling among themselves. It is the *gadje* who credits supernatural powers to Gypsies. A sedentarist society sees the geographically and occupationally mobile as both threatening and mysterious therefore with potential if not real magical power. Thus a people seen as placeless are constructed as with magical powers. They are 'here today and gone tomorrow'.

The so-called gold charms which Gypsies sell as intermediaries between household utilities and the opportunity for fortune-telling are of the cheapest metal quality. But they are sold to the *gadjes* for a relatively high financial price to the Gypsies' advantage. Like the lace, such objects are bought in bulk from long-established *gadje* contacts. They are brass trinkets then sold back to other *gadjes* for perhaps £5 a piece or more if calculated for the money earned in the fortune telling session. Such objects, in this face-to-face encounter, are performatively imbued by the Gypsy with a special power, to bring good fortune to the non-Gypsy recipient. Gypsies or Roma throughout Europe and in North America prize and recognise real gold which they would never mix up with fake gold, but it seems the *gadjes* will accept such goods. The fake gold *gadje*-made objects are thus transformed into 'true' Gypsy items when sold back in the circular cultural exchange. The Gypsies, it seems, have the *Midas* touch.

In my earlier analysis of fortune-telling (Okely 1996 ch. 5), I described how, despite my awareness of the Gypsies' scepticism about fortune-telling for themselves, I found myself having mine told. A Gypsy woman had spotted my anxiety when walking in Durham market place. It proved to be excellent ethnography. But the final irony was the charm, which she then sold me was a small plastic elephant. And it was white. In Britain the 'white elephant' is a powerful metaphor. A dictionary definition is:'anything which gives more trouble than its worth ... an unwanted possession, often given away at a jumble sale: something which proves to be useless' (Chambers 1983: 404). Thus the Gypsy has the last ironic laugh at the property accumulating *gadje*.

Classically, the Gypsy fortune-teller has been associated with another distinct material object, which acted as vital mediating and transitional object; namely the crystal ball. The paintings by Laura Knight give excellent portrayals of Gypsy women advancing their objects for the *gadje* gaze (see image in Okely 1996: Figure 5.1: 96).

The crystal ball exemplifies all the potential ambiguity in objects. The Gypsy here can claim to see what is appropriate for the *gadje* client. Again by trial and error, through exploratory statements and assertions, she can give what the client wants – for a fee. As already noted, such an encounter is also used to ascertain the house-dweller's openness to fortune-telling. That is when the charms come out. They may be sold 'just for luck' without further moves to fortune-telling.

(3) Others' manufactured goods for *gadjes*

From my examination of the literature, it seems that Gypsies, up to the 1950s or later, peddled manufactured goods often in rural areas where the goods may not have been so easily available. There are other manufactured items which have no exotic pretensions but which convey other meanings; not the promise of good fortune but cleanliness. Here the sale of goods from Gypsy to *gadje* reveals the contrasting beliefs among Gypsies that non-Gypsies are dirty, especially inside their houses (Okely 1983: 77–104). I noted throughout my home-based fieldwork in the 1990s, Gypsies acting as door-to-door salespersons selling common household goods such as dusters, brushes, tea towels, mass-produced clothes pegs and car cleaning clothes to us *gadjes*. All such items are associated with washing and cleaning.

The circulation of goods manufactured by *gadjes* or, in some few cases, hand-crafted by Gypsies and then transformed as Gypsy items sold to *gadjes*, reveals aspects of the relations between the ethnic minority and the representatives of the non Gypsy majority. In the Gypsies' case, the recycled, selected items are moments when the transaction reverses the usual asymmetrical power relationship between the dominant sedentarist political and economic majority and the vulnerable, often mobile ethnic minority.

(4) *Gadje* objects selected or commissioned for Gypsy consumption and their cultural validation

(4.1.) Wagons

The classical or traditional horse-drawn wagons were generally commissioned from sedentary *gadje* craftsmen, with some exceptional Gypsies engaging in their construction. The skills and artistic talents of the few specialized Gypsy wagon-painters can be examined for creativity in selective imitation and recreation transferred to new contexts.

In the 1930s, one English Gypsy spent hours looking at shop window displays of carpets whose overlapping designs influenced his style (Smith 1997). Here is an example of the Gypsy as artistic *bricoleur*, taking something from the dominant system and giving it new meaning in the Gypsy context simultaneously subverting other's cultural hegemony. After the era of horse-drawn transport, wagons remained a repository of new decorative traditions. Over time, the painting designs were greatly elaborated and cultural differences were explicitly amplified.

(4.2.) Motor-drawn trailers

From the late 1960s, the wealthy Travellers or Gypsies commissioned from non-Gypsy manufacturers special motor drawn, not horse-drawn trailers as they call

them. These are heavily beaded with stainless steel and their interiors are noted for their ornately designed mirrors (see Okely 1983: 29). In accord with Gypsy pollution beliefs, such trailers have neither internal lavatories nor sinks, (Okely 1983: 77–104) thus unlike caravans designed for dirty *gadjes*. By the late 1990s, the main firm, which constructed these went out of business. At the same time, the Gypsies seem no longer to commission such elaborate easily identifiable exteriors. The reasons are not fully clear. One is that they did not want to appear too conspicuous. Nonetheless, those who now use the Internet enjoy a special website devoted to images of these authentic cultural objects made Gypsy by non-Gypsies. Thus new traditions were created to make sense of and fit with a changed context. Additionally a new generation of semi-settled Gypsy individuals, educated at art school have taken such objects and re-presented them in photographs and other framed forms as art pieces (e.g., Baker 2007: 14f; 43ff). Such re-presentations of Gypsy material culture are again transformed for a *gadje* metropolitan consumption, namely the Venice Biennale.

While becoming less functional as day-to-day living abode, the earlier painted wooden wagons, sometimes with canvas roofs, have been elevated to an even more powerful symbol of authentic Gypsy identity and past history. I have a miniature example of a traditional horse- drawn Gypsy wagon made by a Gypsy. It is largely materially accurate in its mechanics. But it was not made on a Gypsy site as some traditional activity. It was indeed made by someone who was a camp neighbour of mine during fieldwork. But it was made some time later during a lengthy spell in Wandsworth gaol. It does indeed bear the hallmarks of innovation in that it is meticulously constructed from material at hand, namely matchsticks. It shows inside knowledge of how the cart can be pivoted. But this was made in *gadje*-dictated space far from the Gypsy community. Given that I know that the specific Gypsy craftsman had been ostracized by the Gypsy community for his crime of rape, albeit a *gadje* woman, it may be that the exotic artefact helped to restore his dignity where, in prison, he would also be vulnerable to other prisoners as a sex offender. He sold the item to a sympathetic solicitor.

(4.3.) Crockery for Gypsy and *Gadje*

Other especially significant objects acquired from non-Gypsy manufacturers are: antique china (Okely 1983: 87), cut glass vases, stainless steel washing up bowls and water containers. Selected, usually Crown Derby China, is displayed on upper shelves or in glass cabinets (Okely 1983: 82). It is rarely if ever used but is a celebration of purity and the value of objects associated with unpolluted cooking, cleaning and eating. This antique crockery is also a storage of value. Some designs are favoured over others and can in crises be sold to either *gadje* or Gypsy.

On occasions, Gypsies acquire crockery with paintings of Gypsy caravans and similar motif. I only rarely saw such items on display. They were put away in the cupboards. Ironically some could be sold back to *gadjes* who were recognized as sympathetic if not sentimental about Gypsies. I was sold such a set by a Gypsy woman with ethnically near-stereotyped images of long-skirted Gypsies with horse and wagons.

Later, a Finnish Gypsy visiting my house (Okely 1996, Figure 3.2: 54) was fascinated by such items and wept when I gave her one of the cups. This was a tiny and

insignificant repayment for what Gypsies in general have given me in hospitality and shared knowledge. In July 2006, a Bulgarian Roma student whose Master's dissertation I supervised, graduated. Her parents attended the ceremony in Oxford. I gave the remaining 'Gypsy' cup and saucer to the Roma mother. She has, I am informed, put it in on display back home. Thus the anthropologist entered the Maussian circulation of Gypsy cultural objects.

Gold jewellery is greatly valued and perfectly suited to a travelling group, which carries only portable wealth. Acquired from non-Gypsies it takes on its own intense cultural significance. Women wear earrings, men rings. The designs are highly specific, i.e., although made by the 'enemy', only certain kinds are favoured. Earrings are ornate and circular. Mens' rings ideally have jagged edges; lethal in fist fights.

(4.4.) *Gadje* Objects for Gypsy Death Rituals

While Gypsies select and appropriate specific objects for their own cultural significance, it cannot be presumed that such objects are held in perpetuity. Ideally, all property of a deceased person should be destroyed. The traditional wagons and modern caravans are burned. It is said that not only the clothes and personal possessions of the dead are burned but also the valuables. In practice this may be left ambiguous. A smaller trailer may be burned and the more expensive one, worth thousands of pounds, may be transported and resold across the country where its owner was not known to the purchaser. At the elaborate funerals for the dead, wreaths are made in the form of replicas of the most prized items of the dead, e.g., a miniature lorry, a Pepsi-Cola bottle and a pony or a chair as symbol of sedentarization in death (Okely 1983: 220).

These floral items are commissioned from and made by non-Gypsies who in these instances are creating transient items as pastiche of the original items for the Gypsies. This is a reverse activity and the *gadjes* are lucratively rewarded for their handcrafted labour. Like the wax and paper flowers sold by Gypsies to non-Gypsies, these material objects are degradable. But in this case they are more elaborate and costly. Headstones, also commissioned from non-Gypsies are long-lasting material objects and the only long-term monuments but final resting place for this historically nomadic peoples (Okely 2003). Whatever the Gypsies' skills at flower design, they do not put them into practice in death rituals. Like other aspects of mortuary rites, it is the task of *gadjes* to deal with the pollution of Gypsy death and the consequent transformation of individual Gypsy identity (Okely 1983: 215ff).

To Conclude

The Gypsies or Travellers have been deeply involved in the recycling of non-Gypsy waste, broken down into different parts and resold back to the non-Gypsy. As with the waste material which they recycle, so they recycle other manufactured objects represented as their unique 'hand-made objects' as Gypsy exotic culture for non-Gypsy consumption. They also salvage, select and commission objects from non-Gypsies.

These objects 'found', within the non-Gypsy manufacturing process, are then symbolically transformed into material embodiments of their own separate Gypsy ethnicity. Thus both the culture and exchange of material objects can only take this form where there is overlapping geographical place and national polity between different peoples rather than any claims to cultural and regional isolation and separation.

There are some informative parallels between the transformations enacted by Gypsies and the work of the Cubists and Duchamp.[1] Like Duchamp, they elevate 'ready-mades' into aesthetic creations, although specifically into symbols of cultural separateness. What has been dismissed as mere copying or practicality is subtle reformation. Although economic and political inter-dependence is inescapable, the Gypsies yet strive for autonomy by exploiting exoticism in others' desires and longings, while simultaneously constructing difference through an alternative aesthetic. Gypsy cultural identity is constructed through opposition not isolation.

Note

1. 'In making collages and assemblages, Picasso and Braque seized upon discarded materials transforming the detritus of urban life into art. Sculptures too were constructed from found objects. In its most radical form, this introduction of everyday items into the elevated realm of culture became 'ready made'– 'a mass produced article displayed as a work of art' (Tate Modern, Tenth Gallery).

References

Adams, B., J. Okely et al. 1975. *Gypsies and Government Policy in England*. London: Heinemann Educational Books.
Attfield. J. 2000. *Wild Things: The Material Culture of Everyday Life*. Oxford: Berg.
Baker, D. 2007. 'Images'. In T. Junghaus and K. Szekely (eds), *Paradise Lost. The 1st Roma Pavilion*. La Biennale di Venezia: Open Society Institute.
Barth, F. 1969. 'Introduction'. In F. Barth (ed.), *Ethnic Groups and Boundaries*. London: Allen and Unwin.
Bourdieu, P. 1982. *Outline of a Theory of Practice*. Cambridge: Cambridge University Press.
Chambers Twentieth-Century Dictionary. 1983. Edinburgh: Chambers.
Clifford, J. and G. Marcus (eds). 1986. *Writing Culture: The Poetics and Politics of Ethnography*. Berkeley: University of California Press.
Clifford, J. 1988. *The Predicament of Culture*. Cambridge, MA: Harvard University Press.
Gosden, C. and C. Knowles. 2001. *Collecting Colonialism. Material Culture and Colonial Change*. Oxford: Berg.
Gupta, A. and J. Ferguson (eds). 1997. *Culture Power and Place, Explorations in Critical Anthropology*. Durham: Duke University Press.
Hendry, J. 2005. *Reclaiming Culture: Indigenous People and Self-Representation*. New York: Palgrave Macmillan.
Junghaus, T. and K. Szekely (eds). 2007. *Paradise Lost. The 1st Roma Pavilion*. La Biennale di Venezia: Open Society Institute.
Kertèsz-Wilkinson, I. 1997. 'Song Performance: A Model for Social Interaction among Vlach Gypsies in South-eastern Hungary'. In T. Acton and G. Mundy (eds), *Romany Culture and Gypsy Identity*. Hertford: University of Hertfordshire Press. Pp. 97–126.
Leach, E. 1954. *Systems of Highland Burma*. London: G. Bell and Sons.
Lévi-Strauss, C. 1966. *The Savage Mind*. London: Weidenfeld.

Malinowski, B. 1922. *The Argonauts of the Western Pacific*. London: Routledge and Kegan Paul.
____. 1967. *A Diary in the Strict Sense of the Term*. London: Routledge and Kegan Paul.
Mauss, M. 1967. *The Gift*. New York: Norton.
Miller, D. 1987. *Material Culture and Mass Consumption*. Oxford: Blackwell.
O'Hanlon, M. and R. Welsch (eds). 2000. *Hunting the Gatherers: Ethnographic Collectors, Agents and Agency in Melanesia, 1870s-1930s*. Oxford and New York: Berghahn.
Okely, J. 1975. 'Gypsy Women: Models in Conflict'. In S. Ardener (ed.), *Perceiving Women*. London: Malaby. Pp 55–86. (Reprinted in Okely 1996).
____. 1983. *The Traveller-Gypsies*. Cambridge: Cambridge University Press.
____. 1996. *Own or Other Culture*. London and New York: Routledge.
____. 1997. 'Some Political Consequences of Theories of Gypsy Identity: The Place of the Intellectual'. In A. James, J. Hockey and A. Dawson (eds), *After Writing Culture*. London and New York: Routledge.
____. 2002. *Music as Roma Cultural Performance: The Magyar Gypsies in Hungary*. Leverhulme Final Report F/00181/C.
____. 2003. 'Deterritorialised and Spatially Unbounded Cultures within Other Regimes', *Anthropological Quarterly* 76(1) 151–164, Winter.
Olwig, K. Fog and K. Hastrup (eds). 1996. *Siting Culture: The Shifting Anthropological Object*. London: Routledge.
Ortner. S. (ed.). 1999. *The Fate of 'Culture:' Geertz and Beyond*. Berkeley: University of California Press.
Phillips, R. and C. Steiner (eds). 1999. *Unpacking Culture: Art and Commodity in Colonial and Postcolonial Worlds*. Berkeley: University of California Press.
Said, E. 1978. *Orientalism*. New York: Pantheon Books.
Silverman, C. 2007. 'Trafficking in the Exotic with "Gypsy" Music: Balkan Roma, Cosmopolitanism, and "World Music" Festivals', Chapter 10, in D. Buchanan (ed.), *Balkan Popular Culture and the Ottoman Ecumene: Music, Image and Regional Political Discourse*. Lanham MD: Scarecrow Press. Pp. 335–361.
Smith, D. 1997. 'Gypsy Aesthetics, Identity and Creativity: The Painted Wagon'. In T. Acton and G. Mundy (eds), *Romany Culture and Gypsy Identity*. Hertford: University of Hertfordshire Press. Pp.7–15.
Stewart, M. 1997. *The Time of the Gypsies*. Oxford: Westview Press.
Taussig, M. 1993. *Mimesis and Alterity: A Particular History of the Senses*. London and New York: Routledge.

Chapter 12

CULTURAL REGIMES OF AUTHENTICITY AND
CONTEMPORARY ART OF AFRICA

Thomas Fillitz

Looking at publications by anthropologists before the 1970s, authenticity does not seem a major concern in the study of societies and cultures (e.g., Graburn 1999: 350, Steiner 1995: 100). This however does not imply that the authenticity, or the genuineness of a (material) culture, would not have been a concern of researchers in anthropology. If we look at diaries and field notes of researchers of the late nineteenth and early twentieth century, we can see the great interest they had in authentic objects. Personalities like the German ethnographer Leo Frobenius, who collected during his travels in Africa more than ten thousand artefacts and artworks, have developed specific strategies how to get offered such old objects of high quality, and how to get them for good prices.

From the mid-1970s on, authenticity has been a seriously debated topic in relation to works of art and ethnographic artefacts – about criteria of their authenticity, or their inauthenticity. In the context of present-day processes of globalization, claims for culture of minority groups are also claims for preserving an authentic character of it. Nowadays, anthropologists actually are more reluctant to use the notion as an analytical tool (see e.g., Muršič this volume). Regina Bendix suggests that removing 'authenticity and allied vocabulary is one useful step towards conceptualizing the study of culture in the age of transculturation' (Bendix 1997: 9). Why then authenticity?

Authenticity is, as Nelson Graburn remarks, nowadays a 'popularly important concept' (Graburn 1999: 352). Shelly Errington collected new uses of the notion, such as 'the look is authentic', as argument for buying a mass reproduced poster of a Van Gogh painting, or 'authentic museum reproduction', or the 'authentic native' artist (Errington 1998: 70; 150).

The quest for authenticity, as it is analysed in this contribution,[1] is not only referring to the object itself, or to a particular behaviour. It is above all a referent for our social self-positioning vis-à-vis others and the consequence of a specific gaze on

others. In early July 2006, for instance, a journalist of the Austrian Broadcast Company asked me during an interview: 'It is generally acknowledged that African and Aboriginal art are much faked!' Such a statement entails not only the question about the originality, uniqueness, the genuineness and the age of the piece. It is also a question whether African art dealers, African and Aboriginal artists are more fakers than their homologues in the European/North-American art world. There is, moreover, the implicit assumption that there are on the one hand the correctly behaving people, in quest of the authentic piece, who conform to the values and norms of the global art world. On the other there are the incorrect acting ones.

Authenticity, I am arguing, is the social construction of core cultural properties. Value systems are created, are enacted and contested within entangled cultural spaces, and they may be changed. I shall look at such productions and conflicting relations regarding contemporary art of Africa in the global art world. Institutions and particular specialists intervene in various art worlds as authorities in order to determine the particular validity of an artwork, i.e., its quality as authentic work of art of Africa. As contemporary objects, it is hard to argue their authenticity on the grounds of references to some past value, or tradition. Being clearly placed within spaces of post-colonial African modernity, such artworks may hardly be characterized by some genuine, traditional cultural iconographic values. Rather, the aspect of de-traditionalization (Whiteley 2000) determines their cultural position, i.e., the breaking with these old, cultural values of representation and the concomitant search for new ones. Another striking features of the construction of the 'African' contemporary artwork becomes apparent, when considering which ones are transferred into the European/North-American art world and which others are not.

My following reflections are not only placed within the framework of the authentic object as differentiated from the replica, the imitation, the forgery, etc. (e.g., Elkins 2005). More important for my considerations is Denis Dutton's differentiation between two notions of authenticity: nominal authenticity and expressive authenticity (see also Banks, this volume). The former determines 'the correct identification of the origins, authorship, or provenance of the object, ensuring, as the term implies, that an object of aesthetic experience is properly named' (Dutton 2003, n.p.). The latter is what I would call the anthropological context of the object. In Dutton's terms, expressive authenticity has 'to do with an object's character as a true expression of an individual's or a society's values and beliefs' (Dutton 2003, n.p.).

Both notions are closely connected. The correct knowledge of a place of origin, of the artist and of the time when it was produced, is a prerequisite for determining the object's meaning and uses. Regarding traditional African art, nominal and expressive authenticities are strongly determined by some primitive character implicitly requested by collectors and explicitly produced by African traders (Price 1989, Steiner 1995). For nominal authenticity authorship, precise place of origin and various owners are hidden, or not asked for by the client. For expressive authenticity, if the collector was not 'on the spot', the knowledge about the primary meaning and the object's uses are reconstructed either according to information from art dealers, or by referring to publications of researchers who have been in the region at a time. But

do we know, or do we consider, whether the object has been affected by the ongoing social process? Do we know changes in the knowledge and the techniques connected to the object?

In this contribution, expressive authenticity of contemporary art of Africa will be used in order to connect the selected works and discussions to ideas and representations of African societies and cultures, which are imaginative representations of collectors, art dealers, gallery owners, exhibition curators, art historians, artists, etc. The notion thus may be unravelled not as a perennial, essentialist one. Quite on the opposite: the authenticity of the work of art takes different meanings, according the institutions and those specialists who are differently placed in the global and regional art worlds and who are looking from different, multiple viewpoints on these objects.

I shall consider the examples from a broader vantage point in the final section. Considering these processes as 'cultural regimes of authenticity' – I use the notion in analogy to Jay Martin's 'scopic regimes' (Martin 1992) – I aim at showing the politics of authenticity (and of culture), articulated in entangled spaces of power, where the various concepts meet, clash and are contested. If authenticity may have appeared in early twentieth century closely connected to some romantic image of cultural purity, some production to dominate an exotic other, it is, rather, connected to concepts of cultural diversity when we consider the creation of contemporary art of Africa. In all these analytical considerations of the notion, authenticity is a problematic notion, as it seems closely connected to the social agents we as anthropologists are looking at, i.e., the various socio-cultural contexts we are bringing in. This also means that it is a heterogeneous and changeable category, more or less consciously produced, and not an immutable one.

Contemporary Art of Africa and Authenticity

The search for African traditional art by collectors is still prominent today in the European/North-American art world. Nevertheless, other art forms in Africa have reached attention in the second half of the twentieth century. Tourist art came into focus as a specific art form (Graburn 1976, Jules-Rosette 1984), popular art (e.g., Fabian 1978, Jewsiewicki 1991), the *colon* artworks (Liking, undated) and modern or contemporary art (e.g., Beier 1968, Mount 1989, Fosu 1993, Gaudibert 1991, Kasfir 1999). Whereas the high quality of traditional art was considered to be an articulation of the cultural pure, isolated character, we must consider all these new art forms within intensive processes of interaction with Europeans and North Americans. Major European specialists for traditional art despized these new art forms and considered them as markers of the ruin of the high quality of traditional African art (Fagg in Beier 1968: 3): or, else, the notion of the 'death of authentic primitive art' became the dominant metaphor (Errington 1998).[2]

Although we may trace the history of modern art of Africa back to the late nineteenth century, two events stimulated the European/North-American art world to focus on these developments: the *Premier Festival Mondial des Arts Nègres* in Dakar in

1966, and the exhibition *Magiciens de la Terre* in Paris (1989), which led to the consequent collection of contemporary art of Africa, and to the 'Contemporary African Art Collection' (CAAC).³ An American collector, Jean Pigozzi, got interested by these art forms after having visited the Paris exhibition. He hired André Magnin as curator and director of the collection, and in particular to travel intensively within the African continent, and find and collect what they considered as contemporary art.

Questions of authenticity were raized in both contexts: however in quite different ways. The Dakar festival was an important expression of President Senghor's vision of art and culture, his *Négritude* ideology, for the development of the new independent state. Writers, painters, historians, linguists, sociologists and anthropologists from African states, Europe and America debated issues for a contemporary artistic expression in Africa, and of how Senghor's idea of a *civilisation de l'universel* (civilisation of the universal) as expressed in the *Négritude* movement, could be represented. The artistic problem was the question of the representation of modernity as experienced in African societies after independence. The problem in the context of the global art world was the one of selection, between traditional African art on the one hand and Occidental classical modernism on the other.

In his intervention in Dakar, the Nigerian artist Ben Enwonwu remarks that the concepts presented by anthropologists were of little or no use for the contemporary African artist (Enwonwu 1967: 431). Understandably, as at the time of the Dakar festival, contemporary art had been considered neither by anthropologists of African studies, nor by art historians working on African art. Both were engaged with traditional African art, and, mostly, with African (rural) cultures. Some like Michel Leiris had acknowledged the impact, which was at stake for these African artists. After the Dakar festival Leiris nevertheless articulates it from the viewpoint of the European observer who has a distinct image of a particular Africa.

> I found this art a bastard one. They are no more real Africans, as they have been trained according to Occidental standards, or they have had many contacts with Occidentals … In some way they are sitting between two chairs. Further, in order to find again an African authenticity, this notion was spelled out at a point during the symposium, they achieve without wanting it a total inauthenticity. It makes things difficult to want to create an African authentic art, as they are mostly de-Africanized [déafricanisé, in Leiris's terms]. (Leiris in an interview with Paul Lebeer in 1967: Lebeer 1994: 90; my translation)

Leiris in some way builds on a formulation of the *Négritude* philosopher Aimé Césaire. The latter had spoken of the two dangers of inauthenticity for the contemporary African artist, the one of wanting to be exclusively Occidental, and the other exclusively African, 'if one wants at any costs to do it the African way' (quoted by Leiris; Lebeer 1994: 98; my translation).

To understand Leiris's and Césaire's assertions, one has to recall that at the time of the *Premier Festival Mondial des Arts Nègres* artists of the *Négritude* movement had already produced new forms of expression. They were taking up themes of traditional

cultures (e.g., masks), used vivid colours, and aimed at representing rhythms. The Nigerian Ben Enwonwu too had developed new forms in respect to his 'authentic image of Africa' (Enwonwu 1967: 430). I also would like to mention Christian Lattier from Côte d'Ivoire, who was attributed the festival's sculpture price. He had developed a new sculptural expression with his sculptures made of ropes (Konaté 1993). Léopold Sédar Senghor further quotes André Malraux, who had expressed at the inauguration of the Dakar festival that there were in Senegal 'five or six artists who can match the greatest European artists for stature' (Senghor 1995: 218), artists like Ibou Diouf, Papa Ibra Tall, or El Hadji Sy.

The shift of meaning between both statements is significant, and clarifies the use of the notion of authenticity. Michel Leiris operates with the correspondence to either cultural contexts. African culture is obviously what he experienced during the Dakar-Djibouti expedition in the 1930s, rural traditional life. But according to him, the contemporary African artist is stuck betwixt and between European and African cultures: what Leiris calls *déafricanisé* (Lebeer 1994: 90). The artist therefore cannot create African authentic art. In other words, Michel Leiris maintains authenticity as a value of a culture, defined in its pure, homogeneous nature. The formulation of the de-Africanized African person actually raises the question: in which dimension can an African be said to be more or less African, and by whom: who determines cultural authenticity (see Kasfir 1992)?

Further, Leiris's statement refers to two aspects of the notion of authenticity. First, he operates with a fundamental culture core: the real, pure, unaffected African society, obviously less metropolitan and more rural. Second, he mentions the work of creating an African art, the act of finding an African authenticity. This use of the notion refers to the particular production in view of the recognition by others, the European/North-American art world.

Aimé Césaire's formulation of the dangers of inauthenticity does not make reference to any fundamental culture core. Rather, the decision of the authenticity or inauthenticity appears as a matter of the artist's authority in view of recognition of his work. Césaire's warning of the dangers of inauthenticity concerns the aspect of aiming at pleasing the beholder at any cost, or of too easily using a particular system of reference. This brings into discussion the artist in his serious practices, the one who is searching for an apt expression, as against the one who simply uses so-perceived markers to serve the images of the audience. Seriousness actually is given when questioning the cultural context, within which the artists were working at the time. This one was characterized not by any pure African culture, but by the imprints of colonial regimes and specifically too by the struggle for independence. Neither the longing for a pre-colonial culture and art (the traditional African art) could be a solution, nor an artistic production conforming to Occidental modernism.

I would like to speak of a process of de-traditionalization, following Nigel Whiteley, who applied the notion to the European Modernist art rhetoric (Whiteley 2001: 12). The cultural norms, against which authenticity was defined, were those of a pre-existing (traditional) culture. Clearly, Michel Leiris was influenced by this kind of thought. Aimé Césaire's statement shows that this normative system is no

more given, or can no more act as referent for the authentic contemporary artwork. The traditional acknowledged cultural values have been destroyed by the impact of colonialism. In the context of older African societies, contemporary art is placed within a comparable rhetoric, in as far as the norms and validities for its production were given no more.

At the same time, European art cannot act as such a referential system. It is the art of colonial rule and was eroded by the very structure of its regimes of exploitation. If the category of the authentic artistic expression could be used, then by shifting towards the artist himself in relation to local modernity. Authenticity now gets connected to the quality of the artistic endeavour, the consistency of the artist's activity with his means for creating a work of art, his intentions and his experience of local African modernity. This is the meaning of the serious artistic endeavour. Considering these two contexts, de-traditionalization articulates the disjuncture with two pasts and relates the creative new trajectory to the artist's reflexive activity.

The European/North-American longing for an authentic African modern art is fed by another idea of authenticity. When I discussed the issue of contemporary art in Africa with art historians and gallery owners here in Europe, I was often confronted with their claim that African artists should come back to the vernacular, traditional art and innovate it, without relying on stylistic borrowings from modern European/North-American art. This according to them would be authentic modern art of Africa. The idea is not new. It actually was practiced between the 1940s and 1960s in the workshop schools, such as those of Pierre Romains-Desfossés (1946, Lubumbashi), Pierre Lods (1951, Poto-Poto), Frank McEwen (1957, Harare), or Uli Beier (1961, Ibadan-Oshogbo). Beier describes one of the main principles as the 'short cut:' as Occidental modernism of the early twentieth century was largely influenced by the discovery of traditional African art, why should young artists from Africa get formed in European art schools, or be trained in Occidental art history? On the contrary, their training should directly link the experience of traditional African art to the search of contemporary artistic expressions (Beier 1968: 59).

In this perspective, historical norms without European intervention could be reappraised and could determine anew the artwork's authenticity. Leaving apart the social and cultural transformations due to the history of colonialism, these commentators do not see major, implicit aspects of their reasoning. Could the contemporary African artist experience and reflect these genuine pieces from a similar perspective as the traditionally trained one? Which kind of knowledge would be activated?

The student of the workshop schools would look at these artworks from a formal perspective, learning these forms, or copying them. The African artist trained in European art schools too would approach these works from a formal point of view, but in a similar way in which artists from the European/North-American art world would approach them, namely with the knowledge of formal solutions to problems of expression and representation as expressed in Occidental art history. The way these latter would look at these pieces would be the gaze of the modern Occidental artist, whereas the former would adopt a gaze basically unaffected by Occidental education, but not of the experience of local African social modernity. In both areas, the context

of activities would be African modernity, the social, cultural and economic spheres within which s/he would create her/his artworks. Neither the workshop-artist, nor the artist trained in the Occident, has the contextual knowledge the traditional artist had and has. It is a matter of fundamentally different trainings and formations.

If authenticity, however, is a construct of a pure, cultural formation, unaffected from any outside influence – quite similarly to old concepts of culture as bounded and homogenous – there seems to be a serious problem with the authenticity of contemporary art of Africa. Although the workshop schools seem to connect to art practices before the conquest of African social formations, the artistic productions in these centres are centrally influenced by these European colonial agents. The example of the artists having had an Occidental art education expresses the deep breach, which had occurred with the colonial impact. Looking from both sides, the problem is that the old artworks have an intensive connection between the normative dimension and the expressive. That one implies a knowledge, which none of the two groups can reach, as it is connected to some secret knowledge, acquired in particular traditional settings, and to specific uses which do not allow exhibition practices as it is the usual practice in contemporary art worlds in places the world over.

Let us turn now to the other event, the collection of contemporary art of Africa after the *Magiciens de la Terre* exhibition (Paris 1989). Here I refer to debates which stem from the reception of the most prominent Pigozzi collection, the Contemporary African Art Collection (CAAC). The curator, André Magnin, was concerned with collecting modern art, which is largely unaffected from European/North-American art education and which expresses some originality. With his intensive travels in Africa, Magnin brought together a wide range of works of art (Magnin 1992). One could not say that they were all connected in one way or another to traditional art and ritual life: although some works certainly are (see Magnin and Soulillou 1996). Jan Hoet, the former curator of documenta IX – the most important show for contemporary art in Kassel – characterized these works of art as follows:

> In my opinion these works are typical of a period of transition. A period in which the individual experiences the feeling of being trapped in the midst of the conflict between the 'animist' world of yesterday and the quest of today and tomorrow, a quest for survival in a technological and material world. (Hoet 1992: 30)

Curators, art critics and artists from Africa living in Europe or Northern America have critiqued collections such as the one of Jean Pigozzi for its 'neo-primitivising African artists' (Oguibe 1994: 56f) and that most prestigious spaces of exhibition of the European/North-American modern art world have been opened to this kind of art, but not to other images of contemporary art of Africa (see Fillitz 1999; 2002: 278ff).[4] According to these critics, true contemporary art is at stake, the one connected to modernity as a universal category. Such an art is grounded within the artistic knowledge produced by discourses and achievements of contemporary artists, as commented and classified by Occidental art history. Why, they ask, shouldn't this be true for African artists as well? Would not these artists render true authentic images of modern Africa?

In order to give their position a better voice, some of these artists, curators and critics, founded the Forum for African Art. This institution was presented to the public during the fourth Biennale of Dakar, Dak'Art, in 2000 by Olu Oguibe and Salah Hassan. Their claim was to decide in the future the selections of African contemporary artists who would participate at important international venues, such as the Venice Biennale. Olu Oguibe and Salah Hassan, both of African origin and based in the U.S.A., assisted by Emma Bedford from South Africa, were in charge of the selection of African artists for the Venice Biennale 2001 (Hassan and Oguibe 2001) and at the fiftieth Biennale in 2003, other members of the group organized the show 'Fault Lines' (see Tawadros and Campbell 2003).

These controversies are, as Thomas McEvilley emphasizes, two different approaches for exhibiting contemporary art of Africa (McEvilley 2005: 40ff). I would say that two distinct systems of normativity are confronting each other. One pleads for a notion of the contemporary artwork according to the dominant European/North-American determined concepts. The other position considers the contemporary artwork of Africa in relation to local African modernities and in opposition to the dominant European/North-American concepts. Actually both parties also include in their presentations the same artists, such as the Ivoirian Frédéric Bruly Bouabré, the *Béninois* Georges Adéagbo and others. Their work however is subsumed in one case (the Forum for African Art) to art critical discourses and categories (e.g., conceptual art) as they are current in the European/North-American art world for artworks created within these spaces. Regarding the discourse and the preference of the CAAC, these artists are valued for their originality and particularly for finding an expression, which has nothing to do with Occidental art historical discourses. What looks so African, then, is according to André Magnin not a marker for an authentic neo-Primitivist modern African culture. The artwork, rather, is viewed as product of connecting to multiple cultural fields in African societies.

Cultural Regimes of Authenticity

In this section, I would like to deal with those major aspects, which have been discussed so far more empirically, in order to develop to some thoughts about the notion of authenticity further. The search for the authentic object is obviously driven by different criteria. Both the Forum for African Art and the CAAC claim authority for validating the expressive authenticity of contemporary art of Africa. But they do so on the basis of different meanings and different referential systems. Both rely on different concepts of the true, contemporary, serious artist. For the Forum, this notion designates those artists who fit into the global art system according to criteria determined by the European/North-American art world. For the representatives of the CAAC, a preference is accorded to those artists who are more connecting themselves to expressions of local African modernities and less to criteria of the Occidental modernist rhetoric, if at all. In the former case, the serious artist is the one who is concerned with world art discourses, in the latter one, the true and serious are determined by the reference to local cultural experiences.

The claim of authenticity by other members and institutions of the European/North-American art world affects the creation of contemporary art in Africa in another dimension. This notion requests a process of going back to traditional African art (see e.g., Leiris), and of developing a so-intended genuine contemporary art of Africa, without any interference of European academic art education, and Occidental art history: best exemplified by the workshop schools of the 1940s and 1950s. As I have outlined above, this way of thinking is determined by the implicit assumption that such a re-connection to a pre-colonial cultural situation would be possible and could be paralleled by the concomitant negation of any influx of European modernity for further artistic reflections.

Moreover, we have to consider the viewpoints or orientations of local art worlds in various African places. These latter, however, cannot be dealt with in a general perspective and the major question was actually, how these particular, local art worlds were constituted. In the late 1960s Dakar's art world conceived African art according to the *Négritude* ideology. This orientation was rejected by another generation of artists during the 1970s. Academic training, in any case, became a core element of determining authentic contemporary art far into the 1990s. In the 1990s, the art world of Abidjan considered its great masters as those creating such a true art. These artists had been formed in the 1970s at the School of Fine Art in Abidjan, *Institut National des Arts*, most of them had been trained as well in France. Their imperative was first to be trained according to standards of the European/North-American art academies. Artists articulated this dominant criterion as the one which enabled them to consider themselves as primarily belonging to the community of artists of the world: independently of whether their artworks were accepted within the European/North-American art world or not. The other most important, but nevertheless secondary criterion was their search within this concept of (European) modernism in art an African dimension. That latter one was conceived in a quite heterogeneous way. Its most radical expression is in the search of a specific trajectory, which is not linked to European/North-American modernism. It may, further, refer to an African spirit in the act of expression, to an African modernity, to a sensibility of a particular milieu, to the appropriation of regional, vernacular art traditions and so forth (see Fillitz 2002: 230ff).

Considering the contemporary artwork from the viewpoint of various art worlds, we may realize how differently they are perceived, experienced and categorized. We must be aware, however, that institutions and their specialists are distributing the artwork in specific cultural fields. They are claiming authority for determining its validity. This may be the criterion of the unaffectedness from Occidental modernism with the concomitant junctures to local African socio-cultural contexts, mostly branded as traditional, stemming from rural cultures. It may as well be the radical interconnection with categories of the contemporary, Occidental art history, or some in-between positions of local art worlds in African places, which demands the artwork to be a product of the combination of Occidental modernism, or the art world tout court,[5] with the search of some African dimensions. These processes are largely independent of how artists themselves consider their referential systems they are interacting with in their artistic endeavour.

The transfer of artworks between various art worlds, or between differently located institutions within one and the same art world, but also the activity of determining its cultural field, therefore, is equivalent to movement between different classificatory systems (Kasfir 1992). Regarding Occidental art history, James Elkins speaks of discrete steps in distinct epochs for the movement from the authentic work of art to the inauthentic one. Each step is constituted by 'historically determined categories and habits of thought' (Elkins 1993). In connection with the art-artefact dichotomy, mostly applied to the discrimination between the European/North-American fine art and the non-European ethnographic object, James Clifford developed an art-culture system and determined four fields or 'semantic zones:'

> (1) the zone of authentic masterpieces, (2) the zone of authentic artefacts, (3) the zone of inauthentic masterpieces, (4) the zone of inauthentic artefacts ... Most objects – old and new, rare and common, familiar and exotic – can be located in one of these zones or ambiguously, in traffic, between two zones. (Clifford 1996: 223)

The four zones so defined distribute objects between areas of the authentic, such as fine art (1) and ethnographic material culture (2) and those of the inauthentic, fakes and technical objects (3), tourist art and technical reproductions (4). Clifford also calls this art-culture system 'a machine for making authenticity' (1996: 224). Although this model is focusing on the object already within the European/North-American culture world, and mostly on so-called traditional art, it nevertheless unravels this transition when applying different criteria of categorization, according to which the object may belong to one or another of these categories. These are not only acts of inclusion or exclusion, these placements too may consist in relegating contemporary artworks into particular cultural institutions: instead of the contemporary art museum to the museum of ethnography.

Authenticity designates a construction, the production of cultural properties, which are allocated some essentialist or core connotations. These are cultural categorizations we are producing for ourselves of objects of others and thus of these other cultures. But these classifications are neither perennial nor unchangeable, as the values attributed do not form any quality inherent to the artwork.

Individuals from specific institutions, specialists, are at the centre of the construction of such value systems. Clifford's art-culture system is based on analysing such processes of fixing the authenticity of objects, or their relative inauthenticity by considering ideas and images we have of cultures. It highlights that such systems of value ascription are actor centred, dynamic and changeable, and are not isolated from each other, but are operating in entangled spaces. Marcus and Myers suggest a focus on the traffic of artworks, instead of aiming at scrutinizing any original, or vernacular meaning (Marcus and Myers 1995). Given that the category of art of the object is established in the European/North-American art world independently of an original context of that same object, they propose to focus precisely on the very processes of re-contextualization, of boundary tracing, or on the particular form of circulation the work is subjugated. The cultural allocation of the work of art, then, should be consid-

ered as materialization of images of other cultures and as products of specific politics of culture. These latter are politics of determining authenticity and the processes of authentication, politics of authority claims, politics of the power of display, as well as politics of the production of culture (see Appadurai 1995: 57).

All the examples so far developed are embedded within contexts of transcultural interactions. But in all cases so far mentioned, we can find in each case a specific centred construction of the authentic artwork, with the exclusion of the idea of its relationality. The most powerful centre is the European/North-American art world with the tool of Occidental art history: be it by bringing the artwork into its narrative, or by positioning it in opposition to such a way of perceptual subjugation. This implies a first activity of de-traditionalization in reference to the values of Occidental modernism (see Whiteley 2001: 8), but with different means. In the one case it would be a questioning of the forms so far achieved, in the other it is by emphasizing the disjuncture of the artistic activity from any such interaction. There is another de-traditionalization occurring, namely the quest of modernism of the African artist. This modernism is a product of the colonial regimes, of the subordination by European Empires. It further includes the anti-colonial struggles and the times of independences achieved in their aftermath. De-traditionalization in this very context refers to socio-cultural African post-colonial modernity(ies) and forces contemporary artists to reflect on their interaction with some kind of traditional culture as being embedded in the quest for the present expression and not as a turning back into an unreachable (pure) tradition.

Shmuel Eisenstadt proposed to think the project of modernity in the world as 'multiple modernities'.[6] This concept is, first, referring to different projects of modernity of specific cultures at a global scale. The concept of 'multiple modernities' asserts that the project of modernity is not only the one of Europe and North America. This modernity project is being adapted, transformed and repositioned within manifold contexts, which so far would not appear as being congruent with it. Second, the concept pays attention to the reflexivity inherent in the process of modernity and its permanent challenge and re-adaptation in Europe and elsewhere. It is in this latter meaning most powerful insofar as it 'presumes that the best way to understand the contemporary world ... is to see it as a story of continual constitution and reconstitution of a multiplicity of cultural programs' (Eisenstadt 2002: 2).

One therefore should consider in African states the combination of institutions, which had been created by the colonial regimes (e.g., the presidential system) with others, which stem from other social structures, such as local chiefs and kings: which have been altered during these epochs as well. In the domain of visual arts, a new art system was introduced, with conjunctures or disjunctures to pre-existing ones, and other such systems were established during these times. The stories of modern art in Africa are, in this perspective, stories of continual reshaping and readjusting. The social and cultural contexts are manifold and cannot be restricted to such binary relationships as between traditional and modern, rural and metropolitan, or between popular and official culture. There are entangled spaces with ongoing, often asymmetrical, cultural flows, affecting everyday life in multiple manners.

The question is not a matter of modernity as a universal phenomenon, but of articulating the specificity of Afrocentric modernities as differentiated from the European/North-American project of modernity. There have been, since, a plurality of patterns, such as the quest for national artistic expressions during the epochs of the struggles for independence in the 1950s, the search for participating in the creation of national cultures for the newly constituted states in the 1960s, or for debating the place of art of Africa and its diaspora within global art from the 1980s until the present.

Authenticity is no longer determined within pre-conceived, homogenous cultures, and can no more be characterized by some hypothetical cultural core. Processes of authentication take place within heterogeneous spaces of culture. They must rather be perceived and analysed as the production of purity within spaces of intensively crisscrossing trajectories. Acknowledging such heterogeneous cultural spaces allows us to better view the field of artistic creativity, which is not reduced to one cultural context of core values. That latter would imply that the subjugation under one hegemonic narrative would be reproduced, the one dictated by the European/North-American art world. On the contrary, whereas specialists claiming authority for the validity of the artwork conceive of them from a centred and single oriented perspective, the artist's spatial network is constituted by different local, artistic expressions in African cultures – early modern and contemporary ones, traditional and others – and in interaction with the ones of the European/North-American art world. Artists I have worked with in Ivory Coast and Benin have in many different ways connected their endeavour with reflections, discourses, and material realizations of multiple cultural fields.

In these perspectives, the quest for authenticity of contemporary art shifts into a matter of cultural diversity. But is this the same concept in the many discourses of specialists or audiences in the European/North-American art world, or for the artists themselves?

Conclusion

Should authenticity be removed from the anthropology's vocabulary, as Regina Bendix (1997) or Rajko Muršič (this volume) suggest? André Magnin, in charge of the CAAC, also asserts that debates of the authenticity or inauthenticity of contemporary art of Africa, do no constitute a real issue.[7] These categories do not refer to the historical frameworks, within which contemporary African artists should start their reflexive work. Nor do these notions have any relevance in connection to the actually created works of art (and collected by him). According to Magnin, these artworks are not representations of another primitivizing of African cultures and societies by Europeans. He instead insists on the many socio-cultural fields, which have as correspondent a highly varied landscape of contemporary artistic production in Africa (Magnin 1998: 52f).

But the examples showed that there are, actually, a lot of claims of expressive authenticity out there: in this very chapter related to the various art worlds. Should we just leave it at the remark that the quality of authenticity is produced by socially

and culturally differently positioned agents, be they the claimants of authority (the specialists in the art worlds), the wider public (with some ideas and images about cultures in Africa), or the artists, claiming the power of original meaning?

I agree that authenticity is not an analytical tool for anthropologists. We can no more either look for some authentic – primitive? – socio-cultural formation and we cannot pretend that only what is not affected by the colonial encounter is authentic. We should, however, redirect our ethnographic, analytical interest to the social distribution of our interlocutors and the ways they are using the notion. What is achieved with it? What are consequences of the use of the notion? In this contribution, I used the notion of 'cultural regime' to emphasize that the construction of the authentic, contemporary work of art of Africa first means a particular way of looking at this art, which is informed by images of African cultures.

The cultural regimes considered enhance a power of display, a making visible within the global art world or of negating visibility, and hindering the public to see and experience such other works. This power of display further creates a power of economic value production: [8] by exhibiting the artwork in museums of contemporary art, or by positioning it within specialized market institutions, such as galleries, or auction houses like Sotheby's or Christie's. Works of artists from the CAAC had been auctioned on a major scale for the first time by Sotheby's on 24 June, 1999 in London.[9] All works have been sold, most at a higher prize then estimated, thus augmenting the market value of the works of art of these artists. These strategies also render possible a social and cultural differentiation among social actors, for instance the collector or connoisseur in contrast to others such as the less educated, or the less worldly, or less experienced.

There are, obviously, social, cultural and economic implications, at individual, institutional, regional, or national dimensions connected to the production of expressive authentic artworks. At an institutional level, one needs but looking at the tremendous impact of new centres wishing to position themselves as world cities, the politics of city governments, national governments, or transnational corporations to attract, produce and fund new global art centres (see Weibel and Buddensieg 2007). Cultural regimes of authenticity then also refer to seeing these various spaces of authenticity production not as isolated socio-cultural ones. They form, rather, entangled spaces, within which contestation, and asymmetrical flows do occur, but where too, the revolt against subjugation and negation is expressed.

Notes

1. I would like to thank all the participant of the Sokrates Intensive Programme 'Movement I: Debating Authenticity' for their valuable discussion during the programme, and in particular, my colleague and collaborator in many projects, Anna Streissler, for her subsequent highly valuable comments and corrections.
2. One may wonder, as Shelly Errington does, where all these pieces of authentic traditional art still emerge from (Errington 1998: 120).
3. Today, the collection amounts to more than six thousand pieces.

4. Such criticism has recently been renewed following the exhibition 'Africa Now' at the Museum of Fine Arts in Houston (2005; personal communication by Jean and John Comaroff, Vienna, June 2006).
5. Art world here is used in Arthur Danto's meaning, as the egalitarian community of artworks (Danto 1965, 1996).
6. Shmuel Eisenstadt's article 'Multiple Modernities' was first published in 2000 in *Daedalus* 129(1).
7. Personal communication, Paris, February 1997.
8. See Jean-Pierre Warnier's notion of the 'moral economy of authenticity' (this volume).
9. 1999. *Contemporary African Art from the Jean Pigozzi Collection*, Auction Catalogue, Sotheby's, London, 24 June.

References

Appadurai, A. 1995. 'Introduction: Commodities and Politics of Value'. In A. Appadurai (ed.), *The Social Life of Things. Commodities in Cultural Perspective.* Cambridge: Cambridge University Press. Pp. 1–63.
Beier, U. 1968. *Contemporary Art in Africa.* New York: Frederick A. Praeger.
Bendix, R. 1997. *In Search of Authenticity. The Formation of Folklore Studies.* Madison, Wisconsin: University of Wisconsin Press.
Clifford, James. 1996. *The Predicament of Culture. Twentieth-Century Ethnography, Literature, and Art.* Cambridge, MA and London: Harvard University Press.
_____. 1997. *Routes. Travel and Translation in the Late Twentieth Century.* Cambridge, MA and London: Harvard University Press.
Danto, A.C. 1964. 'The Artworld', *Journal of Philosophy* 61: 571–84.
_____. 1996. Wiedersehen mit der Kunstwelt: Komödien der Ähnlichkeit. In A.C. Danto, *Kunst nach dem Ende der Kunst.* München: Wilhelm Fink. Pp. 47–70. *Beyond the Brillo Box: The Visual Arts in Post-Historical Perspective*, New York: Farrar Straus Giroux (Original 1992. *Beyond the Brillo Box: The Visual Arts in Post-Historical Perspective*, New York. Farrar Straus Giroux).
Dutton, D. 2003. 'Authenticity in Art'. www.interdisciplines.org/artcognition/ (Access 14 September 2005; Original in *The Oxford Handbook of Aesthetics*, ed. by J. Levinson. New York and Oxford: Oxford University Press.
Eisenstadt, S.N. 2002. 'Multiple Modernities'. In S.N. Eisenstadt (ed.), *Multiple Modernities.* New Brunswick, NJ and London: Transaction Publishers. Pp. 1–30.
Elkins, J. 1993. 'From Original to Copy and Back Again'. www.interdisciplines.org/artcognition/ (Original in *The British Journal of Aesthetics* 33, no. 2). (Access 14 September 2005).
Enwonwu, B. 1967. 'Le point de vue de l'Afrique sur l'art et les problèmes qui se posent aujourd'hui aux artistes africains'. In *Colloque sur l'Art Nègre – Premier Festival des Arts Nègres.* Société Africaine de Culture/Society of African Culture (ed.). Paris: Présence Africaine, vol. 1. Pp. 429–438.
Errington, S. 1998. *The Death of Authentic Primitive Art and Other Tales of Progress.* Berkeley: University of California Press.
Fabian, J. 1978. 'Popular Culture in Africa: Findings and Conjectures'. *Africa* 48(4) 315–334.
Fillitz, T. 1999. 'Afrikanische Gegenwartskunst und westliche Diskurse der Inklusion oder Exklusion'. In H.P. Hahn und G. Spittler (Hg.), *Afrika und die Globalisierung.* Schriften der Vereinigung von in Deutschland, vol. 18. Münster-Hamburg-London: Lit Verlag. Pp. 283–291.
_____. 2002. *Zeitgenössische Kunst aus Afrika. 14 Künstler aus Côte d'Ivoire und Bénin.* Vienna: Böhlau.
Fosu, K. 1993. *Twentieth-Century Art of Africa.* Accra: Artist Alliance.
Gaudibert, P. 1991, *L'Art Africain Contemporain.* Paris: Diagonales.
Graburn, N.H.H. (ed.). 1976. *Ethnic and Tourist Art. Cultural Expressions from the Fourth World.* Berkeley: University of California Press.
_____. 1999. 'Epilogue: Ethnic and Tourist Arts Revisited'. In R.B. Phillips and C.B. Steiner (eds), *Unpacking Culture. Art and Commodity in Colonial and Post-colonial Worlds.* Berkeley: University of California Press. Pp. 335–53.

Hassan, S. and O. Oguibe. 2001. ' "Authentic/Ex-Centric" at the Venice Biennale: African Conceptualism in Global Contexts'. *African Arts* XXXIV (4) 64–75; 96.

Hoet, J. 1992. Untitled. In A. Magnin (ed.), *Africa Now. Jean Pigozzi Collection*. Catalogue. Groningen Museum Novib. Pp. 29–30.

Jewsiewicki, B. 1991. 'Painting in Zaïre: From the Invention of the West to the Representation of Social Self'. In S. Vogel (ed.), *Africa Explores Twentieth-Century African Art*. New York and Munich: The Centre for African Art and Prestel. Catalogue. Pp. 130–151.

Jules-Rosette, B. 1984. *The Messages of Tourist Art – An African Semiotic System in Comparative Perspective*. New York and London: Plenum Press.

Kasfir, S.L. 1992. African Art and Authenticity. *African Arts* XXV (2) 40–53; 96.

____. 1999. *Contemporary African Art*. London: Thames and Hudson.

Konaté, Y. 1993. *Christian Lattier. Le sculpteur aux mains nues*. Saint-Maur: Sépia.

Lebeer, P. 1994. *Au-delà d'un regard. Entretien sur l'art africain – avec M. Leiris*. Bruxelles: Éd. Sainte-Opportune.

Liking, Werewere. Undated. *Statues colons*. Paris: Les Nouvelles Éditions Africaines.

Magnin, A. (ed.). 1992. *Africa Now. Jean Pigozzi Collection*. Groningen Museum Novib. Catalogue.

____. 1998. 'Welten, Welt'. In *Triennale der Kleinplastik. Zeitgenössische Skulptur Europa Afrika*. Trägerverein der Triennale der Kleinplastik e.V. (Hg.), W. Meyer, Künstlerischer Leiter. Osterfildern-Ruit: Cantz. Catalogue. Pp. 51–58.

Magnin, A. and J. Soulillou. 1996. 'Introduction'. In A. Magnin and J. Soulillou (eds), *Contemporary Art of Africa*. New York: Abrams. Catalogue. Pp. 8–17.

Marcus, G. and F. Myers. 1995. 'The Traffic in Art and Culture: An Introduction'. In G.E. Marcus and F.R. Myers (eds), *The Traffic in Culture. Refiguring Art and Anthropology*. Berkeley: University of California Press. Pp. 1–51.

Martin, J. 1992. 'Scopic Regimes'. In S. Lash and J. Friedman (eds), *Modernity and Identity*. Oxford, England and Cambridge, MA: Blackwell. Pp. 178–195.

McEvilley, T. 2005. 'How Contemporary African Art Comes to the West'. In *Africa Now. Masterpieces from the Jean Pigozzi Collection* (ed. André Magnin). London and New York: Merrell Publishers and the Museum of Fine Arts Houston. Catalogue. Pp. 34–43.

Mount, M. 1989. *African Art. The Years since 1920. With a New Introduction by the Author*. New York: Da Capo.

Oguibe, O. 1994. 'A Brief Note on Internationalism'. In J. Fisher (ed.), *Global Visions. Towards a New Internationalism in the Visual Arts*. London: Kala P. and the Institute of International Visual Arts. Pp. 50–59.

Price, S. 1989. *Primitive Art in Civilized Places*. Chicago: University of Chicago Press.

Senghor, L.S. 1995. 'Ce que je crois'. In C. Deliss (ed.), *Seven Stories about Modern Art in Africa*. London: Flammarion. Catalogue. P. 218.

Steiner, C. 1995. *African Art in Transit*. Cambridge: Cambridge University Press.

Tawadros, G. and S. Campbell (eds). 2003. *Fault Lines. Contemporary African Art and Shifting Landscapes*. London: The Institute of International Visual Arts. Catalogue.

Weibel, P. and A. Buddensieg (eds). 2007. *Contemporary Art and the Museum. A Global Perspective*. Ostfildern: Hatje Cantz.

Whiteley, N. 2000. 'Art in the Age of De-Traditionalisation'. In N. Whiteley (ed.), *De-Traditionalisation and Art. Aesthetic, Authority, Authenticity*. London: Middlesex University Press. Pp. 1–10.

Notes on Contributors

Marcus Banks is Professor of Visual Anthropology at the School of Anthropology, University of Oxford. Research interests: visual anthropology, especially visual methodologies; ethnographic film history; India; Jainism; ethnicity and nationalism. Recent publications: (2007) *Using visual data in qualitative research*. Articles: (2007) 'The Burden of Symbols: Film and Representation in India'; (2006) 'Visual Anthropology Is Not Just Ethnographic Film: The Visual as Material Culture'. Marcus Banks is currently preparing a research project on image use and creation in forensic science contexts, looking at issues of 'skilled vision' and evidentiality.

Roy Dilley is Professor of Social Anthropology at the University of St. Andrews. He has long-standing research interests in West Africa including Islam and craft industries in Senegal, the practice of French colonialism in West Africa, the anthropology of knowledge and ignorance. Recent publications: (2004) *Islamic and Caste Knowledge Practices among Haalpulaaren, Senegal*; (1999) Roy Dilley (ed.), *The Problem of Context*. Articles: (2005) 'Time-Shapes and Cultural Agency among West African Craft Specialists'; (2004) 'Visibility and Invisibility of Production'. A new research project is entitled *Colonial Lives, Imperial Contexts* and examines the historical ethnography of colonial life in French West Africa from 1890 to 1940.

Thomas Fillitz is Associate Professor of Social Anthropology at the University of Vienna. He was visiting professor at the Université des Sciences et Technologies Lille-1 (2001, 2003), at the Université Lumière Lyon-2 (2008), and at the Université Paris-Descartes, Paris-5, Sorbonne (2011). Research interests: art worlds and global art, visual culture, globalization and transnational processes. Recent publications: (2002) *Zeitgenösssische Kunst aus Afrika. Vierzehn Künstler aus Côte d'Ivoire und Bénin*. Article: (2011) 'Worldmaking – The Cosmopolitanization of Dak'Art, the Art Biennale of Dakar'. A recent research project deals with art biennales as contested spaces of a global culture, focusing in particular on the Biennale of Dakar, Dak'Art.

Andre Gingrich is Professor at the University of Vienna's Department of Social and Cultural Anthropology and directs the Social Anthropology Unit at the Austrian Academy of Sciences. He has directed field projects in Tibet, has conducted fieldwork

in south-western Arabia and Austria, archival research on the history of anthropology, as well as methodological analyses. Recent publications: (2006) co-edited with Marcus Banks, *Neo-Nationalism in Europe and Beyond*; (2005) with Fredrik Barth, Robert Parkin, Sydel Silverman, *One Discipline, Four Ways: British, German, French and American Anthropology*; (2002) co-edited with Richard G. Fox , *Anthropology, by Comparison*. Article: (2007) 'Interview with Walter Dostal'.

Rajko Muršič is Professor at the Department of Ethnology and Cultural Anthropology of the University of Ljubljana. Research interests: popular music, theory of culture, methodology of anthropological research, philosophy of music, cultural studies, political anthropology, kinship studies, and social structure in Slovenia, central and south-eastern Europe, and transnational spaces. Fieldwork in Slovenia, Poland, Macedonia, Germany and Japan. Recent publications: (2007) co-edited with J. Repič (eds), *Places of Encounter: In memoriam Borut Brumen*; (2007) co-edited with B. Jezernik, A. Bartulović, and J. Repič (eds), *Europe and its Other: Notes on the Balkans*. Articles: (2008) 'Ambiguities of Identification and Alterity from the Perspective of Popular Culture: A Few Examples from Former Yugoslavia'; (2008) 'The Colourful Airwaves of Skopje: On Macedonian Radio Broadcasting and Its Prospects'.

Judith Okely is Professor Emeritus of Anthropology, Hull University, and Deputy Director IGS, Queen Elizabeth House, Oxford and Research Associate, School of Anthropology, Oxford. Publications: (1996) *Own or Other Culture*; (1983) *The Traveller-Gypsies*. Articles: (2008) 'Knowing without Notes'; (2007) 'Gendered Lessons in Ivory Towers'; (2007) 'Debate with G. Marcus'; (2005) 'Gypsy Justice versus *Gorgio* Law: Interrelations of Difference'.

Jorge Grau Rebollo is Associate Professor at the Department of Social and Cultural Anthropology, Universitat Autònoma de Barcelona (UAB). He was visiting professor at the University of Vienna (2005) and has taught at different universities (Universitat Pompeu Fabra, Universitat de Barcelona, Universitat Autònoma de Barcelona, University of Vienna). Grau Rebollo has also been a visiting scholar at Stanford University. Research interests: kinship, adoption and circulation of children, visual anthropology and cinema. Recent publications: (2006) *Procreación, género e identidad. Debates actuales sobre el parentesco y la familia en clave transcultural*; (2002) *Antropología Audiovisual*. Articles: (2005) 'Antropología, cine y refracción: Los textos fílmicos como documentos etnográficos'; (2004) 'Parentesco y adopción. Adoptio imitatur naturam. ¿Nature vs. nurture?'.

A. Jamie Saris is Senior Lecturer of Social Anthropology at the Department of Anthropology of the National University of Ireland-Maynooth. He has been working for fifteen years in medical and psychological anthropology in Ireland and North America. For the past five years, he has focused on issues connected to poverty and structural violence in European cities, especially in Dublin. He sits on the Editorial Board of *Culture, Medicine, and Psychiatry* and was until recently editor of *The Irish*

Journal of Anthropology. Recent articles: (2008) 'Institutional Persons and Personal Institutions: The Asylum and Marginality in Rural Ireland'; (2008) 'An Uncertain Dominion: Irish Psychiatry, Methadone, and the Treatment of Opiate Abuse'.

Inger Sjørslev is Associate Professor of Social Anthropology at the department of Social Anthropology of the University of Copenhagen. Fieldwork in Brazil and Denmark. Main publication: (1999) *Glaube und Bessessenheit. Ein Bericht über die Candomblé-Religion in Brasilien*. Recent publications have dealt with performance, museology and cultural heritage. Inger Sjørslev is currently working on materiality and sociality in the context of housing in Denmark.

Lawrence J. Taylor is Professor of Anthropology and former Dean of International Education at the National University of Ireland-Maynooth. He has conducted extensive research in Ireland and on the U.S./Mexico Border. Publications: (2001) with photographer Maeve Hickey, *Tunnel Kids*; (1995) *Occasions of Faith: An Anthropology of Irish Catholics*. Articles: (2007) 'Centre and Edge: Pilgrimage and the Moral Geography of the U.S./Mexico Border'; (2007) 'The Minutemen: Re-enacting the Frontier and the Birth of a Nation'. These, along with the present chapter, are parts of a larger project, tentatively entitled, *Lines in the Sand: Moral Geography at the Edge of America*.

Paul van der Grijp is Professor of Anthropology at the Université Lumière Lyon-2, and a member of both the Anthropological Research and Study Centre (CREA) in Lyon and the Research and Documentation Centre on Oceania (CREDO) at the Maison Asie-Pacifique in Marseilles. Recent publications: (2006) *Passion and Profit: Towards an Anthropology of Collecting*; (2004) *Identity and Development: Tongan Culture, Agriculture and the Perenniality of the Gift*.

Jean-Pierre Warnier is Professor Emeritus of Social Anthropology of the Université Paris-Descartes Paris-5, Sorbonne. He is presently a member of the Centre d'Etudes Africaines, (EHESS, Paris). He has done extensive research in the kingdoms of western Cameroon, with particular emphasis on their economic history since 1700, on the local and regional hierarchies, and on the embodiment of power in their material culture and bodily conducts. He taught for three years in Nigeria and six years in Cameroon. For the last ten years, he has been developing a praxeological and political approach to material culture. Recent publications: (2007) *The Pot-King. The Body and Technologies of Power;* (2004) co-edited with J.-F. Bayart (eds), *Matière à politique. Le pouvoir, les corps et les choses*; (1999) *Construire la culture matérielle. L'homme qui pensait avec ses doigts*; Articles: (2005) 'Inside and Outside. Surfaces and Containers;' (2001) 'A praxeological approach to subjectivation in a material world'.

Index

Abbey, E. 70, 77
Adams, B.J. 203, 209
Adéagbo, G. 218
Adorno, T.W. 43n7, 44, 48, 50, 58
agency 47, 65, 74, 106n9, 111, 120–124, 125n1, 125n8, 164, 177
Aïdara, A. 180
Afrique Occidentale Française (A.O.F.) 187, 190
alienable 32, 52, 87–88
alienated 19, 30, 32, 49, 125n8, 135
alienating 30
alienation 3–4, 17, 30–31, 135, 169, 176
Amit, V. 7, 22
Amselle, J.-L. 6, 22
Anholt Nation Brand Index 92
anthem 50, 52
Antiquities Court 33
Appadurai, A. 5, 13, 16, 22–22n5, 85, 86, 88–90, 221, 224
appeal to external sources 161
Appellation d'Origine Contrôlée (AOC) 14, 82
Appiah, A.K. 9, 10, 22, 93, 105, 106
apprivoisement 188
appropriation 9, 39, 41, 49, 52, 68, 200, 219
 reappropriation 15
Ariel 88
Archer, M.S. 47, 58
architecture 146–148, 150–151, 155, 182
 skyscrapers 147, 150
Arendt, H. 124, 126
art 1, 4–5, 8, 11–13, 69–70, 198, 202, 207
 avant-garde 134, 144
 colon 211, 213
 contemporary 19, 21, 128–129, 131, 133, 138, 211–214, 216–223
 contemporary artist 217–218, 221
 Cubism 133–134
 Cubists 135, 209
 Dadaists 133
 elite 135, 144
 exotic 128, 138
 Fauves 135
 folk, local 12, 19, 142, 144–147, 152–153, 155–157
 globalized 128
 Japanism 19, 135
 non-Western 128–129, 133, 135
 Orientalism 19, 135
 popular 213
 primitive 12, 145, 213
 Primitivism 19, 128, 129, 131, 133–135
 Primitivist 129, 133
 Surrealism 133, 135
 Surrealists 133, 135
 tourist 11, 213, 220
 traditional, vernacular 12, 213, 216–217, 219–220, 223n2
 tribal 133–135, 138
 true 219
 Western 19, 128–129,133–135
art-culture system 220
art dealer 13, 136, 143, 212–213
art history (Occidental) 216–221
art market 13
art school 207, 216
 education (Occidental) 216–217
 Institut National des Arts 219
 workshop schools 216–217, 219
art world 143, 162, 212–213, 217, 219–220, 222–223,224n5
 global 21, 212, 214, 223
 local 219
 Abidjan 219
 Dakar 219
 Western, European/North American 12–13, 131, 212–213, 215–222

artefact 1, 8, 10–11, 20, 31, 33, 71, 75–76, 102, 132, 135–137, 176, 179, 189, 193, 198, 207, 211, 220
artwork, work of art 5, 10, 12–13, 16, 47, 129, 153, 156, 209n1, 211–213, 216–223, 224n5
 ready-mades 12, 209
Assouline, P. 133, 139
Attfield, J. 202–203, 209
auction houses
 Christie's 223
 Sotheby's 223, 224n9
audience 38, 42, 48, 51–57, 66, 94, 102–103, 118–120, 125n6, 167–168, 201, 215, 222
aura 5, 44n7, 53, 163
Austin, J.L. 114, 122, 126
Austin, R.C. 70, 77
authenticate 14, 17, 46, 167
authenticating 12–14, 17, 46–47, 52, 54, 80
authentication 13–14, 16, 19, 21, 47, 50–51, 54–56, 80–82, 112, 122–124, 125n10, 221–222
authenticity
 from below 156
 claims of 8, 219
 construction of 87–88, 176
 cultural regimes of 211, 213, 218, 223
 culture of 10, 57, 115
 demands of 52
 discourse of 17, 47, 52
 dream of 6
 economy of 18, 78, 87, 224n8
 ethics 115
 existential 192
 experience of 19, 55, 75, 112, 117, 119, 122
 expressive 20–21, 161–162, 168–169, 192, 212–213, 218, 222
 features of 3
 gradation of 48
 idea of 11, 15, 19, 111, 175, 192, 216
 loss of 29, 163
 miracle of 54
 mythology of 94
 nominal 20, 161–162, 164, 168, 176, 212
 paradox of 3
 performance of 52, 54
 politics of 14, 16, 213
 production of 12
 relational quality of 2
 search of 15
 semantics of 87
 spectre 8
 system of 6, 198
 temples of 135
 zombies of 57
authorship 13, 44n3, 161, 212

bailaora 92–93, 98–100, 102
Baker, D. 207, 209
Banks, M. 6, 9, 20, 23, 95, 144, 158n1, 158, 160–171, 212
Bardem, J. 95
Barth, F. 6, 22, 47, 59, 196, 209
Bartley, B. 37–39, 44–45
Bascom, W. 12, 22
Basso, K. 66, 77
Bastide, R. 118
Bateson, G. 113–114, 124, 126
Bayart, J.-F. 86, 90
bayt 152
Beauvoir, S. de 134, 140
Becker, H. 18, 50, 54, 59, 65–66, 77
Bedford, E. 218
Beier, U. 213, 224
being unique 148
belief 2, 11, 47, 53, 55, 57, 66, 74, 112, 122, 139, 198, 201, 203, 206–207, 212
Bell, C. 163
Bendix, R. 3–5, 15, 22, 27, 44, 55, 112–113, 116, 123, 125n5, 126, 144, 158, 211, 222, 224
Benjamin, W. 5, 22, 43n7, 47, 59, 139n1, 139, 145, 156, 158, 163, 171
Berger, J. 95, 106
Berlanga, L.G. 95
Berman, B. 78, 90
Berman, D. 2, 4–5, 22, 27, 44
Berry, R. 51–52
biennale
 Dak'Art 218
 documenta 217
 Venice 207, 218
Bilmoria, M. 166
Bizet, G. 102
blood sausage 11, 18, 78–80
Boas, F. 5–6, 28, 44n5, 145, 158
Bohlman, P.V. 49, 59
Bonnain, R. 138, 140
Bonnier, Capt. 185
Boorman, J. 167, 171
border 16, 64–65, 74, 86, 103, 130, 146–147, 197
borderlands 65, 199, 201
Borau, J.L. 103, 106
Bourdieu, P. 7, 22, 203, 209

brand 14, 18, 92, 101, 105n4
branded 100, 219
bricolage 196
bricoleur 20, 200, 206
broussard 186
Bruly Bouabré, F. 218
Bryant, P. 91
Buddensieg, A. 223, 225
bull 97–101, 105, 106n16
bullfight 97–98, 100, 104
Bureau Arabe 185
Butman, J. 1, 24
Buvik, P. 130, 140

Caliban 88
camera 161, 164, 166–167, 170n5
Campbell, S. 218, 225
Candomblé 19, 111–112, 115–118, 120–124
capital 65, 71–72, 80, 86
capitalism 1, 5, 43n7, 65
capitalist 31–32, 44n7, 198
 machinery 50
 market 11
 mode of production 4
 ownership 32
 relations of production 138
 system 65
Carrithers, M. 47, 59
carver 130–132, 136, 139
carving(s), woodcarvings 130–131, 136–137, 152, 185
Castaneda, C. 7, 22
Catalan
 donkey 99, 101
 flag 99, 101, 105
catholicism 104, 118
catholic 70, 103, 118
Celticana 42
 Celtic 33–34, 42
 Celtic Tiger 37, 44n9
Centre de Recherche et de Documentation sur la Consommation 86
certificate 22n7, 79
certification 13–14, 87
Césaire, A. 214–215
Chabria, S. 164–165, 171
Chanoine 185
Chao, L. 133, 140
Chaplin, E. 102, 106n18, 106
character
 authentic 211
 biblical 67

fictional 95
inappropriate 16
manipulative 17, 58
moral 76
paradox 11
performative 114
primeval 72
primitive 11
Spanish 93, 102
characteristic 4, 10, 12, 16, 49, 55–56, 101, 103, 105, 135, 142, 147, 151
characterize 14, 16, 22n2, 64, 67, 69, 71, 111, 124, 212, 215, 217, 222
Cheikh Siddiyya 188
Cherry Orchard 36–39, 42
Church, F. 68–69
cinema
 Bollywood 167
 Hollywood 5, 94, 166–167
 Indian 164–166, 169
 mainstream 93, 96, 100, 102, 104–105, 105n7, 105n9
Cissé, C. 180
civilization 3, 4, 29, 34, 167, 194n7
 civilisation de l'universel 214
Clifford, J. 5–7, 10, 22, 91, 106, 125n10, 126, 170n2, 171, 198, 202, 209, 220, 224
Code, H. 94
Cohn, N. 51, 59
Cole, T. 69
colonialism 6, 20, 71, 175, 181, 193, 216
 anti-colonial 221
 colonial 9, 11, 16, 20, 34, 90n4, 164–167, 169, 175–180, 182–193, 194n2, 194n6, 198, 215–217, 221, 223
 colonialist 183, 190–191, 194n8
 colonizer 125n8, 199
 colonization 94–95, 125n10
 post-colonial 15, 21, 167, 212, 221
 pre-colonial 166, 215, 219
Comaroff, J. 2, 23, 224n4
commodity 11–15, 47, 71, 85, 87–88, 188, 202
 authentic 10–14
 mass 11, 14–15
communication 87, 113–115, 123–124, 185–187, 191
communion 54–56
Condominas, G. 130, 140
Confrérie des Chevaliers du Goûte-boudin de Mortagne 79, 82
Conklin, A.L. 190, 194
Conklin, B. 58

connoisseur, connoisseurship 1, 2, 138, 202, 223
consumer 1, 12–13, 16, 30, 50, 81, 83, 87–89, 106n4, 135, 170n8, 204
 society 1, 89
consumption 11–13, 15, 44n7, 53, 72, 75, 86–89, 198, 201, 203–204, 206, 208
 mass 10–11 13, 15, 79, 86–87
 media 53
Contemporary African Art Collection (CAAC) 214, 217–218, 222–223
contextualization, contextualized 13, 144, 146
 decontextualization, decontextualized 85, 175
 recontextualization 12, 15, 146, 220
continuity 6, 8, 19, 83, 86, 142, 144–145, 153, 155–157, 164, 167, 176, 179, 193
 discontinuity 19, 145, 157
Cook, T. 129
core 32–33, 37, 44n8, 58, 111, 113, 115, 120, 157, 212, 219
 cultural (culture) 21, 215, 222
 essentialist 9, 220
 existential 57
 inner 111–112, 115–116, 124
 moral 67
Cornet, J. 12, 23
cosmopolitanism 71, 134
Cottingley Fairy 161–162, 169, 170n7
Courbet, G. 83
Courtenay, J.B. de 48
craftsman, craftsmen 12, 15, 16, 152, 154–155, 206–207
craftsmanship 33
 carpenter 130–132, 152–153, 155–156
creativity 4, 17, 20, 28, 58, 144, 198, 206, 222
cuff 189, 192
cult 52–53, 70–72
cultural
 production 29–35, 42, 44n7, 71, 103, 105
 property 16
culturalism 17, 47
culture
 ancient Irish 35
 avant-garde 9, 15
 entertainment 22n9
 folk 49
 industry 44n7, 49
 mass 49–50
 material 2, 10, 12, 16, 32, 84, 135, 168, 201–202, 207, 211, 220
 national 9–10, 16, 36, 222
 popular 47, 49–50, 52–53
 pure and rooted 10
 regional 147, 157
 transcultural 221
Curtis, E. 162

Dahlhaus, C. 143, 159
Dalrymple, T. 37, 44
Dargan, W. 28–29, 34, 44n8
dark ages 88
Darnell, R. 28–29, 43n4, 44
Darnton, R. 42, 44
déafricanisé (de-Aficanised) 214–215
deceptive 46, 105, 143, 201
Demoiselles d'Avignon 133–134, 139
Derlon, B. 138, 140
desert 18, 63–65, 67, 73–76, 147, 187, 191
 Biblical 64
 Najd 147
 Sonoran 63–64
design 33, 54, 56, 132, 137, 142, 151, 157, 202, 206–208
designed 5, 41, 56, 84, 207
de-traditionalization 212, 215–216, 221
Deutch, M. 133, 140
Devès family 188, 190
Díes Puertas, E. 103, 107
Dilley, R. 8, 20, 175–195
Dilthey, W. 29
Diouf, I. 215
discourse 8, 21, 21n1, 47, 52, 75, 112, 124, 139, 144, 184, 217–218, 222
 of authenticity 17, 47
 collective 19
 emic 19, 112
 essentializing 47
 hegemonic 104
 indigenous 144
 local 157, 185
 marketing 132
 moral 18
 popular, public 18–19, 66, 144, 156
displaced 198
displacement 198
Disneyland 5
dissident 187, 190
 amusement park 154–155
 theme parks 15
diversity 7, 10, 14–15, 17, 21, 129, 156, 176
 cultural 10, 17, 21, 89, 213, 222
 regional 84
divinity 67–68, 76
 divine 67, 69–70, 163
diwan, mafraj 152

domestication 13, 86, 188–190
 domesticate(d) 88–86
Dostal, W. 145–146, 157–159
Douaire-Marsaudon, F. 134, 140
Doyle, R. 38
Duchamp, M. 209
Dumont, L. 116, 126
During, S. 49, 59
Durkheim, E. 29, 114–115
Dutton, D. 6, 13, 20, 23, 160–161, 168–169, 171, 212, 224
Dyer, R. 52, 53

École coloniale 185–186
ecstatic 55–56
Eisenstadt, S. 221, 224n6, 224
Elkins, J. 212, 220, 224
Ellen, R. 120, 126
Emerson 68, 70
Endangered Species Act 73–74
environment 13, 17–18, 37, 43, 64, 73–75, 90n3, 95, 183, 187–188, 191
environmental 66, 72, 74, 167, 170n11
environmentalism 64, 70
environmentalist 64
Enwonwu, B. 214–215, 224
Ereira, A. 167, 169, 171
Eriksen, T.H. 55, 59
Errington, S. 11–12, 14, 23, 139n1, 140, 211, 213, 223n2, 224
Escobar, A. 58–59
Espagne, M.188, 194
essence 12, 15, 18, 21, 46–47, 50, 57 117
essentialism 116
essentialist 9, 15, 17–18, 47, 176, 213, 220
essentialization 47, 72, 164
essentialized 66, 187
essentializing 17, 47, 57–58
essential(ly) 19, 43, 48, 114, 124, 167, 169
ethnogenesis 18, 78, 88–89
Evans-Pritchard, E.E. 2, 6, 23
évolués 57
exclusion 12, 17, 47, 55, 58, 220–221
exclusionism 17
exclusiveness 47
exclusivism 47, 55
exoticism 7, 20, 128–130, 133–135, 139n1, 197, 204, 209
 exotic 1–2, 14, 19, 27, 37, 39, 41, 88, 128–130, 133, 135, 138, 167, 201–203, 205–208
 exoticized 198, 203

expression
 artistic 4, 21, 214, 216, 222
 cultural 21
 of difference 205
 external 4, 8–9, 14–15
 free 4
 fundamental 16
 of an inner essence, of one's inner self, of something inner 117, 139
 natural 9
 radical 219
 stylistic 11
 true 9, 53, 212
 uncoordinated 9

Fabian, J. 6, 23, 28, 44, 57, 59, 192, 194n8, 195, 213, 224
fakatonga 137
fake 2, 11, 31, 43n6, 54–55, 78, 89n1, 138, 160, 168–169, 205, 220
faked 56, 81, 160, 162–163, 170n8, 212
faker 212
 unfaked 162
falsehood 29
 false 55, 66, 111, 125n8, 161
Feld, C. 50, 59
Feld, S. 66, 77
Feleti 132
Ferguson, J. 16, 23, 196–199, 209
fetish 17, 19, 31, 111–112, 120–121, 123–124, 125n8–n9, 143, 176
fetishism 47
Fields, K.E. 114, 126
Fillitz, T. 1–24, 211–225
film, movie 5, 16, 21n1, 38, 44n7, 49, 91–92, 94–96, 103–105, 138, 162–169, 170n9, 170n12, 198
filmmaker, movie maker 165–169, 170n11–n12
filmmaking 166–167
Fischler, C. 87, 90
Fisher, E. 98
Flam, J. 133, 140
flamenco 97, 101–102, 105
Fock, N. 111, 113, 115, 126–127
forged 103, 162
forger 168
forgery 18, 78, 103, 168, 212
form
 abstract 131
 of ancestry 91
 art 213–214
 of authentic engagement 189

of authenticity 52, 168–169
bodily 118
of certification 14
of circulation 220
collective, outer 111–112
of communication 114–115, 124
of consciousness 7
and content 19, 112–113, 117, 119–124, 125n8
crenellated 151
cultural 7, 31, 198–200
of decoration 157
of desire 134
of decoration 157
of ecstasy an catharsis 54
exotic 203
of exoticism 135
of experience 169
of explanation 189
of expression 114, 124
expressive 116
genuine 32
of 'Gypsy culture' 201
of identity 203
of image-content 114
of individualism 115
in itself 113
of inwardness 115
of knowledge 7, 13, 20, 175, 193
of language 160
of learning 186
of life 16, 134, 164
material 120–121
and performance 113
of pilgrimage 76
of racism 58
radical 209
of religions 112
of replicas 208
of reproduction 35
of simplification 133
of socialities 21, 119
standardized 187
stylistic 164
and substance 114
traditional 12, 164
verbal 177
visual 96, 161, 164
fortune telling 203, 205–206
Forum for African Art 218
Fosu, K. 213, 224
Fox, R.G. 7, 23

Francoism 104–105
Frankfurt School 88
fraternity 79–83
fraud 5
fraudulent 66, 160
Frith, S. 52, 54, 56–59
Frobenius, L. 11, 211
From The Heart of the World: The Elder Brothers' Warning 167, 169
Fromentin 129
Frontier 64, 67, 71
future
 doomed 88
 enlightened 88

Gaden, D. 180
Gaden, H. 20, 175–193, 194n2–n4, 194n6, 194n9
gadje 198–199, 203–208
Gaelic Revival 35, 42
Gallieni, General 184–185
Gaudibert, P. 213, 224
Gauguin, P. 7, 128–129, 133–135
gaze 166, 205, 211, 216
Gellner, E. 144, 159
genuineness 5, 27, 31, 36, 53, 211–212
 genuine 1–3, 8, 17, 20, 27–32, 35, 42–43, 43n5, 48, 55, 74, 88, 89n1, 92, 116, 131, 137, 139, 162, 212, 216, 219
 genuinely 7, 33, 42, 86
George, P. 91, 106n2
Gershwin (*Summertime*) 50
gestalting 114
Gibbons, L. 36, 44
Gide, A. 182
Gilbert, C. 79, 90
Gillett, C. 51, 59
Gingrich, A. 9, 19, 23, 142–159, 176
Giroux, H. 103
globalization 8, 16, 21, 85–86, 89, 128, 129, 136, 138, 157, 211
Göring, H. 168
Goffman, E. 113, 126
Goldberg, D.T. 55, 59
Golden Age 3–4, 134–135
Goldman, M. 111, 116, 120, 126
Goldwater, R. 133, 140
good and evil 18, 78, 87, 95
 genuine, real, and true 3
 good/true/beautiful 4, 9
 true and false, true versus false 55, 66
gorgios 20, 168, 198

Gosden, C. 202, 209
Gouraud, H. 193
Graburn, N. 211, 213, 224
Graeber, D. 191, 195
Gramsci, A. 30
Grau-Rebollo, J. 13, 18, 91–108
Great Dublin Exhibition 34, 35
Great Famine 32, 37
Griaule, M. 6
Griffiths, F. 162
Grossberg, L. 57, 59
gruppo folkoristico val Resia 49
guide
 museum 83
 touristic, travel 82–83, 93, 106n6
Gupta, A. 16, 23, 196–199, 209
Gutman, J. 164, 167, 171
Gypsy 12, 20, 57–58, 102, 122, 124, 134, 168, 196–209
 non-Gypsy 202–203, 205–209
 Roma 143, 196, 198–199, 201, 205, 208
 Traveller 39, 168, 199–200, 204, 206, 208
 Vlach 199–200
Gypsy objects
 antique China 207
 bowls 207
 crockery 207
 crystal ball 205–206
 cut glass vases 207
 flowers, paper and wax 203–204, 208
 gadje objects 208
 'gold' charms 205–206
 jewellery 208
 trailers 206–207
 wagons 202, 206–208

habitus 95, 114, 119–120, 123, 203
Hall, S. 50, 59
Hals, F. 168
Hammersley-Houlberg, M. 13, 23
hand-made, hand-make, 20, 135, 201, 203–205, 208
handicraft 33, 131–133, 203
 craft 34, 130–131, 136, 204
 handcrafted 206, 208
Hanganu, G. 163, 171
Hannerz, U. 7, 23
Harris, C. 163, 171
Harvey, D. 18, 65, 77
Hassan, S. 218, 225
Hastrup, K. 197, 210
Hebrew Calvinist 64, 67, 75

Hegel, G.W.F. 4, 23
Helias, P.-J. 36, 44
Hendry, J. 202, 209
Herder, J.G. 3–4, 9, 15, 116
 Herderian 125n5
heritage 5, 11, 49, 69, 83, 86–88, 156
 architectural 82
 authenticated 17
 culinary, gastronomic 82, 83
 cultural 86, 148
 national 82
heroin 36–37, 39
Hervik, P. 7, 23
Hetch Hetchy 70, 76n7
Hiller, S. 133, 140
Hills, M. 53, 59
Hobart, M. 190, 193n1, 195
Hobsbawm, E. 15, 23, 84, 89–90
Hoet, J. 217, 225
homeland 67, 76n6, 89n1, 198–199
homme naturel 3
horse 17, 30, 32, 36–42, 97, 199, 206–207
 Horse Protest 37, 40–41
Howe, J. 8, 23
Hroch, M. 42, 44
Hugo, V. 83
hybridity 20, 32, 177, 198, 200
 hybrid 20, 169, 197–198, 200
Hymes, D. 6, 23

ICOMOS 17
icon 18, 27, 32–33, 54, 69, 92, 96, 100–101, 104, 142, 156, 163
identification 13, 47, 54–55, 144, 156, 161, 212
Iggy Pop 51
ignorance 163, 177, 181–187, 190–192, 193n1, 194n8
image
 authentic 215, 217
 of authenticity 20
 ethnographic 162
 filmic 161
 image construction 204
 image content 20, 162–164, 169
 image as mediator 71
 image as object 20, 161, 169
 image subject 161, 164
 near-stereotyped 207
 photographic 160, 164, 193
 photomechanical 20, 161
 of the primitive character of African societies 11
 romantic 213

of social and cultural realities 6
visual 20, 71, 95, 102, 160–161, 179
In Rural Maharashtra 165
inalienable 11, 49, 87–88
inauthenticity 1, 20, 46, 52, 168–169, 211, 214–215, 220, 222
 inauthentic 2–3, 5–6, 13, 20, 29, 46–48, 50, 56–57, 66, 87–88, 117–118, 160–164, 168–169, 192, 220
inclusion 55, 220
index 32, 35, 39, 42
indigenous 19–20, 39, 58, 135, 144–145, 162, 168–169, 170n11, 180, 191, 198, 204
 non-indigenous 198
inner
 constitution 115
 core 111–112, 115–116, 124
 depth 115, 192
 essence 117
 feelings 112
 person 124
 qualities 4
 self 139
 state 4, 8–9, 14, 15
innovation 4, 7–8, 11, 17, 58, 88, 207
interpretative labour 191
Isma'ili 152, 155

Jackson, J. 10, 22n1, 23
Jackson, W.H. 70
Jaipur Maharaja 169
James, W. 29, 113, 125n3, 126
Jefferson, T. 50, 59
Jensen, T.G. 111–112, 118, 126
Jesus among the Doctors 168
Jeudy-Ballini, M. 138, 140
jewellery 17, 32–36, 39, 112, 208
Jewsiewicki, B. 213, 225
Johnson, R. 54
Jones, S. 57–59
Jules-Rosette, B. 213, 225
Junco, A. 97, 106n19, 107
Junghaus, T. 202, 209

Kasfir, S.L. 213, 215, 220, 225
Keating, T. 162
Keesing, R. 7, 23, 47, 59
Keil, C. 50, 59
Keim, C. 10–11, 24
Kertèsz-Wilkinson, I. 200, 209
Kierkegaard, S. 115
King, R.B. 7, 23

kingfisher (*sikota*) 135–137, 139
Kingsmen 51
Kirk, R.C. 55, 58–59
kitsch 5, 7, 31, 42, 53, 92
Klobb, Capt. 185
Knight, L. 205
knowledge practices 20, 175–178, 187, 191–193
Knowles, C. 202, 209
Koestlin, K. 49, 55, 59
Konaté, Y. 215, 225
Kopytoff, I. 87, 90
Kubrick, S. 91, 106n2

La Tiene 32
Lacan, J. 53, 59
landscape 4, 18, 46, 64–67, 69–70, 73, 75, 76n1, 76n6, 83–85, 103–104, 130, 135, 177–178, 183–185, 222
 American 69–70
 Biblical desert 64
 charismatic 67
 imaginary 55
 national 72
 natural 83, 135
 painting 69–70
 romantic 69
 sacred 64, 66–67, 73, 75
Lang, H. 11
language 4, 28, 43n5, 48–49, 54, 57–58, 73, 85–86, 88, 90n3, 114, 160, 178, 181, 183, 185–186, 188, 200–201
Laplantine, F. 130, 140
Lattier, C. 215
Laughing Cavalier 168
Leach, E. 196, 210
Leave No Trace 63–64, 73, 75
Lebeer, P. 214–215, 225
Lefèbvre, H. 18, 64–65, 77
legitimacy 8, 175–176, 191, 193
Leiris, M. 10, 23, 214–215, 219
Lévi-Strauss, C. 2, 23, 122, 126, 200, 209
Lieberman, L. 55, 58–59
lieux de mémoire 184
lifeworld 1, 10, 15–16, 114, 121, 124, 167
Liking, W. 213, 225
Lindholm, C. 2–3, 22n3, 23
Lipsitz, G. 57, 59
local population 148, 153, 176–178, 185, 187, 191
Lods, P. 216
Londsdale, J. 78, 90
longing 8–9, 12, 14–15, 21, 113, 135, 209, 215–216
 yearning 128–130, 133–135, 138

Lopati 130–131, 139n2
loss
 of aura 163
 of authenticity 29, 163
 of childhood innocence 169
 of control 55
 of faith 169
 of horses 42
 of prestige 185
 of purity of culture 198
Louie Louie 50–52
Lowie, R.H. 29, 45
Lukács, G. 30, 45
Lumière brothers 164–165
lyrics 51, 53

MacAloon, J. 113, 126
Madamba, F. 181, 194n5
Magiciens de la Terre 214, 217
Magnin, A. 214, 217–218, 222, 225
Malinowski, B. 2, 6–7, 23, 196, 201, 210
Malraux, A. 215
mamas 167–169
Marc, F. 135
Marcus, G. 5–7, 22–23, 139n1, 140, 170n2, 171, 202, 209, 220, 225
Maréchaux, P. and M. 150, 154
mariage à la mode de pays, country marriages 180, 194n6
market 1, 5, 14, 17, 30–31, 35, 39, 42, 44n7, 79–80, 89n1, 128, 130, 144, 156, 198, 205
 art 13, 130, 170n8, 223
 for authentic, authenticity 80, 87
 flee 14
 global capitalist, world 11, 89n1
 mass 31, 38
 state and 35, 42
 supermarket 14, 86–87
 tourist 92, 97, 105, 130
marketing 12, 14, 34, 58, 132, 201
marketplace 72, 79
Martin, J. 213, 225
Marx, K. 4, 30, 43, 47, 59, 86, 143
 Marxian 125n8
 Marxist 65
material
 core material 157
 cultural heritage 148
 economy 29, 31
 embodiment 209
 environment 43
 form 95, 120–121

 item, object, product, realization 19–20, 36, 42–43, 93, 112, 120, 123, 128–129, 163, 201–203, 205, 208–209, 222
 organic, local material 155
 practice 112
 production 30
 raw material 42, 49
 relationship 42
 representation 67, 139
 substance 112
 world 217
materiality 14, 111–113, 121, 123–124, 202
materialization 221
Matisse, H. 133
Mauss, M. 22n2, 23, 137, 140
 Maussian 208, 210
Mayberry-Lewis, D. 8, 23
M'Bokolo, E. 6, 22
McCrum E. 34, 45
McDermott, J. 68
McEvilley, T. 218, 225
McEwen, F. 216
meaning
 ambiguous 47
 authentic, *authéntës*, of authenticity 20, 125n1, 128, 142
 contemporary 10
 in content 113
 creation of, making, production 40, 121, 199
 cultural 152
 deep 49
 of diversity 14
 expressive 19, 144
 in form 113, 120
 of landscape, social space 64, 152
 local 42, 144
 multisemantic 143
 of music 56
 original 223
 patterns of 28
 political 101
 in practice 113
 primary 212
 public 43
 in ritual 114
 social 153
 theoretical 113
 vernacular 220
 of words 113
meaningful 29, 32, 39, 42–43, 113, 170n8, 203
meaningless 19, 112, 194n7
mela 166

memorial 34
 commemoration 37
 immemorial 80
 sites of 184
memory 104, 106n20, 131, 156, 161, 184, 192
métissage 20, 177
 métis 180, 188
Midas 205
migrants 64, 85–86, 199
 immigrants 64
Miller, D. 7, 23, 204–205, 210
Miller, P. 67, 77
mimesis 155
Minuteman 64
Mitchell, J.P. 113, 126
mode of production 3–4, 27, 30, 35, 37
modernity 6, 8–9, 15, 27, 29–30, 50, 115, 217, 222
 African 212, 216–219, 222
 Afrocentric 21, 222
 anti-modern 9, 15
 colonial 221
 critique 116
 deracinated and disenchanted 6, 27
 European 8, 10, 219
 inauthentic experience of 47
 individualism of 111
 local 216
 modern world 29, 39
 multiple 221, 224n6
 peak of 47
 postmodern 75–76, 111, 145
 pre-modern 15
 process of 221–222
 project of 15, 221
 representation of 214
 rise of 49
 Saudi 156
 spaces of 10
 suspicion of 36
 tradition and 21, 118
 vices of 116
 waxing star of 37
modernization 138
moral 18, 37, 64–67, 69, 72, 74–76, 76n1, 76n6, 87, 95, 115, 169, 194n7–n8
 burden 187
 construction of wilderness 65
 core 67
 destruction 75
 discourse of authenticity 18
 economy of authenticity 18, 78, 87, 224n8

entrepreneur 18, 65–67, 70, 72–73, 75
geography 18, 64–67, 73, 76
patterns 104
power 70
progress 183
purity of life 72
qualities 184
soul 71
valence 18, 64–65
views of the landscape 64
worlds 16
 immoral 72, 131
morality 115
morally 64, 75–76
Moran, E. 69–70
Morgan, M. 161, 170n3, 171
Mount, M. 213, 225
Muir, J. 70
Muršič, R. 17, 46–60, 78, 143, 211, 222
museification 82, 86
museum 10, 16, 34, 69, 82–83, 88, 125n10, 129, 135, 138, 201–202, 204, 211, 220, 223–224n4
music 17, 46–60, 129, 132, 143
 Afro-American 54
 authentic, authenticity of 48
 blues 51, 54, 57–58
 chamber 56
 classical 48, 57–58
 folk 35, 48–50, 57
 gypsy 57–58, 198, 200–201
 inauthentic 48, 50
 jazz 52, 54–58
 klezmer 57–58
 people's music 50
 popular 47–50, 52–55, 57–58
 power of 54, 56–57
 rap 47, 52, 56–58
 reggae 57–58
 rock 47, 50–55, 57
 traditional 48–49, 58
musician 28, 47, 49, 51–52, 54–58
Myers, F. 139n1, 140, 220, 225
mystique of action 186
myth
 of the artist as outsider 134
 of authenticity 89
 Celtic 42
 communal 54
 of origin 114
 of originality 51
mythic nation 68

mythical
 charter 197
 displacement 198
 drama 166
 epic 165
 film 169
 hero 52
 homeland 199
mythological 76n6, 165–166, 169
mythologized 28
mythology 16, 67
 of authenticity 94
 romantic 168

NARA 17
narrative 42, 169, 221
 Biblical 67
 contextual 168
 hegemonic 222
 imaginative cultural 56
 metanarrative 145
Nash, R. 67–68, 77
nation 4, 17, 32, 47, 49, 55, 64, 66–68, 71, 75, 85, 92, 97, 106n4, 116, 154, 156–157, 185
 nation-state 9, 16, 27, 36, 130
 nationhood 143
 and state 70, 86
national
 allegiance 89
 artistic expression 222
 audience 66
 authenticity 55
 borders 86
 brand 106n4
 character, characteristic, traits 85, 101, 103–104
 consciousness 42
 construction 76n6
 context 84
 dance 101
 depiction 36
 dimensions 223
 ensembles 89
 environment, landscapes 72, 74
 football (soccer) team 9, 101
 formations 47
 genius 4
 governments 223
 heritage 82
 history 118
 hit 51
 icon, symbols 99–100, 105
 identity 82, 97
 ideologies 16
 industries 84
 integration 156
 level 73, 86, 156
 magazines 81
 markets 89n1
 memory 156
 monuments 83
 organizations 18, 63–64
 parks 37, 65, 71
 polity 209
 pride 179
 railways company 89n1
 recognition 193
 redemptive zones 71
 Saudi statehood 19, 157
 simulacra 21n1
 spheres 157
 systems 14
 tradition 3
 treasures 168
 unity 9
 values 18, 96, 104
nationalism 9, 17, 47, 55, 84–85, 89
nationalist 35, 68–69, 71, 76n6, 84, 89, 101, 166–167
 transnational
 changes 196
 corporations, organizations 16, 21, 223
 forces 19, 157
 interconnections 15
 networks 21
 reasoning 145
 spheres 157
 theories 158
nature 63, 65, 67–72, 74, 76n3
 natural 8–9, 12, 14, 19, 27, 57–58, 65, 67, 71–74, 76n4, 83, 90n3, 114, 128–129, 131, 133–135, 145, 187
 naturalist 9
 naturalize, naturalizing 58
 naturally 75
 naturalness 114
Négritude 214, 219
NO-DO (*Noticiarios y Documentales Cinematográphicos*) 104, 106n20
Nolde, E. 135
nostalgia 134, 183
nostalgic 37, 93, 179
notable 187–188
Novak, B. 69, 77

objets culinaires non identifiés (OCNI) 87
Occidental
 art history, art historical discourse 216–221
 artist 216
 education 216–217
 modernism 214–216, 218–219, 221
 science 10
 standards 214
Ofa 132, 136–137, 139
Ogden, P. 40, 45
Oguibe, O. 217–218, 225
O'Hanlon, M. 202, 210
Oho 113
Okely, J. 12, 20, 122, 124, 168, 196–210
Olwig, K.F. 76n3, 77, 197, 210
Orientalism 19, 135, 204
Orientalist tradition 197
origin 6, 13, 82, 88, 152, 189, 212
 African 112, 218
 authentic, of the authenticity 1, 3, 8
 of the blood 80
 common 89
 confirmation of 161
 geographical 81
 historical 84
 Indian 197–199
 myth of 114
 places of 13–14, 212
 regions of 11
 tales of 114
original 14, 34, 111
 African religions 112
 authenticity of the 34
 Context 138, 220
 culture 10, 15
 design 132
 fieldwork 158n2
 glass plate 162
 inner state 15
 items 208
 meanings 220, 223
 negatives 170
 novel 91
 qualities 144
 shape 95
 source 94
 styles 204
 version 51
originality 51–53, 144
 artist's 144, 218
 authenticity and 202
 of black musicians 52
 criteria of 58
 inventive 200
 myth of 51
 uniqueness and 212
originally 34, 133, 188, 217
Orixas 111, 116–119, 121–122
orthodox church 163
Ortner, S. 134, 140, 199, 210

Paget, D. 94, 107
Paine, R. 122, 126
painting 15, 71, 76, 76n6, 128, 130, 133–135,
 155, 164, 168–169, 202, 205–207, 211
 landscape 69–70
 mural (Asir) 19, 142, 145, 147–148,
 151–154, 156–157
Palmer, S. 162
paradox 3, 11, 53, 87, 92, 120, 197, 201, 204
paradoxical(ly) 36, 39, 52, 118, 201
Parkin, F. 160, 171
Pasteur, L. 82–83
pastiche 201, 208
Pattie, D. 52–57, 59
Pechstein, M. 135
Pels, P. 120, 126
Pencil of Nature 163
performance 19, 51–56, 111–125, 125n2, 125n6,
 125n10, 139, 153, 205
Perron 85, 90
Phalke, D.G. 165–166, 169
Pharaohs 51
Philby, H. St J.B. 148, 159
Phillips, R. 144, 159, 198, 202, 210
photograph 6, 16, 20, 28, 40, 71, 88, 160,
 162–163, 165, 169, 170n8, 176, 179, 189,
 203, 207
 photographer 40, 70–71, 163–164, 170n8,
 179, 194n2
 photographic 160–161, 163–164, 167,
 170n6, 193
 pre-photographic 164, 167
 photography 16, 70, 161–164, 167, 169,
 170n5, 170n8
Picasso, P. 133–134, 139
picture 6, 13, 38, 75, 98, 102, 138, 162, 166,
 169, 192
Pietz, W. 120–121, 126
Pigozzi, J. 214, 217, 224n9
pilgrimage 18, 64, 68, 70–71, 76, 163, 189
 pilgrim 18, 64, 68, 70, 73, 75, 166
Pinney, C. 163–164, 167, 169, 171
place

African 219
 of art 222
 bounded 197
 in the cultural patrimony 29
 culturally constructed 76
 exotic 27
 false version of 66
 geographical 197, 209
 holy 70
 imagined 198, 200
 as isolate 199
 knowledge of 186
 natural 76n4
 non-Gypsy 197
 of origin 11, 13–14, 212
 out-of-the-way 39
 privileged 114
 remote 48
 resting 208
 rightful 97
 separate 199
 superb 183
 traditional 204
Plato 57, 59
Pocius, G.L. 135–136, 140
politics of the sugar loaf 188, 190, 194n10
politique des races 176
Pollock, J. 15
pollution 64, 203, 207–208
Porter, E. 71
possession 31–32, 87–88, 128, 205, 208
 alienable 32, 87–88
 inalienable 87–88
possession, spirit 19, 111–112, 116–117, 119–120, 125n7
 possessed 116, 119–123, 125n6
poverty 37, 41, 103
power of display 21, 221, 223
Predoehl, E. 50–52, 59
Premier Festival Mondial des Arts Nègres 213–214
Price, S. 13, 24, 138, 140, 212, 225
primitiveness 162, 170n11
 neo-primitivist 218
 neo-primitivising 217
 primitive 6, 11–12, 58, 72, 133–134, 145, 168, 170n11, 212–213, 223
 primitivizing 222
primordial 88, 197
property 16, 31, 44n7, 71, 75, 153, 176, 205, 208
Prospero 88
Protestant 65, 70
 Calvinist 67, 70
provenance 8, 13, 16, 44n3, 138, 161, 212
pure
 African culture 215
 authentic 10, 55, 134, 200
 bounded, homogenous 10, 215
 cultural formation 217
 and essentialized 66
 exploration of 167
 heart 70
 impurity 7, 153
 isolated 213
 nationhood 55
 and original 15
 and rooted 10
 sincere, real, natural 8, 135, 215
 and unadultared object 198
 unreachable tradition 221
purity
 celebration of 207
 cultural 17, 198, 213
 ethnic 143
 of the landscape 64
 of the physical body 9
 production of 222
 and violation 17, 31, 36
 of wife and home 72
 of wilderness 74

race 2, 27, 47, 55, 58, 164, 168, 176, 181, 194n9
 racial 102, 143, 176
 racism 17, 47, 52, 55, 58
 racist 39, 47, 182, 190
races and types 164
Raja Harishchandra 165
Rajadhyaksha, A. 166, 171
ranchers 64, 73–75
ranger 37, 73–74
Ranger, T. 15, 23, 84, 89
Rappaport, R. 114–115, 120, 126
Rapport, N. 47, 60
real
 Africans 214
 Americans 66
 authentic 18, 94
 authentic wilderness 66
 change 132
 enemy 70
 experience as/of 5, 116
 and fantastic 56
 flowers 204
 gods 115

gold 205
goods 203
grapes 81
group, people 5, 28, 170n3
Gypsy object 20
history 21n1
Ireland 66
kingfisher 139
magical power 205
natural, original, pure, sincere, valuable 8, 15, 11, 122, 148, 152, 215
relationship 128–129, 138
thing 4, 52, 117
scandal 125n8
Spaniards 104
study 134
tapa beater 139n2
and true 3, 11
unreal 53
world 143
realness 52, 119
Redfield, R. 144, 159
reflexivity 7, 16, 114–116, 120, 170n2, 221
 participant objectivation 7
 reflexive 7, 216, 222
 unreflexive 30
refraction 92, 94–96, 105, 106n7
regime 104
 of authenticity 213, 218, 223
 colonial 35, 187, 215, 221–222
 cultural 21, 211, 223
 of exclusion 17, 58
 of exploitation 216
 political 82
 scopic 213
 visual 95
Reich, W. 7, 24
reification 30, 47, 95, 105, 143
Reine and Serre episode190
Reis, J.J. 111, 126
relationality 221
representation
 of African societies 213
 analysis of 95
 authentic 6
 and authenticity 58
 control of 103
 crisis of 8, 160
 of culture (cultural) 10, 18, 105, 197
 erotic 131
 of exoticism 134
 of fluxes 85
 of form 169
 of the horse 32
 imaginative 213
 Indian 167
 of Ireland 36
 material 67, 139
 of modernity 214
 object of 163
 photograph as 162
 physical 176
 process of 95–96
 of ranching 75
 self- 166
 social 96
 of Spanishness 13
 of the state 16
 symbolic systems of 160
 values of 212
 visual 70–71, 102, 160
 of women 166–167
representational 163, 164
 battle 73
 device 104
 mode 164
 practices 163
 processes 94
 space 64
revolt against convention 9, 15
Rhodes, C. 134, 140
Riggs, M. 94, 106n18, 107
ritual 11, 19, 47, 54–57, 67, 111–124, 125n2, 125n10, 138–139, 152, 208, 217
Rivera, P. de 103
Roberts, S. 2, 23
Robinson, D. 188, 195
Rodríguez Mateos, A. 104, 106n20, 107
Romains-Desfossés, P. 216
romantic
 elegy 29
 end of an era 162
 Hollywood fiction 118
 ideal 186
 image of cultural purity 213
 landscapes 69
 movement 27
 mythology 118
 nationalism 76
 period and authenticity 115
 sense 29
 valuing 9
 vision 68
Romantics 27

Romanticism 68–69, 71, 85, 116
　　romanticized 67
root
　　of anthropology 3
　　authentic 9, 51, 125n1
　　of authenticity 94
　　black 51
　　family 188
　　of fetish 125n9
　　folk music 48
　　historical 111, 118
　　of a music style 58
　　of a people 55
　　philosophical 2
　　religious 70
　　rock n' roll 17, 47
　　in Romantic Movement 27
rooted
　　authenticity 58
　　culture 10, 196
　　experience 75
　　popular culture 47
　　popular music 57
　　practice of *Candomblé* 118
　　to be Spaniard 104
rootedness of life 125
Rorty, R. 6, 24
Rose, G. 102, 106n8, 107
Rosenberg, B. 49, 60
Rosselin, C. 80, 87, 90
Rousseau, J.J. 3–4, 9, 15
rural
　　African cultures 214–215
　　areas 206
　　cultures 219
　　folk art 153
　　horse 36
　　Ireland 36
　　life 36, 166, 215
　　and metropolitan 221
　　skyscraper 150
　　town 84
rurality 36

sahih 148
Sahlins, M. 6, 24
Said, E. 194n7, 195, 204, 210
Saint Cyr 178, 185
Sansi-Roca, R. 121, 126
Sapir, E. 17, 28–32, 35–36, 42–43, 44n4–5, 45
Saris, A.J. 1–24, 27–45, 125n8, 143, 176
Sartre, J.-P. 192

savage 2, 7, 57, 88, 133–134, 145
　　sauvages 57
Sayre, N.F. 73, 77
Schieffelin, E. 113, 120, 127
Schildkrout, E. 10–11, 24
Schippers, T. 55, 60
Segalen, V. 128–129, 140
Selwyn, T. 15, 24
semantic zones 220
Senghor, L.S. 214–215, 225
Shaw, R. 117, 123, 127
Sheridan, T.E. 65, 77
Shogo, O. 133, 140
short cut 216
Sieber, R. 13, 24
Silverman, C. 198, 201, 210
Silverstein, M. 1, 24
Simmel, G. 29
sincerity 53, 115, 119, 124–125, 144
　　sincere 8, 111, 115, 122
Singh, R. 169
singularization 13–14
Sjørslev, I. 19, 111–127
Smith, D. 202, 206, 210
Smith, T. 95, 107
Sobchak, V. 57
sociality 19, 57, 111–124
Soja, E. 18, 65, 77
Soulillou, J. 217, 225
Southern, T. 91, 106n2
souvenir
　　authentic 179
　　exotic 129
　　jewellery 34
　　market 105
　　popular 93
　　shops 93, 97
　　Spanish 18
　　Tongan 137
space
　　of authenticity 223
　　autonomous 199
　　conquest of 4
　　construction of 66
　　cultural 15, 200–201
　　encultured 197
　　entangled 212–213, 220–221, 223
　　of exhibition 217
　　gadje-dictated 207
　　heterogeneous 222
　　imaginative 183
　　interior 204

of interstices 10
intimidating 184
meaningful 39
of modernity 10, 212
natural 67
ownership of 38
performance 113
political 199
of poverty 37
of power 213
prestigious 217
public, domestic 71, 153, 166–167
representational 64, 166
scholarly 7
social 152
of social actors 10
social production of 65
wilderness as 75
Spanishness 13, 18, 92, 96–97, 102, 104
spatialization 16, 47
spectacularization 156
spiritual
 being 4
 essence 46, 57
 labour 31
 landscapes 104
 longing 113
 pilgrim 75
 power 169
 selves 30
 transcendence 9
 truth 9
 values of wilderness 64
spontaneity 53, 56
spurious 17, 27–32, 42–43, 43n5, 57, 88
Sreznevski, I.I. 48
star, stardom 52–53, 57
Starr, F. 11
state
 agencies 16
 boundaries of 86
 as broker 16
 custody 42
 disciplining power of 16
 failure of 65
 independent 9, 222
 institutions 16
 market and 35, 42
 meta-state 16
 modern 21
 order of 57
 people and 86
 production and 65
 production of 90n5
 representatives of 65
 spatialization of 16
 task of 16
Steiner, C. 13, 24, 144, 159, 198, 202, 210–212, 225
stereotype 85, 91, 93–94, 97, 105, 106n9
 stereotyped, stereotyping, near-stereotyped 162, 201, 207
 stereotypical(ly) 129
Stewart, C. 117, 123, 127
Stewart, M. 199, 210
Stocking 6, 8, 24, 28, 45
Stone, R. 103, 106n19, 108
Strajnar, J. 48–49, 60
Strinati, D. 49, 58, 60
studio
 film 165
 photographic 164
 photography 164
 portraiture 164
substance 112, 114
Sy, El Hadji 215
symbol
 American land 71
 architectural 154
 authentic 157
 of a bull 97
 of changes 157
 combination of 101
 of cultural separateness 209
 of family honour 162
 Gypsy 124, 207
 national 99, 105
 new meanings of 105
 public 75
 reinforced 157
symbolic
 act 55
 aspects 152
 associations 152
 character 76n1
 commonality 56
 demise 156
 density 188
 items, pieces 42, 135
 logic 152
 manifestation 187
 meaning 153
 order 156
 perspective 153

politics 66
practice 48, 55
referent 101
significance 65
social delimitation 55
status 156
system of representation 160
terrain 32
use 101
value 179
vehicle 36
symbolism 92
symbolization 95
symbolize 120, 201
syncretism 123
anti-syncretism 117
pre-syncretistic 112
syncretistic 112, 117–118
Szekely, K. 202, 209

Talbot, F. 163
Tall, Papa I. 215
Tara Brooch 33–34
Taussig, M. 199, 210
Tawadros, G. 218, 225
Taylor, C. 2, 9–10, 15, 24, 43, 45, 111, 115–116, 127, 192
Taylor, L. 18, 63–77, 167, 170n1, 171
Teale, E.W. 70, 77
terreiro 118
terroir 81, 84, 86–87
 produit de 81, 86
Tevita 131–132
The Beatles (*Yesterday*) 50
The Life of Christ 165
thing
 as-represented 94
 authentic 87, 111–112, 121, 124
 domestic 87
 essence of 21
 in-itself/themselves 94, 120, 161
 Irish 32, 35
 moored, unmoored 85–88
 museification of 82
 real 2, 4, 53, 117
 social biography of 87
 true to own nature 161
Thomas, D. 8, 24
Thoreau, H.D. 68
tiki 131, 138
Tocqueville, A. de 65
Tomasi 132, 137

Touré, S. 178, 194n2
tourism 83–84, 97, 166, 204
tourist 13–14, 18, 81, 83, 88, 92–93, 96–98, 100, 105, 106n4, 106n6, 119, 129–130, 138, 170n12
tourist industry 15
Townsley, G. 168, 171
tradition
 activity 207
 Afro-American 49
 architectural design 157
 artistic 130
 authentic 47, 49, 82, 89, 142
 continental 29
 continuity and 156
 cooking recipes 81
 cultivating 120
 cultural 7, 18, 65, 75, 142
 cultural values 216
 decorative 206
 destruction of 44n7
 disciplinary 18, 65–66
 evidence of 35
 experience 120
 folklorized 82
 form of life 164
 Gypsy 102, 203
 Herderian 125n5
 iconographic values 212
 idea of 39
 and identity 86
 image 169
 industrial 84
 invention of 15, 18, 78, 84, 89, 117
 Irish (authentic) 32, 42
 little and big 144
 local, regional 81, 84, 86, 89, 142, 155
 and modernity 21, 118
 music, songs 48–49, 58
 national 3
 new 207
 non-sedentarist 201
 nostalgic warning of 37
 old, ancient, antique 9, 79, 145, 199
 Orientalist 197
 Orixa, religious 117–118, 157
 patients of 164
 patterns 155
 place 204, 217
 Protestant 65
 reclaim a 42
 and renewal 120

of Romanticism 116
rural life 215, 219
of sausage manufacture 79
self-produced 32
and sociality 117
subsumed and dominated 7
uninterrupted 83
unreachable, pure 221
wagon 168, 206–208
well established 79
traditional(ly)
cultural context 13
folk art 142
objects 15, 39, 81
practice 37, 39
skyscrapers 147
Spain 92
stylistic and formal properties 164
traditionalist(s) 112, 117–123, 125n6
transaction 201, 203, 206
traveller (researcher) 4, 11, 161
Tribal and Folk Art Exhibition 14
Trilling, L. 2, 24, 43n2, 45
true to (one)self, true to life 4, 10, 15, 21, 27, 115, 160, 162, 168, 192
truth
authentic 54
as authenticity 53
claims 2
documentary 169
faked ethnographic 161
far from 92
of images 20, 102, 169
notion of 66
pre-existing 53
religious 9
revealed 53
of rock 'n' roll 53
truthfully 53–54
truthfulness 18, 78, 96
tufunga 131
Turner, F.J. 67, 77
Turner, I. and T. 51
Turner, V. 8–9, 24, 114, 120, 125n2, 127
typical(ly) 18, 37, 46, 56, 72, 75, 81, 91–93, 96–98, 101, 105, 132, 137, 152, 154, 217

Umbanda 112
UNESCO 17, 22n10, 24, 86, 198
uniqueness 147, 212
urban 36–38, 40–41, 44n9, 72, 79, 144, 209n1
métropole 193
metropolitan 163, 186, 207, 215, 221
suburban 17, 37–38
world cities 223
Urkaos 114

Val Resia 48–49
validation 8, 13, 53, 57, 206
valid 111
validate, invalidate 43, 53, 55, 201, 218
validity 1, 144, 212, 216, 219, 222
value
absolute 71
aesthetic 12
artistic 132
and authenticity 17, 175, 215
core 222
cultural 12–13, 15, 17, 20, 30, 93, 105, 176, 203, 212, 216, 223
economic 5, 11, 30, 36, 40, 42, 44n7, 80, 167, 170n1, 201
embodied 52
epistemological 89
generation of 175
hegemonic 103
historical 72
identity 105
modesty 134
national 18, 96, 104
non-Gypsy 199
non-utilitarian 30, 42, 46
and norms 9, 212
of objects 204, 207
Occidental modernism 221
sign- 175–176
of social life 16, 37, 212
socially sanctioned 1, 3
Spanish, Spanishness 92, 104
spiritual 64
symbolic 179
systems 212, 220
storage of 207
Van der Grijp, P. 7, 19, 128–141
Van Gogh, V. 211
Van Loon 47, 58
Van Meegeren, H. 162, 168
Verger, P. 118
Vermeer, J. 78, 162, 168–169
violation 17, 31, 36
visual
marker 148
trope 164
Volk 5, 116

Volkgeist 83, 85
voodoo 111, 125n7
Voulet 185

Wagner, R. 47, 60
wagon, caravan, trailer 168, 197, 202, 204, 206–208
Wahhabi 19, 154, 157, 158n4
Warnier, J.-P. 11, 13–14, 16, 18, 22n2, 24, 78–90, 175, 224n8
Waterhouse and Co. 34
way of life 4, 53, 93, 116
Weber, M. 29, 89–90
 Weberian 67
Weibel, P. 223, 225
Weiner, A. 88
Welsch, R. 202, 210
White, D.M. 49, 60
Whiteley, N. 212, 215, 221, 225
wilderness 18, 63–76

wilderness act 73, 77n9
wilderness groups 64, 73–75
willed-ness 119, 123
Willett, F. 12, 24
Williams, R. 50, 52, 60, 67, 77
Wilson, W.J. 37, 45
Wolf, E. 145, 159
wooden pillars (southern Hijaz) 19, 145, 147–148, 150–152, 155
world fair 32, 35
 Dublin 34
 London 33
Wright, E. 161–162
Wulff, H. 7, 24

Yee, J. 130, 141

Zaelani, R.A. 133, 141
Zahniser, W. 72